THE WALL OF RESPECT

EDITED BY

Abdul Alkalimat

Romi Crawford

Rebecca Zorach

OF RESPECT

Public Art and Black Liberation in 1960s Chicago

NORTHWESTERN UNIVERSITY PRESS

EVANSTON, ILLINOIS

Northwestern University Press
www.nupress.northwestern.edu

 An initiative of
the Terra Foundation
for American Art
exploring Chicago's
art and design legacy. Presenting Partner

Published with generous support from the Terra Foundation for American Art.

Publication is made possible in part by a gift from Elizabeth and Todd Warnock to the
Department of Art History at Northwestern University.

Printed in Canada

10 9 8 7 6 5 4 3 2 1

Library of Congress Cataloging-in-Publication Data

Names: Alkalimat, Abdul, editor, author. | Crawford, Romi, editor, author. | Zorach,
 Rebecca, 1969– editor, author.
Title: The Wall of Respect : public art and Black liberation in 1960s Chicago / edited
 by Abdul Alkalimat, Romi Crawford, and Rebecca Zorach.
Other titles: Wall of Respect (Northwestern University Press)
Description: Evanston, Illinois : Northwestern University Press, 2017. | Includes
 bibliographical references.
Identifiers: LCCN 2017020222 | ISBN 9780810135932 (pbk. : alk. paper) | ISBN
 9780810135949 (e-book)
Subjects: LCSH: Organization of Black American Culture—History. | Street art—
 Illinois—Chicago. | African American mural painting and decoration—20th century. |
 African American mural painting and decoration—Illinois—Chicago—History. |
 African American mural painting and decoration—Social aspects—Illinois—
 Chicago. | African American photography | Black Arts movement—Illinois—
 Chicago—History. | Civil rights movements—Illinois—Chicago—History. | African
 Americans—Illinois—Chicago—Social conditions—20th century. | Chicago (Ill.)—
 Social conditions—20th century.
Classification: LCC ND2639.3.A35 W35 2017 | DDC 751.7308996077311—dc23
LC record available at https://lccn.loc.gov/2017020222

For "the people"
who know themselves
as such

Contents

OBAC Documents

Black Arts Movement Articles

THE WALL OF RESPECT

The Wall of Respect — A Time Line

June 16, 1966	Black Power slogan raised in Mississippi March Against Fear
Winter 1966	Committee for the Arts founded in Chicago
March 19, 1967	OBAC (Organization of Black American Culture) founded
May 28, 1967	OBAC Inaugural Program
June and July, 1967	OBAC Visual Arts Workshop meets
August 5, 1967	Wall of Respect painting begins (scaffolding for upper sections was leased on August 11)
August 24, 1967	Wall of Respect painting completed at Forty-Third and Langley
August 27, 1967	Unveiling of the Wall of Respect
September 1967	"Statesmen" section is whitewashed, and a new version painted by Eugene "Eda" Wade
October 1, 1967	Dedication of the Wall of Respect
December 1967	*Ebony* magazine article about the Wall of Respect
Summer 1968	William Walker paints over the "Religion" section of the Wall of Respect with a new painting called "See, Listen, and Learn"
Summer 1968	Eda covers his version of the "Statesmen" section with new panels, including a Klansman
Summer 1969	William Walker paints "Peace and Salvation" over the "See, Listen, and Learn" section
Summer 1969	Wall of Truth mural begun across the street from the Wall of Respect
August 1969	Both buildings are slated for demolition, and the community rallies to save them
March 1971	Pieces of Wall of Truth are saved from demolition and moved to an outdoor installation at Malcolm X College
1971?	Wall of Respect building is damaged by fire
March 1972	Wall of Respect demolished with its building

Introduction

Abdul Alkalimat,
Romi Crawford, and
Rebecca Zorach

In August of 1967 a remarkable public artwork came into being before the eyes of residents of a neighborhood on the South Side of Chicago. That artwork, created by the Visual Arts Workshop of the Organization of Black American Culture (OBAC, pronounced *Oh-bah-see*), depicted Black heroes and was quickly dubbed the Wall of Respect. This book documents the history of the Wall from the planning stages to the many changes that occurred over the few short years of its life as an outdoor mural. The Wall created ripples around Chicago, the nation, and the world, but it has been studied surprisingly little by scholars in the fifty years since its creation. We hope to remedy this situation by allowing readers to enter into a wealth of original visual and textual documents presented here. With this volume, we invite researchers, students, teachers, and interested readers to grasp a key moment in the history of public art, the history of Chicago art, and African American history. The Wall offers a crucial case study in how public art can be a staging ground for debates about community and identity. With this book, we hope to shed light on the important role the arts played in defining the Black Liberation Movement in Chicago, and on how the mural generated artistic responses both nationally and internationally.

This book chronicles how the Visual Arts Workshop of OBAC—a collection of fourteen designers, photographers, painters, and others—designed and produced a mural in collaboration with Chicago's Black South Side communities. OBAC artists worked together to define the mural's seven themed sections, which showcased the portraits of such varied figures as Muddy Waters and W. E. B. Du Bois. Over the few years of its existence the Wall became a mirror

3

of the turbulent internal and external politics of the Black Liberation Movement. While the Wall was collectively and amicably developed in summer 1967, by October of that year conflict had developed that initiated a series of artist revisions, edits, and breakdowns in communication. Ultimately the Wall was torn down after damage by a fire in 1971. Virtually forgotten by the mainstream art world, the Wall nevertheless remained an important touchstone for local community members, artists involved in the Black Arts Movement, and muralists around the world.

The year 2017 marks the fiftieth anniversary of the Wall's completion. Over the years, a number of original participants have passed on, creating a new urgency to record the recollections of those who remain. Issues that were addressed in the Black Arts Movement have also increasingly come to the fore in the political consciousness of new generations, energizing the study of this period.

As coauthors of this volume, each of us brings specific backgrounds to bear on the task of understanding the many aspects of the Wall. We want to share these with you, each in our own voice.

Abdul Alkalimat

Art and politics have always been connected for my family and hence for my life, so it now seems quite natural that I would end up being in OBAC and part of the process that created the Wall. In the 1960s I served as both the chair of Chicago Area Friends of the Student Nonviolent Coordinating Committee (SNCC) and chair of OBAC, so while a graduate student in sociology at the University of Chicago I was an activist in the community. It is also true that I served as president of the Society for Social Research, a graduate student organization in sociology on campus. I was busy in the three realms of profession, politics, and culture.

The Wall moment was a great declaration of Black unity based on a collective process of self-determination. Many of us became a posse, a band of brothers and sisters who shared an awakening of cultural identity grounded in a politics of liberation. We shared music—the tunes of the late 1960s blasted our heads full of sounds that still keep us positive fifty years later, from Aretha to James Brown to John Coltrane. We read the trio of Richard Wright, James Baldwin, and Ralph Ellison with eager appetites and critical minds, always debating, taking positions, but learning from all the texts and all the debates. Yeah, we smoked a little bit, drank some, but always pursued our rising sense of being Black and beautiful.

There was a great deal of unity around the search for revolutionary politics, more than has been made public. The artists were always free thinkers, and in tune with the condition of the masses of people. As a young social scientist I dug hanging out with them more than with many of my academic peers. They were steeped in Black consciousness; militant, free thinkers; and very very hip in language, appearance, and attitude.

To capture what OBAC was about at a philosophical level, I coined the concept Black Experientialism. Our search for truth and beauty was to clarify for ourselves what were the actual experiences of Black people and to immerse ourselves in that. This was opposite to the racist negation of the Black experience as deviant and inferior. We set out to proclaim that Black beauty was not only our particularity of beauty but an open door to grasp the most abstract concept of beauty itself. We set out to challenge the Mona Lisa as the global standard.

The Wall was Black Experientialism in several respects: content, context, and commitment. The men and women depicted on the Wall were carefully chosen, debated, and vetted to be a representation of how we saw and understood heroism for Black people. The Forty-Third Street location could not have been more "down"—it was also known as "Muddy Waters Drive," given its reputation as part of a neighborhood where blues musicians lived and performed. And finally it was the commitment of the artists to volunteer their time and money to make it work. It was beautiful, located deep in a Black working-class neighborhood, and done by Black people themselves.

When the Wall was being painted and assembled, Joe Simpson (a fellow graduate student and member of OBAC) and I would frequently go down to the Wall and join in the process. In the middle of the process the first National Black Power Conference took place in Newark, New Jersey. Hoyt Fuller and I co-chaired the workshop there on Black professionals. Our Chicago process was part of the national movement. But shortly after the Wall was done many of us went our separate ways. I joined the faculty of Fisk University that fall, so I missed lots of the day-to-day process of how the Wall was a site of celebration and struggle. But I kept close to Hoyt Fuller, Jeff Donaldson, and others. At Fisk I continued discussions of Black art with such legendary figures as Aaron Douglas and David Driskell, who were then still on the Fisk faculty.

My involvement in this book project began in 2015, when I made a presentation to a conference at Northwestern University on the Wall of Respect. Discussions regarding art in the Black community have changed dramatically since the late 1960s. I was a voice from the past, exciting and refreshing for some, too Black and too militant for others. What knocked me out was the contact that came from Northwestern University Press, that they would be interested in a book on the Wall. I knew I wanted to be part of it and reached out to find col-

leagues for the project. This led to the collaboration among the three of us doing this book together.

The combination of our essays, the documents, and the photographs are a wonderful collection to document the Wall experience and to serve as a model for how many other moments of Black political culture can be studied and preserved for continued study in the years to come. This collaboration between myself, a veteran activist and social scientist, and two contemporary art historians has been a good experience for me, to share and to learn. My feelings were expressed at the end of one of our editorial meetings when we shared a group hug.

While I am not the same person I was in 1967, if given the opportunity, I would engage in an organization like OBAC and a project like the Wall again with as much energy and enthusiasm as I could muster. In fact one of the outcomes of this book, I hope, will be a new mural movement that can be inspired by and be created by the militants of the new affirmation and struggle that is Black Lives Matter.

Romi Crawford

It's difficult to teach, publish, or make exhibits on the Wall of Respect without the photographs that attest to its short-lived presence from 1967 to 1971. Because the Wall of Respect is such an exemplary case, reflecting the ethos of the Black Arts Movement and an overt Black aesthetics, it is hard even to teach or publish in these related areas without referring to photographic images of the Wall. There is no way to convey with words only the social, political, and artistic forms expressed at the Wall of Respect that are so daringly and unabashedly Black. Black beyond words one might say. For this reason it is important to include photographs among the compulsory texts and documents on the Wall of Respect that are gathered in this book. Like the other documents included here, they are important to the study of the Wall of Respect and also to examinations of American culture more generally. My interest in the work of the photographers who worked on, or at close proximity to, the Wall of Respect, including Billy Abernathy, Darryl Cowherd, Bob Crawford, Roy Lewis, Onikwa Bill Wallace, and Robert Sengstacke, has been ongoing for the past twenty years. In 1994 I opened (with Steve Sloan) a small art gallery, Crawford and Sloan Gallery, in New York. With an emphasis on Black photographers, it was conceived as an extension of my graduate school work on racial and ethnic aesthetics. The first exhibit, "Urban Style Politics," comprised photographs by my father, Bob Crawford, many of them taken in 1967 during events and programs at the Wall of Respect. The second exhibit was planned to be the work of his close friend, the photographer Billy Abernathy, best known for the book *In Our Terrible-*

ness, which paired his photographs with the writings of Amiri Baraka (LeRoi Jones). His wife, Sylvia Abernathy, who was responsible for the Wall of Respect layout, designed the book. In a last-minute hiccup Mr. Abernathy was not able to deliver the show. My father put me in contact with Roy Lewis, another member of this close-knit band of photographers, and together we scurried to pull together an exhibit of his work, "Tobacco Road," instead. Robert Sengstacke also showed in the gallery; he lent two works to a later group exhibit which showcased, among other works, selections from the 1973 *Black Photographers Annual*. In a sense I wanted to forge a space for this cohort of Black photographers whose work was lost between the currencies of documentation and art. The section of this book, "The Impact of Photography," has a similar function. It makes a place for the work of the Wall of Respect photographers who between them created a camera aesthetic from the tenets of OBAC. How OBAC principles were articulated through the form of photography has not to this point been elaborated.

Each of the Black photographers that I worked with in the mid '90s made his mark on or at the Wall of Respect. Roy Lewis, Robert Sengstacke, and Billy Abernathy (along with Darryl Cowherd) are in fact credited as Wall of Respect artists, meaning they each contributed photographs to the surface of the Wall itself. For the book I have gained access to the archives of three of the four photographers considered Wall of Respect artists: Darryl Cowherd, Roy Lewis, and Robert Sengstacke. Their work, as well as that of Bob Crawford, who joined the loose fraternity of Black photographers who worked at the Wall, will be highlighted and examined in "The Impact of Photography."

This section has two main agendas. One is to formally work photo-based documents into the study and interpretation of the Wall of Respect. The second agenda is to expose the vital import of photography as a form to the Wall of Respect. The stakes of this are tremendous. Photography is important not only because if offers a historical trace of the Wall. Evidence reveals that the Wall of Respect was designed and conceived with photography as well as paint in mind. Full disclosure of the significance of photography to the Wall of Respect helps in our understanding the full scope of the Wall of Respect in terms of its innovation. It was a multi-form site from its inception. The juxtaposition and layering of forms, such as paint and photographs, signals and even encourages the layering of additional forms such as music, poetry, and performance, which also took place at the site of the Wall.

Like my coauthors I was encouraged to think about the photographers affiliated with the Wall of Respect again after taking part in a public discussion on the topic. In spring 2015 the School of the Art Institute of Chicago (SAIC) as well as the Museum partnered with many other collaborators to produce a symposium entitled "The Wall of Respect and People's Art." It was a planning

meeting of sorts for the fiftieth-anniversary events for the Wall of Respect to take place in 2017. It was organized by my SAIC colleague Drea Howenstein and my coauthor Rebecca Zorach. There was a bit of fanfare on the first evening, with dignitaries in attendance including U.S. Representatives Danny Davis and Bobby Rush, SAIC President Walter Massey, and Tracie Hall, then Chicago's Deputy Commissioner of Arts and Culture. The poet Haki Madhubuti, who in 1967 (as Don L. Lee) wrote a poem titled "The Wall," was there, and, most importantly perhaps, several of the artists who contributed to the Wall of Respect, including Wadsworth Jarrell and Eugene "Eda" Wade. Also present were several of the Black photographers associated with the Wall of Respect, including Roy Lewis, Darryl Cowherd, Robert Crawford, and Robert Sengstacke. I was invited to give the opening address for this event (included here on pages 324–28), based on research I was conducting with the support of a Graham Foundation grant for a project called "Leaning into the City: The Photographs of Bob Crawford 1966–76."

Ironically, this project was meant to explore Bob Crawford's photo archive beyond the Wall of Respect images, but even as I investigated how people relate to the city on a haptic level, I realized and learned that many of the images that most effectively represented this were at the scene of the Wall of Respect and its dedication. In effect, I was looped back in to an investigation of the Wall of Respect in my research, but also at the symposium event, when I was, for the first time in many years, with a majority of the Black camera workers. There and then I realized how they helped to make the Wall literally and also how they helped to make the Wall what it is to us today. Their images of and on the Wall of Respect affirmed Black people unconditionally. Twenty years earlier these images spurred me on to a practice of making space for Black art and cultural matters. Making a place for them in this book is an absolute honor.

Rebecca Zorach

I was born in 1969, a daughter of white liberals whose experience of the 1960s was profoundly shaped by the Civil Rights Movement, even though they were not activists themselves. I grew up with stories of my dad's experiences doing biology fieldwork in the South in the wake of the murder of his Cornell classmate, Michael Schwerner, one of the three Congress of Racial Equality (CORE) workers killed by the KKK in Philadelphia, Mississippi. On the way to a medical appointment in Ithaca while pregnant with me, my mother heard reports on the radio of the armed Black students' occupation of Willard Straight Hall, where she had shaken Bobby Kennedy's hand the previous year. I absorbed these stories as a child. My parents later became active in local environmental politics—

they took me on my first antinuclear march when I was seven. They also made sure I had literature by Black authors and books about Black history when the schools I attended didn't teach it. We visited the Harriet Tubman home, we sat down together as a family to watch *Roots* on TV. Though I was drawn to European art in college and graduate school, it also seemed entirely right when I moved to Chicago that I would inform myself about the history of Black art here. And it was the great richness of the cultural history of the South Side, and the comparative lack of scholarly study of it, that compelled me to seek to help promote the spread of knowledge about it.

To anyone teaching activist art and public art on the South Side of Chicago, the Wall's legacy is unavoidable, even if it has not been prominent in mainstream art history. To me, when I began teaching at the University of Chicago, it was important to help students understand that the neighborhoods surrounding the campus—neighborhoods they were typically taught to avoid—had a deep and rich history of art and culture, as well as political struggle. The Wall of Respect is Black history, but that doesn't give non-Blacks license to be ignorant of it. More strikingly, talking with socially and politically engaged artists active today, I realized, too, that although they might superficially recognize the history of the Wall of Respect, they did not typically understand their work to be in dialogue with it. If they knew the Wall, they knew it mainly through a few iconic images—which, important as they are, did not tell the full story. Certainly the Wall was a visual representation of important Black men and women in many spheres of activity. It was about representation in more than one sense. But it was also about intervention, action, collaboration, tactics, and performance, and thus turns out to be a key precedent to contemporary activist art practices.

Thus I approach the Wall of Respect from a scholarly perspective, but with a sense of its profound importance to Black Chicago's political and social history, the Black Arts Movement, the national multiethnic Community Mural Movement, and histories of activist art in the broadest sense. My acquaintance with the Wall has deepened over time in a number of ways. As plans came together for a series of events to commemorate the fiftieth anniversary of the Wall's production, Brother Mark Elder of DePaul University contacted Faheem Majeed, former director of the South Side Community Art Center, who, knowing my research on Chicago's Black Arts Movement, put him in touch with me, and I joined in conversations about the planning process. Among the key themes were a need to generate new research on the Wall and its legacy, and a desire to bring the Wall to new audiences and think about the continuing relevance of this history to the present.

Meanwhile, together with the artist-organizer Daniel Tucker, I was developing an archiving project, Never The Same, that assembled interviews and ephemera relating to socially and politically engaged art practices in Chicago

since the 1960s. In the course of research for Never The Same I sought out some key figures in the Black Arts Movement and Chicago's Community Mural Movement. These included Robert Abbott "Bobby" Sengstacke, whose iconic photograph is perhaps the best and most comprehensive view of the first state of the Wall and indeed has come to stand in for it (that first state existed, complete, for less than a month); Mark Rogovin, whose Public Art Workshop included both a community mural painting workshop and a comprehensive slide archive of the local, national, and international mural movements; and Georg Stahl, who extensively photographed and documented murals in Chicago and taught classes on them at the School of the Art Institute of Chicago in the 1970s. They made images available for scanning by the Visual Resources Center of the University of Chicago (located at http://sengstacke-archive.lib.uchicago.edu, http://pawma.lib.uchicago.edu, and http://stahl-collection.lib.uchicago.edu). The VRC continues to scan images of relevance to research on the Wall and the broader mural movement. This work has facilitated the election and compilation of images for the present volume.

As part of the anniversary planning process, I worked with Drea Howenstein, an artist and faculty member at the School of the Art Institute of Chicago, to organize a panel at the College Art Association meeting in Chicago in 2013. Our speakers were muralists Bernard Williams and John Pitman Weber, artist-educator Nicole Marroquin, and OBAC cofounder Abdul Alkalimat. The quality of the panel was excellent and it was well received, but we knew even at the time that the audience was too restricted—a professional conference with a very steep cost of admission. So we set about planning a public conference. This occurred at the School of the Art Institute, with support from many sponsors—chiefly the Terra Foundation, but also the University of Chicago's Smart Museum and Center for the Study of Race, Politics, and Culture—in April 2015. It is largely thanks to Drea's heroic efforts that this event was brought off. It was a challenge to bring together the surviving artists—original artists as well as later contributors—and ask them to speak to one another. It was a tough event in many ways. Fireworks that erupted included a challenge to the legitimacy of our organizing the event at all, as two white women representing largely white institutions, as well as vehement disagreements among participants about both basic facts of chronology and more philosophical matters of interpretation. It was our hope that articulating these concerns would clear the air to enable events commemorating the anniversary of the Wall to move forward less gingerly, more substantively. When Abdul asked me to join in the project of this volume, it made sense to contribute material generated as part of the conference, conversations and interviews, as well as the outcome of related archival research, and I happily agreed. Curatorial research for an exhibition at the Smart and DuSable Museums has also contributed to the documents we present here, and I acknowledge the work of Marissa Baker in tracking down materials as well.

I have had several constituencies in mind as I assembled materials for the fifth section of this book: students and artists as well as scholars and members of the general public. In a certain sense the choices are obvious. My aim was to gather and reprint contemporary responses to the Wall, whether journalistic or poetic, as well as later texts that help make sense of the divergent viewpoints on the Wall. These later texts include essays, portions of interviews, and transcripts of recorded conversations. In addition, my essay "Conflict and Change on the Wall" will provide an overview of responses to the Wall and help contextualize the selection of texts that together constitute "Reverberations."

This Book

The historical documents, interviews, essays, and images assembled here have never been published together in one place; some have never been published at all. We include a set of OBAC's founding documents, largely unpublished and mainly drawn from Abdul Alkalimat's personal archive, with a few from the Jeff Donaldson collection of materials at the Archives of American Art in Washington, D.C. We also include published but hard-to-find items, including early articles from *Negro Digest* (which later became *Black World*), along with a key theoretical statement on the Black aesthetic by its editor, Hoyt Fuller Jr., who cofounded OBAC, and articles from the *Chicago Defender* and *Ebony* magazine. We also include poems written about the Wall at the time of its creation, as well as later essays, interviews, and roundtable discussions with artists who were involved in creating the Wall. Finally, one of the core contributions of this book is its selection of photographs that represent the planning, making, unveiling, reception, and changing state of the Wall. They document the Wall and its community, but they also document the work of the photographers themselves.

Full of vivid detail, these primary documents can facilitate research for undergraduate and graduate level work. They enable the Wall to be studied with unprecedented historical rigor. They present a comprehensive account of the making of the Wall and the responses to it, but they also allow readers points of entry for their own investigations, inviting a critical reflection on controversies and debates surrounding the Wall. In the newly written essays that follow, we provide general summations and critical perspectives. We address historical and political context as well as the Wall's painters, the poets and performers for whom the Wall was an inspiration and platform, and, importantly, the photographers who played such an important role in the Wall and its evolution; their work was included on the Wall alongside painted portions, they documented the appearance of the Wall in its several states, they observed and interacted with the community, and they shaped the very concepts of community and art for the period.

The book proceeds as follows. In the first section, Rebecca Zorach's essay "Painters, Poets, and Performance: Looking at the Wall of Respect" studies the visual appearance of the Wall in its initial form, addressing the painters' individual styles, their focus on performance, and the performances—poetic, musical, and dramatic—that "spilled out" beyond the bounds of the Wall's visual form. Four poems written as immediate responses to the Wall follow. The next section, "Heroes and Heroines," presents detailed images of each section of the Wall along with short biographies of the heroes depicted there and the artists who created these depictions. The third section, "The Wall in History and Cultural Politics," opens with two essays by Abdul Alkalimat framing the significance of the Wall within the broader Black Liberation struggle in Chicago, and recounting the beginnings of OBAC and how the Wall of Respect became the organization's opening artistic salvo. An array of primary documents of OBAC's early years follows, many of them drawn from Alkalimat's personal archive, as well as articles that constituted some of the earliest public presentations of OBAC's principles and early activities. The fourth section, "The Impact of Photography," includes Romi Crawford's essay "Black Photographers Who Take Black Pictures," which establishes and explores the centrality of photography to the Wall of Respect and how we make meaning of it today. The section also features "Camera Works and the Wall of Respect," Crawford's selection and categorization of photographs by many of the key photographers involved in the Wall's creation and representation, with photography understood as an art form unto itself, related to but distinct from the function of documenting the mural. The fifth and final section, "Reverberations," includes Zorach's essay on the changes made to the Wall, and the conflicts they generated. The last section also gathers together essays, both journalistic and scholarly, that responded to the Wall and to these conflicts, in its own time and beyond, concluding with recent reflections by several of the creators of the Wall.

This book can be read in many ways. It can contribute to curricula in at least three fields: Black studies, art history, and Chicago history. There are many uses of this book in Black studies that all converge on the militant Black Power Movement of the 1960s. This is the origin of the Black Arts Movement and its relationship to popular culture, art, and politics. It will add to and complicate art history's understanding of the visual arts in the late 1960s—so long studied from the point of view of that particular province called New York City, and often excluding Black artists, especially those who worked in concert with the political aims of Black Power. The Wall was not only a two-dimensional representational artwork, but a major intervention into street and community life, a participatory project that foreshadows many of the preoccupations of later artists working in "social practice" and related fields. It recenters the visual arts of the Black Arts Movement squarely in Chicago. Finally, it enlarges upon

an important moment in Chicago's history that is often alluded to but rarely studied at this level of detail.

In addition to this book, the editors curated the first sizable exhibition on the Wall of Respect. Held at the Chicago Cultural Center from February 25 through July 30, 2017, "The Wall of Respect: Shards, Vestiges, and the Legacy of Black Power" brought together for the first time rare OBAC documents and photographs relating to it, including a photo fragment by Darryl Cowherd, the only existing piece of the original Wall of Respect mural. Other exhibitions and events have commemorated the anniversary year of 2017 and have built on growing attention to and renewed interest in studying and sharing the history of the Black Power era and Black Arts Movement. As the Wall receives the scholarly attention and worldwide public acclaim that is its due, we offer this book as a starting point for discussion and inspiration, both artistic and political.

Note

As the Black Arts Movement and the Black Liberation Movement unfolded, people got creative with their birth names. They flipped these "slave names" in various ways or adopted new names altogether. In my case, McWorter (son of word) became ibn Alkalimat (son of word), later shortened to simply Alkalimat. Other examples are Lew Alcindor, who became known as Kareem Abdul-Jabbar, or LeRoi Jones, better known as Amiri Baraka. To communicate this to today's audience and to help with research and identification, in this volume we typically follow the usage of the time in the first instance, followed by alternative names in parentheses. —Abdul Alkalimat

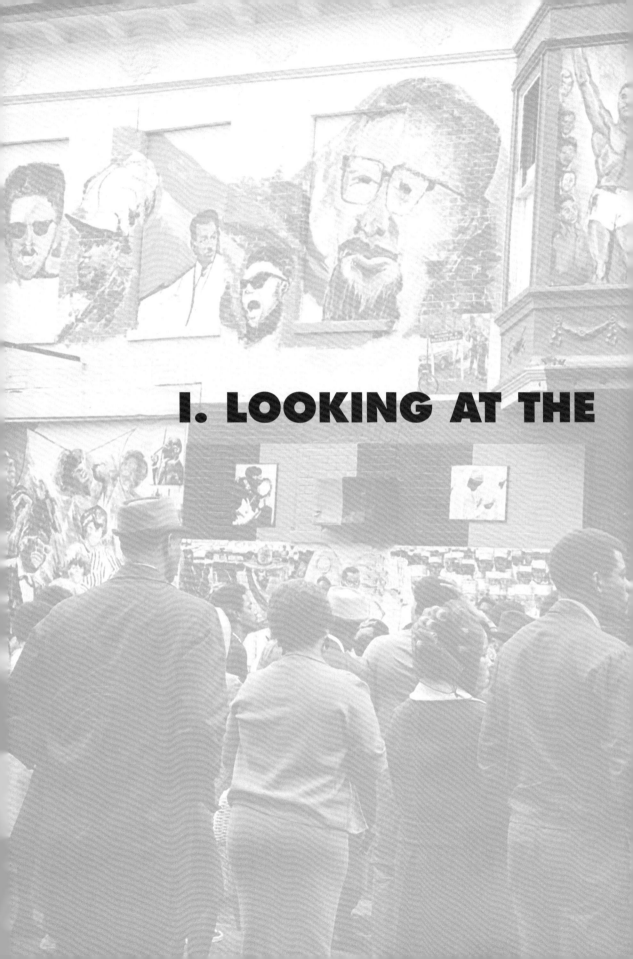

I. LOOKING AT THE

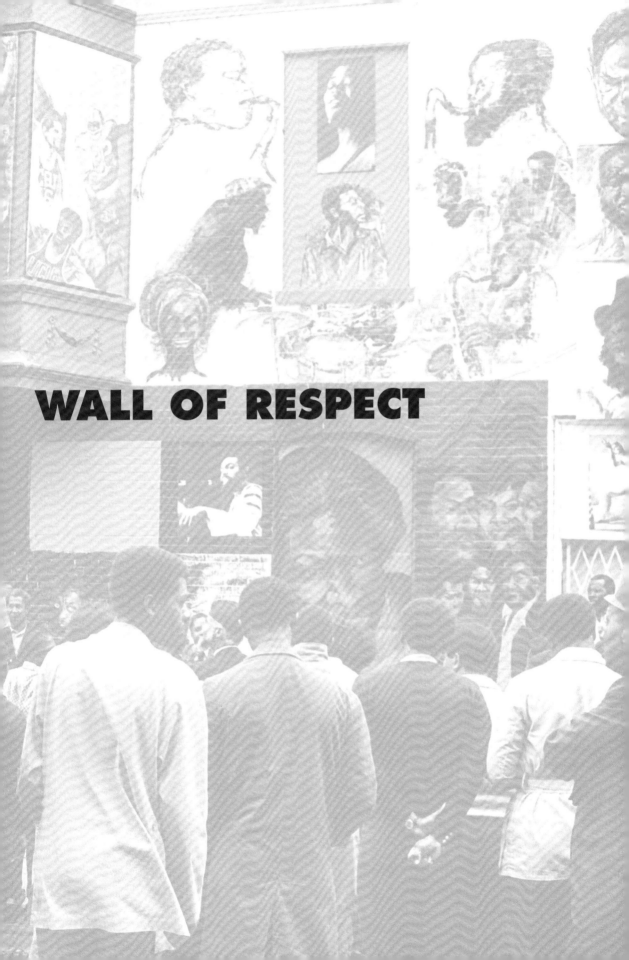

WALL OF RESPECT

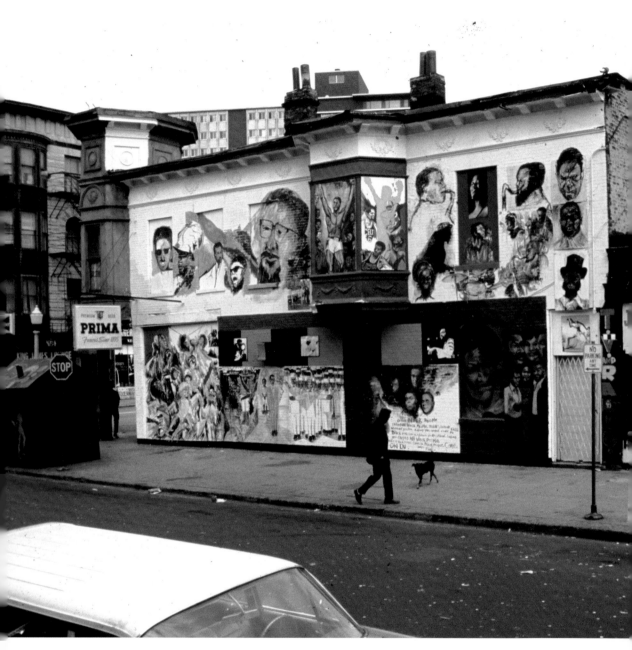

The Wall of Respect. Copyright © Robert A. Sengstacke, 1967.

Painters, Poets, and Performance: Looking at the Wall of Respect

Rebecca Zorach

In his essay "Public Art That Inspires: Public Art That Informs," artist Seitu Jones describes visiting the Wall of Respect with his grandfather in 1968:

> It was not listed on any official travel brochures as a must-see attraction, but it was a stop that many Black people made while visiting Chicago. My grand-father first showed me the wall; it was in the neighborhood where he grew up. It was a symbol of pride pointed to as a ray of hope by residents of the South Side like my grandfather. Whenever I visited the Wall, there were always other African-American visitors there as well, coming to a modern-day shrine.[1]

Jones—as impressed by the effects on the community as he is by the mural—went on to become an artist and muralist himself, and he describes this early experience with the Wall of Respect as part of his inspiration. There are many such stories—of people who were energized to make art of their own, to organize collectively, to know Black history, to feel good about themselves. William Walker, in the interview he did with Victor Sorell (included in this

volume), described an interaction that took place at the Wall: "I saw a young man sitting . . . in front of the Wall. His back was just resting. He was resting on the Wall. So I said, 'How are you doing, brother?' He said 'I'm getting my strength.'" Many individuals who witnessed the Wall and went on to have careers in the arts—in or outside Chicago—speak with reverence of this moment. Members of the church across the street I bumped into while bringing a group to look at the (now utterly transformed) site spoke fondly of it. People who happened upon it were obviously amazed (as can be seen in Robert Sengstacke's photograph of a cab driver stopping to marvel at the sight). When I co-organized a conference on the Wall held at the School of the Art Institute of Chicago in spring 2015, the roster of speakers kept growing—eventually becoming almost unmanageable—because so many people felt such a strong connection to the Wall and its moment.

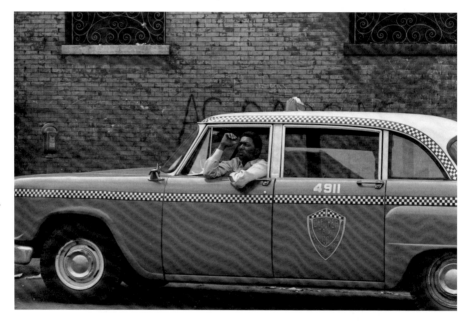

Cab driver viewing the Wall of Respect. Copyright © Robert A. Sengstacke, 1967.

This impact reflects the intervention the Wall made into the visual space of its neighborhood by its very presence as a mural, but also because of the activities that went on around it. These activities are richly documented in the many pictures of the neighborhood taken by street photographers (to be discussed in Romi Crawford's essay). This essay attempts to provide an introduction to what the Wall looked like as an object, but also to expand from that object to what it put into motion. Elsewhere in this volume, we consider the political context in which the Wall was created and the organizational energies that brought it about. We also address in more detail the conflicts that arose as the Wall was

altered, first early in its existence, and then again over the four years it stood on the corner of Forty-Third and Langley. I will begin by analyzing the differing approaches taken by painters of the various sections of the Wall, then move to considering it as a collective performance and as a visual intervention that spawned many and varied performances.

The Visual Structure of the Wall

The artists of OBAC were able to draw inspiration from an older generation of African American artists who had painted murals. A burst of mural activity had occurred in the decade of the Great Depression, supported largely by the WPA, which sponsored several mural projects by African American artists. In the 1930s and '40s, Hale Woodruff and Charles White studied mural painting in Mexico with the Mexican muralists Diego Rivera and David Siqueiros. Like Aaron Douglas, Woodruff and White painted important indoor murals at historically Black colleges and universities (Fisk, Talladega, and Howard, in particular). Mexico provided inspiration through ambitious outdoor murals, of which there were few examples in the United States.

William Walker with Sylvia Abernathy's design for the Wall of Respect at OBAC meeting, 1967. Copyright © Robert A. Sengstacke, 1967.

William Walker himself had painted murals in Columbus, Nashville, and Memphis in the 1950s, but none of the other artists had painted murals on a large scale before they took up the project of the Wall.[2] This project represented a major practical challenge to the artists. By their very nature, murals—especially street murals—are often collaborative. It typically takes more than one painter to plan and realize a large-scale mural. Its presence on the street calls for community involvement: neighbors feel they have a stake in what their neighborhood looks like, and children (or even adults) who wander by ask how they can help. As community mural painting has evolved, typically one or a small number of artists take the lead, with community members involved in defining themes and imagery, lead artists directing the development of the overall composition, and assistant painters performing defined subtasks. The project of the Wall of Respect assembled fourteen artists who were accustomed to working alone in a studio and asked them to collaborate on a shared political project. The fact that they were a collection of individuals creating the representation of another collection of individuals could have made for a very chaotic visual impression. To solve this problem, the artists proposed designs for the Wall's overall compositional structure and settled on the one created by Sylvia Abernathy (see page 19), a designer trained at the Illinois Institute of Technology. She proposed an overall pattern of blocks of color that divided up the sections and provided their backgrounds.

Thus, the Wall's overall composition was an abstract one suggestive of collage. Unlike many murals, it was not composed of a sequence of historical vignettes, nor was it a unified representational field. Within this structure, each painter worked in his or her own style on the Wall. None of them worked in the social realist narrative painting style that characterized most of the murals any of them might have seen (whether by African American, Mexican, or other artists). Elliott Hunter had previously painted in an abstract style that could be called Abstract Expressionist. Wadsworth Jarrell painted landscapes and streetscapes in vivid, Fauve-inspired, broad parallel strokes of color. Jeff Donaldson painted figures in an impressionistic style that made brilliant use of negative space. There was no imperative to achieve stylistic unity in their representation of the figures, and painters used their own, quite diverse approaches.

The Wall was not simply a static wall of portraits. Many of the figures were represented in action—in the activities that reflected their areas of achievement —and in interaction with one another. In some of the strongest sections, figures come together in performances that echo the collective performance of the muralists themselves. For example, on the left side of the lower register, Wadsworth Jarrell, painting the "Rhythm and Blues" section, stacked figures in an animated space, hinting at a collective performance (see page 26). Setting bodies in rhythmic motion, he created a dynamic vision of the centrality of music to the Black

Aesthetic. Jarrell worked with base wall colors split between red and white, and skillfully used dark and light values in his figures to maintain a high contrast with the background. The decorative stripes of the Marvelettes' outfits echoed in the densely packed rhythmic stripes that made up the other figures, with similar lyrical strokes suggesting a dark cityscape.

To the right of the "Rhythm and Blues" section was "Religion" (see page 26). OBAC's own radical politics are reflected in the relatively small number of religious figures the artists chose to place on the Wall. The list Jeff Donaldson and Geneva Smitherman Donaldson published in their essay "Upside the Wall" includes only Albert Cleage, Elijah Muhammad, and Nat Turner (who is known for leading a slave insurrection but was also a popular religious leader), and two photographs by Robert Sengstacke. Walker's approach emphasizes the group: the individual personalities he depicted stand before religious populations they lead and represent, many of them appearing in the parallel, pared-down profile series that would become a hallmark of Walker's murals. Nat Turner leads a group of freedom fighters, while Elijah Muhammad, in the original design, stood at the head of a group of men in Muslim garb. The central section, figuring Wyatt Tee Walker, is less clear and not as overtly heroic. Walker, a pastor and former executive director of the SCLC, stands with his arms at his sides. Behind him are a boy clad in tattered clothing who appears in a church-like space, and a series of horizontal faces in profile laid one on top of the other (perhaps slain Civil Rights workers?). Sengstacke's photographs take a different approach: in the context of a wall of heroes, these photos lend heroic character to anonymous young women. A photograph taken at a neighborhood storefront church displays two girls playing the tambourine. The second, *Spiritual Grace*, presents a young Muslim woman in prayer; it happens that she was a granddaughter of Elijah Muhammad.[3]

In Edward Christmas's masterful "Literature" section, he established a precedent for future Black murals in Chicago by including poetry: lines from LeRoi Jones's "SOS—Calling All Black People." (LeRoi Jones [Amiri Baraka] was also represented in a photograph, above the painted section, by Darryl Cowherd.)

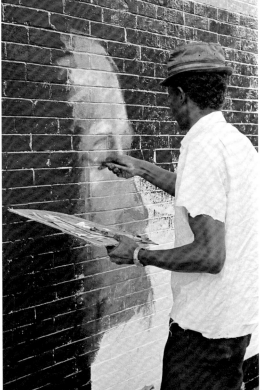

Edward Christmas painting W. E. B. Du Bois, 1967.
Copyright © Darryl Cowherd.

21

Painted directly on the wall at the left side of the section, as if overseeing it, is a large profile face of W. E. B. Du Bois; Christmas appears painting it, palette in hand, in several photographs by Darryl Cowherd. Floating in a cloud of black, above the poem painted in black on white, were rounded panels bearing portraits of Gwendolyn Brooks, John Oliver Killens, Lerone Bennett, and James Baldwin. Though presented at different scales and with different orientations, the writers' faces are unified by the black background from which they emerge. To the right of the "Literature" figures, Barbara Jones (later Jones-Hogu) carefully plotted the arrangement of the figures with preparatory drawings. She gave a dominant presence to the figure of actress Claudia McNeil, devoting the much larger space of a boarded-up window opening to her face. She posed the rest of her solid "Theater" figures in two triads—Oscar Brown Jr., Ruby Dee, and Ossie Davis above, and Sidney Poitier, Cicely Tyson, and James Earl Jones below.[4] In this conversational arrangement, the figures stand out dramatically against the red background of her section of wall. (The triadic composition also anticipates other triads of figures in Jones-Hogu's work, such as her powerful silkscreen *Rise and Take Control*, made in 1971. Like Donaldson and Jarrell, Jones-Hogu was a founding member of the important Black Arts Movement artists' group, AfriCOBRA. In her print, she uses the triad of faces to suggest the AfriCOBRA principles of addressing past, present, and future.)

Above the "Theater" section, in "Jazz," Donaldson and Hunter combined expressive portrait heads with figures in action. In an active scene at its core, figures engage visibly and dynamically with one another, as well as with the viewer's space. Miles Davis, Charles Mingus, and Sonny Rollins play together as if performing in an ensemble; Max Roach's oversized hand crosses the boundary of the window frame he sits in, extending outward to the wall's bricks and beyond as he plays his drums. The tilt of his head mirrors Sarah Vaughan's in the photograph by Billy Abernathy above him. Around this ensemble scene painted by Donaldson, Hunter arranged a collection of independent portraits. Hunter painted the three on the right edge of the mural—John Coltrane, Elvin Jones, and Ornette Coleman—on removable panels. They overlap the edges of these panels, extending onto the wall's bricks and onto one another. A 1970 photograph of the right side of the Wall (page 65) shows a wreath placed just to their right, a memorial for Hunter, who died that year. Signatures added after the mural's unveiling by the three artists who worked on the section—Abernathy, Donaldson, and Hunter—are also visible.

On the smaller but visually prominent area of the second-story oriel window, Myrna Weaver was slated to do the "Sports" section with photographer Onikwa Mugwana (originally named Bill Wallace). Mugwana had been involved in the OBAC Visual Artists' initial conversations, but, as Walker later put it, he "dropped out of sight" because his political activities were drawing police attention.

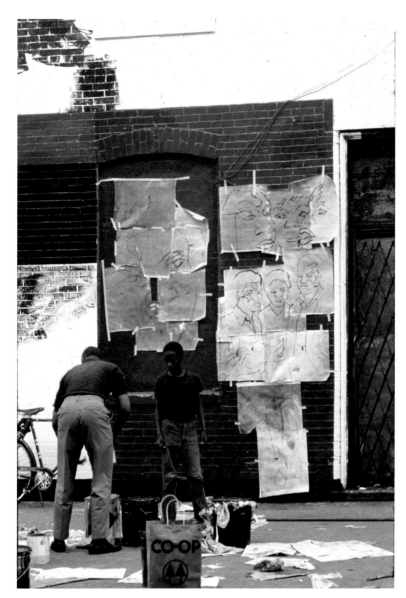

Barbara Jones-Hogu's "Theater" section in progress. Copyright © Robert A. Sengstacke, 1967.

So Weaver collaborated instead with Florence Hawkins, an art student living in the neighborhood who came by and asked to join in, and wound up painting Lew Alcindor, who was to become Kareem Abdul-Jabbar.[5] Weaver placed a victorious Muhammad Ali in the central panel, surrounded by admiring spectators. Other athletic figures—Jim Brown, Bill Russell, and Wilt Chamberlain—were depicted in action, playing their respective sports. If there were any doubt about their identities, their jerseys helped viewers identify them through their team affiliations and numbers.

Norman Parish's "Statesmen" section, on the upper left of the Wall, posed a collection of portrait heads, mostly depicted in three-quarter view: H. Rap Brown, Marcus Garvey, Adam Clayton Powell Jr., Stokely Carmichael, and Malcolm X.[6] The section also included Roy Lewis's photograph of Washington Park, which activists had claimed and renamed as Malcolm X Shabazz Park earlier in 1967.[7] In a politically tense moment, this was a challenging section to take on. Parish painted the smaller portraits with deft, economical strokes and wove the heads together with abstract wedges of color. In treating his entire section as a single representational field, he apparently did not observe the blocks of differing value by which Abernathy's design had planned to use the wall's boarded-over window frames. The portrait of Malcolm X, substantially larger than the rest, was rather sketchily painted in, almost wispy. Perhaps the section was never entirely finished, as Walker later stated. As it appeared at the time of the Wall's dedication, it seems Parish had chosen to humanize (perhaps even sentimentalize) the fallen leader rather than monumentalizing him.

The Wall as Performance

Painting in public under the critical eye of the community was a new experience for most of the artists. It meant an ongoing conversation with neighborhood residents that in several cases resulted in changes. As an object, the Wall was not static. But to think of the Wall in its changing imagery is to introduce one of the more painful elements of its history—the departures from the initial plan made by William Walker and Eugene "Eda" Wade. The question of why William Walker chose to have Parish's section in particular repainted, and without his consent, may never be fully answered. In his essay on OBAC in this volume, Abdul Alkalimat addresses the break in group unity that was precipitated by Walker's intervention in September 1967, immediately following the Wall's unveiling. I also take up the controversy these changes produced in my essay in the final section of this volume, "Reverberations."

For now, it is worth noting that the Wall was produced as a call and response. It emphasized the performing arts in many of its sections, but it was also a kind of performance. The original plan received several adjustments and some of the changes were uncontroversial. We have already seen that Florence Hawkins joined as the mural was in progress. Not only did she contribute the image of Lew Alcindor to the "Sports" section, she also added the figures of Duke Ellington and Dick Gregory visible in some photos on the facade of Johnny Ray's TV and Radio shop. Carolyn Lawrence (a future member of AfriCOBRA along with Donaldson, Jarrell, and Jones) joined the group after the Wall was planned. William Walker suggested she paint the corner newsstand, which she

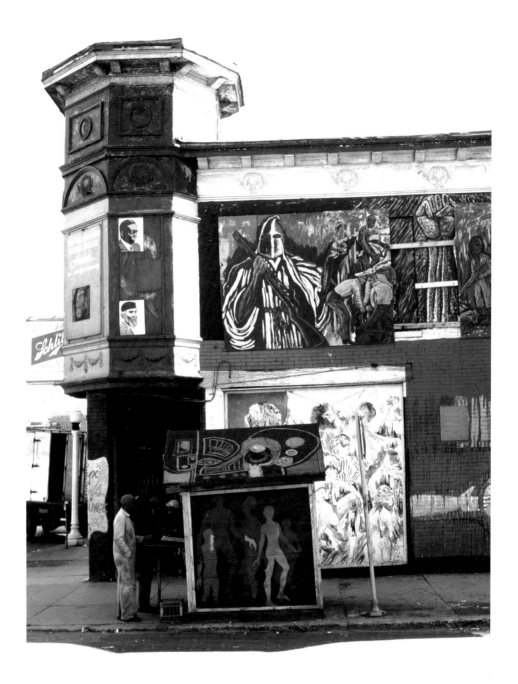

Detail of final state of Wall of Respect showing Klansman and corner newsstand.
Photograph copyright © 1970 by Bertrand Phillips. Courtesy Bertrand Phillips.

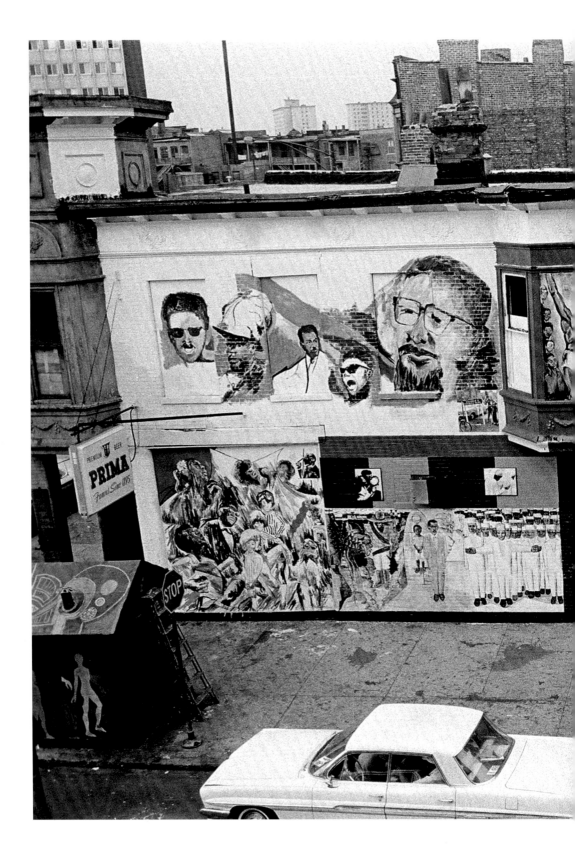

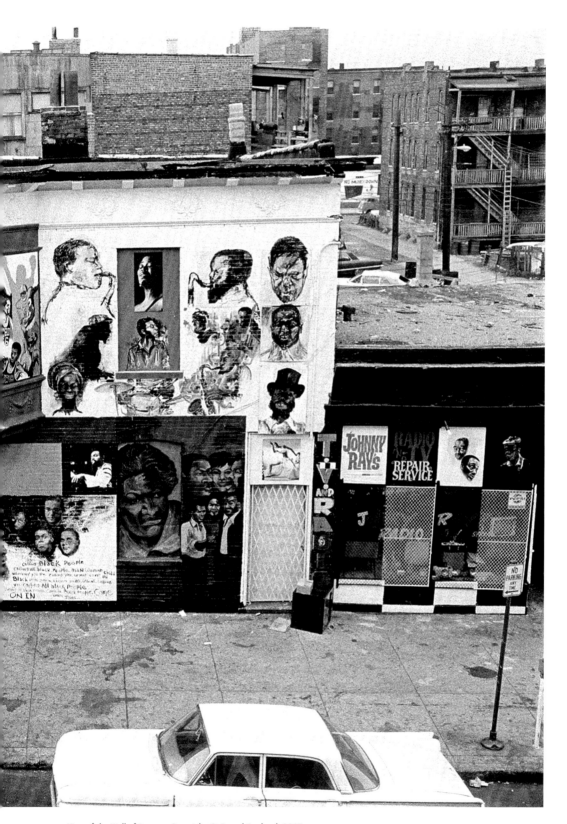

View of the Wall of Respect. Copyright © Darryl Cowherd, 1967.

did, with abstracted figures representing "Dance." Only a few photographs of the site provide a view of the painted newsstand. "Dance" was also represented by Roy Lewis's photograph of Darlene Blackburn, placed over a doorway on the far right of the Wall, the endpoint of the cascade of "Jazz" figures above. Blackburn was a pioneering and much-photographed figure as a dancer and choreographer in the Black Arts Movement in Chicago.

Critique and opinions also came from neighborhood residents, such as the woman who called Jeff Donaldson over to ask him to change his portrait of Nina Simone (which he did).[8] Walker also stated later that militant community members "would not permit" Martin Luther King to be painted on the Wall, and thus Walker painted King's colleague Wyatt Tee Walker instead. In Gerald McWorter's draft list and in Donaldson's published list of the Wall's heroes, Albert Cleage appears (with neither King nor Walker present), suggesting another difference of opinion, with Cleage representing a more radical tendency and Walker remaining closer to King.[9] It seems OBAC members had already determined not to include King, who was also decidedly absent from the "Statesmen" section. Later, Elijah Muhammad personally asked that his portrait be removed.

Other artists added imagery to the Wall. David Bradford, a California artist, painted a second storefront. Sign painter Curly Ellison painted the lettering "Wall of Respect." Will Hancock later painted local heroes on the building's corner turret; Kathryn Akin painted a musician in a doorway (see page 279). Across the street, many local artists contributed to the Wall of Truth, begun by Walker and Eda in 1969 as a harder-hitting counterpoint to the Wall of Respect.

For the time of its existence, as Seitu Jones's recollections suggest, the Wall radically changed the immediate space around it. It turned the street into a public forum for poetry, music, theater, and political rallies. Stokely Carmichael and other militant political figures spoke there. Poets read. For Eugene Perkins, the Wall represented "a citadel of black strength." For Don L. Lee—perhaps thinking of the mural as the visual analogue of LeRoi Jones's "poems that kill"—it was "a weapon." For Gwendolyn Brooks, the Wall was "our sister." She published her poem about the Wall as a pair with her dedicatory poem on the Chicago Picasso, unveiled on August 12, 1967, at Civic Center Plaza (now Daley Plaza). The Picasso's unveiling was an event that much of Chicago's population had awaited avidly and bemusedly for months. But the Wall spoke to a different kind of public, an African American, community-based audience not addressed by monumental European art situated in the Loop. Thus, Brooks implicitly contrasted the Wall with the Picasso. Where her take on the Picasso is cool and abstract, her poem about the Wall is all organic warmth. The comparison was evident in other poets' writings as well. Lee criticized Picasso sharply: " 'picasso aint got shit on us. / send him back to art school.' " So did Perkins: "Let Picasso's

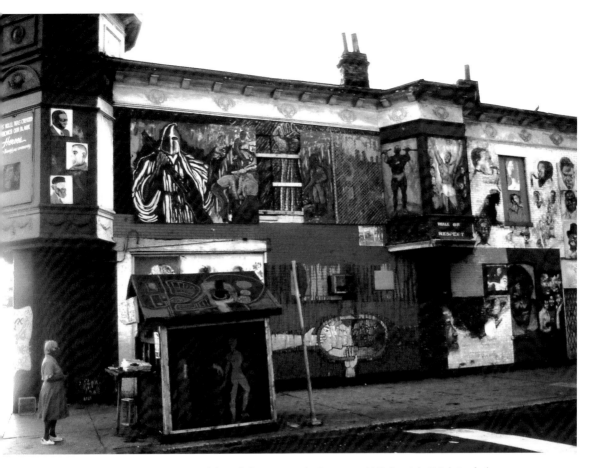

View of the Wall of Respect in its final state, circa 1969. Copyright © Bob Crawford.

enigma of steel/fester in the backyard of the/city fathers' cretaceous sanctu-ary." Alicia Johnson made more oblique reference to downtown public art in her poem "Black Art Spirits": "BULLETIN:/seen last PICASSO & KLEE perched high on a BIRD in/chicago's civic center."

Gwendolyn Brooks's poem also suggests how important performance around the Wall was, and how many different artistic media were represented in events there. The Wall served as a platform for both informal encounters and formal events. Brooks alludes to two performing artists who plied their craft at the un-veiling on August 27, 1967: Phil Cohran of the Artistic Heritage Ensemble and Val Gray Ward of Kuumba Theatre.[10] With her mention of them, Brooks pro-vides an initial hint of the mural's existence not merely as static object but as ongoing event. The August 27 unveiling was just the initial event among the many that occurred at the Wall. Along these lines, *Ebony* even referred to it as a Happening, alluding to the informal event-based mode of artwork invented by Allan Kaprow: "in this era of the happening, the Wall might be called a 'black-

Phil Cohran performing at the Affro-Arts Theater, circa 1968. Copyright © Robert A. Sengstacke.

hap.'" Milling about the Wall was a panoply of artists, poets, actors, musicians, activists, journalists, community residents of all ages, local visitors and tourists from afar, undercover cops, and the ever-present gang members-turned-community organizers ("the Young Militants"). All these individuals are part of the history of the Wall as object and as performance.

Legacies of the Wall

The Wall of Respect and most of the artists who worked on it have received little discussion from art historians. In particular, few scholars have noted its extraordinary gesture of taking possession of space and establishing new forms of coalition among artists and relationships between artists and community residents. More typically it has been looked at as a form of Afrocentric representation—a crystallization of the ambitions of artists to create revolutionary art for the people.[11] The collaborative nature of the project, the changes and controversy involved, contribute to the difficulty of nailing down even basic facts. Thus, errors have been published and perpetuated, even in writings by people who were involved or were close to those who were.[12] The cultural nationalist mood of the time would have made the Wall resistant to mainstream art historical scholarship

even if that scholarship had devoted serious attention to it. At the time, in the late 1960s and '70s, the mainstream art world barely took notice of the African American artists who showed in galleries in New York or the white artists who made political art. The hangover of reactions to fascist and socialist realist forms of propaganda had led to a hardening of the modernist line that art should be absolutely without politics, and this position was only just beginning to fray. And even as art practices that stress community participation have received more and more attention in recent years, few theorists of "social practice" consider how important the Wall of Respect and the mural movement that followed were as precursors. As Jeff Huebner pointed out in "William Walker's Walls of Prophecy and Protest," critics and scholars have tended to downplay the contributions of the mural movement to contemporary art in a broader sense, missing the chance to demonstrate its relevance to current concerns with performance and community cooperation.[13]

Most of the artists involved in the Wall did not remain deeply engaged with the immediately surrounding community. But the community took ownership, both protecting the Wall and, in a sense, exploiting it. Bobby Sengstacke recalls that children would give "tours" to visitors for a quarter (see image next page). Jeff Donaldson took a somewhat more cynical view, noting in his short essay, "The Rise, Fall, and Legacy of the Wall of Respect Movement" (see page 293) that "visitors and even photographers who had contributed to the Wall were required to pay fees to view and photograph the mural by 'gang bangers' from outside the immediate neighborhood." Perhaps there was a bit of both. It is not surprising that the Wall would be seen as a unique resource to be tapped for a little cash. For outsiders to the neighborhood, such as the white visitors from the Museum of Contemporary Art who came during the "Murals to the People" exhibition there, it was surely worth paying something for safe passage through what was viewed as a dangerous neighborhood. Dangerous for some, especially. Herbert Colbert, the local gang leader turned community organizer who had helped smooth the way for the mural's creation, was at some point—according to several reports—found shot dead, propped up against the Wall.[14]

Several of the artists who had worked together on the Wall—Donaldson, Jarrell, and Jones—came together a year later to form AfriCOBRA, the African Commune of Bad Relevant Artists. Part of their creed was to emphasize "positive images" like those that had appeared on the Wall over images that critiqued current conditions. But Walker's trajectory was almost the opposite. "We left from honoring the heroes," he stated, speaking for himself and Eda, to "making statements about conditions in the community" (see page 311). Walker's later work emphasized political critique and conflict, but also racial reconciliation. The Wall's basic impact included simple visibility. As Jeff Donaldson wrote, speaking of the basic presence of African Americans in visual culture, "It should

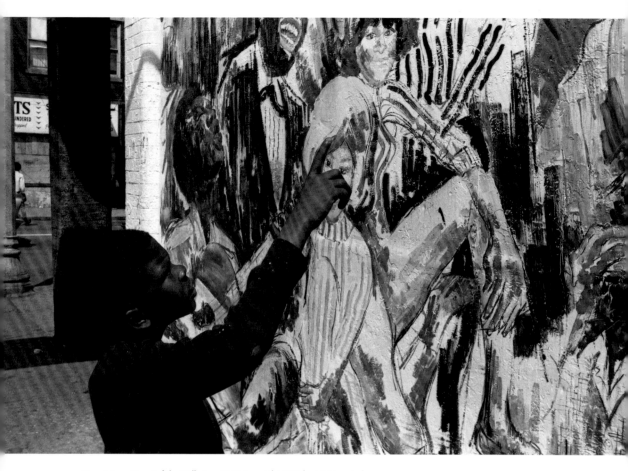

Boy giving a "tour" of the Wall, circa 1967. Copyright © Robert A. Sengstacke.

be remembered that blacks were rarely seen in billboards, in print or other public media before 1967" (see page 297). And despite the conflicts that emerged from the Wall itself, its contribution in terms of the visibility of Black history, political action, and coalition was deeply felt. Even in 1968 Donaldson emphasized these achievements over the conflicts: the Wall was, he said, "where people feel better when they walk by there, and we made it so."[15]

And yet the conflicts themselves also have value as a teaching tool. As we regard the Wall in historical perspective, perhaps we can hold side by side the sense of betrayal experienced by members of the original group of artists with an appreciation of the fact that it became something else in the hands of the community. And rather than being chagrined at the lack of clarity about major facts and minor details in writings about the Wall, we can recognize that this is an effect of the process of its creation and reception. In all ways it was a collective project, and thus it is only to be expected that people do not agree about what happened, or emphasize different aspects of the story, or remember differently at different times in their lives. The collection of texts presented here allows these divides to

live side by side. It does not seek to present a unified voice. Indeed, in a sense, by putting certain texts and authors together it invites conflict. It may not change any minds about what happened in the past. Yet, by putting these documents into circulation, I hope to enable us (as Gerald Graff put it in another context) to "teach the conflicts." To work through conflict and live with it and grow from it—necessities, I believe, for building strong political movements and their artistic components—we need practice. It's for this reason that we can address the conflicts and divergences represented here to the future, and not to the past.

Notes

1. Seitu Jones, "Public Art That Inspires: Public Art That Informs," in *Critical Issues in Public Art*, eds. Harriet F. Senie and Sally Webster (Washington, D.C.: Smithsonian, 1998), 280.

2. Jeff Huebner, "William Walker's Walls of Prophecy and Protest," in *Art Against the Law*, ed. Rebecca Zorach (Chicago: School of the Art Institute of Chicago, 2014), 31–46.

3. Jeff Donaldson and Geneva Smitherman Donaldson, "Upside the Wall: An Artist's Retrospective Look at the Original 'Wall of Respect,'" in *The People's Art: Black Murals, 1967–1978* (Philadelphia: African American Historical and Cultural Museum, 1986), unpaginated. Another discrepancy in this list is the omission of James Baldwin, whose portrait in the "Literature" section is absent from some later photographs of the Wall.

4. James Earl Jones appears in the document reproduced in this volume ("Who Is on the Wall and Why"); Dick Gregory substitutes for him in Jeff Donaldson's list, but this seems to be an error.

5. Florence Hawkins, interview with the author, April 2015.

6. Paul Robeson appears on Jeff Donaldson's list, but not in photographs of the Wall.

7. See "White Women Set Off Two-Hour Melee in Chicago," *Jet* 32, no. 9 (June 8, 1967): 7.

8. Margo Natalie Crawford, "Black Light on the Wall of Respect," in *New Thoughts on the Black Arts Movement*, eds. Lisa Gail Collins and Margo Natalie Crawford (New Brunswick, N.J.: Rutgers University Press, 2006), 26.

9. Donaldson and Smitherman Donaldson, "Upside the Wall."

10. Cohran, also a cofounder of the AACM, the Association for the Advancement of Creative Musicians, would soon go on to found the Affro-Arts Theater, a multi-use cultural space in Bronzeville. Ward, "little black stampede," was a force to be reckoned with in Black theater, founder and director of Kuumba Theatre, which was of signal importance for the Black Arts Movement theater in Chicago.

11. Kirstin L. Ellsworth briefly discusses the Wall of Respect in an essay on Afrocentric ideology in relation to AfriCOBRA, "Africobra and the Negotiation of Visual Afrocentrisms," *Civilisations* 58, no. 1, American Afrocentrism(e)s Américains (2009): 21–38. Michael D. Harris briefly addresses OBAC and the Wall of Respect in a broad discussion of Afrocentrism in the work of African diasporic artists in "From Double Consciousness to Double Vision: The Africentric Artist," *African Arts* 27, no. 2 (April 1994): 44–53 and 94–95.

12. See, for example, Crystal Britton, *African American Art: The Long Struggle* (New York: Smithmark, 1996), 77. Britton says the Wall of Respect was painted by AfriCOBRA, and her list of those involved includes people on the list who were AfriCOBRA members but not while they lived in Chicago (Frank Smith), members who did not paint on the Wall ("Napoleon Henderson Jones" and Nelson Stevens), and an actual Wall of Respect painter who was not in AfriCOBRA (William Walker).

13. Huebner, "William Walker's Walls," 41–42.

14. Donaldson interview with Margo Crawford, cited in "Black Light," 25; Huebner, conversation with Walker, "The Man Behind the Wall," *Chicago Reader*, August 29, 1997, sec. 1, pp. 1, 14–32.

15. Norman Mark, "A Matter of Black and White," *Chicago Daily News, Panorama* magazine, May 18, 1968.

Poetry

Poets responded energetically to the Wall of Respect. Gwendolyn Brooks, who had been invited to provide a dedicatory poem for the unveiling of downtown Chicago's monumental Picasso sculpture earlier in August 1967, took it upon herself to produce her own poem warmly celebrating the Wall, which she read at its dedication. Together the two poems constitute her "Two Dedications." Don L. Lee (Haki Madhubuti) published a more aggressively worded poem in the *Chicago Defender*, which was then published with slight changes in his book *Black Pride* (Broadside Press, 1968). Eugene Perkins placed the Wall in the context of Black art, as distinct from European traditions. Alicia L. Johnson, with her more fleeting allusion to the Wall, took a spiritual approach to Black art.

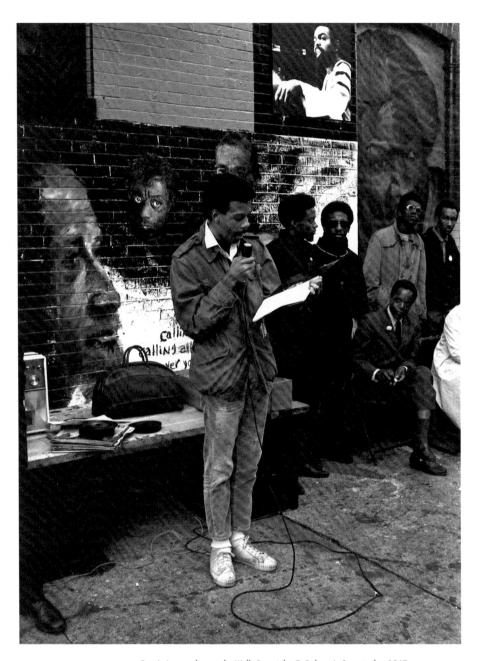

Don L. Lee reading at the Wall. Copyright © Robert A. Sengstacke, 1967.

The Wall

from "Two Dedications,"
In the Mecca, 1968

Gwendolyn Brooks

August 27, 1967

> *For Edward Christmas*

"The side wall of a typical slum building on the corner of 43rd and
Langley became a mural communicating black dignity . . ." —*Ebony*

A drumdrumdrum.
Humbly we come.
South of success and east of gloss and glass are
sandals;
flowercloth;
grave hoops of wood or gold, pendant
from black ears, brown ears, reddish-brown
and ivory ears;

black boy-men.
Black
boy-men on roofs fist out "Black Power!" Val,
a little black stampede
in African
images of brass and flowerswirl,
fist out "Black Power!"—tightens pretty eyes,
leans back on mothercountry and is tract,
is treatise through her perfect and tight teeth.
Women in wool hair chant their poetry.

Phil Cohran gives us messages and music
made of developed bone and polished and honed cult.
It is the Hour of tribe and of vibration,
the day-long Hour. It is the Hour
of ringing, rouse, of ferment-festival.

On Forty-third and Langley
black furnaces resent ancient
legislatures
of ploy and scruple and practical gelatin.
They keep the fever in,
fondle the fever.

All
worship the Wall.

I mount the rattling wood. Walter
says, "She is good." Says, "She
our Sister is." In front of me
hundreds of faces, red-brown, brown, black, ivory,
yield me hot trust, their yea and their Announcement
that they are ready to rile the high-flung ground.
Behind me, Paint.
Heroes.
No child has defiled
the Heroes of this Wall this serious Appointment
this still Wing
this Scald this Flute this heavy Light this Hinge.

An emphasis is paroled.
The old decapitations are revised,
the dispossessions beakless.

And we sing.

The Wall

from *Black Pride,* 1968

Don L. Lee
(Haki Madhubuti)

(43rd & Langley, Chicago, Ill. painted by the artists and
photographers of OBAC 8/67)

sending their negro
toms into the ghetto
at all hours of the day
(disguised as black people)
to dig
the wall, (the weapon)
the mighty black wall (we chase them out—kill if necessary)

whi-te people can't stand
the wall,
killed their eyes, (they cry)
black beauty hurts them—
they thought black beauty was a horse—
stupid muthafuckas, they run from
the mighty black wall

brothers & sisters screaming,
"picasso ain't got shit on us.
 send him back to art school"
we got black artists
who paint black art
the mighty black wall

negroes from south shore &
hyde park coming to check out
a black creation
black art, of the people,
for the people,
art for people's sake
black people
the mighty black wall

black photographers
who take black pictures
can you dig,
 blackburn
 le roi,
 muslim sisters,
 black on gray it's hip
they deal, black photographers deal blackness for
the mighty black wall

black artists paint,
 du bois/ garvey/ gwen brooks
 stokely/ rap/ james brown
 trane/ miracles/ ray charles
 baldwin/ killens/ muhammad ali
 alcindor/ blackness/ revolution
 our heros, we pick them, for the wall
the mighty black wall/ about our business, blackness
 can you dig?
if you can't you ain't black/ some other color
negro maybe??

the wall,
the mighty black wall,
"ain't the muthafucka layen there?"

Black Culture

from *Black Is Beautiful*, 1968

Useni Eugene Perkins

(*For the WALL at 43rd and Langley*)

even though they were not given
commissions to paint black heroes.
In the past buildings in the ghettos
have only been marked with names like
 Nigger Baby/ Blue Daddy/
 Shinola/ and the Hadean
decadence of slum landlords
According to white sociologists
black communities are void of culture.
They wanted black people to forget
about the august kingdoms of Ancient
Africa which made European cultures
look like primitive archipelagoes.
But the WALL is for black people.
It is too black to decorate the
 galleries of Baroque museums,
 or adorn the Victorian mansions
 of clamorous belly aristocrats,
 who refuse to appreciate
 the sacredness of blackness.
It has too much pride to be viewed
as a freak attraction for white tourists
seeking snap shots of ghetto life, to
show their suburban friends how niggers
survive on welfare reservations.

Let Picasso's enigma of steel
fester in the backyard of the
city fathers' cretaceous sanctuary.
It has no meaning for black people;
only showmanism to entertain
imbecilic critics who judge all art by
 European standards,
 and forget the Greeks and
 Romans were inspired by
 black cultures.
The WALL is for black people
A soulful mural of blackness
depicting black ideology and
 a third world
 that has awaken
 from enslavement.
It is a citadel of black strength
conceived by black artists to remind
black people they have black music/
 black politics/black religion/
 black literature/and black heroes/
It is a black culture commemorating
black people who have a black heritage that
is inferior not even to a lily white god.

Black Art Spirits

from *Black Arts, An Anthology of Black Creations*, 1969

Alicia L. Johnson

1

BLACK ART SPIRITS
are
LOVE SPIRITS
HOLY ALMIGHTY & PRAISE SPIRITS
flowing thru infiltrating & penetrating thru deadly destruct-
 tive membraines.
membraines of the children of GOG.
in a beautiful dream
that wld appear frightful to some with WET eye-bal-less
 eyes
i saw the SPIRITS cling to my naked body/i felt their
 fingerless hands &
mouthless tongues smooth my skinless body.
i saw some SPIRITS zoom past me in route to destroy GOG
 the land of MAGOG.
these ART SPIRITS
changed their shape
into 5 western art periods
in order to destroy that false imitative art of the WEST.
ART SPIRITS
brought fire of doom on GOG's land
crushing it to tid-bits/wiping out all its' faceless people
give me

strength
ORISIS
to continue on. . . .

the LOVE SPIRITS used their magnifying element weapons
 WATER&DUST:
REACT . . .
 DEAL . . .
 REACT . . .
 DEAL . . .
klee & picasso tried to fight off the SPIRITS
with apologies from having borrowed BLACK ART FORMS
 from the SPIRITS . . .
REACT . . .
 DEAL . . .
 REACT . . .
 DEAL . . .
BOOM . . .
 BOOM . . .
 BOP . . .
 BOP
BULLETIN:
BULLETIN:
seen last PICASSO & KLEE perched high on a BIRD in
 chicago's civic center.

2

dreams come frequent these days
believe me
they do.

HOLY ALMIGHTY SPIRITS
traveled underground by way of TRANE
above ground to groundless grounds by way of TRANE
past 43rd on route
thru MAGOG
firery magog
hellish magog
worish magog R-A-C-I-S-T magog

to the beautiful land of MU.
ALMIGHTY ART SPIRITS
reached the heights of MU
and touched the armless arms of RA.

THESE ART SPIRITS
in the end & beginning became beautiful PRAISE SPIRITS.

that skipped like i use to wen al was kept a scret from me.

these PRAISE SPIRITS
are soft
and hard like
opposites
like rootless trees & stemless stems.

3

dreams come frequent to me these days
believe me
they do.

ART SPIRITS are LOVE SPIRITS
HOLY ALMIGHTY SPIRITS &
PRAISE SPIRITS
that flow in and out OUR BLACK MINDS
the minds
of
the
CHILDREN OF MU.

II. HEROES

AND HEROINES

Bill Russell 1934–
Wilt Chamberlain 1936–1999
Jim Brown 1936–
Muhammad Ali 1942–2016
Lew Alcindor (Kareem Abdul-Jabbar) 1947–

ATHLETES

Marcus Garvey 1887–1940
Adam Clayton Powell Jr. 1908–1972
Malcolm X 1925–1965
Stokely Carmichael (Kwame Ture) 1941–1998
H. Rap Brown (Jamil Abdullah Al-Amin) 1943–

STATESMEN

DANCE

RHYTHM & BLUES

Muddy Waters 1913–1983
Billie Holiday 1915–1959
Dinah Washington 1924–1963
Ray Charles 1930–2004
James Brown 1933–2006
Smokey Robinson 1940–
Aretha Franklin 1942–
The Marvelettes all born in the 1940s, some still living
Stevie Wonder 1950–

RELIGION

Nat Turner 1800–1831
Elijah Muhammad 1897–1975
Albert Cleage 1911–2000
Wyatt Tee Walker 1929–
Girls in Church
Spiritual Grace

JAZZ

Thelonious Monk 1917–1982
Charlie Parker 1920–1955
Charles Mingus 1922–1979
Sarah Vaughan 1924–1990
Max Roach 1925–2007
John Coltrane 1926–1967
Miles Davis 1926–1991
Elvin Jones 1927–2004
Eric Dolphy 1928–1964
Ornette Coleman 1930–2015
Sonny Rollins 1930–
Nina Simone 1933–2003

THEATER

Claudia McNeil 1917–1993
Ossie Davis 1917–2005
Ruby Dee 1922–2014
Cicely Tyson 1924–
Oscar Brown Jr. 1926–2005
Sidney Poitier 1927–
James Earl Jones 1931–
Dick Gregory 1932–
Darlene Blackburn 1942–

LITERATURE

W. E. B. Du Bois 1868–1963
John Oliver Killens 1916–1987
Gwendolyn Brooks 1917–2000
James Baldwin 1924–1987
Lerone Bennett 1928–
Ronald Fair 1932–
LeRoi Jones (Amiri Baraka) 1934–2014

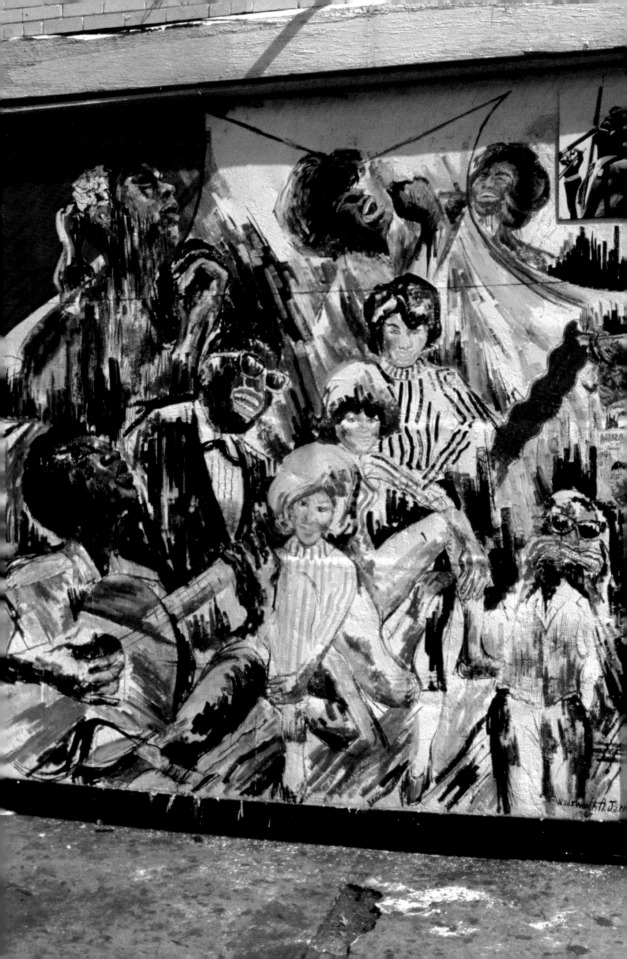

The Heroes and Heroines of the Wall of Respect

Abdul Alkalimat, with contributions by Rebecca Zorach

In 1967 the Organization of Black American Culture (OBAC) laid out its definition of a Black hero.

> OBAC declares that a Black hero is any Black person who:
> 1. honestly reflects the beauty of Black life and genius in his or her style.
> 2. does not forget his Black brothers and sisters who are less fortunate.
> 3. does what he does in such an outstanding manner that he or she cannot be imitated or replaced.

The Wall was created at a time when Black faces were not prominent in the mainstream. We were not in the newspapers or on television. BET was not there constantly showing Black people giving awards to each other. The Wall's heroes and sheroes shot way past *Ebony* magazine's attempts to publicly proclaim those whom we ourselves honored. The Wall portrayed people whose accomplishments helped us honor ourselves.

Every person on the Wall had excelled at a national level as well as making a mark in or on Chicago. The Wall was

"Rhythm and Blues" (detail of the Wall of Respect). Copyright © Robert A. Sengstacke, 1967.

51

produced in Chicago, by Chicago artists, and so it was dominated by heroes and sheroes who were actually from Chicago. And while every person on the Wall lived (and many are still living) a unique and inspiring biography, understanding them in their generations, in the succeeding waves of Black cultural production and innovation, is the best way to make sense of the Wall.

A description of the heroes and heroines portrayed on the Wall would not be complete without also identifying the artists, photographers, and one designer who created the Wall. Two women with unique roles in creating the Wall were Sylvia Abernathy and Carolyn Lawrence. Sylvia ("Laini") Abernathy trained as a designer at Illinois Institute of Technology's Institute of Design. She worked out the overall structure of the Wall and its organization into topical sections. Abernathy also created record jacket designs for Delmark Records and the book design for *In Our Terribleness* (1970). The artist and educator Carolyn Lawrence painted the newsstand in front of the wall. Lawrence earned a B.F.A. from the University of Texas at Austin and an M.A. in Art Education from the Illinois Institute of Technology. A painter, she joined AfriCOBRA in 1969 and participated in the collective exhibition "10 in Search of a Nation" at the Studio Museum in Harlem in 1970. She taught art at Kenwood Academy High School in Chicago for more than thirty years.

1. Rhythm and Blues

Muddy Waters (1913–1983)	Smokey Robinson (1940–)
Billie Holiday (1915–1959)	Aretha Franklin (1942–)
Dinah Washington (1924–1963)	The Marvelettes (all born in the 1940s, some still living)
Ray Charles (1930–2004)	
James Brown (1933–2006)	Stevie Wonder (1950–)

The combination of Saturday night and Sunday morning cultures combined the blues and gospel music to create the popular urban genre called rhythm and blues. Much of this creativity lived and unfolded in the very neighborhood of the Wall. So it was appropriate that in addition to a jazz music section, the Wall devoted a section to rhythm and blues.

The "Hoochie Coochie Man" Muddy Waters personified the link between urban Chicago blues and rural Mississippi. He was a working-class troubadour who at least in part defined the roots of Black culture and made the world wake up to the blues as a great art form.

Billie Holiday, Dinah Washington, Ray Charles, and James Brown are four unique voices depicted in this section. Each of these highly regarded figures was given a special name: Holiday was "Lady Day." Her special contribution to the struggle was her performance of the song "Strange Fruit," that hauntingly sober critique of lynching. Washington was "Queen of the Blues," a brilliant singer who emerged from the clubs of South Side Chicago. Ray Charles was the "Genius," as he took the church into blues, jazz, and country and western forms, always on multiple instruments. James Brown was the "Godfather of Soul." He created a sound, a dance form, and a singing style that made hearts beat in rhythm under his command. His 1968 tune "Say It Loud—I'm Black and I'm Proud" became an anthem of the Black Liberation Movement.

Aretha Franklin, Smokey Robinson, Stevie Wonder, and the Marvelettes were all products of the working-class Black culture of Detroit, rooted in the church, the public housing projects, and the auto plants. Aretha Franklin, daughter of one of Detroit's major church leaders, the Rev. C. L. Franklin, became the "Queen of Soul." Along with James Brown, she sang the background score for the 1960s movement. In fact, her tune "R-E-S-P-E-C-T" helped give the Wall of Respect its name. The other three all came through the musical organization formed by Barry Gordy and called Motown. The Marvelettes gave Motown its first number one pop hit, "Please Mr. Postman." They represented all the doo-wop groups who stood on corners singing their hearts out in every big city that was full of working-class Black people. Smokey Robinson was a master story-teller and one of the most famous vocalists (and leader) of the renowned Mir-acles. Stevie Wonder was a singular voice and instrumentalist. He began as a child prodigy, signing his first contract with Motown at the age of eleven. His well-known support for Black liberation took many forms, one of which was leading the movement to make Martin Luther King's birthday a national holiday.

Wadsworth Jarrell and Billy Abernathy worked on the "Rhythm and Blues" section of the Wall. Wadsworth Jarrell (born 1929) is a painter and sculptor whose long career as an artist has been committed to making works dedicated to a Black aesthetic and Afrocentric forms and themes. Jarrell moved to Chicago in the 1940s. He earned his B.F.A. from the School of the Art Institute of Chicago and an M.F.A. from Howard University. Jarrell shared his studio in Hyde Park, WJ Studios, with his wife, Jae Jarrell. There they hosted performances by Chicago musicians and poets, art exhibitions, and early AfriCOBRA meetings. Jarrell has held teaching positions at Howard University and the University of Georgia. He is the recipient of numerous awards, and his work has been exhibited widely in the United States and abroad.

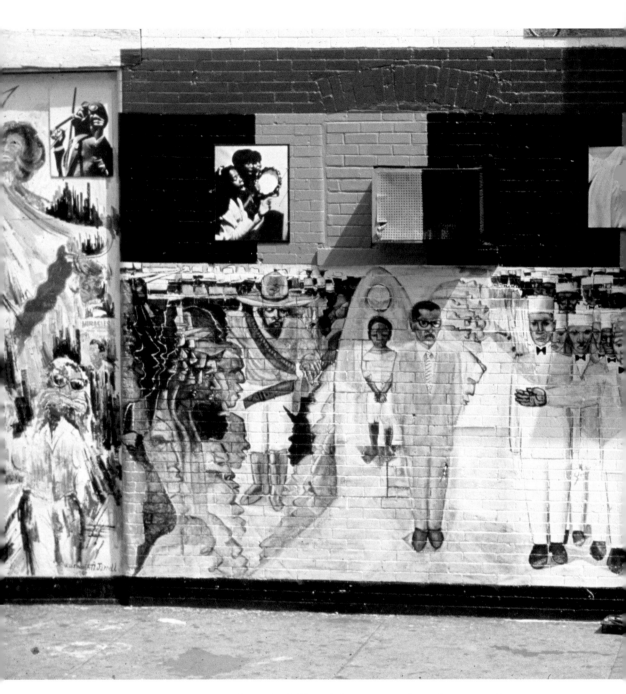

"Religion" (detail of the Wall of Respect). Copyright © Robert A. Sengstacke, 1967.

Billy ("Fundi") Abernathy (1938–2016) was a photographer who was a key figure in Chicago's Black Arts Movement. Abernathy's photograph of Stevie Wonder was part of the Wall's "Rhythm and Blues" section. He collaborated with his spouse, designer Sylvia Abernathy, and with poet Amiri Baraka on the groundbreaking multimedia book, *In Our Terribleness*.

2. Religion

Nat Turner (1800–1831)

Elijah Muhammad (1897–1975)

Albert Cleage (1911–2000)

Wyatt Tee Walker (1929–)

The religious beliefs and practices of the Black community have been at the core of the Black experience. Spirituality and strong social organization go a long way to explaining how Black people have survived the hell of slavery and racist oppression. The religion section of the Wall contains images of three people (one of them a substitution) who exemplify the historical continuity of religion as a force of resistance. Nat Turner was a slave whose religious beliefs led him to use violence as a force to free Black people. He was moved in much the same way as the German pastor and theologian Dietrich Bonhoeffer, who adopted violent means in an attempt to get rid of Hitler and Nazism. Elijah Muhammad rejected Christianity as the religion of the slave masters and took up Islam as his form of religious resistance. Chicago was his home base, where he mentored Malcolm X and published the influential newspaper *Muhammad Speaks*. Albert Cleage emerged as a major religious leader after the 1967 Detroit rebellion. He founded the Church of the

Black Madonna and was a leading force in fusing militant Black Nationalism and Christianity. Wyatt Tee Walker was an Atlanta minister and executive director of the Southern Christian Leadership Conference (SCLC). In 1967 he became minister of a church in Harlem.

William Walker and Robert A. Sengstacke worked on the "Religion" section of the Wall. After OBAC discussed and rejected Walker's proposal to replace Cleage with Martin Luther King, Walker responded by replacing Cleage with Wyatt Tee Walker.

William Walker (1927–2011) was a painter and muralist. Born in Alabama, he moved to Chicago in 1938. He served in the military in World War II and the Korean War, then studied art at the Columbus College of Art and Design in Ohio. He worked for the U.S. Postal Service in Chicago. Following the creation of the Wall of Respect, he continued painting murals for more than twenty years. He cofounded the Chicago Mural Group, now the Chicago Public Art Group, and painted important murals throughout Chicago and elsewhere, most as collaborations with other artists.

Robert A. Sengstacke (1943–2017) was a prominent photographer and documentary filmmaker of the Civil Rights generation, whose work focused on the history and daily lives of African Americans. Born into the Abbott-Sengstacke publishing family, Sengstacke worked as a photographer and editor at the *Chicago Defender* and is known for his photographs of key figures of the Civil Rights era, including Martin Luther King Jr., Muhammad Ali, Gwendolyn Brooks, and Amiri Baraka.

3. Literature

W. E. B. Du Bois (1868–1963)	Lerone Bennett (1928–)
John Oliver Killens (1916–1987)	Ronald Fair (1932–)
Gwendolyn Brooks (1917–2000)	LeRoi Jones (Amiri Baraka, 1934–2014)
James Baldwin (1924–1987)	

Writers have been the most consistent source of inspirational knowledge against the imposed silence of a racist educational system and media. Black institutions led by teachers and librarians have been the conveyor belt keeping Black authors a vital component of the vibrant reading culture in the Black community. W. E. B. Du Bois was the central intellectual of the twentieth century: the first

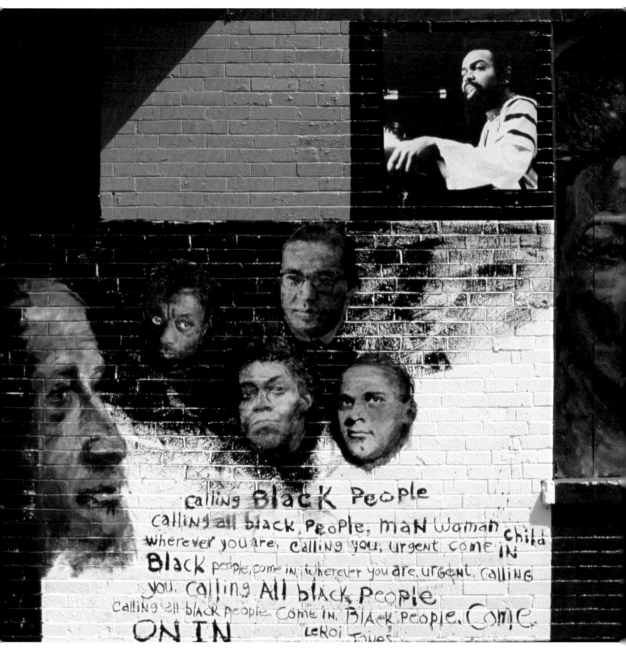

"Literature" (detail of the Wall of Respect). Copyright © Robert A. Sengstacke, 1967.

African American to earn a Ph.D. from Harvard and the long time editor of the *Crisis* magazine of the NAACP, which he helped found. He was the Black Aristotle of the twentieth century. Gwendolyn Brooks and James Baldwin were two pathbreaking writers. Brooks, in her quiet, unassuming way, broke the barriers to Black achievement in the McCarthy 1950s by winning the Pulitzer Prize. Baldwin's essays led a generation to make their names known, to make their experiences the stuff of social and philosophical reflection. The generation of the 1960s jumped on each of Baldwin's essays as they arrived; he chronicled the times for us. John Oliver Killens was a major novelist of the Black struggle in the community and in the military. He founded the important Harlem Writers Group in 1950 and subsequently worked with Malcolm X. Lerone Bennett, LeRoi Jones (Amiri Baraka), and Ronald Fair represented the generation of artists working in OBAC and creating the Wall. Jones (Baraka) was the poet spokesperson for the Black Arts Movement of the 1960s. His voice was known to all of us as he raged against the racist machine of critics and gatekeepers of culture and politics. Bennett was the people's historian. His essays in *Ebony* and his popular *Before the Mayflower* history of Black people were required reading for all conscious Black people in the 1960s. Fair was already a brilliant Chicago-based novelist, the author of *Many Thousand Gone: An American Fable*. For reasons unknown, he seems to have been omitted from the final version of the "Literature" section. He currently lives in Finland.

Edward Christmas and Darryl Cowherd worked on the "Literature" section of the Wall. Edward Christmas (born ca. 1941) is a painter, photographer, and commercial artist. Following his creation of a portrait of Gwendolyn Brooks for the Wall of Respect, Brooks dedicated her poem "The Wall" to him.

Darryl Cowherd (born 1940) has been a professional photographer since 1960. He was mentored by Adeoshun Ifalade (Robert Wilson). His work has been shown at the Booker T. Washington Foundation, the U.S. Civil Rights Commission, the Motown Record Corporation, Arts Media Service, and Malcolm X College, and has appeared in *Down Beat* magazine, *Muhammad Speaks* newspaper, and Sweden's *Aftonbladet*. After moving to Washington, D.C., he worked in television and public affairs.

4. Theater

Claudia McNeil (1917–1993)

Sidney Poitier (1927–)

Ossie Davis (1917–2005)

James Earl Jones (1931–)

Ruby Dee (1922–2014)

Dick Gregory (1932–)

Cicely Tyson (1924–)

Darlene Blackburn (1942–)

Oscar Brown Jr. (1926–2005)

The eight people portrayed in the "Theater" section of the Wall (with one addition elsewhere) reflect two cultural-historical moments. Claudia McNeil, Ossie Davis, Ruby Dee, and Sidney Poitier were the foundational figures, with roots in the 1930s Works Progress Administration Theater Project and the 1940s American Negro Theater. Their performances in *A Raisin in the Sun* were a high point. It was the first play written by a Black woman (Lorraine Hansberry) and directed by a Black man (Lloyd Richards) to open on Broadway. In this and many ways these four opened the mainstream stage for Black people. The other actors on the Wall continued this progress into the 1960s. In his many roles on stage and in film, James Earl Jones represented the bold and uplifting image of a Black man. As a result he was awarded the Marian Anderson award, given to people "whose leadership benefits humanity." Oscar Brown Jr., Dick Gregory, and Darlene Blackburn lived in Chicago. Brown brought Black literature to life with his hip urban rap style. Gregory (who, in the end, appeared on a separate panel on Johnny Ray's storefront and not in the main "Theater" section of the Wall) used humor as a vehicle to advance critical thinking about Black liberation. And Blackburn (depicted in Roy Lewis's photograph) used dance to reconnect the community with its African origins. Cicely Tyson's acting performances won her a string of mainstream acting awards, and her consistent support for the movement won her the NAACP Spingarn Medal. In truth, each of these performers won mainstream recognition while keeping their focus on social justice and Black liberation.

Barbara Jones-Hogu and Roy Lewis worked on the "Theater" section of the Wall. Barbara Jones-Hogu (Barbara J. Jones, born 1938) is a painter and printmaker, and a founding member of AfriCOBRA. Her brightly colored prints, in a signature style that fuses political messages, images, and text, provided some of AfriCOBRA's most striking images. Jones-Hogu earned a B.A. from Howard University, a B.F.A. from the School of the Art Institute of Chicago, and an

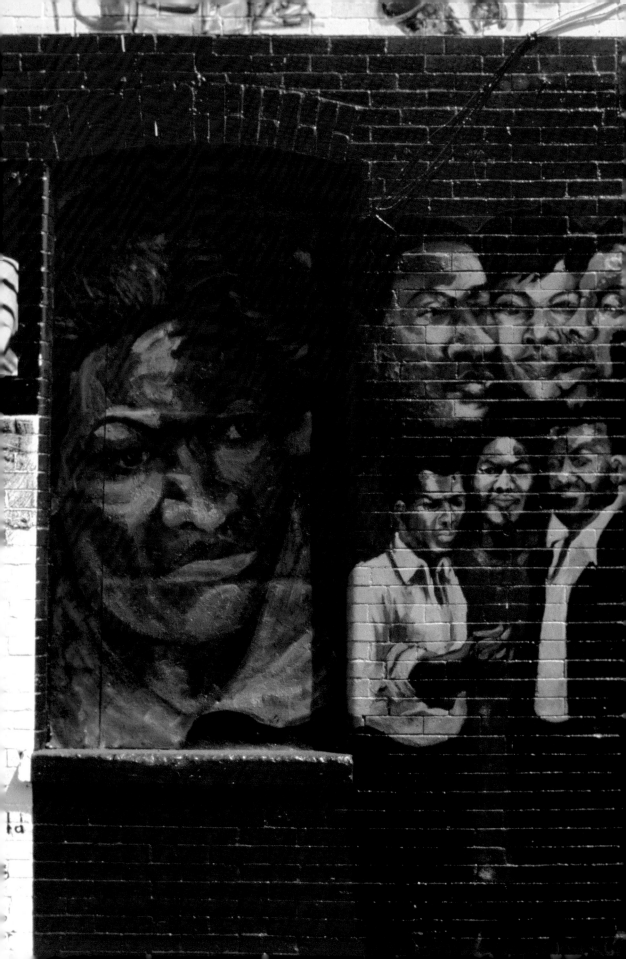

M.S. in printmaking from the Illinois Institute of Technology. She directed the production of most of the AfriCOBRA prints created in the group's collective printmaking project in 1971.

Roy Lewis (born 1937) is a photographer. Born in Natchez, Mississippi, he migrated to Chicago following his high school graduation in 1956 and went to work for Johnson Publishing. He first developed skills as a photographer after being drafted into the U.S. Army in 1960 and later worked as a freelance photographer and videographer both in Chicago and on extensive travels in the United States and abroad. He has received numerous awards for his photojournalism, including the Maurice Sorrell Lifetime Achievement Award.

5. Jazz

Thelonious Monk (1917–1982)	Miles Davis (1926–1991)
Charlie Parker (1920–1955)	Elvin Jones (1927–2004)
Charlie Mingus (1922–1979)	Eric Dolphy (1928–1964)
Sarah Vaughan (1924–1990)	Ornette Coleman (1930–2015)
Max Roach (1924–2007)	Sonny Rollins (1930–)
John Coltrane (1926–1967)	Nina Simone (1933–2003)

The people included in the "Jazz" section were all masters of the most important musical tradition that linked to the Black freedom movement. They were master instrumentalists, composers, band leaders, and innovators. Saxophonist Charlie Parker represented bebop. He led the post–World War II revolution linking jazz to the militant transformation of Black political culture in the northern urban experience. Trumpeter Miles Davis, drummer Max Roach, bassist Charlie Mingus, and saxophonist Sonny Rollins led further innovation in the bebop tradition. While firmly in the bebop tradition, Monk was one of the most uniquely innovative pianists and composers of his generation, producing such standards as "Round about Midnight." Saxophonist John Coltrane, drummer Elvin Jones, reed player Eric Dolphy, and saxophonist Ornette Coleman moved beyond bebop into the free-spirited 1960s. In other words, they were about freedom. Parker's tune "Now's the Time," Mingus's "Fables of Faubus," "We Insist! Max Roach's Freedom Now Suite," and Trane's "Alabama" all demonstrate this unfolding musical progression. Vocalist Sarah Vaughan and pianist-vocalist Nina Simone exemplify the bebop and freedom moments.

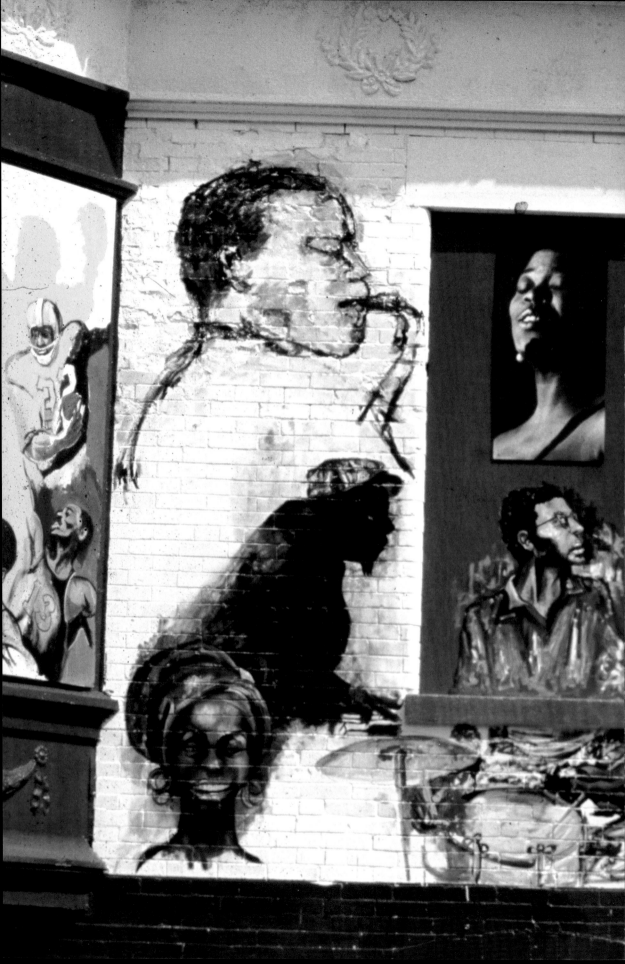

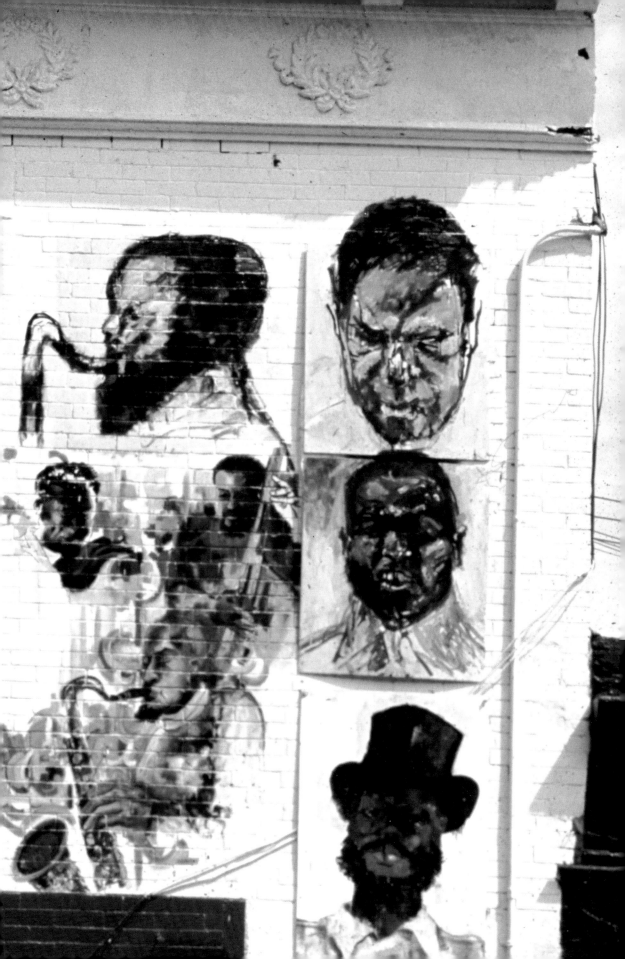

Vaughan was "The Divine One" because she delivered lyrics with an unmatched range and texture. Simone, with her classical training, carried church and folk traditions into bluesy jazz riffs. She was always the militant diva connecting the music and the Black Liberation Movement, as in her tune "Mississippi Goddam!"

Jeff Donaldson, Elliott Hunter, and Billy Abernathy worked on the "Jazz" section of the Wall. Jeff Donaldson (1932–2004) was an artist, art historian, and educator whose work focused on Black revolutionary politics and Afrocentric themes. A key figure in the Black Arts Movement, Donaldson was a founding member of OBAC's Visual Arts Workshop and AfriCOBRA. Donaldson earned an M.F.A. from the Institute of Design of the Illinois Institute of Technology and a Ph.D. in African and African American art history from Northwestern University. In 1970, he became the chair of the art department, and later dean of the College of Fine Arts, at Howard University in Washington, D.C.

Elliott Albert Hunter (1938–1970) was a talented artist who painted sensitive portraits and large abstract and figurative canvases. He studied at the School of the Art Institute and worked at Chicago's main post office. He exhibited widely and won awards in the University of Chicago's Festival of the Arts (FOTA) show, the 1965 Illinois Festival of Art, and in several Motorola Art Competitions of the mid-1960s. He died at age 31 after a brief illness.

Billy ("Fundi") Abernathy (1938–2016)) was a photographer who was a key figure in Chicago's Black Arts Movement. He collaborated with his spouse, the designer Sylvia Abernathy, and with the poet Amiri Baraka on the groundbreaking multimedia book, *In Our Terribleness.*

Overleaf "Jazz" (detail of the Wall of Respect).
Copyright © Robert A. Sengstacke, 1967.

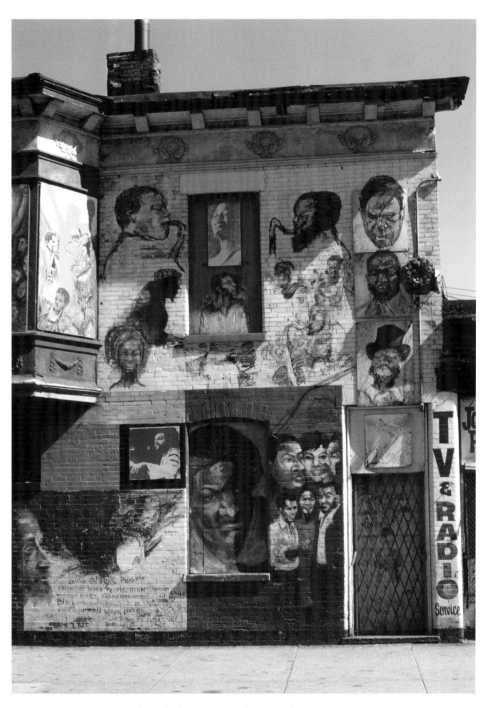

Jazz section with wreath. Photograph copyright © 1970 by
Bertrand Phillips. Courtesy Bertrand Phillips.

6. Sports

Bill Russell (1934–)

Wilt Chamberlain (1936–1999)

Jim Brown (1936–)

Muhammad Ali (1942–2016)

Lew Alcindor (Kareem Abdul-Jabbar, 1947–)

Sports have always been a proxy arena for the Black liberation struggle, allowing for direct competition between Blacks and whites. Professional sports has also been a path for upward social mobility and high income for Black youth, whose options were quite limited in the racist societal institutions and job markets of the United States. Basketball in particular has been a sport of great Black achievement. In the NBA, Bill Russell, Wilt Chamberlain, and Lew Alcindor (Kareem Abdul-Jabbar) dominated the game for more than forty years, winning every award and leading their teams to more championships than ever before. In each case they faced racism but stood their ground, opening up the game for those who followed them. Jim Brown was a demon on the football field. As a ball carrier he was running around you or over you. And he was often speaking out about discrimination and how Black athletes should give back to their communities. Finally, the most demonstrable sport that linked to the Black Liberation Movement was the direct combat sport of boxing. Jack Johnson and Joe Louis had set the example, but it was Muhammad Ali who took boxing to the highest level. He was winning his matches and always refusing to take low and please the white mainstream. He befriended Malcolm X and joined the Nation of Islam under the leadership of Elijah Muhammad. To cap this off, he refused to enter the military to fight the Vietnamese. Black people experienced victory through the exploits of each of these athletes.

Myrna Weaver and Florence Hawkins worked on the "Sports" section of the Wall. Myrna Weaver (born ca. 1936) was a painter and co-owner of the art gallery The Arts, on Stony Island Avenue, where OBAC's Visual Arts Workshop held its initial meetings.

Florence Hawkins (born 1936) worked as a commercial artist after taking classes at Roosevelt University and the School of the Art Institute. Her work focuses on murals and design projects, including painting Black themed images.

"Sports" (detail of the Wall of Respect). Copyright © Robert A. Sengstacke, 1967.

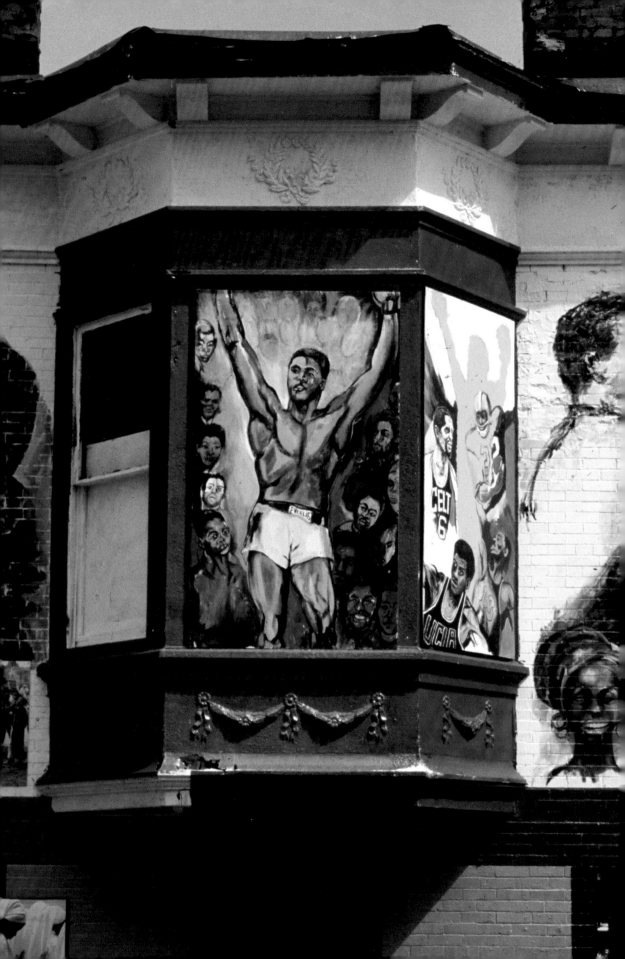

7. Statesmen

Marcus Garvey (1887–1940)

Adam Clayton Powell (1908–1972)

Malcolm X (1925–1965)

Stokely Carmichael
(Kwame Ture, 1941–1998)

H. Rap Brown (Jamil Abdullah
Al-Amin, 1943–)

The Wall of Respect was produced in 1967 at a high point of radical Black consciousness, following the rallying cry of Black Power in 1966. Focus was on Black unity, Black pride, and unfailing commitment to Black resistance. Marcus Garvey was the earliest individual reclaimed as central to this process. He led the largest mass organization in the history of Black resistance, the Universal Negro Improvement Association (UNIA). Garvey had been persecuted by the U.S. government, so it was an act of courage to feature him as a historical force on the Wall of Respect. Adam Clayton Powell and Malcolm X made their mark after World War II. New Yorker Powell was a militant insider who cried out Black people's interests inside the halls of Congress. He combined service as congressman with his post as minister of Harlem's Abyssinian Baptist Church and convened the first Black Power conference. Malcolm X became the alternative to Martin Luther King and was a leader in transforming the 1960s Civil Rights Movement into the Black Liberation Movement. As a Muslim minister and a leading theoretician of Black Power, Malcolm was also key in uniting religion with politics. By the time the Wall was conceived, Stokely Carmichael (Kwame Ture) and H. Rap Brown (Jamil Abdullah Al-Amin) had become the best known of a new generation of activists, a generation led by militants from the most vanguard force of the Civil Rights Movement, the Student Nonviolent Coordinating Committee (or SNCC).

Norman Parish and Roy Lewis worked on this section of the Wall. Norman Parish (1937–2013) was a painter who worked primarily in a "stylized realist" mode. He graduated in 1960 from the School of the Art Institute of Chicago. After moving to Washington, D.C., in 1988, he opened the Parish Gallery in the Georgetown neighborhood in 1991. The gallery became an important center for the work of African American artists.

Roy Lewis (born 1937) is a photographer. Born in Natchez, Mississippi, he migrated to Chicago following his high school graduation in 1956 and went to

work for Johnson Publishing. He first developed skills as a photographer after being drafted into the U.S. Army in 1960 and later worked as a freelance photographer and videographer both in Chicago and on extensive travels in the United States and abroad. He has received numerous awards for his photojournalism including the Maurice Sorrell Lifetime Achievement Award.

William Walker and Eugene "Eda" Wade worked on the Wall in its later versions. Eda (born 1939) grew up in Louisiana and received his B.S. in art education from Southern University in 1964 and an M.F.A. from Howard University in 1971. Eda returned to Chicago in 1971 and was active as a muralist while teaching at Kennedy-King College from 1979 to 2005. His work appears at Kennedy-King College, Malcolm X College, Olive-Harvey College, and the DuSable Museum, all in Chicago.

Other artists who painted on or near the Wall but were not members of OBAC include Kathryn Akin, Curly Ellison, Will Hancock, and David Bradford.

Overleaf "Statesmen" (detail of the Wall of Respect).
Copyright © Robert A. Sengstacke, 1967.

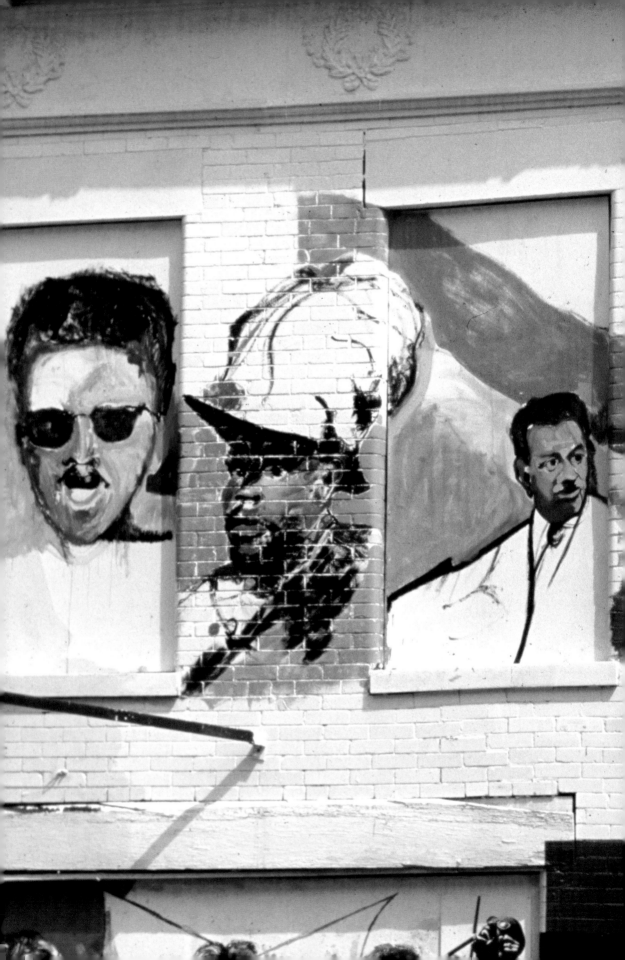

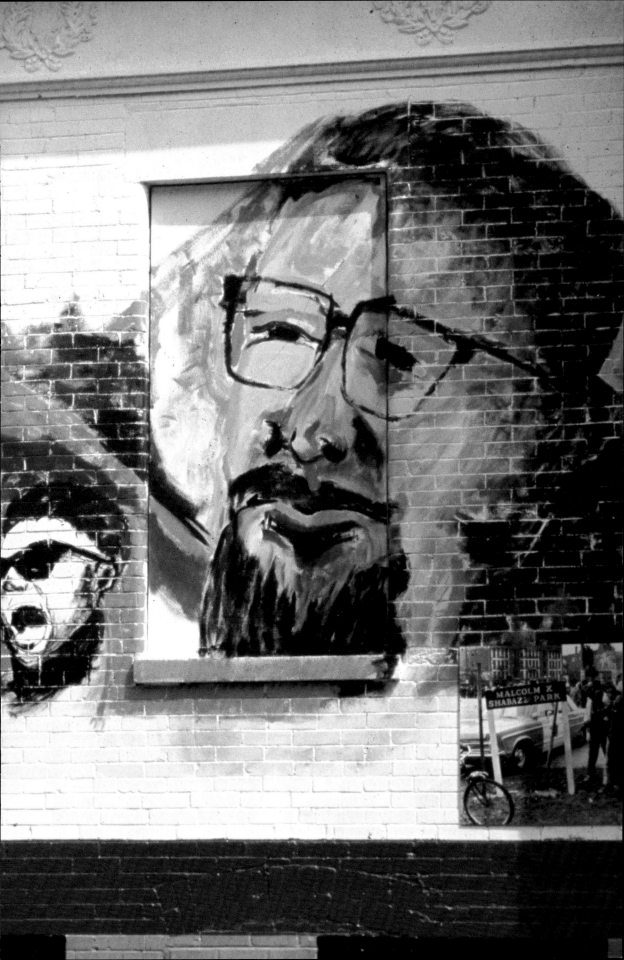

III. THE WALL IN HISTORY

AND CULTURAL POLITICS

Black Chicago: The Context for the Wall of Respect

Abdul Alkalimat

The Wall of Respect was a major project of the Chicago Black Arts Movement. It made a great impact on the city of Chicago. But more than that, it led to a national movement and made an impact globally as well. It was part of the fundamental transformation of consciousness that swept the country after the rise of the "Black Power" slogan in 1966 and the activities of the social movement that took that slogan up as its main ideological focus. But the Wall came from somewhere, and that somewhere was Black Chicago.

By Black Chicago, I mean the city's Black political culture. This culture contains the fundamental contradiction between class and power, as Black people face those two realities, and the values and norms of our everyday life as expressed in art and cultural creativity. Black cultural agency promotes Black unity by affirming Black identity. It rejects the racism imposed on Black people and counterattacks by exposing that racism, which is often regarded as normal. What is more, the struggle for freedom, justice, and equality has always been a context for understanding and explaining the meaning and importance of Black cultural creativity.

This essay lays out the Wall's historical background in the political culture of Black Chicago and the social and ideological forces that shaped the Wall's artists and motivated them to make this courageous project as powerful as it was.

The National Background

Before 1966, the main public advocacy for the identity of African Americans was anchored in the word "Negro." This was a controversial naming that was affirmed and rejected in different ways. In 1925 W. E. B. Du Bois famously sent a letter criticizing the *New York Times* for writing the name in lower case as if it wasn't a legitimate name for a nationality or ethnic group.[1] On the other hand, in his pamphlet *The Name "Negro": Its Origin and Evil Use* (1960) Richard Moore attacked the term as disconnecting people from their ancestral homeland of Africa, arguing that it was an anomaly among names usually given to ethnic groups and nationalities in the United States.[2] The naming of African American people has always been a serious issue.[3]

Many African American artists, for their part, rejected any label that would make them representatives of a group, due in part to mainstream pressure. They demanded to be thought of as individual artists and not be limited to what was considered the proper role for a "Negro artist." This was especially true of those who were trying to penetrate the mainstream market for their artistic creations and thus wanted art critics to recognize the potential of their work to speak to people of all colors.[4] Of course, even with this naming controversy the subject matter for the overwhelming majority of Black artists has always been the Black experience, as they made art about what they knew. One interpretation of this controversy is that these artists were arguing that the Black experience was a profound example of what it means to be human, hence it was as worthy of serious consideration as that of the Europeans or any other people in the world.

The 1960s broke this identity crisis wide open. After the two great migrations around the times of World Wars I and II, for the first time the critical mass of African Americans coming of age had been born in the North. Key to understanding the historical origins of the African American debate around identity in the 1960s is a dialectic within the African Diaspora. The 1945 Fifth Pan-African Congress, held in Manchester, England, led to Ghana's 1957 independence from British colonialism. So many African countries shook off their colonial bondage that the United Nations proclaimed 1960 "Africa Year."[5] Meanwhile the freedom struggle in the United States broke out in stages as well: The U.S. Supreme Court made the 1954 *Brown v. Board of Education* decision to integrate public education, a landmark case won by NAACP lawyers under the leadership of Charles Houston and Thurgood Marshall. Televised coverage of the 1957 school integration struggle in Little Rock, Arkansas, heightened the impact of this decision. Finally 1959 and 1960 saw a wave of sit-ins to integrate public accommodations.

The liberation dynamic sweeping the African continent ripped out the shame and degradation that racist domination had forced into the consciousness of

the African American people. Of course there had always been a pro-Africa tendency that had survived from the slave trade up through the twentieth-century Garvey movement and the Du Bois Pan-African congresses. But in the mainstream of African American life there was a tendency not to identify with Africa.[6] The mass media taught negative stereotypes about Africa and the movies promoted respect for the fictional white Tarzan over the intellectual and cultural achievements of the indigenous African peoples. So as the Africans rose up, and as the African American people were also rising up, a new Black consciousness was reborn, leading to the transformation of political culture on both continents.

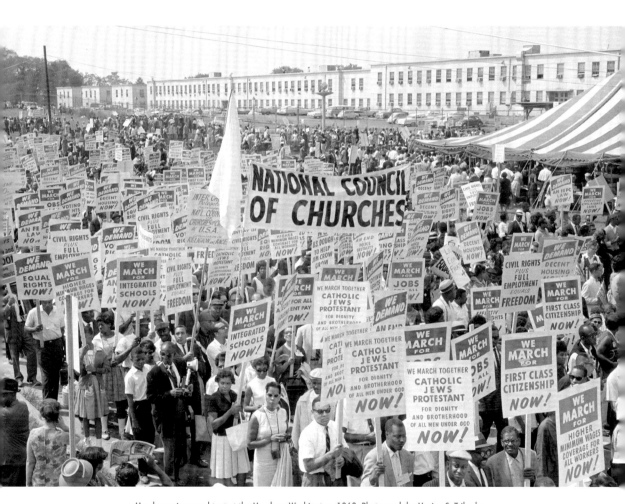

Marchers, signs, and tent at the March on Washington, 1963. Photograph by Marion S. Trikosko. Library of Congress, U.S. News & World Report Magazine Photograph Collection.

Martin Luther King and Malcolm X waiting for press conference, 1964. Photograph by Marion S. Trikosko. Library of Congress, U.S. News & World Report Magazine Photograph Collection.

This new militant consciousness fought the Civil Rights battle wherever it needed to be fought. The 1963 March on Washington proclaimed the universal validity of the demand for jobs and freedom, while at a local level the 1964 Mississippi Summer Project rallied national forces to confront political apartheid in the most racist state in the country. In 1963 Martin Luther King Jr. became a national hero after delivering his "I Have a Dream" speech in Washington, D.C. A 1964 counterattack felled three martyrs in the battle for justice in the Mississippi Delta: James Chaney, Andrew Goodman, and Michael Schwerner. In February 1965 Malcolm X was assassinated. Seven months later the Black community struck back with the great Watts Rebellion. When viewed in its totality, this was a war of diametrically opposed forces fighting for the soul of the country.[7]

In a 1966 Mississippi march, James Meredith, the African American who integrated the University of Mississippi, was shot. In response, the militant forces of SNCC (the Student Nonviolent Coordinating Committee) raised the slogan of Black Power.[8] This ideological blow to the heart of racist oppression lit a fire in the consciousness of the masses of Black people, those who had been forced into silence until then. As its first proponent in the mass movement, Stokely Carmichael (Kwame Ture) said, "When you talk of Black Power, you talk of building a movement that will smash everything Western civilization has

created."[9] This unleashed intellectual and cultural forces that began to examine the 360 degrees of the Black experience and attack every perceived instance of racism. A new offensive was on.

The political expression for this was a 1967 national conference on Black Power in Newark. It was at the heart of a time of great resistance.[10] It was the year of great insurrections: including those in Newark, July 12–17, and Detroit, July 23–27. The Newark Black Power Conference was smack in the middle, July 20–23. Representatives of 300 organizations from 126 cities and 26 states participated. The conference spoke to the potential power of the masses of Black people, reaching far beyond the traditional leadership of the Black middle class.

Painting the Wall of Respect got under way just as the Newark Black Power Conference convened. Hoyt Fuller and I left Chicago briefly for Newark to chair the workshop on "Black Professionals in the Struggle." We were both officers of the Organization of Black American Culture, which initiated and sponsored the Wall of Respect. So the activity in Chicago fed people throughout the country and the national Black Liberation discourse fed directly into Chicago.

Political Culture of Chicago

The political culture of a city is the historical foundation for understanding whatever emerges. In this case we have to discuss population changes, class forces, and the autonomous institutional development of the Black community. Key individuals always stand out as representatives of a broader process. This is especially true in Chicago.

Year	Total population	Black population	Percent Black
1890	1,099,850	14,271	1.3
1900	1,698,575	30,150	1.8
1910	2,185,283	44,103	2.0
1920	2,701,705	109,458	4.1
1930	3,376,438	233,903	6.9
1940	3,396,808	277,731	8.2
1950	3,620,962	492,265	13.6
1960	3,550,404	812,637	22.9
1970	3,366,957	1,102,620	32.7
1980	3,005,072	1,197,174	39.8
1990	2,783,911	1,087,711	39.1
2000	2,893,666	1,065,012	36.8
2010	2,695,598	887,608	32.9

Chicago's total population and the percent African American, 1890–2010, from the U.S. Census Bureau.

The baseline is a twentieth-century demographic shift in Chicago. The Black population rose to almost 40 percent of the city, and it was in the 1960s that the Black population first exceeded one million.

Until Illinois Harvester introduced the mechanical cotton picker in 1944, the masses of Black people were picking cotton in the fields of the South. The mechanical picker was a vital causal factor of the second great migration of Black people to the northern states. Chicago was a direct destination for Blacks coming from Mississippi, Alabama, and Louisiana in the Deep South.[11] As a result, Chicago developed its own internal *Black Metropolis*, the title of a 1945 book by St. Clair Drake and Horace Cayton.[12]

In Chicago, rural tenant farmers transformed themselves into industrial workers. This proletarianization process was the result of employment in the manufacturing economy, notably in steel, the stockyards, the railyards, and the post office. Class forces placed Black people in a new environment that required them to adapt to a massive commodification of social life. And so the culture they brought with them from the rural South changed. The spirituals of the slave legacy became the urban gospel tradition. Bandleader Thomas A. Dorsey and his lead singer Mahalia Jackson, both Chicagoans, were pivotal in this development. The rural blues became the urban blues in Chicago, as musicians like Howlin' Wolf, Muddy Waters, Willie Dixon, and Jimmy Reed relocated from Mississippi.

On an ideological level a strong tradition of Black radicalism provided the worldview for a counterpublic sphere rooted in the Black community. Racist norms in public opinion and political action, especially virulent forms like the KKK, were mainstream obstacles facing Black people. Ideological resistance by Black people took the form of Pan-Africanism, nationalism, liberation theology, feminism, and socialism.

As in most big-city Black communities in the first two decades of the twentieth century, the mass movement led by Marcus Garvey and his United Negro Improvement Association influenced people very broadly. This led to the founding of two religious organizations, the Moorish Science Temples and the Nation of Islam. Noble Drew Ali moved his Moorish Science Temple headquarters from Newark to Chicago and Elijah Muhammad moved his Nation of Islam headquarters from Detroit to Chicago.[13] Each of these three Black Nationalist organizations were the early twentieth-century precedents for the Black Power movement of the 1960s. They were not aggressive agents of social change based on protest activity like the 1960s Black Power movement, but they were definite manifestations of independent Black thought. They were changing consciousness and personal behavior, and this was a necessary step that led to Black Power in the 1960s.

The best popular case of ideological debate and discussion in this counterpublic sphere was the Washington Park Forum. This was an open-air demo-

Overleaf Black Power graffiti, circa 1967. Copyright © Robert A. Sengstacke.

cratic space for public speaking on Chicago's South Side. In the Black community this was like Bughouse Square on the North Side or Hyde Park Speaker's Corner in London. People came to hear the ideologists of the community run it down, spanning from Black nationalists to communists of many flavors. People came to learn about history and current events as well as artistic and cultural developments. It was about what you knew and how well you could communicate with everyday people, not what degrees you had or what level of white acceptance put you into mainstream visibility.

Living in the most segregated big city in the country, the Black community of Chicago had to develop its own set of autonomous institutions to produce and provide access to information about itself and its cultural practices. These included media, a museum, an art center, a special collections library, record stores, and bookstores. Each of these provided Black cultural grounding based on memory of the past, community of the present, and a launch pad for cultural innovations.

The community stayed aware of itself through its own media. What is more, the major Black media of Chicago were also the national media of the entire Black community. Robert Abbott (from Georgia) resettled in Chicago and founded the weekly *Chicago Defender* newspaper in 1905. It became a daily in the 1960s. John H. Johnson migrated from Arkansas to Chicago and started a media conglomerate, beginning with *Negro Digest* in 1942, then *Ebony* in 1945, and *Jet* in 1951. Elijah Muhammad, born in Georgia, came from Detroit to Chicago and founded *Muhammad Speaks* in 1960 with the inspiration and legwork of Malcolm X. In diverse ways these publications each represented a Black perspective, featuring Black images, recognizing Black achievement, and celebrating Black cultural excellence. Even when the focus was on the Black middle class, they built pride in community and optimism that racist oppression could be overcome. This was a form of nationalist consciousness.

The breakthrough in building a memory institution came with the long-sought 1932 opening of a Chicago Public Library branch in the Black community and the appointment of Vivian Harsh as the city's first African American branch director. She headed the George Cleveland Hall Branch Library, named after a Black physician who served on the library board. She established the Special Negro Collection, harnessing private funds ($500 to start, none of it from the library), collecting Works Progress Administration (WPA) historical research materials, and organizing with cultural producers of the day. After her death this grew into the Vivian G. Harsh Research Collection housed at the Carter G. Woodson Regional Library. The collection has been led by such librarians as Donald Joyce, Alfred Woods, and Robert Miller, assisted by Michael Flug. Also important at the Hall Branch was the legendary children's librarian Charlemae Hill Rollins.

In 1940 the South Side Community Art Center was founded as part of the WPA. This amazing institution nurtured artists and spread cultural awareness broadly in the community. Associated with the center were photographer Gordon Parks; painters Charles White, Archibald Motley, Elizabeth Catlett, and Margaret Burroughs; sculptors Marion Perkins and Richard Hunt; and writers Ted Ward, Richard Wright, Gwendolyn Brooks, David Crowder, Vernon Jarrett, and Frank London Brown, among others.[14]

Margaret Burroughs distinguished herself in many ways. The most enduring has been her founding of the DuSable Museum of African American History with her husband Charles Burroughs in 1957. Launched in their own home, the museum provided artifactual displays that connected its audience to the history of Black people from their African roots to the present in Chicago. Margaret was a Chicago icon, teaching generations of local artists in her capacity as head of the art department at DuSable High School on the South Side in the heart of the Black community. Noted historian Sterling Stuckey shares his personal experience:

> Though I never took a class from Margaret Burroughs while at DuSable High School, I knew very early of her presence and somehow found myself at her home from time to time, drawn there because the beginnings of what was to become the DuSable Museum of African American History were housed there. Consequently, her impact on me was made mainly out of the classroom, and there was no other such influence from any teacher at DuSable. That is how I first came to know Margaret's quietly expressed yet intense interest in social justice, which was hardly unrelated to her interest in art. It was many years before I understood what a great artist she is.[15]

The music tradition has been the most solid and sustained cultural force in Chicago. The blues came up from rural Mississippi, and jazz jumped up from New Orleans through other cities like Kansas City and St. Louis. In Chicago the training of Black musicians was centered at DuSable High School under the tutelage of Captain Walter Henri Dyett. He was a music teacher at that high school from 1932 until 1962, running his program with a discipline that reflected his service in the military. His great success is demonstrated by his stellar students: Gene Ammons, Nat King Cole, Bo Diddley, Dorothy Donegan, Von Freeman, Johnny Griffin, Joseph Jarman, Wilbur Ware, Dinah Washington, John Young, Redd Foxx, and scores more. In the community from 1945 to 1961 the great music elder Sun Ra evolved his unique style partly by recruiting young musicians from Captain Dyett's program. Sun Ra's band was a school and had the greatest innovative impact after that of the musical revolution of bebop.

Another major musical force on the Chicago scene was Oscar Brown Jr. He was a poet, composer, and performer who anchored his art in the lived experience of the Black community and the history of Black literature. In 1965 he put together a musical stage production called *Summer in the City*. This gave new expression to the talent in the neighborhoods. In 1967 he reached out to the most notorious gang (or "teen nation," as it was sometimes called), the Blackstone Rangers, later the Almighty Black P Stone Nation.[16] Brown challenged them to be cultural activists. Their membership stepped up and became the cast for another of his major musical productions, *Opportunity Please Knock*.

Books have been important beyond the local library, especially for the section of the community already won to reading and following Black intellectual history. In the 1920s, after studying law at Northwestern University, F. H. Hammurabi (Robb) began a life of public scholarship, publishing, and bookselling to advance positive knowledge about the world African experience. He was the Chicago equivalent of the famous J. A. Rogers, the most popular African American public historian. Ishmael Flory, a leading Black militant activist of the Communist Party, operated a bookstore in Chicago's Englewood neighborhood. He specialized in Black intellectual history and socialist literature about world revolution. In 1960 he founded the African-American Heritage Association and led many activities to bring awareness of the freedom struggles in Africa and of key African American leaders like W. E. B. Du Bois and Paul Robeson.

Curtis Ellis (*right foreground*) works a table at an OBAC event at Dunbar High School on the South Side of Chicago, November 1968. Copyright © Robert A. Sengstacke.

In the 1960s the most important book dealer was Curtis Ellis. He began his bookselling on a single rack in a candy store he owned in Woodlawn just south of the University of Chicago. He grew his business as part of the explosion of the 1960s. At its height he had five Chicago-area bookstores, two of them on college campuses. His bookshop became a destination for any African American political and artistic celebrities visiting Chicago as well as for all local Black political and cultural activists. It also became the main commercial outlet for the locally produced literature that built the Black Arts Movement of Chicago. Two major book-publishing ventures started during the 1960s in addition to Johnson Publishing: Path Press in 1961, led by Bennett Johnson and Herman Gilbert, and Third World Press in 1967, started by Haki Madhubuti (Don Lee).

The major event that protected and extended Black historical consciousness early in the twentieth century was the 1915 founding in Chicago of the Association for the Study of African American (then Negro) Life and History. And there were literary circles throughout the twentieth century. One example is the Pobla literary club based at the Church of the Good Shepherd, which has met every month since 1950. This is a club of middle-class Black women who love to read books, especially those about the Black experience. The senior writers who preceded the 1960s explosion were Gwendolyn Brooks, Lerone Bennett, St. Clair Drake, Allison Davis, and Lorenzo Turner. These were the scholars and artists of the Black experience who led the intellectual life of the community.

This tradition of grassroots study of African American life, history, and culture, both in Chicago and across the United States, gathered strength in the 1960s. In 1962 an organization formed in anticipation of the centennial of the Emancipation Proclamation called American Negro Emancipation Centennial Authority (ANECA). The top leadership of this organization was very much within the political and economic mainstream, with board members being appointed by political officials and funding granted from state legislatures and African countries.

It was the youth group, the ANECANS, that gathered together the young militants who spearheaded the Black consciousness movement in 1960s Chicago. This included Jeff Donaldson, Sonja Stone, Russell Adams, and me. In fact, the main publication of this group was by Russell Adams, then a Ph.D. candidate at the University of Chicago working as a social worker. This volume, *Great Negroes Past and Present*, could be seen as an early expression of the same focus later taken up by the Wall of Respect. Adams went on to head the Department of African American Studies at Howard University. Donaldson went on to head the Art Department there and later served as Dean of Fine Arts. Sonja Stone, after heading the Center for Inner City Studies in Chicago, went to head African American Studies at the University of North Carolina in Chapel Hill, where the African American Cultural Center is now named after her. I went on to head

African American Studies programs at several institutions, including the University of Illinois at Urbana-Champaign.

An important educational innovation was focused on the educational experiences of Black, Latino, and poor students in the inner city: the Center for Inner City Studies of Northeastern Illinois University, founded in 1966. It is located in a Frank Lloyd Wright building in the same Grand Boulevard community area as the Wall of Respect. The Center has been a major locus for Black Nationalist activities, including cultural work of all kinds. Key figures at this institution in addition to Sonja Stone have been Jacob H. Carruthers, Anderson Thompson, Conrad Worrill, and Robert Starks.

In sum, the agency of Black political culture in Chicago was characterized by transgenerational networks, autonomous institutions of memory, cultural creativity, and a militant rhetorical tradition of radical Black thought. There was more unity than met the eye in public discourse. For example, Bennett Johnson arranged for Martin Luther King and Elijah Muhammad to meet. More often than not, what the mass media portrays as impossible can and does happen. King and Muhammad were each strong advocates for Black freedom and against all forms of racism, and while they held quite different ideological views, respect and understanding were possible. Black consciousness was in the air, for self-defense and for the celebration of self and community.

Militant Black Protest in Chicago

Chicago has historically been the scene of militant labor struggles and Black social protest. Among many critical events were the Haymarket Affair (1886) and the Pullman strike (1894).[17] In 1905 the International Workers of the World was founded in Chicago. In 1919 the U.S. Communist Party was founded in Chicago; it maintained its headquarters there throughout the 1920s.

By the mid-1930s Black workers made up 6 percent of steel workers and 20 percent of packinghouse workers. Nearly all of the full-time organizers of the CIO (Congress of Industrial Organizations) organizing in steel were members of the Communist Party, several being cadres on loan from the National Negro Congress, which held its first national congress in Chicago in 1936. Police were caught on film killing ten unarmed demonstrators in the 1937 Memorial Day massacre at Republic Steel.[18] In 1942 the Congress of Racial Equality (CORE) was formed in Chicago. By 1947 they started freedom rides out of Chicago into the South.[19] The early rumblings of the nonviolent protest movement had begun.

The first half of the twentieth century was a time of intense class struggle in Chicago, which shaped a class-conscious, pro-union, Black working class. Michael Dawson, professor of political science at the University of Chicago

and great-nephew of the former Chicago congressman William Dawson, sums this up, noting the importance of the Communist Party for Black workers in Chicago:

> For the Communist Party of the United States (CPUSA), Chicago proved to be a rich source of African American members. Chicago communists also recruited more successfully in the Black areas of the city than in other local racial or ethnic communities. Black membership in the CPUSA's Chicago branch was proportionately larger than any other chapter—in Chicago the membership was 24 percent Black. Perhaps even more surprisingly, in absolute numbers Chicago also had the largest number of Black CPUSA members. The more than four hundred Black members of the Chicago branch represented nearly six times the membership of the famed Harlem branch. The large number of Black cadres aided the unemployment councils' work—in Chicago the councils had more than a thousand Black members.[20]

In Chicago, access to higher education helped a generation of Black militant leaders acquire skills needed for the struggle. In 1945 Roosevelt University opened its doors in downtown Chicago and was dedicated to maintaining a diverse student body. This placed the school in the vanguard of postwar democratic transformation. The GI Bill provided tuition support for veterans of World War II. So a strong cohort of Black veterans attended Roosevelt. Many of these Black veteran-students later took the lead in the political culture of Chicago. For instance, Dempsey Travis became a leading Black realtor and the author of several books on local history. Harold Washington became a lawyer and served in the Illinois state legislature and in Congress before becoming the first Black mayor of Chicago. Gus Savage became a local community newspaper publisher and congressman. Oscar Brown Jr., the son of a prominent businessman and politically active nationalist, became a leading musician-activist in the Chicago Black Arts Movement. Frank London Brown became a prominent writer; his novel *Trumbull Park* tells of the struggle to integrate a housing project in Chicago. Bennett Johnson became a prominent political and cultural activist in Chicago and Evanston and a founding board member of OBAC. These people stand out among those who propelled Black political culture in Chicago leading up to, during, and following the 1960s.

There was also a powerful dialectic that marked the early beginnings of the activism of the 1960s generation in Chicago. The May 1954 Supreme Court decision to force school integration was followed by the brutal murder of a teenage Chicagoan, Emmett Till, in the Mississippi Delta on August 28, 1955.[21] *Jet* magazine published a photo of his face, which had been beaten into a near monster-like image.[22] His mother toured Chicago's neighborhoods, deepening

public outrage at the lynching of a son of Chicago. The sit-ins began a few years later, and a support group started in Chicago after SNCC was formed at Shaw University in North Carolina in April 1960. This group was called the Chicago Area Friends of SNCC (CAF-SNCC).[23] It soon became much more than a support group for the Southern struggle.

Yet another dialectical power confrontation propelled history forward. On June 12, 1963, Medgar Evers, state leader of the Mississippi NAACP, was murdered in front of his house. On August 27, 1963, two hundred fifty thousand people mobilized for the powerful March on Washington for Jobs and Freedom Now under the joint cooperation of the labor movement and the Civil Rights Movement. In Chicago Timuel Black, then leader of the Negro American Labor Council and a close collaborator with A. Philip Randolph, led the mobilization.[24] Chicago was on fire and sent two train loads, fifteen bus loads, and one full plane, while unknown numbers of cars and individuals made their own way. The Chicago mobilization center was the Packinghouse Workers Hall, with CAF-SNCC militants as the main source of on-the-ground organizers. Then Chicago sent a critical number of militants to the 1964 Mississippi Summer Project, including Mimi Shaw, Loren Cress, and Monroe Sharp.

The movement in Chicago had the broadest coalition of forces of any city in the country: the Coordinating Council of Community Organizations (CCCO). Chicago public school teacher Al Raby was elected convener, but he was only one of many militant activist-educators alongside Barbara Sizemore, Anderson Thompson, and Harold Pates. The CCCO was made up of groups associated with Civil Rights Movement organizations, local communities, places of worship across faiths, and many other kinds of activist constituencies.[25]

Connecting broadly to all these individuals was the crisis of the public school system. Here the dialectic emerged in 1963 when ten-year-veteran school superintendent Benjamin Willis responded to school overcrowding, not by building more schools, not by allowing transfers to underutilized white schools, but by placing portable classrooms without bathroom facilities in schoolyards. City-wide protests broke out identifying him as the protagonist of evil. The fight against school segregation and lack of school quality had spread from the Southern movement into the North. Community members dubbed the portable classrooms "Willis Wagons." They became a rallying symbol of school segregation and inequality.

Segregation in Chicago was no secret. A full 64 percent of Black high school students and 88 percent of Black elementary school students attended schools that were at least 90 percent Black.[26] The system was based on the neighborhood school model; the segregation of the schools reflected the segregated housing reality of the city due to the restrictive covenants the real estate industry had helped create. (Outlawing such covenants was another prolonged struggle in Chicago.)

The CCCO called for a public school boycott, and in October 1963, 225,000 students out of 469,733 joined in. The headquarters for this effort was a former bank building on the southwest corner of Oakwood Boulevard and Cottage Grove. Again in the Grand Boulevard area, this same building housed the CAF-SNCC headquarters and the South Side office of the National Lawyers Guild. More than one million leaflets were printed at this location and taken into every neighborhood in the city, especially the Black, Latino, and poor neighborhoods. Among the key leaders here were Lawrence Landry, a University of Chicago graduate student and chairperson of CAF-SNCC, and Rosie Simpson, mother of six and a community leader. This shook up the local political machine headed by Mayor Richard J. Daley.[27]

There were six Black members of the city council who were famously called the "silent six" for their lack of support of the movement—they served Daley instead. So when a second boycott was called for February 25, 1964, the six began to threaten people that if they kept their children out of school, parents who were city workers would lose their jobs and others would be the targets of lawsuits. But these feeble efforts failed. Only some of the middle-class Black families defected. The masses spoke as 175,000 people supported the second boycott. Once again militancy in Chicago led the way, as a national movement of boycotts of urban school systems, including that of New York City, took hold.

After the school boycotts Chicago became a major focus of the Civil Rights Movement coming north. Jesse Jackson had moved to Chicago in 1963 to attend divinity school. Martin Luther King Jr. followed in 1965. Again the nation was watching Chicago and that helped Chicago to be more conscious of itself. The national crisis was intensifying and so was Chicago. The "Black Power" slogan erupted during a June 16, 1966, march in Mississippi after James Meredith was shot down. That put the nation on alert. The Black community stood up once again in Chicago with an urban insurrection the following month. King marched in Chicago the month after that and was struck down by a rock on August 5. He had been stabbed in Harlem, attacked in many southern places, and now hit in the head in Chicago. What was going to happen next?

All of this—the internal development of institutions, organizations, and cultural developments, and the fighting tradition of resisting racism and class oppression—led to that great moment of the Wall of Respect. Nothing comes from nowhere. The Wall of Respect is a product of Black Chicago, the Black political culture of Chicago. And the Wall was embraced by Chicago's Black Liberation Movement and used as a site for promoting Black unity.

Notes

1. A copy of the letter is available at http://credo.library.umass.edu/view/full/mums312-b030-i210.

2. Richard Moore, *The Name "Negro": Its Origin and Evil Use* (Baltimore: Black Classic Press, 1992 [1960]).

3. Sterling Stuckey, "Identity and Ideology: The Names Controversy," in *Slave Culture: Nationalist Theory and the Foundations of Black America* (New York: Oxford University Press, 1987), 216–74.

4. The best essay that deals with this is a manifesto by Langston Hughes written in 1926. Langston Hughes, "The Negro Artist and the Racial Mountain," in *The Collected Works of Langston Hughes: Essays on Art, Race, Politics, and World Affairs*, ed. Christopher C. De Santis (Columbia: University of Missouri Press, 2002), 31–36.

5. For this history see Vincent Harding, *There Is a River: The Black Struggle for Freedom in America* (New York: Harcourt Brace Jovanovich, 1981); Vijay Prashad, *The Darker Nations: A People's History of the Third World* (New York: New Press, 2007); and Ronald W. Walters, *Pan Africanism in the African Diaspora: An Analysis of Modern Afrocentric Political Movements* (Detroit: Wayne State University Press, 1993).

6. Walters, *Pan Africanism*.

7. Juan Williams, *Eyes on the Prize: America's Civil Rights Years, 1954–1965* (New York: Viking, 1987).

8. Stokely Carmichael and Michael Thelwell, *Ready for Revolution: The Life and Struggles of Stokely Carmichael (Kwame Ture)* (New York: Scribner, 2003).

9. See Biography.com Stokely Carmichael entry, http://www.biography.com/people/stokely-carmichael-9238629.

10. Peniel E. Joseph, *Waiting 'Til the Midnight Hour: A Narrative History of Black Power in America* (New York: Henry Holt and Co., 2006).

11. James R. Grossman, *Land of Hope: Chicago, Black Southerners, and the Great Migration* (Chicago: University of Chicago Press, 1989).

12. St. Clair Drake and Horace R. Cayton, *Black Metropolis: A Study of Negro Life in a Northern City* (New York: Harper & Row, 1962 [1945]).

13. Essien Udosen Essien-Udom, *Black Nationalism: A Search for an Identity in America* (Chicago: University of Chicago Press, 1962).

14. Bill Mullen, "Artists in Uniform: The South Side Community Art Center and the Defense of Culture," in *Popular Fronts: Chicago and African-American Cultural Politics, 1935–46* (Urbana: University of Illinois Press, 1999), 75–105.

15. Margaret T. G. Burroughs, *Life with Margaret: The Official Autobiography* (Chicago: In Time Publishing and Media Group, 2003), 13.

16. Natalie Y. Moore, and Lance Williams, *The Almighty Black P Stone Nation: The Rise, Fall, and Resurgence of an American Gang* (Chicago: Chicago Review Press, 2011).

17. Philip Sheldon Foner, *Organized Labor and the Black Worker, 1619–1973* (New York: Praeger, 1974).

18. Erik S. Gellman, *Death Blow to Jim Crow: The National Negro Congress and the Rise of Militant Civil Rights* (Chapel Hill: University of North Carolina Press, 2012).

19. August Meier and Elliott M. Rudwick, *CORE: A Study in the Civil Rights Movement, 1942–1968* (New York: Oxford University Press, 1973).

20. Michael C. Dawson, *Blacks In and Out of the Left* (Cambridge, Mass.: Harvard University Press, 2013), 1–2.

21. Lerone Bennett, *Before the Mayflower: A History of Black America* (Chicago: Johnson Publishing, 1969).

22. "Nation Horrified by Murder of Kidnapped Chicago Youth," *Jet* 8, no. 19 (September 15, 1955): 6–7.

23. See Library of Congress Chicago SNCC history project archives, http://www.loc.gov/folklife/civilrights/survey/view_collection.php?coll_id=2606.

24. Foner, *Organized Labor.*

25. Alan B. Anderson and George W. Pickering, *Confronting the Color Line: The Broken Promise of the Civil Rights Movement in Chicago* (Athens: University of Georgia Press, 1986).

26. Philip Hauser, et al., *Integration of the Public Schools, Chicago: Report to the Board of Education, City of Chicago* (Chicago, 1964).

27. Ramon J. Rivera, Gerald A. McWorter, and Ernest Lillienstein, "Freedom Day II in Chicago," *Equity and Excellence in Education* 2, no. 4 (August 1964): 34–40.

Black Liberation: OBAC and the Makers of the Wall of Respect

Abdul Alkalimat

The creation of OBAC and the Wall of Respect is a story of specific people in dynamic relationships that spanned generations and expressed nothing so much as the freedom impulse of the moment: Black liberation. Chicago gave rise to one of the most important local expressions of the national Black consciousness and Black Arts Movement. OBAC is part of this story, an innovative and vibrant movement toward a new Black aesthetic that emerged in virtually every city in the country. OBAC represented continuity with the past, reflected the present, and set the stage for much of what was yet to develop. It was founded in 1967 by three people: Conrad Kent Rivers (1933–1968), Hoyt Fuller (1923–1981), and myself (1942–). It grew quickly and launched several projects, particularly the Wall of Respect.

Three Founders

In the beginning there were three of us. We each brought something different to the project. Who we were (Conrad and Hoyt have passed) and how we united is also part of the story.

I was Chicago born in the famous Cabrini projects (long before the Green additions were built). My father was a steel worker, my mother was a clerical worker, and neither had graduated from high school. On my father's side the ancestral patriarch spoken of at every holiday meal was great-great-grandfather

OBAC meeting at Hoyt Fuller's apartment:
Joe Simpson, Gerald McWorter (Abdul
Alkalimat), Roberta Johnson, and E. Duke McNeil.
Copyright © Hoyt W. Fuller, 1967.

Conrad Kent Rivers, OBAC meeting at Hoyt Fuller's
apartment. Copyright © Hoyt W. Fuller.

Frank McWorter, the first African American in the United States to found a town: New Philadelphia, Illinois. Frank bought sixteen family members out of slavery, obtained his citizenship rights via an 1836 law voted on by the state legislator Abraham Lincoln, and organized his family and the town into practical abolitionism. The town is today recognized by the National Park Service.

My father's older sister Thelma was part of the Black Arts scene in Chicago during the 1930s and '40s. Her house was full of original paintings and traditional African sculpture. She was a close colleague of Margaret Burroughs and a longtime associate with her in the DuSable Museum and the South Side Community Art Center. Like most Black families, the McWorter clan sacrificed for education. In 1914 a relative earned the family's first college degree—from the University of Chicago.

My mother's family was rooted in labor struggles. Her brother Otto and his wife Eleanor, full-time progressive activists with the National Negro Congress and the Steel Workers Organizing Committee, turned all of us kids on to W. E. B. Du Bois and Paul Robeson. In elementary school they gave me a spoken-word record about the Underground Railroad that I memorized, and a book about great Black people called *Thirteen against the Odds* by Edwin Embree, president of the Julius Rosenwald Foundation. My influences were strong in Black culture and working-class politics.

The Cabrini projects were built to house war workers, and they vibrated with cultural activity. Win Stracke, the Pete Seeger of Chicago, taught us the songs of labor and struggle rooted in the tradition of American folk music. Curtis Mayfield, Jerry Butler, and Terry Callier were among those of us singing doo-wop on street corners every weekend evening. Ramsey Lewis lived nearby, practicing the piano. For several years St. Clair Drake also lived in Cabrini, which was an integrated public housing development in Chicago in the 1940s.

During the summer of 1962, I was working at the downtown post office as a weekend sub. The hours varied almost to your individual taste, and the money was good. One day, while I was standing on a very crowded bus reading Ashley Montagu's *The Natural Superiority of Women*, someone tapped me on the shoulder and said, "I know Ashley Montagu." It was Conrad Kent Rivers.

Conrad was about thirty then, advanced for his age and seeming much older. He was from Philly and had been close to Langston Hughes, virtually a protégé. His other influences were Casper Jordan, a librarian in Ohio, and an uncle in Atlanta, a brilliant literary critic. Once through an entire night in Paschal's Motor Hotel this uncle held forth, quoting Black songs from poets known and not, including much of what is eternal and beautiful in that great white muse, Bill Shakespeare. Conrad had great teachers and was well schooled.

We rode the Cottage Grove bus to Sixty-Third Street and took the El to the post office, where he happened to be working as well. We went through the as-

signment station after punching in and got assigned to the same place. We talked all day—I had found a mentor, and he an energetic student. Our relationship developed quickly. He opened doors to the world of Black literature. He taught me what he knew and I challenged him and drove him to discipline and self-renewal, like every good student should. That summer he set me to reading all of Richard Wright, Ralph Ellison, James Baldwin, Chester Himes, and all of the major poets of the Harlem Renaissance. We used to ride down the street in his green convertible Thunderbird reciting Black poetry. Once we pulled up in front of a bus stop. Standing up on the seat, I recited to the people waiting that great sonnet by Claude McKay, "If We Must Die." I was singing, they were amused and bewildered, and as we sped away through a red light everyone smiled, laughed, and waved good-bye. I was in love with Blackness, and in that moment everyone knew that what was happening was a good thing.

Conrad introduced me to Hoyt. He was a sophisticated world-class literary figure, an editor, a journalist, and an inveterate critic of injustice and immorality from a Black perspective. Most important of all, Hoyt was concerned about listening to and assisting the younger generation. As I was soon enrolled as one of the few and isolated Blacks at the University of Chicago (pursuing a Ph.D. in sociology), Hoyt joined Conrad in providing me with a rare form of Black mentorship. They gave me a bibliography. They made me privy to several previous decades of Black intellectual discussion and debate. In return, I served as their resident angry theoretician from the youthful 1960s scene.

Hoyt seemed to have been wherever intellectuals of his generation wanted to go. He had been an expatriate in Europe and Africa. He had achieved professional excellence in mainstream journalism, both Black and white. And he was in the process of building the premier Black journal of the 1960s: *Negro Digest*, later known as *Black World*. He published most of the young writers of Chicago, many for the first time, and reported on the relevant artistic and literary trends. He was our Alain Locke, Charles Johnson, or Du Bois, all editors of important journals.[1] Hoyt dared to publish new and innovative work, going beyond an editor's mandate by sometimes publishing us not for the work submitted, but to encourage us so that we would persevere and create work beyond what we might otherwise have achieved. He was the impresario par excellence of the Black Arts literature of the 1960s. The OBAC Writers' Workshop became what it did because of Hoyt Fuller.

Hoyt, Conrad, and I would meet in Hoyt's apartment, where scotch and water flowed in oversized glasses. He lived in a South Side high-rise near the lake, in an apartment filled with books and art from all over the Black world, as well as some of the best from world culture in general. Hoyt was not a narrow person, but he was adamant about fighting in the interest of Black people.

Sometimes others would join us. When Ronald Fair, the novelist-sculptor, joined us in heated debate, the meeting ended just short of physical violence as

Conrad and Ronald fought over their respective views of Hemingway's craft, its relevance to their work, and Black writing in general. We have yet to have a full discussion of the intellectual and technical issues that fueled the debates of the 1960s. I understood some of the issues, but felt that the Rivers–Fair debate was an agenda item plaguing the older set, and that we of the '60s had other more pressing issues to deal with.

An Organization Emerges

Out of these many varied discussions, we were able to reach a common view that a positive Black consciousness (image of self and the world) was essential, and that we should and could do something about it. We named ourselves the Chicago Committee for the Arts and planned a public meeting at the South Side Community Art Center, the only WPA cultural project still going strong. We had a program of three people: Arna Bontemps (poet/historian/librarian), Margaret Danner (poet), and Terry Callier (poet/musician).

Hoyt summed it up this way in "OBAC: A Year Later" (see page 179):

> Miss Danner, whose poetry long had reflected the now-fashionable "black is beautiful" philosophy, represented the venerable: Mr. Callier, a rising and as yet "undiscovered" star, represented that which is ever-new in simple, ungarnished black talent; and Mr. Bontemps, a national treasure, was black literary history on the hoof, a virtual walking encyclopedia of the past half-century of literary labors among black people. It was a stimulating Sunday afternoon.

We began to network and build the group, targeting activists in the current scene. I pulled in Jeff Donaldson, then a high school art teacher at Marshall, my former school, and mutual friend Bennett Johnson, a politico and publisher with a commitment to community cultural advancement. I also pulled in a rare Black close friend from the University of Chicago, Joe Simpson, then a Ph.D. candidate in psychopharmacology. He became the secretary of OBAC and coordinator of the Community Workshop programs. Diana Slaughter, recently retired from the University of Pennsylvania after many years at Northwestern University, was my other close running buddy.[2]

Another friend I brought in was the attorney E. Duke McNeil. We used to meet above his record store on Forty-Seventh Street, just west of King Drive (then South Parkway). The printer Ronald Dunham; the activist Brenetta Howell; George Ricks, a musicologist with the Board of Education; the actress and theater personality Val Gray Ward; and Donald Smith of the Center for Inner City Studies at Northeastern Illinois University joined as well.[3]

As the group was developing, we needed a new name. Jeff Donaldson and I developed the name OBAC in a phone conversation. We were both interested in Africa, and we had had a working relationship for several years, including working together on *The Civil Rights Yearbook*, his 1964 book of sketches with commentary. The key was that the acronym had as its root "OBA," which was Yoruba (a Nigerian language) for "royal," "chief," or "leader," and this was the role we envisioned for our organization. Shortly thereafter Jeff designed the OBAC logo. Our creativity and inspired interaction reflects the positive vibes of the period, the organization, and friends and colleagues who worked together and made history.

Black Chicago has always had exciting community-level arts activity. So, when OBAC formed and began to expand it did so alongside other organizations that already existed. The best example was the Association for the Advancement of Creative Musicians (AACM), formed in 1965 by Muhal Richard Abrams, Phil Cohran, Steve McCall, and Jodie Christian. The AACM was a direct part of the legacy in Chicago created by Captain Walter Dyett and Sun Ra. More than any other group, AACM was the foundation of the Black arts cultural scene in Chicago. Music was foundational in many cities. Musicians were the most sustained cultural force of creativity, going all the way back to our African origins but also leading the way with innovations that defined the future: the Black Artists' Group in St. Louis, the Pan Afrikan Peoples Arkestra in Los Angeles, Creative Musicians Association in Detroit, and the Jazz Composer's Orchestra Association in New York.

Several aspects of the AACM organizational experience set the style for the Black Arts Movement. First and foremost was the rejection of the operating procedures of the commercial mainstream. The AACM was a cooperative by and for the musicians. The division of labor was inclusive, so when a group was to be featured in a performance and rehearsing, other AACM members did the promotional and logistical tasks. They were driven by an ethic of absolute freedom for creativity and a dedication to affirming and inspiring the community for self-realization and focus on freedom. Muhal Richard Abrams and John Shenoy Jackson laid out their perspective in *Black World*:

> The Black creative artist must survive and persevere in spite of the oppressive forces which prevent Black people from reaching the goals attained by other Americans. . . . The AACM is attempting to precipitate activity geared toward finding a solution to the basic contradictions which face Black people in all facets of human structures, particularly cultural and economic. There is an incessant demand in Black communities to solve the disparity between participation and non-participation in the social process. Our concerts and workshops in the schools and in the community are an effort to expose our Black brothers and sisters to creative art-

Gerald McWorter speaks at an OBAC event at the Affro-Arts Theater, circa 1968. Copyright © Robert A. Sengstacke.

ists contemporary to their time and present to them a factual account of their glorious past as an understanding for facing the future.

After forming and consolidating an OBAC leadership group, we organized a public program at the Center for Inner City Studies in order to introduce ourselves to the community. Ann Smith in speech and theater at Northeastern Illinois University joined to direct us and pull the program together.[4] It was quite a spectacular event. Each member of the leadership spoke and explained his or her area of expertise and responsibility (see page 123). The key artistic moment was the inspired poetry recital by Amus Mor (David Moore), then the reigning underground Black Poet Laureate in Chicago. He recited his "Poem to the Hip Generation," which concluded with these inspirational words:

> we are the hipmen
> going into sun
> stand up against us
> mister gog youre done
> where are we going
> into the sky

halt our boggie
and a continients shy
we are the hipmen
singing like black doves
why were we sent here
only to love[5]

I chaired the program and presented the general theoretical statement. The set was the best example of Du Bois's talented tenth of the Chicago Black Arts scene, Black-style noblesse oblige all the way. But two thirds of the way into the program, tension arose between the rational or conceptual and the emotional or experiential. There was theory and there was demonstration, but between them there was a gap. I was an "egghead" not associated with the expressive. Sherry Scott had been invited to participate in the program as a hip bebop-inspired singer and dancer who turned everyone on. The tension reached a high point, someone put on Aretha—it was the period of Aretha's great spiritual power of feeling and rhythm—and Sherry began to dance. The OBAC leadership turned to me and demanded that I join her. As chairperson of the organization, it was up to me to demonstrate that we had the commitment to overcome ourselves and bring the two aspects of our organization into one dynamic union. I was embarrassed for a moment, hesitant because my dancing skills were weak from parental control after dark and too much library time. As she danced on, I leaped to my feet and began to get down, Afro-boo-ga-loo. The Black U of C egghead had soul, and OBAC at its launch married theory with the inspired cultural dynamic of Black people getting down.

Black Experientialism: A Philosophy for OBAC and the Wall

At the highest level of abstraction, the theory that emerged from OBAC was Black Experientialism. This was a philosophical concept to sum up the social content and the historical foundation of the new Black aesthetic that OBAC advanced. It describes the intentionality of all art forms, how the art is created, its audience, and the experiences of the artist and the community. The innovative ideological breakthrough that helped me name this concept for OBAC was the cry for Black Power by the SNCC militants Willie Ricks and Stokely Carmichael on the 1966 March Against Fear in Mississippi.

Black Power is the multidimensional proclamation of a paradigm shift from the Civil Rights Movement back to the freedom focus of the Black Liberation Movement. The Civil Rights Movement placed the Black struggle within the parameters of the legal system based on the U.S. Constitution and formal implementation of government policy. The Black Liberation Movement called all of

that into question and placed the Black struggle in a global context for human rights and self-determination. One was a fight for reform while the other was a fight for revolution.

The Civil Rights Movement as a reform movement mandated that Black people conform to the norms of the mainstream, suggesting that this was the path to social mobility and integration into mainstream society. The Black middle class led the way for Black people to act as "white" as possible. The unintended consequence of this was that the masses of Black people were relegated to a marginalized status. Black Power was an ideological proclamation to flip that script and affirm the power of Black reality from the bottom up. SNCC led the way by anchoring its organizers (called field secretaries) in the rural Black communities in order to facilitate and develop leaders from those communities. This necessitated SNCC adopting their lifestyle, culture, and language. It gave rise to a new kind of Black leader, neither middle class nor urban. (Fannie Lou Hamer was just one standout example.) This was followed by the urban insurrections and new militant organizations, especially the Black Panther Party and the League of Revolutionary Black Workers, a performance of collective politics from the bottom up by the masses of poor and working-class Black sufferers.

The cultural application of Black Power in slogan form was the expression "Black is beautiful." This was a cultural war cry with philosophical content. Beauty is the universal, all too often connected to symbols of European identity and cultural practice. By connecting this universal to the particularity of Blackness, a new cultural path to freedom was laid out for all to see. It was a self-affirmation performed by the Black Arts Movement in every genre. It was every physical aspect of being Black: color, hair texture, lips, eye color, body types, and so on. It was every way of being in the social context of the Black community: language, clothes, dancing, ways of walking, humor, food, and so on. It was being able to define our own heroes and sheroes. What was once bad became good. It was almost biblical: the last became the first. And it all relied on the experience of the vast majority of Black people.

In naming Black Experientialism as OBAC's philosophy, I must have also drawn on my undergraduate majors in sociology and philosophy at Ottawa University. My main instruction in philosophy came from John Lee Smith, whose doctoral dissertation at Yale was a study of the French phenomenologist Maurice Merleau-Ponty. After Smith's Ottawa seminars in phenomenology and existentialism, he took me (a nineteen-year-old undergraduate) to the 1962 founding conference of the Society for Phenomenology and Existential Philosophy at Northwestern University. As Merleau-Ponty wrote, "We know not through our intellect but through our experience." The Black Power moment freed us to escape from our "miseducation," as described by Carter G. Woodson, to learn from our actual experience—about which we began to theorize and create art.

OBAC Takes Off

The summer of 1967 was really quite an experience—it was what James Fore-man had called "the high tide of resistance." Three OBAC workshops got things off to a whirlwind start, and OBAC became known on the national scene almost immediately. But OBAC didn't include every aspect of the arts. The AACM cov-ered music, and OBAC linked with and supported them. Groups led by Darlene Blackburn and Joseph Holmes covered dance. And while we started with drama in the mix, that was soon covered by companies led by people like Val Gray Ward, Abena Joan Brown, and Jerry Jones. OBAC brought together the writers, the visual artists, and everyone with a focus on the community and the national Black Arts Movement.

A school of Chicago street photography had emerged alongside this process. The photographers were part of OBAC, which gave them an insider's posi-tion to document the history. Billy Abernathy, Bobby Sengstacke, Roy Lewis, Onikwa Mugwana (Bill Wallace), Ed Christmas, Bob Crawford, and others caught images of our community in creative acts of political culture. Mostly they were magical in capturing images of fundamental human reality in the everyday motion of the African American people. They made us look timeless.

Hoyt Fuller led the Writers' Workshop and patiently guided the initial discus-sions in which the topic that dominated was: What is Black writing? What is the Black aesthetic? On a philosophical level, this was an exploration of the contra-diction between the universal and the particular, between the universal of beauty and the proclamation of the particularity that "Black is beautiful!" The main fo-cus was on understanding the history of Black writing and its relationship to the everyday life of Black people. Another question was what could be learned from the Chicago writers from other ethnic groups, such as Nelson Algren, Upton Sinclair, and James Farrell. In all this, the main focus was to find a way of doing things that fit into the lived experience of the masses of Black people.

The writers gathered every week to share their work, which was followed by critical discussion, known for its combination of heat and love as a collective search for the Black aesthetic. From the beginning the writers included Don L. Lee (Haki Madhubuti), Carolyn Rogers, Sterling Plumpp, Walter Bradford, Mike Cook, Rhonda Davis, Ebon Dooley, Cathy Slade, James Cunningham, Randson Boykin, Alicia Johnson, Jewel Latimore (Johari Amini), Kharlos Wimberli, and James Yaki Sayles.

Meanwhile Joe Simpson led the Community Workshop, which hosted dis-cussions and guest speakers from other cities to explore the meaning of art and cultural innovation in the larger social setting of the fight for Black liberation. Chicago was hungry to learn what was happening in its sister cities of Los An-geles, San Francisco, St. Louis, Detroit, Cleveland, Boston, New York, Philadel-phia, New Orleans, and Atlanta.

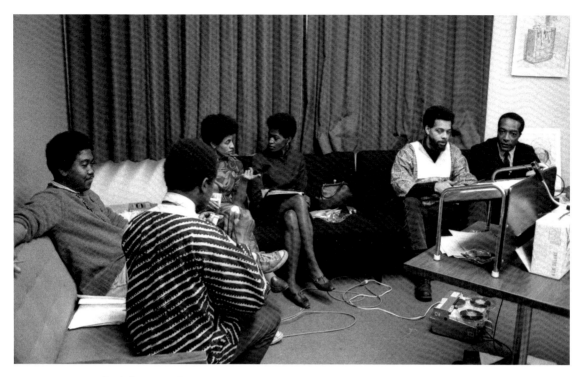

Writers at the Black Arts Festival at Chicago State University, March 1968. From far left, Ebon Dooley (Leo T. Hale), unidentified man with back turned, Jewel Latimore (Johari Amini), Carolyn Rodgers, Haki Madhubuti (Don L. Lee), and Hoyt Fuller. Copyright © Robert A. Sengstacke.

Finally, Jeff Donaldson led the OBAC Visual Arts Workshop through an amazing process of collective action in creating the first public mural of the movement, the Wall of Respect. The Wall was jazz, a collective product inspired by tradition, guided by the politics of Black art, and created by gifted, creative, art makers.

Creating the Wall of Respect

Black visual artists in Chicago usually had a "day job" and did not pay their everyday bills by selling their art. They made art at night or on the weekends, and during the summer if they were fortunate enough to have a teaching job. Most art making was also solitary, with artists working alone in a space with materials and imagination to guide their skill and technique. Their usual social interaction was with the critic and the dealer, the source of evaluation and the source of sale. Local art fairs gave every artist direct contact with the broader community. But the Black Liberation Movement called on artists to do something new, to find ways to unite. They had the musicians as an example, and they could look to previous periods of Black art history when other generations had been called to unite with some success.

Jeff networked with some folks and the first meeting of the Visual Arts Workshop was held June 14, 1967. Some sat back and checked the scene, greeting friends and tolerating others, but many jumped in and had their say. The artists had been absorbing the ideological debates of the day without a full platform for themselves. This was their chance to put the ideology of Black liberation together with art in a group discussion with people who were fully informed about what was being discussed. What resulted was a statement about the times and who they had become. They agreed on the main political points, but lacked any unity on their art. These artists had diverged in many ways on the main issues of art—style and technique, color, representation versus abstraction, basic issues of media, and aesthetics in general. But given the times and the political culture of Black Chicago at that point, their common concern with the ideology and politics of Black liberation kept them together finding ways to unite.

The unity was expressed in the desire to find a project for the collective as a way to become agents of Black liberation, based on art as the basis for positive self-esteem and community values. This was a discussion aimed more to the street and not the art gallery scene, as it was an attempt by the artists to join the movement. William Walker volunteered that he had made arrangements to paint on a building wall at Forty-Third and Langley, deep in the "hood." People dug the idea. And a new round of debate emerged as to what would be on the Wall, who would paint it, and many related issues.

The location of the Wall was going to be a major factor in all of this. Chicago is divided into seventy-seven community areas and the Wall was to be in area number thirty-eight, Grand Boulevard. This is in the heart of what had become known as the Black Metropolis or Bronzeville. Grand Boulevard had been at least 94 percent Black since the 1920s. It held the Regal Theater, the leading venue for movies and stage shows of all the great Black entertainers. Major churches were there, like Mount Pisgah Missionary Baptist Church and Ebenezer Baptist Church. But along with these cultural institutions were the working-class population and the dire poverty that has plagued Black people since the days of slavery and the peonage trap of sharecropping.

During the same period that OBAC went to Forty-Third Street to paint the Wall, the AACM went to Forty-Third Street to play their vanguard sounds: Joseph Jarman, Roscoe Mitchell, Christopher Gaddy, Charles Clark, and others. The herb tea and orange juice crowd was a different clientele for the blues joint. But musicians so often can communicate their authenticity, their absolute truth telling, that even when being spoken to in an unfamiliar language of sound people can find a way to dig it.

This was where the Wall needed to be, in the blues and funky scene of Forty-Third Street, later renamed Muddy Waters Drive. This was the blues man's street, where Theresa Needham relocated her legendary club Theresa's Lounge, where the musicians performed and lived. Just like the Black Arts Theater of

Amiri Baraka was located in the heart of Harlem, so it was with the great Wall of Respect in Chicago. The name was no accident. In the community sometimes a work of art takes on a meaning well beyond its origin. On April 29, 1967, Aretha Franklin released her great hit, "R-E-S-P-E-C-T." When it was first played on the radio Jeff Donaldson and I were headed from Hyde Park to Gladys' Luncheonette on Indiana Avenue for her famous soul food. I was following him, as we each drove. He heard it and I knew because his fist was waving in the air, as was mine, and we had the same beat going. Aretha had stuck deep into our soul. The word "respect" became a critical reference—it reminded you of the militants of the Nation of Islam who called Black men "sir," a rare event in their lives. We had begun to call each other brother and sister. We knew that Black unity could only happen if it was based on respect.

The OBAC Visual Arts Workshop decided collectively to make a selection of Black men and women who should be recognized as heroes and sheroes. All of the usual Black leaders in politics, religion, and the arts were listed, but the artists voted for the most militant people grounded in the respect of the Black masses. These were the people to be honored with respect by being placed on the great Wall of Respect. The lists included in this volume (pages 164, 166) do not match exactly what was actually painted on the Wall, as the artists kept a dialogue going even while painting.

The work started on August 5 and ended on August 24. The Wall lasted for four years, before the building was torn down after a fire. Donaldson and Geneva Smitherman list the three points of unity the workshop participants agreed on:

> Workshop artists agreed on three specific courses of action. First, there were to be no signatures affixed to the Wall to de-emphasize the artists as individuals and to advance the concept of collective activity in the struggle for Black liberation. Furthermore, this anonymity would serve to protect artists from media exploitation and from police harassment. A second course of action was the decision that all statements to Black media would be subject to approval by the entire group. Finally the Wall belonged to the community, and as such, there was to be no individual or group attempt to capitalize on the celebrity status of the Wall.[6]

All of this of course was based on local community agreement, even though community members were unsure of what was actually going to take place. Mr. Baker, owner of the store in the building with the Wall targeted for the project, was cool with it, but no one consulted the absentee owner of the property. This was an act of Black self-determination. But the street force of Black youth was also consulted and they agreed not only to let it happen, but that they would protect it as an act of Black unity. The Blackstone Rangers were involved; the local gang leader was Herbert Colbert. But don't get the idea that this was a nice and

gentle affair. Across the street, while the artists were working, there was often a group of young brothers observing and commenting on what they saw.

In fact, Jeff Donaldson recounts one example of basic community art criticism:

> I was painting Nina Simone when this old lady who lived across the street asked me to come over. She said, "I got to look at that ugly mothafucka you just painted every day." So I changed it. She had all kinds of collages and doilies that she starched so that they took on sculptural forms. Art was all around her house and the walls were painted different colors.[7]

We all would gather at the Wall and have our say. It was a new experience for the artists as it was for all of us. Some of us were trying to make the leap from the printed page to the images on the Wall, and some of us were there to share our art in word and sound to bring additional cultural energy. Of course every now and then someone would take a break for a smoke, a drink, or just to kick it with the folks for the hell of it. We had a ball at the Wall, and the photographers documented what they saw: people creating social art as part of a cultural community festival. The police began to send their representatives, but some gang members had transformed into soldiers to protect the Wall and its artistic creators. At times people were apprehensive, somewhat scared, but nothing happened, much to the surprise of everyone.

It was a critical time because we were in the debate to define OBAC's ideological orientation, and this was part of the national debate. My ideological position (yet to fully emerge) was suggested by a paraphrased quote from Lenin in my report to the final plenary of the Newark Black Power Conference in July 1967: "We must not only help to develop revolutionary professionals, but we must develop professional revolutionaries!" The conference was a turning point, as we were all being confronted by the vicious repressive powers of the U.S. state in putting down urban rebellions all over the country. I kept hearing Amiri's mandate about Black art: We want poems that shoot guns. Our theories must lead to practice. I took my commitment to Black people seriously and so in fall 1967 I followed my commitment from the University of Chicago and the chairmanship of OBAC to Fisk University, a historically Black university with deep roots in all phases of the Black radical tradition.

After the Wall Was Made

The Wall hit a nerve at the center of Black consciousness. News of it spread from coast to coast. Major national exposure happened when *Ebony* published a photo essay on the Wall in December 1967. It was not just about the Wall, but

featured how the community responded, inspiring people to think that if they did a wall, they could affect their community in the same way.

Artists in St. Louis, most of them sign painters, read the *Ebony* article and decided to paint their own Wall of Respect at the intersection of Leffingwell and Franklin Avenues. Still more Walls of Respect appeared. Jeff Donaldson estimated that more than 1,500 wall murals were created in the United States from 1967 to 1972, after the Chicago Wall of Respect hit the scene.[8]

But this intensity fed another dialectic, as the Wall artists split into two divergent camps. One was an aggressive "gangster move" to seize control of the Wall. The spark was William Walker's militant move of taking ownership of the Wall without any collective discussion or decision making. He recruited Eugene "Eda" Wade, another artist who had not been involved in any OBAC Visual Arts Workshop activity, and together they painted over sections of the Wall that they disagreed with.

In the words of Roy Lewis, some people felt that this turned the Wall into "the Wall of Disrespect"! Walker painted over Norman Parish's portrait of Malcolm X, replacing it with a Black Power fist. Another paint-over added the huge figure of a Klansman. Walker claimed that since he felt the Wall was his idea, he had no need to consult with the OBAC Visual Arts Workshop. In his estimation he stood above that collective ethics.

In this way, as they moved into the Black Liberation Movement, the Wall of Respect activists were hit hard by the same kind of ideological dialectics that other battlefronts had to work through. What is more, in addition to this negative and divisive action, Walker stayed true to making murals on walls in various low-income inner-city communities. He also continued his association with Eugene "Eda" Wade.

These murals took on a more explicit political focus, including militant figures like Malcolm X, labor leaders, leaders of slave insurrections, African symbolism, and the hated figures of the KKK, state violence, and drug dealers. But because they were not collective works, the cost of each mural was beyond what one or two artists could afford out of personal funds. Walker helped set up the Chicago Mural Group, but this was to become a foundation- and state-funded process that involved writing proposals and being vetted by appointed committees. So the turn to be more political on the one hand tied artists to mainstream funding sources on the other. What started out as an autonomous act of self-determination ended up being a program under mainstream control.

It is important to mention that mural making in Chicago passed into the able hands of Mitchell Caton and Calvin Jones, as well as several others. The Caton-Jones murals were noted for their use of traditional African imagery with images of African American life. Three of the important ones from the 1970s and '80s are the following: *Another Time's Voice Remembers My Passion's Humanity* (1979), *Ceremonies for Heritage Now* (1980), and *Builders of the Cultural Pres-*

ent (1981). Meanwhile, a retreat from the Wall resulted in a new leap forward. In 1968 the core of the original Wall group (Jeff Donaldson, Wadsworth Jarrell, and Barbara Jones-Hogu), together with Jae Jarrell and Gerald Williams, went on to form a new collective called AfriCOBRA (originally "African Collective of Black Revolutionary Artists" and soon changed to "African Commune of Bad Relevant Artists"). They moved from the exterior walls of buildings back into their studio facilities, which they controlled and in which they were free. They carried their politics forward to create a common Black aesthetic, in these terms a step beyond what they were able to accomplish with the Wall. This retreat to the gallery scene was paralleled by the OBAC Writers' Workshop moving from the street to the campus. Having won some notoriety, writers sought faculty jobs in English departments and as writers in residence. This was facilitated by both Hoyt Fuller and Gwendolyn Brooks.

But it must be said that some of the artists closest to the inner-city community never made it to security in the mainstream. Amus Mor had a chance but never made it, never could come to terms with being "in the box." He was too far out there. On the visual front, some of the early AfriCOBRA members, including Omar Lama, remained ghetto bound. Class factors continued to shape the path of the movement, including some and excluding others.

As a place for cultural and political expression, the Wall of Respect came down in 1971. But Chicago had more going for it. The forces that led to the Wall were strengthened by the Wall. The path from the OBAC Writers' Workshop led Haki Madhubuti (Don Lee) and others to found Third World Press in 1967 and the Institute of Positive Education in 1974. On the music front, one of the original founders of the AACM, Phil Cohran, took over the Oakland Theater on Thirty-Ninth and Drexel and created the Affro-Arts Theater in the fall of 1967, the second "f" meaning "from" as in "from Africa." Its success was also part of its undoing, as it offered free classes that drew in community members, including gang members, which gave the police and the authorities an opening. As a result, the Affro-Arts Theater ceased operations around 1970, and the Blackstone Rangers, later known as the El Rukns, turned the space into its headquarters. Again it was raided by the police and forced to close in the cat-and-mouse game whereby the elites used the gang to fight Harold Washington's mayoral candidacy and then broke it, thereby transforming the illegal drug trade from a centralized system to today's chaotic pattern of small gangs and constant street killings.

The Wall of Respect and the Black Arts Movement made a great impact on the Black community, on the movement for social justice, and on art. This is all summed up in the following quote from Larry Neal, one of the great theoreticians who understood Black art within the context of Black political culture:

> The Black Arts Movement is radically opposed to any concept of the artist that alienates him from his community. This movement is the aesthetic

and spiritual sister of the Black Power concept. As such, it envisions an art that speaks directly to the needs and aspirations of Black America. In order to perform this task, the Black Arts Movement proposes a radical reordering of the western cultural aesthetic. It proposes a separate symbolism, mythology, critique, and iconology. The Black Arts and the Black Power concept both relate broadly to the Afro-American's desire for self-determination and nationhood. Both concepts are nationalistic. One is concerned with the relationship between art and politics; the other with the art of politics.

Recently, these two movements have begun to merge: the political values inherent in the Black Power concept are now finding concrete expression in the aesthetics of Afro-American dramatists, poets, choreographers, musicians, and novelists. A main tenet of Black Power is the necessity for Black people to define the world in their own terms. The Black artist has made the same point in the context of aesthetics.[9]

Notes

1. Alain Locke edited the special issue of *Survey Graphic* that became the seminal book *The New Negro* (1925). Charles Johnson edited *Opportunity* for the National Urban League. W. E. B. Du Bois edited *Crisis* for the NAACP. All these journals were national outlets for writers on the cutting edge of cultural production.

2. Jeff Donaldson later earned a Ph.D. at Northwestern and became professor of art and dean of fine arts at Howard University. Bennett Johnson is now vice president of Third World Press. Joe Simpson has had a distinguished career, doing cancer research after getting a medical degree at Harvard University. See http://radonc.wustl.edu/clinical/simpson.html.

3. Donald Smith was later at Bernard Baruch College in New York.

4. Ann Smith was later a top administrator at several Illinois public universities.

5. See Woodie King, ed., *Black Spirits: A Festival of New Black Poets in America* (New York: Vintage Books, 1972), 134–41.

6. Jeff Donaldson and Geneva Smitherman Donaldson, *The People's Art: Black Murals, 1967–1978* (Philadelphia: African-American Historical and Cultural Museum, 1986).

7. Margo Natalie Crawford, "Black Light on the Wall of Respect," in *New Thoughts on the Black Arts Movement*, eds. Lisa Gail Collins and Margo Natalie Crawford (New Brunswick, N.J.: Rutgers University Press, 2006), 26.

8. Thorson, Alice, "AfriCobra—Then and Now: An Interview with Jeff Donaldson," *New Art Examiner* 17, no. 7 (March 1990), 26–31.

9. Larry Neal, "The Black Arts Movement," *TDR: The Drama Review* (1968): 29–39.

OBAC Documents

The Organization of Black American Culture documents in this section come primarily from the personal archive of Abdul Alkalimat (Gerald McWorter); several others are drawn from the Jeff Donaldson collection at the Archives of American Art. Together, these internal documents and self-presentation create a vivid picture of the organization's founding and early years of existence. Each is briefly introduced here by Abdul Alkalimat, who provides context and amplification.

As primary documents, many not originally intended for public circulation, these texts occasionally contain typographical errors. In such cases we have used brackets [like this] to correct individual letters and entire words. Where possible, we have reproduced the original document. In other cases, we present the document with a gray background and maintain the original layout of the document as much as possible, as well as the original spelling and punctuation.

Invitation Letter and Statement of Purposes
The Committee for the Arts (Gerald A. McWorter, Hoyt W. Fuller, Conrad Rivers)

Over several weeks during the fall of 1966, Hoyt Fuller, Conrad Kent Rivers, and Gerald McWorter met to discuss the state of Afro-America in general, particularly in arts and letters. Fuller and Rivers carried the historical background of the previous decades and McWorter was at the cutting edge of debates among the rising intelligentsia. Abdul Alkalimat recalls, "We usually met at Hoyt's apartment in Lake Meadows. We came to the conclusion that we had to bring more people into the discussion and somehow begin to reach out to the community." These two documents were the first outreach effort.

The Committee for the Arts
3001 South Park Way
Apt. 314
Chicago, Illinois 60616

Dear _____:

The Committee for the Arts believes that this is a time of crisis for the black community, and that, in time of crisis, it is appropriate that families come together. While we can all agree that the arts are an intrinsic part of a people's experience, it is not so clear that we, as a people, are embracing our responsibility to mobilize our art forms and artistic energies in the service of our people. We feel that it is time to unite and to address ourselves with force and resolution to our common culture, our heritage and our needs.

The enclosed "Statement of Purposes" provides a general outline of what the Committee for the Arts is about and what it seeks to accomplish.

We are planning a series of programs designed to realize the aims outlined in the "Statement of Purpose" , and the programs will be presented under the general theme, "Our Image: Inside the Black Metropolis". We will begin by gathering together particular groups of black people and exposing them to a view of the black man's Chicago, calling their attention anew to our common experiences as projected by those among us who have the creative gift to transform those experiences into art.

To assure the success of our projects, we need your talent, your glow, your strength, your Negritude. If you agree with our goals and wish to join us in seeking to bring new interest and vigor into the arts in Chicago, please reply immediately to the above address, indicating a phone number by which you may be reached. We wish to hold our first meeting with you at the earliest possible date.

The first of our projected programs is scheduled for January 29 at the South Side Community Art Center, 3831 S. Michigan Ave., so that there is no time to lose.

Very truly yours,
The Committee for the Arts:
Gerald McWorter
Conrad Kent Rivers
Hoyt W. Fuller

STATEMENT OF PURPOSES

The Committee for the Arts is organized for the general purpose of bringing together the Black Artist with the Black Masses into a solid union which will establish the bedrock for the flowering of art and the regeneration of the spirit and vigor of the Black Community.

Specifically, the Committee for the Arts will concern itself with the following list of projects and principles:

- To provide the Black Community with a positive image of itself, its history, its achievements, and its possibilities for creativity

- To reflect the richness and depth and variety of Black History and Culture

- To encourage and to bring to the public eye talent from the Black Community

- To encourage Black People in other communities to also channel into constructive endeavors the creative energies from their communities

- To spread an appreciation of the Arts among all Black People

- To work toward the ultimate goal of bringing to the Black Community indigenous art forms which reflect and clarify the Black Experience in America

- To create an ever-stronger relationship between Black Artists and the Black Community

- To provide the mechanism for the honest presentation of the Black Experience as it profoundly proclaims the human condition

Because the Black Artist and the creative portrayal of the Black Experience have been consciously excluded from the total spectrum of American Arts, we want to provide a new context for the Black Artist in which he can work out his problems and pursue his aims unhampered and uninhibited by the prejudices and dictates of the "mainstream".

114

Black People and Their Art
Gerald A. McWorter

By March 1967 the Committee for the Arts had expanded to include Marshall High School art teacher Jeff Donaldson, University of Chicago graduate student Joseph Simpson, community activist Bennett Johnson, and lawyer-businessman E. Duke McNeil. A meeting was held at McWorter's apartment. At this early stage the original idea was to have a festival of all of the arts by August or September. The name Organization of Black American Culture (OBAC) was developed during a phone conversation between McWorter and Donaldson. It reflects an identification with Africa and the proclamation of a new leadership in Chicago's political culture.

Memorandum

NORC
1941 NATIONAL OPINION RESEARCH CENTER 196[?]
University of Chicago
6030 South Ellis Avenue
Chicago Illinois 60637
312–684–5600

TO The Committee for the Arts
FROM Gerald McWorter, Temporary Chairman
SUBJECT Black People and Their Art

DATE 3–15–67

As we continue to discuss these matters, let nothing short of a full appreciation of our historical possibility motivate our thoughts, feelings, and movements. At no time can we afford to let our personal interests suppress the communal good. We must be responsible to the insights we have, as we must be responsive to the needs and movements of our people. Nothing short of a religious zeal will work!

Proposed A[g]enda:
1. SHALL WE DO IT?
2. WHAT IS INVOLVED?
 a. Jeff visual arts
 b. Conrad writing
 c. Hoyt organizing

 d. Joe Black people
 e. Duke promotion & legal
 f. Gerald money

The intention of these reports is [t]he evaluation of how we can do the Festival. We ought to prepare short written outlines so records [will] not be a problem later in the game. Two questions: What do we have to do? and How can we do this?

3. WHEN SHALL WE DO IT?

The suggestion before us is six months, to have the Festival in August or Sept.

4. WHAT DO WE CALL OURSELVES?

The suggestion is OBAC (Organization for Black American Culture)

5. WHERE DO WE GO FROM HERE?

<u>Next meeting</u> March 19 (Sunday)
 3:00 p.m.
 7206 S. Bennett
 Gerald McWorter

Festival of the Arts
OBAC

This document reflects an early discussion in the Visual Arts Workshop of OBAC. This predates the discussion of doing a mural. Jeff Donaldson led this effort.

ORGANIZATION OF BLACK AMERICAN CULTURE

FESTIVAL OF THE ARTS, 1967

PREPARED BY JEFF DONALDSON , CHRM. PRO TEM

MARCH 19, 1967

OBJECTIVES

1. to provide a meaningful context for Black people to experience the art of their community;

 a. to isolate and implement those aspects of the Black psyche which reflect the singularity of the Black sensibility in all life styles;

 i. to encourage the creation of indigenous visual art forms which reflect and clarify the Black experience in America;

 ii. to encourage the creation of indigenous visual art forms which affirm and acclaim the richness and depth of Bl[a]ck culture;

 b. to define and reflect <u>Black Experientialism</u> in visual art forms;

2. To provide a setting for the exposure of mature artistic expression from the Black community;

 a. to display those works of art which encompass and express the spirit of "a" and "b" above;

 b. to award prizes for meritorious Black art expression (Details to be provided by the visual art sub-committee);

 c. to arrange and conduct a traveling exhibition at the conclusion of the Festival;

3. to move toward the establishment of an aesthetic which is relevant to Black Experientialism;

 a. to question the adequacy and/or relevancy of current art techniques materials and image modes to the visual art expression of the Black experience in America;

 b. to establish a criteria for Black art expression;

 c. to proclaim, acclaim, extol, and glorify Black Experientialism in visual art expression.

Procedure	Deadline
1. The appointment of a 3 to 5 member sub-committee	March 27, 1967
2. Development of a philosophy of Black Experientialism	April 15
3. Public issuance of a manifesto of intent	April 30
4. Announcement of the Festival	May 8
5. Conduct seminars and institutes in Black Experientialism	May, June, July
6. Deadline for submission of work for the Festival	August 1
7. Selection of work	August 7
8. Public Issuance of a manifesto of Black Experientialism	August 11,
9. <u>Festival Opens</u>	
10. Mount and conduct traveling ex[h]ibits of the art forms	Sept, 67— July, 1968
11. Announcement of OBAC Festival II	

OBAC Position Paper: Some Ideological Considerations
Gerald A. McWorter

This document was discussed by OBAC and contributed to its ideological consensus. It reflects an obsolete characterization of Black men as the protectors and Black women as mothers and love partners. But as the Wall project developed, women joined in as equals, making the Wall a projection of heroes and sheroes. The position paper was reprinted in the OBAC journal *Nommo*, vol. 1, no. 1 (Winter 1969), the cover of which appears below. We reproduce the typescript on the following pages.

OBAC POSITION PAPER: SOME IDEOLOGICAL CONSIDERATIONS

Gerald A. McWorter, Chrm.

The purpose of this policy paper is to state some of the notions
relevant to my thinking about OBAC. I hope that it will be consistent
with what my brothers think and feel, but, if not, I hope that it will
serve as a beginning for the dialogue the result of which is one and the
same with the future of OBAC. I hope to address myself to the following
questions: 1) In general terms, what is the fundamental posture of OBAC?
2) What are the goals of OBAC? and 3) What programatic directions are
implicit in our goals?

There are two sides to our general approach, the realities of the
everyday cultural life of Black People, as well as the development of
a special set of standards with which to interpret and evaluate. On the
one hand we are saying it is necessary to establish a new positive acceptance
of our cultural resources, our treasures. The boo-ga-loo might thus be
understood for men as a warriors dance, arrogant, strong, and Black, and for
women as an uninhibiting form for the portrayal of Black sensuality. We
join WEB DuBois in saying (1900): "Especially do I believe in the Negro
race: in the beauty of its genius, the sewwtness of its soul." However, we
are not saying that whatever is Black (i.e., found among Black People) is
good. We must develope standards which establish our self-conscious control over ou
own culture. Consider for a moment the disc jockey and the art museum curator.
The DJ is most sensitive to mass reactions, while the curator is most sensitive
to a small elite of art critics. We must find/discover the dynamic of synthesis,
and hopefully not be forced to choose between the mass approach and the elite
approach.

A primary fact about the life style of Black People is the intensity of the "now." We must incorporate this into OBAC and avoid being static in the current context of Black life. This is relevant in a number of ways: 1) a shortcoming of many groups dealing with knowledge about Black People is the indicriminant concern for chronicle and "facts." OBAC mush have as a criteria for its substance "the now possibility" of it; so, rather than chronicle and facts, our concern is with living legend and myth. As a social scientist once wrote, "Whatever men define as real to themselves, is real in its consequences." 2) Remember the British man having formal tea in the bush of Africa. We must not inadvertantly allow OBAC to generate such conflict and farce. We must not superimpose something on anything. Ours must be a new, nowtimed Black dialectic. We have as a given the Black community in all its complexity and splendor, and we have a developing set of ideas, ideals, and visions of the good. In being responsible yo both, new forms, new content, new programs must be projected as our only legitimate future.

What of our goals? We have to be concerned with an end result which includes the art produced; the artists involved, the people involved, and the context within which everything happens. While no definitive statement can be made at this point, let us consider a few tentative notions. Recognize that we beginning something new, we must inspect and consider everything, even the familiar. Our goal in art is to develope and project new themes, heroes , and attitudes. This content must stand the test of being contemporary, authentically related to Black Peoples exp riences, and consistent with the ideas and values developed as the overall ideology of OBAC.

The People. We must develope a critical audience, an audience which is at once receptive and demanding. We must recruit those Black artists robbed of creative expression. We must mould our cudience and young artists, not into some ambiguous undifferentiated mass public, but a selfconscious brotherhood moving with a purpose and a method.

This, then, is the job ahead. It is the job of building OBAC into an organization deeply grounded in the Black community, all inclusive of both the people and their artists. It is the job of building an organization which far transcends individual differences, the job of building a movement so people will have faith in themselves and the strength of self confidence. ART CAN BE REVOLUTIONARY, AND SO IT MUST BE WITH OBAC.

We must remember that among the most denigrating aspects of what happened to our people in America is the systematic attempt to deny them history, a link with a past of proud kindgoms, mighty warriors, and wise scholars, and art, the process whereby symbols, images, and sounds express the spiritual truth of a people.

OBAC must ring fear and terror into the ears of those who are guilty.

OBAC must be celebrated with joy among Black People, soul clap hands and sing.

Inaugural Program
OBAC

This is the inaugural program that introduced OBAC to the community at an event held in the Abraham Lincoln Center, famously designed by Frank Lloyd Wright in 1905. OBAC embraced artists who could showcase the diversity and excellence of what was happening in the Chicago Black Arts scene. The break-out performance was by Amus Mor, who recited his classic "Poem to the Hip Generation." The auditorium was standing room only. The document had a tear-off portion at the bottom for attendees to sign up to become involved.

ORGANIZATION OF BLACK AMERICAN CULTURE

852 EAST 47ᵀᴴ STREET
CHICAGO, ILLINOIS 60653

INAUGURAL PROGRAM

May 28, 1967
Abraham Lincoln Center

Introductory Remarks	...	Gerald A. McWorter
The Dance	...	Sherry Scott
OBAC	...	Hoyt W. Fuller
The Music	...	The Delections · Rudy Howard Ronald Christian, Wayne Jackson Donald Foxx, Patrick Keen
OBAC	...	Bennett J. Johnson, E. Duke McNeil
The Spoken Word	...	The Magnificent Seven + One
OBAC	...	Donald H. Smith
The Music	...	The Fred Humphrey Quartet w/Sherry Scott
OBAC	...	George R. Ricks
The OBAC Direction	...	Gerald A. McWorter
The Spoken Word	...	David Moore
The Visual Image	...	Jeff R. Donaldson
OBAC Announcements	...	Joseph R. Simpson
OBAC Concluding Remarks	...	E. Duke McNeil

Visual Arts Workshop Report
OBAC (prepared by Myrna Weaver and Jeff Donaldson)

These are the minutes of an OBAC Visual Arts Workshop meeting, with a complete listing of the participants and their agreements. Note in the "General Conclusions" section how the artists were formulating tenets of ideological unity.

OBAC VISUAL ARTS WORKSHOP REPORT
June 29, 1967
Prepared by Myrna Weaver / Jeff Donaldson

Meeting of June 28, 1967 at THE ARTS, 7032 S. Stony Island Ave.

I. AGENDA
 A. Analysis of current work of assembled visual artists
 1. Artists and media
 a. Myrna Weaver, oils
 Sylvia Abernathy, silk screen
 Barbara Jones, graphics
 Edward Christmas, mixed media
 Robert Glover, mixed media
 Bill Walker, drawings
 Jeff Donaldson, mixed media
 b. Photographers
 Billy Abernathy
 Roy Lewis
 Bobby Sengstacke
 Oniqua [Bill Wallace]
 c. Artists present without examples of their work
 Wadsworth Jarrell Caton Mitchell
 Norman Parrish [*sic*] Charles & Ann McDonald
 B. Areas of concurrence
After viewing, analyzing, and lengthy discussion the artists agreed that there was a common thread which permeated, binded and dominated the entire array of work displayed. Namely:
 1. Paintings and Drawings
 a. SPACE—the treatment of space was generally ambig[u]ous and somewhere between 3-D and 2-D in concept
 b. COLOR—when used, tended to be bold, clean and intense. Work in values (black, white and the full range of grays) showed the same characteristics.

124

c. CONTRAST—high in all cases, i.e., color, value, space (positive and negative) and 3-D and 2-D effects.

d. LINE—when employed, explored the full spectrum of expression, from subjective (emotional) to objective (analytical) but in each case the application was direct and unlabored.

2. Photography

a. CONTENT—area in which most agreement was felt

1. Subject matter

a. All photographers (as well as painters, draughtsmen and printmakers whose work interpreted visual reality) employed Black models exclusively.

b. Environments (mostly cityscapes) reflected conditions under which Black people live and work.

b. TECHNIQUE—high value contrasts consistently used creating dominant dark patterns which emphasis the dignity, beauty and blackness of the subject.

II. GENERAL CONCLUSIONS

A. BLACK EXPERIENTIALISM

1. Work in all media reflected the Black Experience

2. Truth about Black social conditions, attitudes and personalities reflected on all levels.

3. Overwhelming agreement reached on responsibility of the Black artist to honestly express his experiences on all levels though his personal aesthetic (style, medium, visual art elements approach, etc.,) sensibility.

B. AN ART MOVEMENT?

The artists expressed unanimous agreement on the question of whether their collective efforts could result in the formation of a visual art movement in the spirit of OBAC.

The artists requested that all group activities be recorded visually and verbally for our posterity.

III. FUTURE PLANS

A. Finance

1. Memberships in OBAC

2. Establishment of Visual Art financial base for our workshop

B. Black Experientialism

1. Definition

2. Objectives

3. Standards

4. Manifesto

OBAC: Organization of Black American Culture ("all-purpose handout")
Gerald A. McWorter

Apart from the writings of Hoyt Fuller and Jeff Donaldson, this document is the most complete explication of the theoretical orientation of OBAC. It emerged from writings by Gerald McWorter in discussion with Joseph Simpson and Diana Slaughter, all three graduate students at the University of Chicago. It was reproduced and shared with members of OBAC and the community; it was never formally published or widely circulated. The version presented here includes handwritten corrections made on the typescript.

COPY NUMBER _# 10_

COPY TO BE REVIEWED BY _____

COPY TO BE RETURNED BY JULY 15, 1967

COPY TO BE RETURNED TO GERALD A. MCWORTER

7206 S. BENNETT

CHICAGO, ILLINOIS

(phone 667-2075)

NOTE: You are being asked to review this document, an all purpose hand out to represent the initial position of OBAC. Your every comment should be written on the document so that it can be thoroughly revised and readied for publication. The projeected publication date is July 20.
Your help is appreciated. Thank you.

O B A C

Organization of Black American Culture

(OBA is a Yoruba word for royal, leader or chief.
We profess an affinity with our African sisters
and brothers)

July, 1967
352 E. 47th Street
Chicago, Illinois

INTRODUCTION

 The position of Black People in the United
States of America is charged with a great deal of
ambiguity, a great deal of suffering, and a great
deal of frustration. The sensible thing for Black
People to do during times such as these is to,"get
themselves together," We need to get ourselves
together as individuals and get ourselves together as
a community. <u>This paper is an outline of one idea</u>
<u>and program geared to bringing about a revolution in</u>
<u>the consciousness of Black sisters and brothers.</u>
Take the time and carefully read this paper so that
we might be able to chart a course away from the evils
which destroy us Mentally, Spiritually, and Culturally.

 OBAC (The Organization of Black American Culture)
is an effort to organize artists in the Negro community
for:

 (1) the sharing of creative artistic ideas about
 the Black experience;

 (2) the collective search for new meanings of the
 Black experience;

 (3) the development of a creative social function
 for the Art of Black peoples.

 OBAC is an effort to develop programs throughout
the total Black community which produce:

(1) Increased self-understanding and
 heroic self-images;

(2) Positive community values;

(3) Images and values about beauty which
 reflect the Black experience.

There are several important aspects to the
black community which make up the need for some-
thing like OBAC. There are reasons why something
like OBAC must exist.

(1) The cultural development of the black
community is rich and dynamic, particularly in terms
of music, dancing, and a multitude of styles bringing
to bear the Black Sensibility on doing something.
This is true whether it is Muhammed Ali and prize
fighting, Willie Mays and catching baseballs,
Gayle Sayers and running through football lines, or
our great preaching tradition, our way of addressing
audiences, our verbal style. The fact is, ~~that~~ this
sensibility has been more developing on a general
level in the black community and has not been subjected
to serious, systematic, and disciplined attempt to
bring it to bear on a great number of other things.
One possible explanation of this is, ~~that~~ in our
history we were allowed by white people to do certain
things and consciously prevented from doing other
things. While it was possible to sing songs, even
dance while picking cotton and spending those few
precious hours before the next day's work, it was
not possible to continue to paint, to participate
in the great, glorious African tradition of carving
images, and many other such things. When one looks
at the cultural state of the black community today,

one feels a glorious tradition on the one hand,
and a serious vacuum on the other hand. This
rather schizophrenic situation can only be
alleviated by a conscious of a group of people who
are concerned about this Black Sensibility and are
disciplined enough to systematically attempt to
bring it to bear, to try to understand it, and to
try to use it in making our lives more creative,
~~and~~ more beautiful, and more black.

(2) One of the important reasons that cultural
expression is allowed to develop with all of it's
creative, free possibilities has to do with who controls
the conditions under which this cultural expression
is carried on. That is, who determines when its done,
who determines whether its good, who determines whether
it can continue, and who is going to do it. In the
black community there are certain things that we do
control in terms of the cultural expression coming from
within the black experience. Certainly we control that
expression, but the question is, who controls those who
are the artists, and who controls the art before it
gets to the community. If we understand that only a
very small percentage of black artists, and only a
very small percentage of cultural and artistic expression
which black people appreciate is controlled by black
people themselves, if we understand that the people who
control our cultural lives are not black, then we can
understand why in many cases black people get the short
end of the deal! Black people are excluded from a process

whereby they can achieve an authentic relationship
with their artists. Part of this reason is the
fault of black people themselves, we are at fault
here. But on the other hand, we have to recognize
the fact that history has given us a legacy of horror,
history has given us a legacy of powerlessness.
And only by coming to understand this powerlessness,
only by coming to understand the fact that we do
not control our cultural lives, we do not control
those things which make us, the self-consciousness,
the understanding of people in the black community,
And only by coming to grips with this, coming to understand
it, can we move on and do something to change it!!
The fact is, that OBAC is an attempt to bring a new
context in Chicago, a new situation, a new structure
for cultural creativity and expression, a structure
which is Black, is rooted in the Black community, and
belongs to the Black community. And only by understanding
the fact that control and ownership is most important,
do we understand that something like OBAC must be, parti-
cularly because it is _owned_ by the black community.

(3) Most people in the black community are
aware of the nature of the black community in which
they live, but in most cases, in most cities, and
this is particularly true about Chicago, the black
community is fractured, it is destroyed as a living
community and it is separated into groups of areas
wherein particular kinds of black people live.

There are black people who have money and who own
homes, there are black people who live in tenements.
There are black people who are dark-skinned and
recently from the South, there are black people
who are light-skinned and who have been North for
three or four generations. There are black people who
live with white people, there are black people who
live only with black people. There are black people
who have jobs with the government, there are black
people who have never been employed for three generations,
who live in this city. And if one understands this, the
fractured nature of the black community, one will
understand the fantastic need that exists for some kind
of unity, that is to say we have to raise the question,
What is the nature of Blackness? What is the nature of
Community? And what kind of consensus, what kind of general
basis that cuts through all of these various black communi-
ties is there to justify talking about unity, and talking
about the black community as one entity, and not as a
series of different kinds of entities. We think it is
necessary to approach this in terms of the experiences
of the people. There is no black person in the United
States who is not linked to the suffering and the horror
of what black people have had to experience in this country.
And since that particular time in any individual's life
when an experience defined him as Black, he has gone through
a series of experiences which link him to a tradition of
black experience. We think that dealing with this from a
cultural perspective, bringing to bear the artistic black

133

sensibility on this experience, we can generate a
cultural context within which any black person in
the city whether he is high yellow and makes $10,000
a year, or whether he is black, from Mississippi,
and has been unemployed for ten years, whoever he
be he black, brown or beige etc
is, he can identify with this, and he can become
and
a better person by understanding himself, understanding
his black brother, be he black, brown, or beige in hue,
The fact is that the black experience is all-pervasive
and plugs us into this tradition of experience. If
this can happen, if we can permeate our consciousness,
if this can deal with the way we relate to each other,
the way in which we look at each other, the way in which
we bring to bear values in evaluating and understanding
each other, we'll have found a basis of unity to overcome
the class and color and caste kinds of systems which
separate us. In one sense, what we are saying is that
the black community is separated from itself, is fractured.
They have used the old philospphy of divide and conquer!
The only way in which we can come to grips with this is
to go underneath their divisions. There is a black
experience which units us, which is ours, if we can only
recognize it, and celebrate it, and find in it that which
is good and heroic and valuable for us. We will have
found that unity which will regenerate us as one
community, as one entity, as one meaningful and loving
community of people.

(4) Now much of what has been said above,
and certainly much else, are things which you the

reader of this document are no doubt already
familiar with. But there are two other
things which one needs to face along with this
analysis and discussion. One is the answer
to the question why is unity necessary, and the
other is what is happening now, today, in light
of those rather negative things, horrible things,
we have discussed above. It is clear that only
by maximizing the use of one's resources, only
by using everything you've got can you seriously
plot your road in overcoming the kind of problems
you have. The black community has been separated
from its intellectuals; the black community has been
separated from its men of learning; the black community
has been separated such that its numbers have not been
in one army, have not been in one cadre, but have
been spread out. No war, be it violent or non-violent,
can be fought with a disorganized army.a The black
community cannot protect itself, cannot grow unless
the people in the community are grouped together, are
organized, are unified in a certain context, the context
which is relevant to its life and which has some imme-
diate relevance to overcoming the kinds of problems and
the pathologies which characterize it. But that's a
rather simple explanation of why unity is necessary.
The philosophy becomes clear when we examine what is
going on today. Briefly, put, one can say that there is
a cultural revolution going on which has meaning in terms

of what kind of art is being produced, what kinds
of experiments are going on, and what is happening
in the consciousness of vast numbers of people, as
they think about their place in the black community
and the nature of this community within which they
belong. Now this cultural revolution has meaning
both when one thinks of John Coltrane, Archie Shepp,
Ornett Coleman, Albert Ayler. It has meaning when
we think of what the Detroit sound means. It has
meaning when we think of what is happening in the
urban blues circuit in Chicago. It has meaning when
we think of what is happening on college campuses in
terms of the kind of questions being raised, the kinds
of demands being made, in terms of curriculum, the kinds
of courses being demanded, the kinds of attitudes that
groups of black students have which are permeating the
black college campuses, forcing them to deal with the
question What does it mean to be a black college in a
white society? Now these kinds of developments, these
kinds of questions are things which are happening in a
very diffuse way, that is they are happening almost in
an unrelated sense. Certainly ~~conditions~~ musicians in Chicago are
related to ~~conditions~~ musicians in New York, in the sense that they
hear each other play, either on record or in concert.
The same is true with regard to Negro colleges, that there
is some relationship. People meet at conferences, people
read about each other. But in terms of all of the kinds
of things that are happening, there is no one context in
which all of the kinds of people that are involved can

interact with each other. The intellectual who is bringing
to bear his scientific precision in understanding the nature
of the black pathology needs to sit down and talk with
blues singers making their comment on their black experience,
need to sit down and talk with the young artist who is
attempting to do something on canvas. We all know that a
jazz singer can be funky--but can a black social scientist
be funky? Can a black painter be funky? Can a black woman
who is walking down the street embody soul in the same way
that Aretha Franklin embodies soul when she sings? Now
some of these things we can feel immediately, and we can
say yes! On the other hand many of these things right
now are not familiar to the black community, but are alien
because of this dismnified structure which has been super-
imposed on us. But if we are able to create that kind of
structural unity, if we are able to bring together all
of the kinds of creative things that are happening in the
black community and let them interact, the chances are
much higher that this creative blackness, this Black
Sensibility, this Soul, this Thing Which is Ours, can
permeate our lives. We can use it to make ourselves more
beautiful, and we have to do that--more beautiful to
ourselves, more beautiful to each other, more beautiful
to everybody, because somebody who knows they are
beautiful Is beautiful, and that's exactly what we have
to do. We have to recognize that we can't shortstop when
we're doing this--there is no way that we can do what we
have to do by giving half an effort. The kind of direction,
the kind of questions that are being raised here are ques-

tions which are the great questions. These questions
may be rooted in any individual or organization that
might come in contact with them, but the fact is that
we have to push ahead, we have to try--this is what
it is about, these are the important things. Once
we get ourselves to the point where we start pushing
ahead, we have to raise the question what are our
standards, and have some understanding of whether we
are making any progress. We have to know whether we
are going forward or backward. We have to know how
fast we are going and whether or not we need to alter
course. It seems to me that first it needs to be said
that if black people begin to move, the mistakes will
be mistakes that are incorporated into our body of
knowledge in a way in which they are not done now, such
that people learn in a new way from these mistakes.
But in a positive sense it seems that if we can overcome
the disunity between the leadership and the elite,
the people who are chosen, the "chosen"--if we can get
them to refuse the Apple and stay with the community.
If we can the people in the community to accept them; if we
can get the leaders to use as a barometer of his leadership
not the man closest to him in the black community, but the
man farthest from him in the black community--the man who
might be on the so-called "top" needs to judge his performance
by how the man on the bottom views what he is doing. This
is the way in which unity can overcome that traditional problem.
Also, a very dangerous phenomenon on the current sense is what
might be called the pseudo-black consciousness. It is

characteristic of a person who adapts to a contemporary
style or rhetoric in an external sense. He wears the
clothes of someone who is together, but his mind and
his spirit, his real way of life, his way of living,
has not changed substantially. Many of us have at
times worn black skin, but have white minds, fractured
personalities, and broken spirits. In order to overcome
this there needs to be a dynamic, intensive, and over-
whelming emotional cathartic experience whereby people
who have been separated can be united, people who have
been disjointed can be unified, people who have been
diffuse can become specific, intense, and in focus. In
this kind of process, this kind of dynamic self-examination,
this kind of dynamic community established will give rise
to a redemptive life where all the brothers who are about
something in a serious way can involve themselves in a
new way in overcoming problems. The question of direction
and progress will emanate from our experiences. We will
know, those of us who are together will know when we are
making progress.

This document is addressed to the Black community. Specifically,
it is addressed to those people who are actively interested in
OBAC. The idea for the structure is addressed to artists, to
patrons of the arts, to Black college students, to Black parents.
It is addressed to any Black people in school; it is addressed
to any Black person who recognizes that he is disatisfied with
the conditions of Black people in the United States and colored
people throughout the world. This document is addressed to anybody
who is Black. We are concerned about Black people moving together.
We must unite; it is impossible for any Black person to be free
of the shit that we have to go through unless all Black people
are themselves united together in some way. And then together,
we can move to remove the kind of shackles, the kind of things
which keep us down. All of the people who might read this must
find in it something which speaks to them. Recognizing the
difficulty in writing to all kinds of people at once, we plead
with the readers, whoever you may be, to search, if it means
putting different words in, if it means using other examples, if
it means --whatever it means: find yourself in here. Join us,
if you will. The situation is grim, the time is now. We invite
you to join us in this one effort. Check this idea.

The kinds of questions which will be addressed in the rest
of the document have to do with an elaboration of one: What is
OBAC? How does OBAC view the community? How does OBAC view
artists? What is culture, and why is it important? What kinds
of dangers are involved? What has our historical legacy been?
And what solution is contained in the idea of OBAC? Further,
we concern ourselves with questions of structure and process.
What kind of organization is OBAC? How is the idea given flesh
and structure? And also, how is OBAC as an organization going

to attempt to bring about our realization of the idea? How is it
going to act in the real world? How is it going to organize the
Black people and what is it going to do? And then, we want to try
to summarize this, and to get it to you, for your evaluation.

THE IDEA: CULTURE AND CONSCIOUSNESS

We are concerned with the development and relationship between cultural development in the Black community and Black consciousness. Before there can be any fruitful discussion of what we mean here, it is important that several things be kept clear. We are concerned with destroying what has been used as a definition of culture, and redefining it in a pro-Black sense. Words mean what you want them to mean, and we want culture to include us. As will become evident, we are not merely playing with words; rather, the facts of our lives are being reevaluated and identified in a new way.

By culture we mean that which Black people do well by utilizing a certain set of values, a special sensibility which makes things Black and beautiful. In a general sense, everybody is cultured in that everyone in the Black community identifies with some aspect of Black culture, and celebrates an example of culture which is done particularly well. An example of this would be going to a 'way out "soul food" place to eat, or diggin' Aretha Franklin, or diggin' the way a particular cat might wear his clothes and walk down the street. All of that is culture, and all of that is ours --the Black community's. Also, it is important to recognize that the collective experiences of a people are transformed into culture by the artists, those with the gift of verse, melody, dance, and whatever else is needed to express the essential thing. Culture can be what everybody does or what a group of special members of the community do. Either way, it is culture for the people, it is culture of the people, it is about the experiences of the community of love, the Black community.

142

Black consciousness means an attitude, values, and a set of ideas which, to a Black person, means (a) a self-declaration that you are Black and beautiful, because Black is beautiful; (b) that all Black people are your sisters and brothers, (c) that you are outraged about the social condition of Black people and are committed to disrupting it and changing it with a revolutionary spirit (meaning abruptly and totally).

The development of culture and Black Consciousness. Consider four (4) parts of a system, each part playing a very important role (See Figure A)

Figure A

The community (meaning the people, their institutions, and their way of life) produces or gives rise to culture; one might call this folk culture. This folk culture is everything that is distinctive about a people, whether it's the way clothes are worn or the way people walk, the music made or food cooked. At the same time, from within the community, there are artists. Artists are special people in that they combine the communal experience and the folk culture with technique (disciplined craftsmanship) and a special insight. The result is a cultural form to be celebrated in a special way. This celebration of culture, this living experience of culture, is what we have chosen to call a spiritual reality. It can really only be done by those

to whom the cultural expression belongs. And it is for these
owners to derive from this spirit a new birth, a new consciousness
to propel the same process on and on.

Figure B points out the same thing with examples.

Out of the experience of the Black community, the Blues was
transformed into an urban (Northern) form of music. This was
done by such cultural heroes as Lou Rawls, Muddy Waters, Junior
Wells, as well as the countless Black people whose life-styles
authenticate the new Blues. Contained in the lived experience
of a Ray Charles concert, or the presence of "Lee Cross," is
the soul of a people, the soul of Black folk. And by grasping
all of this soul force and incorporating it into every aspect
of our lives, we can rise above the depths of despair into the
power of a beautiful Black conscious community.

But more specifically, the diagram applies to OBAC.

Figure C

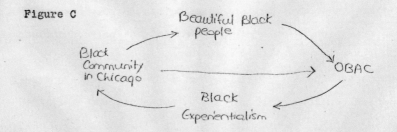

144

Let's begin with the community. The Black community in Chicago consists of many different kinds of Black ghettoes. These ghettoes are different in some respects, but OBAC defines them as being the same in essentially one respect, and that is, a Black common identity, an identity grounded in the experiences discussed above. And out of these separate Black ghettoes come various kinds of beautiful Black people. In some communities, the people tend to be professional, xxxBlack professionals come out of all of the various kinds of Black ghettoes, and in all of the Black ghettoes, we have artists; in all of the Black ghettoes we have people who are concerned, and in all of the Black ghettoes we have people who are committed and willing to do something about their committment. And if these Black people, these beautiful Black people that come out of all the different Black ghettoes, can move together, out of this concern, out of their abilities, their driving motivation, if they can move together into an organization like OBAC, and in grouping ourselves together in OBAC, relate to these various ghettoes, out of this kind of interaction will come the kind of artistic creativity, the kind of cultural regeneration, which OBAC posits as being its goal.

There are a number of different phases to this process of organization out the community. On the one hand, we have the question, who are our artists? We have the question, who are the committed people and how do we determine committment? We also have the question, who is able to do certain things, and what are our stamdards for ability? These kinds of questions are not being raised in a sterile or abstract or objective sense. We must find a subjective basis for affirming our Black brothers. The

nature of this affirmation, xduring the initial phase, comes close
to what happens in a mass movement or a social movement. That is,
in a general context of committed people, people applying them-
selves to certain questions, to certain tasks, it is in the
process that one is affirmed. That is to say, it's in the context
of doing that you become part of the organization. It's not a
matter of drawing a line, excluding some people and including
others according to certain standards. It's a matter of people
becoming involved in tasks that are set by people in the group,
and in the process of fulfilling these tasks, of taking care of
the business at hand, one becomes affirmed as being a member, an
active and important member of that community of people, that
small movement of people. Once this process goes on, out of
this process will come a core number of people who will constitue
OBAC, which then becomes an organization, a structured organi-
zation, where there are a number of things that happen in a
systematic fashion, in some order. This is rather distinct and
different from the movement. Now, once OBAC is formed, the
important thing that needs to be recognized now is, what do we
think of as being art, that is, that part of culture that is
being created, that is being redefined, that is being given new
meaning through the experience of OBAC. There are a number of
important things to note here.

 1. Art is held to be a complex of sounds, symbols, and
images, reflecting the actual experience of the people, at the
same time embodying a spiritual message of the truth, or the
insight, or the meaning, of that experience. So, on the one
hand, art deals with managing the ambiguity of our lives, as
well as making a prophetic declaration about our lives. On the

one hand, dealing with the black, and the white, and the many
grays of our communal and personal experiences, as well as making
a profound, precise, and forceful declaration about that experi-
ence. It's very important also to note that art, as produced by
specific individuals, is the end product of tensions that come
out of the community experience on the/hand, and the personal
experience of the artist, on the other, that at some point the
communal aspirations, the communal experiences, the communal
hopes, the communal gods, are the context in which artixix is
produced, but on the other hand, thxxx artist himself has a
particular, personal, individual view of reality, that is obviously
related to the communal view of reality, but they are not one
and the same. It is out of this kind of tension and interaction
between these two things, that art is produced which has the
integrity of being Black, because it represents the fusion between
the communal experience and a Black artist who has a particular
kind of insight;that special gift is brought to bear with the
personal sensibility of that person or group of people, and the
community out of which he comes, over which he stands against,
toward which he is moving his art, for whom he want to present
his art. One other comment need be made about the top half
of the figure. While we can say that these beautiful Black
people exist, and that they will address themselves to certain
tasks and answering certain questions, and that out of this
common x movement will emerge the organization of OBAC as a
living organizational entity in the Black community, we've got
to xxxx recognize that the whole process of finding and cultivating
and making demands of and rewarding these beautiful Black people,

means
necessarily/that we have to ☐☐ define these beautiful Black people
as being our cultural heroes, our heroes. Now what this means
is, in a sense, we have to think of other ways to find these
people than the ways that are projected in a normal society. It's
certainly true that many Black people have gone to schools which
have been set up by the society in various areas of the arts; but
it's important for us to recognize that our experiences have not
been included in these institutions, hence, it very well may be
necessary for us to return to these experiences themselves and
create our own way in which to develop schools who cultivate and
select and recruit these beautiful Black people. In one sense,
I'm saying we either have to create our own institutions; one
the other hand, I'm saying we need to create parallel institutions
to supplement the experience of those Black people who go through
those things that already exist. So that it's very important that
people understand that we have to reaffirm each other as being
heroes, as opposed to fighting each other to become heroes in
somebody else's point of view. This once again relates back
to what we said in the introduction in terms of finding that
basis of unity which can make ours a community of love, a
community of respect, in which we can affirm each other. And
here the point is that our artists have to be affirmed, have to
be rewarded, in terms of the kind of respect, of attention given
to what they have to say, because they are the people in our
community who are ☐ relating with that special insight, special
gift, that we need so desperately. Now, given this kind of
process by which OBAC becomes an organization, the bottom half
of the diagram relates to the question, what does OBAC do for
the Black community? Now, in the creation of art forms, the

creation of expressive artistic performances, in the communication
of the art that OBAC represents and of the cultural components of
the Black community that OBAC identifies and wants to celebrate,
in this whole process, we have coined the term "BLACK EXPERIENTIALISM."
Black experientialism is a way of digging something, a way of
experiencing art, a way celebrating art, a way of appreciating
art, that has to do with the Black experience. If the artist
who is producing the art is concerned about his Black experience,
is concerned about the Black community, and coming to grips with
himself as a person with this, and if he deals artistically, out
of this context, bringing to bear the Black sensibility in pro-
ducing a work of art, and if the social conext for viewing or
experiencing the art has to do with the same Black context, and if
the people who constitute the audience for this art, if these
people are the Black community, then the entire process is a
Black process. And this is the goal of OBAC. This is the core,
the essential process, and this is a process, this is an
art movement, this is a perspective, this is a pattern of Black
behavior and Black consciousness which we call Black Experiential-
ism, because the key element in this whole process is the nature
of the Black experience, the integrity of those who are involved
who areBlack and who are relating totheir experience, and very
basically, how honest people are in terms of being Black and
relating their experiences to their own salvation. Now, as
with the example of the Blues, Black Experientialism must be
lived and realized in the everyday experiences of the people
who are involved, or it will remain a possibility and not a
reality. So once the Black Experientialism, once this movement
emerges and becomes a reality, then it is quite clear that as

the numbers of people multiply, so will the influence in the
Black xpm community become more diverse, become more diffuse,
become more involved with all elements of the total Black
community in Chicago. And this is the process that will unify
the various components of the Black community. This is the
process that will serve as the context for recruiting new
people to all aspects of OBAC, all aspects of those things
which have to do with the salvation of the Black people in
this city. <u>Survival, Black Experientialism and Survival.</u>
I think one of the things we have to do is try to clear up what
is Black Experientialism, from what's already been said. One
of the things that'sxmxxxmxm relevant to recognizing Black experi-
entialism has to do with how Black people are at one with them-
selves. What this means is, in a superficial way, it means
looking at women who are wearing naturals and men who are
accepting themselves as being Black, whatever the color of
their skin, whatever their station and social class, accepting
themselves as being Black and relating to their people as such.
That is, the kind of problems that you have, many of the prob-
lems you have in the Black community, have to do with what
has happened to us outside the Black community, but the
symptoms of the problem, have to do with how we relate to
each other. It is mostly the gang behavior that is directed
at the gang members themselves, and the other Blacks who live
in the Black community and their mothers and fathers, and from
the standpoint of Black experientialism, this is a very, very
negative thing. That is, Black people have to start res-
pecting each other, start dealing with each other as they
would deal with their own family. The concept of ujamaa, which

is the Swahili word for family, brotherhood; this is the basis
on which Tanzania is building a policy, and this is the policy
which we think is relevant to Black people in this country.
If we think of ourselves as an extended family, if one does
that, one redefines himself in terms of the other Black people
he's around, and comes to know them in a different way. In
one sense we're talking about this level, but on another level,
it has to do with your mind, has to do with being so Black that
you do not ~~expect~~ accept much of the terminology, many of the standards,
many of the categories, and the assumptions that people make
about Black people. That is to say, people are loyal to many
things. Black experientialism means that on a social level
your first loyalty is to the Black people, of which you are a
part, which is the most basic thing in defining who you are,
not where you live, not where you work, not what your relatives
made, what they've done or what they haven't done. It is the
fact that you are one of the people who are bound to a tradition
in this country. And you come to grips with that, it is the
basic social element in determining who you are. Now how does
this relate to surviving in this alien society, and how does
it relate to the necessary kinds of things that have to happen
in ths Black community?? Well, essentially, as reflected in
the title of this section, Culture and Consciousness, what we're
concerned about is the consciousness of people. We're concerned
about their minds, concerned about their spirits, about their
values, their attitudes. We feel that if a person is able to
define a way of believing that Black is beautiful; that which
is beautiful in an authentic way has to relate to Blackness in
terms of that which I relate to as a person as a fundamental or

tribal level, that this is a very, very key part of the whole
process, the necessary process of overcoming the kind of self-
hate, the kind of hatred that exists in our community, hatred
for each other, for ourselves, self-hate. And it also has to
do with overcoming the kind of ties that we have with white
standards. Black people are hung up in many ways with accepting
white standards as being beautiful and Black standards as being
just there, and this is both true in Chatham or in middle-class
society, or in the ghetto too, in what we think of as the lower-
income ghetto. In Chatham, or in the middle-class community,
people might try to completely deal out anything that's Black
and deal in anything that's white. People listen to the symphony,
people go downtown to so-called cultural events and they define
that as being good. They deal out anything that's Black. And
that's pathological. They're Black and they know it and they're
trying to escape it. And they can't escape it, so they live in
a world of fantasyx fantasy. But the same kind of pathology
exists in the lower-income Black community. People hold in their
minds values that symphonies represent high art, and going to
listen to blues, or going out to dance, you do to have a lot
of fun. This is not defined as culture, it is not defined as
good, it is not defined as beautiful. People still think that
Beethoven and Mozart were better musicians, were greater people,
than Charlie Parker and B.B. KINg, Howlin' Wolf, Junior Wells, many
many other people.
The fact is that we have to define those subjective Black standards
which take a person like Charlie Parker or Muddy Waters and
project him in the same way that germans can project Mozart, that
they would project Bach, that Frenchmen would project Debussy,
that Englishmen could project Purcell, and that Americans could

project Leonard Bernstein, Aaron Copeland, or John Philip Sousa.
But the fact ~~xxxxx~~ is that we have heroes, those heroes are ours,
they talked about us, they were us, and we've got to accept them,
we've got to project them and use them to overcome the kind of
hangups we have because of living in a white society, and thinking
that white is good and Black is bad. One very important series
of dangers must be pointed out. For every arrow in the figure
there is another arrow which points away from the chain of
things. The arrow that points away from the chain of things
has to do with the way in which the process can not go to help
the Black community but can be stolen, bought, or given away
for other people's benefit. The Chicago Black ghetto can deny
its beautiful Black people, or the beautiful Black people can
deny the Chicago ghetto. In this case nothing can happen.
The Black people are out there stranded, separated, beautiful
Black people are, first of all, not very beautiful, and second
of all, living a lie, living a fantasy, separated from their true
base of communal experience. Or on the other hand, continuing
the circle, beautiful Black people can emerge from the Black
community and not engage in enterprises which would lead to OBAC,
but rather become involved in enterprises which have to do with
the white society, that have to do with other things, other than
that which can unify Black people around their meaningful cultural
tradition, cultural experience. Or, continuing around the circle,
OBAC could be formed and violate its real calling, and merely
peddle the experience, the cultural forms, to the white community.
And we know many examples of this, where someone has taken of
his Black experience and of his cultural tradition, only to go
sell it to white people. But to some extent this also has to do

with the extent to which Black people become involved in terms of
the community. I mean, if I'm an artist, if one is an artist, and
one tries to become involved in the Black community and the Black
community rejects him, then in terms of the demands of eating and
living, one can be forced into the white community in order
to survive. This is something that Black people in general, as
well as the Black artist, have to come to grips with. We have to
be able to deal with that in terms of uniting ourselves.

And continuing aroundthe circle, in terms of Black Experi-
entialism, in terms of Soul, in terms of the ethos of Black
culture, these are things that people have to accept, and as long
as Black people are psychologically sick, psychologically
pathological, this kind of free and open and honest experience,
this kind of loving experience, is not to be realized. And that's
why many white people who are coming to the Black community to
find this Soul, to find Black experientialism, to do our thing,
it may be because they don't have a thing like we have a thing,
it may just be that they want their thing and our thing, but what
we're concerned about, what OBAC is concerned about, is that
Black people have their thing and are able to use their thing and
to have it in such a way as to become freer and better people.
So that when one looks at this diagram one has to understand that
for
every arrow there is another arrow, and both arrows are at
work. We are concerned with the arrows that are on this page.
Other people, and some of us, in fact are involved in some of those
other arrows, and that's something that each of us as individuals
and all of us as a community have to deal with so that as much
of what we need as we can get, we can have operating in the arrows
that we think are the better arrows, than those other arrows

which have to do with helping somebody else, or letting somebody
else use us. If Black people are together as individuals, if
Black people are together as a community, if Black people can
be together in OBAC, we can establish these arrows, we can set
in force a process to regenerate the Black community to move
forward, to move forward as one unit, one community, one living
community of Black culture.

PART III THE PLAN: A MOVEMENT AND AN ORGANIZATIONAL STRUCTURE

(Forthcoming!!)

CONCLUSION

OBAC has been presented in this document as a developing
idea and program for reversing the tide of physical and psycho-
logical opression that has been crushing Black people for too long.

Q 1. <u>How does OBAC relate to other organizations
 -cultural etc.- in the Black community</u>?

A 1. OBAC seeks to cooperate with and support other groups and
organizations in the Black community which share in the same con-
cerns and purposes. It might sponsor programs, help publicize,
or put on directly, programs with or for various organizations.

Q 2. <u>Who can be in OBAC and what does it mean to
 belong to this organization</u>?

A 2. OBAC is an organization of Black artists, Black professionals,
and all kinds of regular, everyday Black people, conerned about
the art, culture, and spirit of the Black community. Membership
in OBAC means (1) an affirmation of positive attitudes toward
being part of the Black community in America and (2) committment
to work persistently both formally and informally to further the
aims of the organization for Black people.

Q 3. <u>Why concentrate on the arts</u>?

A 3. First, we believe that the arts represent a process whereby
symbols, images, and sounds express the spiritual truth of a
people. Second, we believe that art can be revolutionary and
that some artists of our communiÿ have long been involved in
a creative revolution. By bringing artists and community into a
greater mutual appreciation and positve acceptance of being Black,
we hope to reflect the richness and depth and variety of Black
culture, the beauty of its genius, its soul. This common spiritual
base can then promote increased self-understanding, heroic self-
image, positive

images, positive community values, and images and convictions
about beauty which reflect the Black experience.

Q 4. <u>Who are you trying to reach with your program</u>?
A 4. Our program is primarily aimed at adults and young adults
throughout the total Black community. Sufficient resources and
personnel, of course, could allow adaptation of sections of the
program for Black youths as well.

Q 5. <u>What really is the purpose of your organization</u>?
A 5. Its purpose is to create a revolution of consciousness to
promote unity in the entire Black community around common cultural
treasures, and self-dignity.

We hope this document has stimulated and encouraged you
sister, or you brother, to <u>check</u> your relationship with the
Black community and the larger American society, to re-examine
where <u>you</u> stand in relation to the Black experience in America.
We have described a program for action growing out of a new
awareness and evaluation through "Black consciousness" focussing
on our contemporary lot. Are you ready for pride? Do you have
the vision? 25 years ago, Margaret Walker wrote

> Let a new earth rise. Let another world be born.
> Let a bloody peace be written inthe sky. Let a
> second generation full of courage issue forth,
> let a people loving freedom come to growth, let
> a beauty full of healing and a strength of final
> clenching berthe pulsing in our spirits and our
> blood. Let the martial songs be written, let the
> dirges disappear. Let a race of men arise and
> take control!

And today, David Moore says:

Is Now The heyday
Mr. John C. tells of
Tenor Screams, bellow of Revolt
And Revolution Comes itsway
Born of Romanesque Decay

It's time to do what must be done. OBAC is one part of what must
be done if Black people are going to survive.

The destiny of a people, a community of sisters and
brothers, is so important that only what we usually call gods
should influence it. But, the gods choose to work through men,
and this fact can only be realized by those men themselves. If
Black people don't choose to determine the future of their
community, white people will continue to do so (remember they
once owned you like a chair or a pair of shoes, and still own
many of us just like that). We have dared to present this
paper to you, the Black community, our sisters and brothers,
and only you can judge our work. Whatever happens, this paper
is yours; it became yours as soon as it was conceived and
written.

We will continue in this direction. Help us if you
think we're wrong. Join us if you agree. If you don't think,
get the hell out of the way.

OBAC!!

An Invitation to OBAC Dialogues: Rappin' Black

Joseph Simpson

This program included the first formal public announcement of the Wall Project. Phil Cohran helped to found Chicago's vanguard jazz performance group the Association for the Advancement of Creative Musicians. In fact, they do not use the label "jazz," calling the music they play Black classical music. David Llorens was a writer who worked on the staff of *Ebony* magazine.

**ORGANIZATION
OF BLACK
AMERICAN
CULTURE**

352 EAST 47TH STREET
CHICAGO, ILLINOIS 60653

AN INVITATION TO OBAC DIALOGUES: "RAPPIN'" BLACK

 This an Invitation. It is extended to you by OBAC to
come to know yourself better by knowing more about your Black Artists.

 This Sunday, July 23rd, the first of a series of biweekly programs
called OBAC Dialogues will be presented at the South Side Community Art
Center, 3831 S. Michigan Avenue, at 7:00 p.m.

 Painter, William Walker, Musician, Phillip Cohran, and Writer
David Lorens, all well-known local Black Artists will speak to the theme:
"Sights, Sounds, and Symbols of the Black Experience." Jeff Donaldson, painter
and Coordinator of OBAC Visual Arts Workshops will moderate the program.

 OBAC (THE ORGANIZATION OF BLACK AMERICAN CULTURE) is an effort to
organize artists in the Black Community for the sharing of creative ideas
and the search for new meanings which reflect the Black experience.

 OBAC is also an effort to develop programs throughout the total
Black Community which produce:

 (1) Increased self-understanding and heroic self-images;

 (2) Positive community values; and

 (3) Images and values about Beauty which reflect the Black
 Experience.

 Join us this Sunday, and in the future, in this step
towards the collective search for our Black Consciousness.

Signed_____for OBAC.

By-laws of the Organization of Black American Culture
Hoyt W. Fuller and Gerald A. McWorter

This document was drafted by Hoyt Fuller and Gerald McWorter with the assistance of lawyer and OBAC member E. Duke McNeil. While it sets forth careful bureaucratic rules that functioned to safeguard the organization, the actual experience of OBAC was more of a participatory flow.

O.B.A.C. THE ORGANIZATION OF BLACK AMERICAN CULTURE
(A non-profit, non-partisan organization which maintains spiritual relationship with all organizations and activities which are PRO-BLACK)
Summer, 1967
Chicago, Illinois

By-laws of the Organization of Black American Culture

SECTION I. Composition of the OBAC Council

A. The OBAC council is the executive body of the organization, and is self-generating (it alone invites individuals to join it).

B. The council shall be composed of a chairman, or chairmen, vice chairmen, keeper of records (secretary), workshop coordinators, and such other members as the council sees fit to include.

SECTION II. Rules for Council Membership.

A. Council members are selected from the OBAC membership on the basis of their achievement in their chosen field, as well as with a consideration to requirements for representativeness.

B. Council members shall have demonstrated an active interest and role in an OBAC workshop.

C. Council membership entails a financial obligation of $25.00 to the organization, payable at the time of admittance to the council.

D. Council members are expected to attend every regular and call meeting of the council. The chairman has authority to recommend removal from the council of any member for negligence in attendance at council meetings, lack of participation in a workshop, failure to carry out designated and accepted council responsibilities, and/or any behavior detrimental to the image or best interests of OBAC.

SECTION III. Function of the OBAC Council.

A. To set policy for OBAC.

B. To maintain organizational resources, such as treasury, records, etc. for all organizational (including individual workshop) projects.

C. To coordinate the overall activities of the workshops, such as artists sessions, community-oriented programs, etc., and set and carry out policy in terms of fund raising and public relations.

D. To be the official representative of OBAC at any and all events relating to the organization.

SECTION IV. Duties of OBAC Officers.

A. The chairman shall:
1. call meetings of the council and, on advice of the council, call general membership meetings.
2. preside at all meetings of the council or general membership; have discretionary power to invite non-council members to such meetings.

B. The vice chairman shall:
1. serve in the capacity of the chai[r]man in the event of his absence or disability.

C. The keeper of records shall:
1. maintain up-to-date files and records of the proceedings of [the] council, as well as general membership meetings, and distribute minutes as directed by the council.
2. maintain permanent files of the organization and handle correspondence both for the council and the organization as a whole.

D. The treasurer shall:
1. maintain current files and records of finances and all financial transactions of the organization.
2. co-sign with the chairman all financial transactions of the organization.

E. O[B]AC workshop coordinators shall:
1. maintain active membership in one or more OBAC workshops, and function as the official lia[i]son between the council and one specific workshop;
2. submit regular written reports on the activities of the aforementioned workshop, at intervals determined by the council.
*All council members are ex-officio members of all workshops of OBAC.

SECTION V. OBAC Organizational Membership.

A. OBAC membership falls into two categories:

1. participating: those in OBAC workshops.

2. general contributing: those not necessarily in a workshop, but who've paid membership fees to support the organization.

*Members of an OBAC workshop shall determine criteria for membership in it. The council rules on criteria for general contributing membership.

SECTION VI. OBAC Workshops.

A. OBAC workshops functions as self-governing bodies within the overall policy, structure, and program of OBAC as determined by the council:

1. membership in OBAC workshops must be coterminous (hold simultaneously) with membership in OBAC.

2. membership in OBAC is not tantamount to membership in a workshop, rather members of the workshop shall determine such criteria for both admission and continued good standing.

3. any fund raising must be approved by the OBAC council.

[page missing in original]

C . Tasks of the nominating committee.

1. to establish a timetable for the election process, to be completed by the end of September.

2. to develop a recruitment process for the candidates for the slate of offices; hence, recruit candidates and establish an initial screening process.

3. to arrange a schedule for all candidates to visit every OBAC workshop to make a statement and be questioned by the members of each respective workshop.

4. to arrange a meeting of the entire OBAC membership for the purpose of electing officers.

5. to maintain records of its deliberations, and make all official transactions in writing.

SECTION VIII. Amendment procedure.

A. Changing the by-laws.

1. An affirmative vote of two-thirds (2/3) of the participating and general contributing membership shall be required to change these by-laws. No proxies shall be valid at such a vote.

Who Is on the Wall and Why
Gerald A. McWorter

These are Gerald McWorter's notes taken during the discussion of who should
be on the Wall. While the group operated by consensus, each person was re-
sponsible for presenting ideas for their section. These names are merely some of
those discussed. The main question was: who could we possibly exclude?

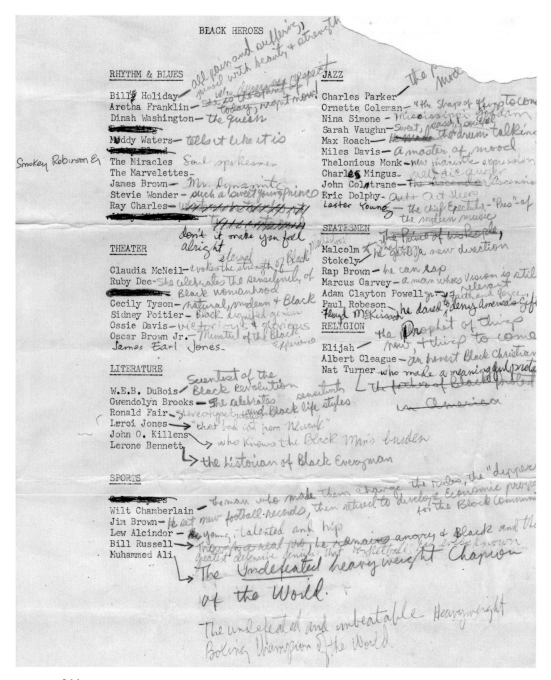

What Is a Black Hero?
OBAC

This document includes text that was distributed as part of OBAC's handout at the Wall (see next page) as well as words of thanks given at the Wall's dedication. It reflects OBAC's determination to define the project to the community and to express appreciation for their support. Note the importance of including people's names so that they are acknowledged as real people making a real contribution, without which there would be no Wall.

We, the Organization of Black American Culture (OBAC), declare that a Black hero is any Black person who:

1. honestly reflects the beauty of Black life and genius in his or her life style;

2. does not forget his Black brothers and sisters who are less fortunate;

3. does what he does in such an outstanding manner that he or she cannot be imitated or replaced.

Therefore, the following list of persons and groups are heroic to us, Black people. This WALL is a celebration. We pay respect to our heroes, we are proud of them, we are proud of you, we are proud of ourselves.

We in OBAC wish to thank all the beautiful Black people of this neighborhood for their protection of the WALL and our equiptment, for their generous aid in moving the scaffolding, and their sincere criticism and general appreciation of the project. Special thanks to Brother Baker for making the WALL available, to Brother Johnny Ray for the electronic hospitality, Brother Charles, Brother Herbert, and the Young Militants and to all the other Sisters and Brothers, young and old.

We further wish to add that this project was financed entirely by the members of the OBAC Visual Arts Workshop whose works are on this wall. The Organization is not sponsored by, affiliated with, or any way connected with any political organization, community group or any other type organization.

Black Heroes
OBAC

This handout was distributed at the inauguration of the Wall of Respect in August 1967. It introduces OBAC to the public, presenting the selection of heroes and the artists who worked on each section, and thanking the community for their support of the mural. This is at least the third typed version of the list of heroes. It reflects changes following the early draft presented here (page 164) as "Who Is on the Wall and Why." (Struck from that early version already, for whatever reason, were B. B. King, Bobby Bland, Jimmy Witherspoon, Ivan Dixon, and Gale Sayers.) The version presented here adds the names of the painters and photographers (with corrections in brackets) to an otherwise substantially similar second draft. A few other changes between versions 2 and 3 are as follows: Heroes' names in brackets below were present on the second draft, but not in this one. An asterisk marks names that were crossed by hand off the second draft version, but restored on this one. James Earl Jones was not on the second draft, but included on this one. Finally, "Muhammad" was inserted by hand after "Elijah" on the second draft version, but was not added to this one; either it was obvious enough who he was, or sensitivities surrounding his representation encouraged a certain deployment of ambiguity.

OBAC
(Ob-bah-see)

*OBAC is organized to enhance the spirit and vigor of culture in the Black community.

*OBAC seeks to involve the total Black community in every aspect of its undertakings.

*OBAC conducts a series of creative workshops in music, art, dance, drama, oratory, and literature.

*OBAC will showcase the products of these workshops in a Festival of Black Art in the fall of 1967.

*OBAC seeks themes, attitudes and values which will unite Black artists and Beautiful Black people around heroic self-images and standards of beauty relevant to the Black experience in America.

OBAC needs your participation in the realization of these objectives.

OBAC declares that a Black hero is a Black person who:

1. honestly reflects the beauty of Black life and genius in his or her style.
2. does not forget his Black brothers and sisters who are less fortunate.
3. does what he does in such an outstanding manner that he or she cannot be imitated or replaced.

Therefore, the following list of persons and groups are heroic to us, Black people. This <u>WALL</u> is a celebration. We pay respect to our heroes, we are proud of them, we are proud of you, we are proud of ourselves.

BLACK HEROES

LAYOUT AND DESIGN: Sylvia Abernathy

NEWSTAND ARTIST: Carolyn Lawrence

RHYTHM & BLUES Artist: Wadsworth Jarrell
 Billie Holiday—all pain and suffering joined with beauty and strength
 Aretha Franklin—deserves respect
 Dinah Washington—The Queen
 Muddy Waters—tells it like it is
 Smokey Robinson and the Miracles—Soul Spokesman
 The Marvelettes
 James Brown—Mr Dynamite
 [Stevie Wonder—such a sweet young prince]
 Ray Charles—don't it make you feel all right

JAZZ Artists: Elliot[t] Hunter, Jeff Donaldson Photographer: Billy Abernathy
 Charles Parker—prophet of the modern age
 Ornette Coleman—shape of things to come
 Nina Simone—Mississippi goddess
 Sarah Vaughn—sweet, sassy and soulful
 Max Roach—the talking drum
 Miles Davis—the master of mood
 Thelonious Monk—new pianistic expression
 Charlie Mingus—melodic anger
 John Coltrane—
 Eric Dolphy—out there
 Lester Young—the "Pres" of modern music
 Sonny Rollins

THEATER Artist: [Barbara] Jones Photographer: Roy Lewis
 Claudia McNeil—evokes the eternal struggle of Black motherhood
 Ruby Dee—celebrates the sensitivity of Black womanhood
 Cecily Tyson—natural, modern and Black
 Sidney Poitier—Black dignified genius
 Ossie Davis—victorious and glorious

Oscar Brown, Jr.—minstrel of the Black experience

James Earl Jones

Dick Gregory—

STATESMEN Artist: Norman [Parish] Photographer: Roy Lewis

Malcolm

Stokely—the power dimension

Rap Brown—with Black in his rap

Marcus Garvey—a man whose [vision] is still relevant

Adam Clayton Powell, Jr.—Faith and Force

Paul Robeson—dared to deny America's gift

*Floyd McKissick

RELIGION Artist: Bill Walker Photographer: Bobby Sengstacke

Elijah—The Prophet of things now and things to come

Albert Cleague—an honest Black Christian

Nat Turner—made a meaningful protest

LITERATURE Artist: Edward Christmas Photographer: Darryl Cowherd

W. E. B. DuBois—Scientist of the Black Revolution

Gwendolyn Brooks—She celebrates sensitivity and Black life styles

*Ronald Fair—butchers stereotypes

Leroi Jones—"that bad cat from Newark"

[John O. Killens—who knows the Black man's burden]

Lerone Bennett—Historian of Black everyman

SPORTS Artist: M[y]rna Weaver

Wilt Chamberlain—the man who made them change the rules

Jim Brown—new g[ri]d-iron records, then economics for his people

Lew Alcindor—young, talented and hip

Bill Russell—angry, Black and greatest defensive genius that basketball
has ever known

Muhammed [sic] Ali—the undefeated and unbeatable heavyweight Boxing
Champion of the World

We in OBAC wish to thank all the beautiful Black people of this neighborhood for their protection of the WALL and our equipment, for their generous aid in moving the scaffolding, and their sincere criticism and general appreciation of the project. Special thanks to Brother Baker for making the WALL available, to Brother Johnny Ray for the electronic hospitality, Brother Charles, Brother Herbert, and the Young Militants and to all the other Sisters and Brothers, young and old. We further wish to add that this project was financed entirely by the members of the OBAC visual arts workshop whose works are on this WALL. The organization is not sponsored by, affiliated with, or any way connected with any political organization, community group or any other type of organization.

Officer Transition (memorandum)
OBAC

This is an important transition document, as two of the OBAC cadre were finishing their graduate study at the University of Chicago and moving on. Gerald McWorter took a job at Fisk University in the sociology department and eventually founded the Black Studies program in this historically Black university, with its rich tradition of Du Bois, Charles Johnson, Horace Mann Bond, David Driskell, Aaron Douglas, and many other important scholars. Joseph Simpson took a postdoctoral position at Yale, then went on to earn a medical degree at Harvard.

Officer transition
This is a letter which will outline the process of transition for OBAC officers th[is] fall during the month of September.

1. The Chairmanship will be temporarily occupied by Hoyt Fuller, the Vice Chairma[n] of OBAC. The Chairman Gerald McWorter and Secretary Joseph Simpson are leavi[ng] and the offices need to be filled as soon as possible.
2. The election process will be organized and directed by a nominating committee [?] be appointed by the Chairman.
3. The task of the nominating committee will be:
 a. To establish a timetable for the election process to be completed b[y] the end of September;
 b. To develop a recruitment process for candidates for the slate[d] offices. The nominating committee will recruit candidates, and establish an initial screening process.
 c. The nominating committee will arrange a schedule for all candid[a]tes to visit every OBAC workshop and make a statement and be question[ed] by the memb[e]rs of each respective workshop.
 d. to arrange a meeting of the entire OBAC membe[r]ship for the purp[o]se [of] holding an election for officers.
4. The entire transition process must carried on in the spirit and letter of the OBAC By-Laws
5. The meeting of the entire membership must be limited to xx card carrying memb[ers] and could also deal with the othe[r] organizational matters to be decided by the OBAC Council and the nominating committee.
6. The nominating committee sho[u]ld maintain records of its deliberations, and ma[ke] all official transactions in w[r]iting. The workshops should be notified in wr[it]ing as should the membe[r]ship when it is notified for the general membe[r]ship. All notifications should be made giving people as much planning time a[?] [...]

OBAC Progress Meeting (letter)

Hoyt W. Fuller and Joseph Simpson

This meeting reflected the end of the first stage of OBAC, its origin and its successful Wall project. Many people relocated and both the Community Workshop and the Visual Arts Workshop were disbanded. OBAC became reorganized around the Writers' Workshop.

September 25, 1967

Dear Sisters and Brothers in OBAC,

Having been in operation for about five months, it[']s time for some evaluation of our progress and projection for the immediate future.

On SUNDAY, OCTOBER 8th., at 4:30 P.M. there will be a <u>closed</u> meeting of the entire OBAC membership at the SOUTH-SIDE COMMUNITY ART CENTER, 3831 S. Michigan. This meeting will be for the purpose of:
 1. reviewing the progress of the organization, with some live demonstrations and displays, and
 2. nominating candidates for offices in the organization.
The second purpose is the most important since, as you may have heard, several council members have left or shortly will be leaving the city for positions elsewhere.

The enclosed copy of the OBAC by-laws outlines how the election process shall be carried out. The OCTOBER 8th meeting will allow for recommendation of candidates to the nominating committee from the membership. Candidates will then be screen[ed] and begin campaigning in accordance with the procedure indicated in the by-laws.

Please plan to be present and to actively take part in this important meeting. If you have any urgent suggestions regarding this meeting. the organization in general, or know of persons who would like membership prior to this meeting please contact H. Fuller, at CA 5–1000, or J. Simpson, at MI 3–0800, ext. 3946 as soon as possible.

Yours in OBAC,
Hoyt W. Fuller,
Vice Chrm.
Joseph R. Simpson,
Sec'ty.

Black Arts Movement Articles

Hoyt W. Fuller Jr. was the wise man of the OBAC Writers' Workshop. Like Ella Baker, he was not heavy-handed, but rather guided the group in such a way that they were only conscious of their collective development. He was a sweet brother who was firm but subtle, had a great smile, gave sage advice in the group, and always gave time for a one-on-one. He was an early advocate of the search for a new Black aesthetic.

Fuller edited the influential literary magazine *Negro Digest* (later renamed *Black World*), published by Johnson Publishing. His editorial policy created a large umbrella under which a dynamic, diverse movement found a home. He was a major source of information on the Black Arts Movement, maintaining a national scope in his monthly *Negro Digest* column, "Perspectives." People in cities such as New York, Boston, Philadelphia, St. Louis, Cleveland, San Francisco, Los Angeles, New Orleans, Atlanta, Washington, D.C., and of course Chicago, read his reports on events, publications, and performances in all areas of the arts and letters. The articles presented here were all written by Fuller and/or published in *Negro Digest*, and they provide, in condensed form, an overview of Chicago's Black Arts Movement as it presented itself in print to a national audience. Articles are reproduced here exactly as they were published with regard to punctuation and spelling.

Muhal Richard Abrams and John Shenoy Jackson introduce readers to the closely connected experimental musicians' organization, the Association for the Advancement of

Creative Musicians (AACM), and provide accounts of the founding of OBAC and the AACM, along with a discussion of the animating principle of the "Black Aesthetic." As Hoyt Fuller was to the writers, Muhal Richard Abrams was to the musicians. His leadership was wise and free, to advise, to liberate, not to force any sort of imitation. There was a big arts community booming in Black Chicago and the musicians were at the center of it. The photographers were teaching us to look at each other in new ways. The painters were teaching us that we could take images and do magical things with them. The dramatists taught us that we could relive our lives on stage with great imagination. And the AACM musical organization put it all together. The AACM continues to be a vibrant force in the Chicago Blacks Arts scene.

Fuller's "Culture Consciousness in Chicago" is a report on the inaugural public meeting of OBAC and gives an account of OBAC's principles and discusses its early public manifestations.

His "OBAC: A Year Later" gives an account of the activities of OBAC's different workshops, including the Visual Arts Workshop's work on the Wall. Finally, his "Towards a Black Aesthetic," first published in the Chicago-based liberal Catholic journal *The Critic*, addresses the urgency of the principles animating the Black Arts Movement and studies the reactions to it both inside and outside the movement itself.

Culture Consciousness in Chicago

Hoyt W. Fuller

from *Negro Digest*, August 1967

In Chicago, the Organization for Black American Culture (which is abbreviated as OBA-C and pronounced *Oh-bah-see*) launched its community-directed program with a dramatic session in the South Side's Abraham Lincoln Center. The organization's inaugural presentation was designed to illustrate its cultural emphasis, and community talent was enlisted for the occasion. *Black Experientialism* is the guiding philosophy behind OBA-C, and the performers were selected to demonstrate the impact of the *black experience* on the various artistic expressions.

For both the dance and blues singing, singer-dancer **Sherry Scott**, a lissome beauty in a sexy *boubou*, opened the program. She was followed by The Delections, a quintet of versatile young men **(Rudy Howard, Ronald Christian, Wayne Jackson, Donald Foxx, Patrick Keen)** who swung easily from gospel to Rhythm and Blues. The Magnificent Seven Plus One, another group of young men (all high school students), provided biographical vignettes of such black men as Malcolm X and W. E. B. Du Bois. For jazz, black music, the Fred Humphrey Quartet did the honors. Miss Scott is vocalist with the quartet.

Poet **David Moore** recited from his own works, and painter **Jeff Donaldson**, using examples of paintings by black artists, described to the audience the problems and challenges confronting the black artist who is determined to invest his work with the essence of his unique experience.

The OBA-C presentation, however, was not so pedestrian as the above might indicate. The program was conceived as a fast-moving [word missing here in the printed piece], with each illustration of black experientialism in the arts buffeted by a brief "statement" by an OBA-C member. Following the musical interlude, for example, musicologist **George R. Ricks** outlined the peculiar history of musical expression among black Americans. In dealing with The Visual Image, which he illustrated, Jeff Donaldson explained how the tradition of sculpturing among Africans had been discouraged, and finally prohibited, in America, thereby robbing black artists of their link with this tradition.

The entire presentation was directed by **Anne McNeil**.

OBA-C members at the time of the inaugural program were: **Gerald McWorter,** chairman; **Hoyt W. Fuller,** vice chairman; **Joseph R. Simpson,** secretary; **Ernest (Duke) McNeil,** treasurer; Jeff R. Donaldson; George R. Ricks; **Donald H. Smith; Ronald C. Dunham; Bennett J. Johnson** and **Conrad Kent Rivers.** These members also constituted the Executive Council. Later, **Brenetta Howell** and **Val Gray Ward** joined the Executive Council.

In early summer, OBA-C initiated a series of workshops in the arts and announced that works created in the workshops would be featured in the Festival of Black Arts which is scheduled for October in Chicago.

Like dozens of similarly-oriented organizations which have sprung up across the country in recent months, OBA-C is dedicated to arousing and then seeking to focus the energy of black people toward an appreciation of themselves and their human possibilities. However, OBA-C is concerned with the creative aspect of this often-dormant reservoir of energy. "Because the Black Artist and the creative portrayal of the Black Experience have been consciously excluded from the total spectrum of American Arts," an OBA-C release stated, "we want to provide a new context for the Black Artist in which he can work out his problems and pursue his aims unhampered and uninhibited by the prejudice and dictates of the 'mainstream'."

Among the purposes of OBA-C, as spelled out in the organization's documents, are the following:

—To work toward the ultimate goal of bringing to the Black Community indigenous art forms which reflect and clarify the Black Experience in America;

—To reflect the richness and depth and variety of Black History and Culture;

—To provide the Black Community with a positive image of itself, its history, its achievements, and its possibilities for creativity.

A key question posed in all the OBA-C workshops to its participating artists is the following: "Do you consider yourself a Black Artist, or an American Artist who happens to be Black, or a writer, period?"

The Association for the Advancement of Creative Musicians

Muhal Richard Abrams and John Shenoy Jackson

from *Black World*, November 1973

The Association for the Advancement of Creative Musicians' (AACM) primary concerns are about survival, accountability and achievement. The Black creative artist must survive and persevere in spite of the oppressive forces which prevent Black people from reaching the goals attained by other Americans. We must continue to add copiously to an already vast reservoir of artistic richness handed down through the ages. Black artists must control and be paid for what they produce, as well as own and control the means of distribution. Black organizations must have the proper legal framework in order to afford maximum protection to their artists. Regular publication of a newsletter and/or magazine is of prime import to keep the public abreast of artistic activities.

Black cultural missionaries (perhaps a more suitable name for Black artists) should demand that all interviews given to all media and forums outside of and separate from the Black community be tape recorded and disseminated verbatim except for minor editing. In countless instances, leading publications and the media have utilized the interview technique to play one Black artist against the other, thereby creating confusion among Black as well as white audiences, in an effort to sell what they want the consumer to have. The prevalent attitude that anybody can play jazz and blues has given rise to a plethora of white groups who are now being accepted as true purveyors of Black music. The public spends millions of dollars on these groups, while seminal Black artists literally starve. Many Black artists of exceptional capabilities in the Chicago area are unable to secure work because the so-called Black stations project only what is allowed by the white power structure.

In the area of accountability, Black artists should be held responsible to their brothers and sisters, who, in turn, should demand excellence and give their support to Black endeavors. For years the mass-media scavengers have stolen and feasted on Black creativity, literally forcing ersatz art on the total American community in general and the Black community in particular.

Blacks must demand that radio and TV stations be held accountable. Since these stations are using the Black community for gain, they must begin to project what is relevant and valid in the Black community. (If some stations in the Chicago area were more public spirited or had a sense of obligation to the Black community, they would cease channeling such pap as prominent clergymen hawking pork chops, cabbage greens and mini-skirts; talk-show hosts of Mata Hari proportions whose only contribution is to exhort the brothers to dress up in clown clothes and have their pictures taken smoking a cigar.) We must be about more important things by making demands on all radio stations to present current extensions of Black music and other facets of Black endeavors.

Achievement is a concern in that it is the prime requisite for those of us who wish to embrace Blackness in its fullness. This means a commitment to the idea that the creative learning process should never cease. Black people have now reached a juncture where they have assumed and/or rekindled a spirit of pride—an intelligent pride that has become so infectious and inspiring that other ethnic groups have rediscovered their heritage and are beginning to place high premiums on their ethnic backgrounds.

The AACM is attempting to precipitate activity geared toward finding a solution to the basic contradictions which face Black people in all facets of human structures, particularly cultural and economic. There is an incessant demand in Black communities to solve the disparity between participation and nonparticipation in the social process. Our concerts and workshops in the schools and in the community are an effort to expose our Black brothers and sisters to creative artists contemporary to their time and present to them a factual account of their glorious past as an undergirding for facing the future. Demonstrating the creation and production of art will enhance the cultural and spiritual posture of a people; and it is our firm belief that artistic appreciation will so enhance cultural and spiritual growth that the individual's participation in the social process will be highly accelerated. It is the contention of the AACM that it is not the potential which Black people have which will determine what they do but, rather, how they feel about themselves.

Finally, the AACM intends to show how the disadvantaged and the disenfranchised can come together and determine their own strategies for political and economic freedom, thereby determining their own destinies. This will not only create a new day for Black artists but for all Third World inhabitants; a new day of not only participation but also of control.

OBAC: A Year Later

Hoyt W. Fuller

from *Negro Digest*, July 1968

During the winter of 1966–67, a trio of Chicagoans—a poet, a sociologist and an editor—met periodically in the apartment of one of the trio, wrestling with an idea. Out there in that sprawling city lived upwards of a million black people, at least a third of the city's population, but—for all practical purposes—those million black people were without effective power to rule their own lives. For decades, the machinery of politics had served to render the burgeoning black community powerless in the crucial areas of government and finance, but that was an old—if ever-scandalous—story. What brought the trio together was their concern about what the specious form of political and economic colonialism in Chicago had done to the morale and the consciousness of the masses among that black million. The idea with which the trio labored had to do with attempting the task of touching the masses with the wand of understanding which would, magically, open up to them the bright and beautiful world of their human possibilities. The trio envisioned the Arts as the means by which the people might be reached, for true art—unlike politics—was beyond the corrupting power of the entrenched coalition of the White Establishment and the Self-Satisfied Black Bourgeoisie.

In the spring of 1967, the Committee of the Arts—as the group then called itself—went before the community at the South Side Community Art Center with a modest program featuring poet **Margaret Danner,** folk singer **Terry Callier** and poet-novelist-anthologist **Arna Bontemps**. Miss Danner, whose poetry long had reflected the now-fashionable "black is beautiful" philosophy, represented the venerable; Mr. Callier, a rising and as yet "undiscovered" star, represented that which is ever-new in simple, ungarnished black talent; and Mr. Bontemps, a national treasure, was black literary history on the hoof, a virtual walking encyclopedia of the past half-century of literary labors among black people. It was a stimulating Sunday afternoon.

From the small audience that day, three additions were made to the group which later came to be known as the Organization of Black American Culture—or OBAC, pronounce *Oh-bah-see*. The African sound of the initials was not accidental: hours had been spent by some especially inventive members of the group

in coming up with a name which would lend itself to that sound. (In Nigeria, *Oba* is the word for ruler or royalty.)

It was important to OBAC that all the arts be represented on its executive council, and a search was undertaken to bring into the group individuals with a strong background in the various arts. At length, a cadre of 10 men was assembled and OBAC announced its presence in the community with a deliberately brief and symbolic program at the Lincoln Center that summer.

The 10 men involved were: **Gerald McWorter**, sociologist; **Jeff Donaldson**, artist; **E. Duke McNeil**, attorney and actor; **Donald Smith**, educator; **George R. Ricks**, musicologist; **Conrad Kent Rivers**, poet; **Joseph R. Simpson**, scientist; **Ronald C. Dunham**, printer; **Bennett J. Johnson**, social worker; and **Hoyt W. Fuller**, editor.

Workshops in writing and art were established immediately, as was a Community Workshop, designed to involve people with interests other than the specific arts. The Community Workshop meetings came to be known as "Rapping Black" sessions and, in them, communicants were exposed to the ideas and arguments of proponents of Black Consciousness. **Ron Karenga**, of the Los Angeles organization US, made several "Rapping Black" appearances for example.

The Artists Workshop proceeded to create "The Wall," that now famous mural on the side of the building at 43rd and Langley. That "The Wall" (Later termed "The Wall of Respect") more than served its purpose was evident in the community's emotional response to it. In an area in which vandalism is rife, "The Wall" has remained unviolated in its highly-publicized year of existence. The people understood from the beginning that the mural belonged to them: it brought them a representation of their own heroes and heroines, the black artists and statesmen with whom they, ordinary black people, could identify. They have revered and protected it, guarding it even against over-exploitation by the commercial invaders from the White Establishment.

"The Wall" became a symbol and a meeting place during the late summer and early autumn of 1967, and The Man nervously moved in, stationing his spies in the crowds and on the rooftops, taping the words of black people who came to rap and recording the faces of those who dared to tell the truth about racist America. Things got complicated. The story went around that The Man intended to discredit "The Wall" by instigating a riot there. OBAC played it cool. When a "raid" was pulled on a pad next door to "The Wall," there was no way the people downtown could implicate the artists.

Meanwhile, the Writers Workshop sought to clarify and promote the idea of "the Black Aesthetic," urging young writers to reject the assumptions of the Literary Establishment and to consciously strive to invest their works with the same free, soulful qualities which the great jazz innovators had brought to music.

Throughout the winter that followed, and into the spring of 1968, the writers argued and debated and worked, reading and analyzing their works, learning to break away from the "mainstream" thinking which is a natural consequence of their education. By summer, the Writers Workshop was involved in plans for the publication of two anthologies featuring the works of the writers.

The Writers Workshop also involved its members in the community. In order to reach the people, the writers went to taverns where adults congregated and to community centers where young people assembled. Poetry, they found, is welcome entertainment if it speaks to the people.

By summer 1968, however, the normal shifts of time and career had decimated the ranks of the original OBAC Executive Council. Gerald McWorter had joined the faculty at Fisk University; Joseph R. Simpson was at Yale University; Jeff Donaldson was seeking an advanced degree at Northwestern University; Bennett J. Johnson was working in Milwaukee; and George R. Ricks and Donald J. Smith had withdrawn into Academe. In March, Conrad Kent Rivers had died tragically. People of comparable energy and enthusiasm had not yet stepped forward to replace the departed, and most of the projects which OBAC had set out to bring to fruition within the community remained unrealized.

Of the originals workshops established within OBAC, only the Writers Workshop still functioned with the vigor and determination which had characterized it at the beginning. However, there was renewed interest in the other Workshops; and the Drama Workshop, which had never gotten underway, had new adherents. The great hope that had inspired and animated OBAC was not yet dead.

Towards a Black Aesthetic

Hoyt W. Fuller

from *The Black Aesthetic*, 1971

The black revolt is as palpable in letters as it is in the streets, and if it has not yet made its impact upon the Literary Establishment, then the nature of the revolt itself is the reason. For the break between the revolutionary black writers and the "literary mainstream" is, perhaps of necessity, cleaner and more decisive than the noisier and more dramatic break between the black militants and traditional political and institutional structures. Just as black intellectuals have rejected the NAACP, on the one hand, and the two major political parties, on the other, and gone off in search of new and more effective means and methods of seizing power, so revolutionary black writers have turned their backs on the old "certainties" and struck out in new, if uncharted, directions. They have begun the journey toward a black aesthetic.

The road to that place—if it exists at all—cannot, by definition, lead through the literary mainstreams. Which is to say that few critics will look upon the new movement with sympathy, even if a number of publishers might be daring enough to publish the works which its adherents produce. The movement will be reviled as "racism-in-reverse," and its writers labeled "racists," opprobrious terms which are flung lightly at black people now that the piper is being paid for all the long years of rejection and abuse which black people have experienced at the hands of white people—with few voices raised in objection.

Is this too harsh and sweeping a generalization? White people might think so; black people will not; which is a way of stating the problem and prospect before us. Black people are being called "violent" these days, as if violence is a new invention out of the ghetto. But violence against the black minority is in-built in the established American society. There is no need for the white majority to take to the streets to clobber the blacks, although there certainly is *enough* of that; brutalization is inherent in all the customs and practices which bestow privileges on the whites and relegate the blacks to the status of pariahs.

These are old and well-worn truths which hardly need repeating. What is new is the reaction to them. Rapidly now, black people are turning onto that uncertain road, and they are doing so with the approval of all kinds of fellow-travellers who ordinarily are considered "safe" for the other side. In the fall 1967

issue of the *Journal of the National Medical Association* (all-black), for example, Dr. Charles A. De Leon of Cleveland, Ohio, explained why the new turn is necessary: "If young Negroes are to avoid the unnecessary burden of self-hatred (via identification with the aggressor) they will have to develop a keen faculty for identifying, fractionating out, and rejecting the absurdities of the conscious as well as the unconscious white racism in American society from what is worthwhile in it."

Conscious and unconscious white racism is everywhere, infecting all the vital areas of national life. But the revolutionary black writer, like the new breed of militant activist, has decided that white racism will no longer exercise its insidious control over his work. If the tag of "racist" is one the white critic will hang on him in dismissing him, then he is more than willing to bear that. He is not going to separate literature from life.

But just how widespread is white racism—conscious and unconscious—in the realm of letters? In a review of Gwendolyn Brooks's *Selected Poems* in the old *New York Herald Tribune Book Week* back in October 1963, poet Louis Simpson began by writing that the Chicago poet's book of poems "contains some lively pictures of Negro life," an ambiguous enough opener which did not necessarily suggest a literary putdown. But Mr. Simpson's next sentence dispelled all ambiguity. "I am not sure it is possible for a Negro to write well without making us aware he is a Negro," he wrote. "On the other hand, if being a Negro is the only subject, the writing is not important."

All the history of American race relations is contained in that appraisal, despite its disingenuousness. It is civilized, urbane, gentle and elegant; and it is arrogant, condescending, presumptuous and racist. To most white readers, no doubt, Mr. Simpson's words, if not his assessment, seemed eminently sensible; but it is all but impossible to imagine a black reader not reacting to the words with unalloyed fury.

Both black and white readers are likely to go to the core of Mr. Simpson's statement, which is: "if being a Negro is the only subject, the writing is not important." The white reader will, in all probability, find that clear and acceptable enough; indeed, he is used to hearing it. "Certainly," the argument might proceed, "to be important, writing must have *universal values, universal implications*; it cannot deal exclusively with Negro problems." The plain but unstated assumption being, of course, that there are no "universal values" and no "universal implications" in Negro life.

Mr. Simpson is a greatly respected American poet, a winner of the Pulitzer Prize for poetry, as is Miss Brooks, and it will be considered the depth of irresponsibility to accuse him of the viciousness of racism. He is probably the gentlest and most compassionate of men. Miss Brooks, who met Mr. Simpson

at the University of California not many months after the review was published, reported that the gentleman was most kind and courteous to her. There is no reason to doubt it. The essential point here is not the presence of overt hostility; it is the absence of clarity of vision. The glass through which black life is viewed by white Americans is, inescapably (it is a matter of extent), befogged by the hot breath of history. True "objectivity" where race is concerned is a rare as a necklace of Hope diamonds.

In October 1967, a young man named Jonathan Kozol published a book called *Death at an Early Age*, which is an account of his experiences as a teacher in a predominantly Negro elementary school in Boston. Mr. Kozol broke with convention in his approach to teaching and incurred the displeasure of a great many people, including the vigilant policeman father of one of his few white pupils. The issue around which the young teacher's opponents seemed to rally was his use of a Langston Hughes poem in his classroom. Now the late Langston Hughes was a favorite target of some of the more aggressive right-wing pressure groups during his lifetime, but it remained for an official of the Boston School Committee to come to the heart of the argument against the poet. Explaining the opposition to the poem used by Mr. Kozol, the school official said that "no poem by any Negro author can be considered permissible if it involves suffering."

There is a direct connecting line between the school official's rejection of Negro poetry which deals with suffering and Mr. Simpson's facile dismissal of writing about Negroes "only." Negro life, which is characterized by suffering imposed by the maintenance of white privilege in America, must be denied validity and banished beyond the pale. The facts of Negro life accuse white people. In order to look at Negro life unflinchingly, the white viewer either must relegate it to the realm of the subhuman, thereby justifying an attitude of indifference, or else the white viewer must confront the imputation of guilt against him. And no man who considers himself humane wishes to admit complicity in crimes against the human spirit.

There is a myth abroad in American literary criticism that Negro writing has been favored by a "double standard" which judges it less stringently. The opposite is true. No one will seriously dispute that, on occasions, critics have been generous to Negro writers, for a variety of reasons; but there is no evidence that generosity has been the rule. Indeed, why should it be assumed that literary critics are more sympathetic to blacks than are other white people? During any year, hundreds of mediocre volumes of prose and poetry by white writers are published, little noted, and forgotten. At the same time, the few creative works by black writers are seized and dissected and, if not deemed of the "highest" literary quality, condemned as still more examples of the failure of black writers to scale the rare heights of literature. And the condemnation is especially

strong for those black works which have not screened their themes of suffering, redemption and triumph behind frail façades of obscurity and conscious "universality."

Central to the problem of the irreconcilable conflict between the black writer and the white critic is the failure of recognition of a fundamental and obvious truth of American life—that the two races are residents of two separate and naturally antagonistic worlds. No manner of well-meaning rhetoric about "one country" and "one people," and even about the two races' long joint-occupancy of this troubled land, can obliterate the high, thick dividing walls which hate and history have erected—and maintain—between them. The breaking down of these barriers might be a goal, worthy or unworthy (depending on viewpoint), but the reality remains. The world of the black outsider, however much it approximates and parallels and imitates the world of the white insider, by its very nature is inheritor and generator of values and viewpoints which threaten the insiders. The outsiders' world, feeding on its own sources, fecundates and vibrates, stamping its progeny with its very special ethos, its insuperably logical bias.

The black writer, like the black artist generally, has wasted much time and talent denying a propensity every rule of human dignity demands that he possess, seeking an identity that can only do violence to his sense of self. Black Americans are, for all practical purposes, colonized in their native land, and it can be argued that those who would submit to subjection without struggle deserve to be enslaved. It is one thing to accept the guiding principles on which the American republic ostensibly was founded; it is quite another thing to accept the prevailing practices which violate those principles.

The rebellion in the streets is the black ghetto's response to the vast distance between the nation's principles and its practices. But that rebellion has roots which are deeper than most white people know; it is many-veined, and its blood has been sent pulsating to the very heart of black life. Across this country, young black men and women have been infected with a fever of affirmation. They are saying, "We are black and beautiful," and the ghetto is reacting with a liberating shock of realization which transcends mere chauvinism. They are rediscovering their heritage and their history, seeing it with newly focused eyes, struck with the wonder of that strength which has enabled them to endure and, in spirit, to defeat the power of prolonged and calculated oppression. After centuries of being told, in a million different ways, that they were not beautiful, and that whiteness of skin, straightness of hair, and aquilineness of features constituted the only measures of beauty, black people have revolted. The trend has not yet reached the point of avalanche, but the future can clearly be seen in the growing number of black people who are snapping off the shackles of imitation and are wearing their skin, their hair, and their features "natural" and with pride. In a poem called "Nittygritty," which is dedicated to poet LeRoi Jones, Joseph Bevans Bush put the new credo this way:

. . . We all gonna come from behind those
Wigs and start to stop using those
Standards of beauty which can never
Be a frame for our reference; wash
That excess grease out of our hair,
Come out of that bleach bag and get
Into something meaningful to us as
Nonwhite people—Black people . . .

If the poem lacks the resonances of William Shakespeare, that is intentional. The "great bard of Avon" has only limited relevance to the revolutionary spirit raging in the ghetto. Which is not to say that the black revolutionaries reject the "universal" statements inherent in Shakespeare's works; what they do reject, however, is the literary assumption that the style and language and the concerns of Shakespeare establish the appropriate limits and "frame of reference" for black poetry and people. This is above and beyond the doctrine of revolution to which so many of the brighter black intellectuals are committed, that philosophy articulated by the late Frantz Fanon which holds that, in the time of revolutionary struggle, the traditional Western liberal ideals are not merely irrelevant but must be assiduously opposed. The young writers of the black ghetto have set out in search of a black aesthetic, a system of isolating and evaluating the artistic works of black people which reflect the special character and imperatives of black experience.

That was the meaning and intent of poet-playwright LeRoi Jones' aborted Black Arts Theater in Harlem in 1965, and it is the generative idea behind such later groups and institutions as Spirit House in Newark, the Black House in San Francisco, the New School of Afro-American Thought in Washington, D.C., the Institute for Black Studies in Los Angeles, Forum '66 in Detroit, and the Organization of Black American Culture in Chicago. It is a serious quest, and the black writers themselves are well aware of the possibility that what they seek is, after all, beyond codifying. They are fully aware of the dual nature of their heritage, and of the subtleties and complexities; but they are even more aware of the terrible reality of their outsideness, of their political and economic powerlessness, and of the desperate racial need for unity. And they have been convinced, over and over again, by the irrefutable facts of history and by the cold intransigence of the privileged white majority that the road to solidarity and strength leads inevitably through reclamation and indoctrination of black art and culture.

In Chicago, the Organization of Black American Culture has moved boldly toward a definition of a black aesthetic. In the writers' workshop sponsored by the group, the writers are deliberately striving to invest their work with the distinctive styles and rhythms and colors of the ghetto, with those peculiar quali-

186

ties which, for example, characterize the music of a John Coltrane or a Charlie Parker or a Ray Charles. Aiming toward the publication of an anthology which will manifest this aesthetic, they have established criteria by which they measure their own work and eliminate from consideration those poems, short stories, plays, essays and sketches which do not adequately reflect the black experience. What the sponsors of the workshop most hope for in this delicate and dangerous experiment is the emergence of new black critics who will be able to articulate and expound the new aesthetic and eventually set in motion the long overdue assault against the restrictive assumptions of the white critics.

It is not that the writers of OBAC have nothing to start with. That there exists already a mystique of blackness even some white critics will agree. In the November 1967 issue of *Esquire* magazine, for instance, George Frazier, a white writer who is not in the least sympathetic with the likes of LeRoi Jones, nevertheless did a commendable job of identifying elements of the black mystique. Discussing "the Negro's immense style, a style so seductive that it's little wonder that black men are, as Shakespeare put it in *The Two Gentlemen of Verona*, 'pearls in beauteous ladies' eyes,'" Mr. Frazier singled out the following examples:

"The formal daytime attire (black sack coats and striped trousers) the Modern Jazz Quartet wore when appearing in concert; the lazy amble with which Jimmy Brown used to return to the huddle; the delight the late 'Big Daddy' Lipscomb took in making sideline tackles in full view of the crowd and the way, after crushing a ball carrier to the ground, he would chivalrously assist him to his feet; the constant cool of 'Satchel' Paige; the chic of Bobby Short; the incomparable grace of John Bubbles—things like that are style and they have nothing whatsoever to do with ability (although the ability, God wot, is there, too). It is not that there are no white men with style, for there is Fred Astaire, for one, and Cary Grant, for another, but that there are so very, very few of them. Even in the dock, the black man has an air about him—Adam Clayton Powell, so blithe, so self-possessed, so casual, as contrasted with Tom Dodd, sanctimonious, whining, an absolute disgrace. What it is that made Miles Davis and Cassius Clay [Muhammad Ali], Sugar Ray Robinson and Archie Moore and Ralph Ellison and Sammy Davis, Jr. seem so special was their style. . . .

"And then, of course, there is our speech.

"For what nuances, what plays of light and shade, what little sharpnesses our speech has are almost all of them, out of the black world—the talk of Negro musicians and whores and hoodlums and whatnot. 'Cool' and all the other words in common currency came out of the mouths of Negroes.

"'We love you madly,' said Duke Ellington, and the phrase is almost a cliché. But it is a quality of the Negro's style—that he is forever creative, forever more stylish. There was a night when, as I stood with Duke Ellington outside the

Hickory House, I looked up at the sky and said, 'I hope it's a good day tomorrow. I want to wake up early.'

"'Any day I wake up,' said Ellington, 'is a good day.'

"And that was style."

Well, yes. . . .

Black critics have the responsibility of approaching the works of black writers assuming these qualities to be present, and with the knowledge that white readers—and white critics—cannot be expected to recognize and to empathize with the subtleties and significance of black style and technique. They have the responsibility of rebutting the white critics and putting things in the proper perspective. Within the past few years, for example, Chicago's white critics have given the backs of their hands to worthy works by black playwrights, part of their criticism directly attributable to their ignorance of the intricacies of black style and black life. Oscar Brown, Jr.'s rockingly soulful *Kicks and Company* was panned for many of the wrong reasons; and Douglas Turner Ward's two plays, *Day of Absence* and *Happy Ending*, were tolerated as labored and a bit tasteless. Both Brown and Ward had dealt satirically with race relations, and there were not many black people in the audiences who found themselves in agreement with the critics. It is the way things are—but not the way things will continue to be if the OBAC writers and those similarly concerned elsewhere in America have anything to say about it.

IV. THE IMPACT

OF PHOTOGRAPHY

Black Photographers Who Take Black Pictures

Romi Crawford

Photography is just as vital as painting to the Wall of Respect. Photography is not just the primary way that we can experience the Wall after its 1971 demise, but was also a strategic formal component from the Wall of Respect's inception.

The Wall was demolished almost fifty years before the writing of this book, but it is extant in a sense, activated in scholarship and discussion through photographs. Like the written documents pulled together in this volume, photographs offer a critical historical trace of the Wall of Respect. The photo documents of the Wall of Respect have done the valuable work of helping to maintain its ongoing significance and viability within the contexts of American art and culture. Yet this short-sighted take on the form doesn't take into account its full consequence and value. Photography has a more robust and complex tie to the Wall of Respect than has been heretofore noted. It (1) offers a record of the Wall as an entity and artwork; (2) uniquely captures the esprit and vitality of the environment, the scene that circled the Wall of Respect, including its creators, community, and participants; and (3) is embedded into the Wall of Respect's endo- and exo-design. I use the term "endo-design" to denote the skeleton or foundation of the Wall, to speak to the way that photography was plotted directly onto the surface of the Wall and how it functions in the original schema. I use "exo-design" to refer to the Wall's external boundary, to address how photography helps contain and convey other art forms and expressions, including performance, music, protest work, and sociality that are external to the Wall itself, but are part of its territorial bounds and logistics nonetheless. The stakes, then, of photography are multivalent.

The aim of this chapter is to more fully explore the import of photography to the Wall of Respect and to incorporate camera works into its history. To this end, it activates the archives of four Black photographers based in Chicago who in 1967 worked on or in the vicinity of the Wall of Respect. It includes images by Darryl Cowherd, Roy Lewis, and Robert Sengstacke, three of the four Black photographers who had works on the Wall of Respect, as well as by Bob Crawford, a member of this informal fraternity, who worked at the Wall site.[1] Works from their respective archives are mobilized at the end of the section and convene in a gallery, "Camera Works and the Wall of Respect," that sheds new light on the work of the Black photographers, including their efforts to produce a camera-based art around the project of the Wall of Respect.

The primacy of photographs, as well as paint, to the Wall of Respect is evident from the way photographers and painters are paired to realize the various "Black Heroes" sections of the Wall (see pages 166–69). Photographer Billy Abernathy is paired with artists Elliott Hunter and Jeff Donaldson for the "Jazz" section. Photographer Roy Lewis is paired with artist Barbara Jones-Hogu for the "Theater" section and with artist Norman Parish for the "Statesmen" section. Photographer Robert Sengstacke is teamed with artist William Walker for the "Religion" portion, and photographer Darryl Cowherd is paired with artist Edward Christmas for the "Literature" panel. These photographers and their photo works were considered an integral part of the Wall of Respect.

Don L. Lee, in his 1967 dedication poem, "The Wall," makes note of the "black photographers / who take black pictures." The title of this section is borrowed directly from the 1967 Don L. Lee poem. His words draw out the significance of this cohort to the Wall experience, speaking to their active involvement in the Wall scene, where they were a regular and noteworthy presence. Lee's poem posits an image of the Black photographer (with camera in hand or around the neck, active in the work of taking pictures), just as the photographers literally imaged Lee and other poets who read their poems at the dedication, including Val Gray Ward and Amus Mor (David Moore).[2] This allusion to the Black photographers, as well as the reference to them in the OBAC planning notes, makes it clear that photography was considered a vital form to OBAC and to others involved in realizing the Wall of Respect.

Sylvia Abernathy, who is credited with designing the layout of the Wall of Respect, proposed filling the Wall's surface with a wide swath of images depicting Black heroes in the areas of sports, music, politics, literature, religion, and theater. This included figures such as Billie Holiday, Dinah Washington, James Brown, Ray Charles, John Coltrane, Eric Dolphy, Sarah Vaughan, Miles Davis, Charlie Parker, Sonny Rollins, Thelonious Monk, Marcus Garvey, Adam Clayton Powell, Malcolm X, Jim Brown, Muhammad Ali, Lew Alcindor, Bill Russell, Nat Turner, Elijah Muhammad, W. E. B. Du Bois, Lerone Bennett,

Dick Gregory, James Baldwin, Gwendolyn Brooks, LeRoi Jones, Oscar Brown Jr., Darlene Blackburn, Nina Simone, and Sidney Poitier. Abernathy was well disposed to the capacity of photography to uniquely reflect the affirmations of Black beauty that were called out as core values of OBAC and the Black Power Movement more generally. She was married to Billy Abernathy, a noted force among the Black photographers, who would later publish *In Our Terribleness* with Amiri Baraka, a book that Sylvia designed.[3] She was also a very close friend of the other Black photographers who ended up working at the Wall of Respect.[4]

What is clear is that Sylvia Abernathy's schema allowed photographs to enter the space of the Wall's endo-design—its foundational scheme—and that she involved photographers whom she knew well at the ground level, not after the fact. The photographers assigned to or matched with the various sections of the Wall (reflected in the "Heroes and Heroines" section of this book) affixed their photos of more contemporary heroes to the Wall's surface.

Sylvia Abernathy and Bill Walker (in painter's cap) at the Wall of Respect. Copyright © Robert A. Sengstacke, 1967.

Darryl Cowherd's photograph of LeRoi Jones, for example, was attached to the Wall in the "Literature" section. Similarly, Roy Lewis included both a photograph of Darlene Blackburn in the "Theater" portion of the Wall and one of the renaming of Washington Park as Malcolm X Shabazz Park in the "Statesmen" section. Robert Sengstacke contributed scenes of Black religiosity, a young Muslim woman praying and a scene from the church down the street from the Wall in "Religion"; and Billy Abernathy added a photo of Sarah Vaughan to the "Jazz" portion of the Wall as well as an image of Stevie Wonder to "Rhythm and Blues." Interestingly, the photographic elements of the Wall of Respect were not very bumped up in size and only minimally treated to meet the environmental challenges of an outside mural.[5] The effect of a black-and-white photograph, 29 × 29 inches in scale, in close proximity to a large, colorful mural painting produced a somewhat jarring, but successfully inventive, effect.

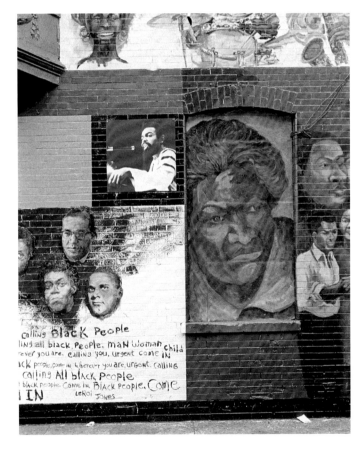

Portion of completed Wall of Respect showing images by Ed Christmas (*lower left*), Darryl Cowherd photo of LeRoi Jones (Amiri Baraka), and images by Barbara J. Jones (*right*). Copyright © Darryl Cowherd, 1967.

Roy Lewis's "Darlene Blackburn Dance Sculpture" was placed on the Wall of Respect. Copyright © Roy Lewis, 1967.

The element of photography at the Wall of Respect was not just innovative mural making. It was also advanced within the context of photographic art form. The Wall photographs emphasized their object-ness, a conceit that strayed from the historical import of photo form, which hinges upon the reproducibility of an image. The unframed photographs had a solid backing and a tactile, structural, more three-dimensional, quality. As such they stood out as, and were treated as, objects or works not unlike the paintings. Darryl Cowherd's image of LeRoi Jones (Amiri Baraka) attests to this. It is the only existing fragment of the original Wall of Respect.[6] It is significant that photography is the form through which current audiences can witness the Wall of Respect. It is even more profound that the only physical trace of the Wall is a photo-based object or camera work since the photographers at the Wall of Respect were concerned, among other things, with the robust materiality of photographs.

In fact, the Wall of Respect experience triggered the photographers' interest in experimenting with city walls as public display spaces for their photo works, and several of them continued to experiment with placing photographs on the surface of city walls in later projects. Lewis shared $3,000 in grant monies with Crawford, Sengstacke, and Abernathy to produce photo-based murals in various locales in Chicago. In addition to the West Wall in Lawndale, Crawford made a project at Pershing and Giles, and Sengstacke worked near Sixty-Eighth Street, west of Halsted Street.[7]

Darryl Cowherd installing LeRoi Jones (Amiri Baraka) photograph. Copyright © Robert A. Sengstacke, 1967.

Original LeRoi Jones (Amiri Baraka) photo object by Darryl Cowherd. Copyright © James Prinz.

Darryl Cowherd at his home in 2016 with the original LeRoi Jones (Amiri Baraka) photo object removed from the Wall of Respect circa 1970. Copyright © John O'Hagan.

While the Wall of Respect's progressive social content was cutting-edge and would go on to influence mural making locally, nationally, and internationally, including the Chicano mural movement in Chicago and the propagation of mural art in Philadelphia, the ensconced photographs on the Wall of Respect were an equally innovative aspect. The act of placing photographs on the Wall moved it beyond traditional mural practice. The photographs worked against a rectified surface, with clear formal and spatial limits or bounds. They also worked against a fully consummated or finished mural. Instead, they produced an unusual, less conclusive surface quality, signaling the Wall of Respect as a more open-form, receptive, and flexible mural space than was customary. While the Mexican mural movement of the 1920s through the '60s had established a precedent of forceful social and political messages and extraordinary painting as important aspects of mural art form, the photograph layer at the Wall of Respect also introduced an important innovation, the idea of formal receptivity. It implicated the Wall of Respect as a site where art forms might play off of and intervene with other art forms.

The Wall was in fact an intentional place for multiple art forms to converge. The photographs on the Wall of Respect gestured toward an interdisciplinarity that was eventually realized through the various activities and performances that took place in close proximity to it. One could say that the Wall of Respect was a

Umoja Student Center wall with photos on the building surface. Copyright © Bob Crawford, 1968.

scene or placeholder. The poet Gwendolyn Brooks read her poem "The Wall" there, as did several other Black Arts Movement poets, such as Amus Mor and Alicia Johnson. Musical artists, including AACM members Roscoe Mitchell and Lester Bowie, performed at the Wall, and visual artists, activists, and scholars were regularly in residence on Forty-Third and Langley.

At its core the Wall of Respect addressed ideas that resonate to this day within the realm of visual arts. Even before the language of "place making" to describe how social commitment might evolve from embedding art in all, even the most disenfranchised, communities, the Wall of Respect experimented with this idea. Similarly, it offered a "residency" of sorts, where Black artists might dialogue and engage with, as well as learn from, makers and thinkers across a diverse range of disciplines. This was at a time when formal opportunities for Black artists to critique with other makers were scarce. Cowherd and Lewis both attest to the significant impact that working at the Wall had on their craft. It served a vital role in pulling together not only an artist community but also a learning community of Black photographers.

Poet Amus Mor (David Moore). Copyright © Bob Crawford, 1967.

OBAC founders Gerald McWorter, Hoyt Fuller, and Conrad Kent Rivers seem to have been committed to creativity in various fields, and the May 1967 Inaugural Program mentions workshops in music, art, dance, drama, oratory, and literature (see page 123). In addition, the inaugural program included myriad forms: a dance by Sherry Scott, music by the Delections and the Fred Humphrey Quartet, an address to art by Jeff Donaldson, and spoken word by the Magnificent Seven + One and Amus Mor. The Wall of Respect from its start anchored various art forms. Perhaps, then, one way to interpret the Wall of Respect is through the formal strategy that the photographs signify— that of layering. Layering was endemic to the Wall's design and present as an idea at most phases of its existence. In addition to the photograph layer I discussed above, in the Wall's vestigial stages Sylvia Abernathy plotted a busy and replete schematic that would force some paintings to be close to and abutting others, sometimes partially covering up, or lying over, other paintings. There were also layers of text and newspaper or magazine clippings affixed to the Wall of Truth— the later, related mural painted across the street. Even the reality that there were *walls* (plural) to describe the edits and wipeouts of content (such as the removal

of Elijah Muhammad in the "Religion" section and the covering up of Norman Parish's "Statesmen" section), and that the spirit of the Wall expanded to the Wall of Truth across the street, aligns with the idea of layering. Ultimately, introducing photographs into the physical space of the Wall of Respect interrupts any expectations for its visual, formal, or spatial resolution.

In addition to their direct contributions to the Wall of Respect, the Black photographers who were active at the Wall also help to register the mural's exodesign, or outer plane—its reach into a territory beyond the surface of the wall itself. The works from the photographers' archives reveal this other pertinent layer, that of audience participants at the Wall. In addition to the active presence of noted Black poets and musicians whose performances and showcasing heightened the sense of multidisciplinarity at the Wall, the surrounding community participated and held social activities there, establishing another strata of formation (if not form) at the site. The photographs reveal a layer of people who didn't win the Pulitzer Prize or innovate in music, but who helped to hold down the Wall: people protecting the paint and materials, people on the lookout for cops, people looking at the work, people being with each other. Several of the Wall photographers are adamant in interviews about the central role of the community. Despite the important function that artists such as Bill Walker, Jeff Donaldson, Wadsworth Jarrell, and others played, they intone that the "community, they were the producers."[8]

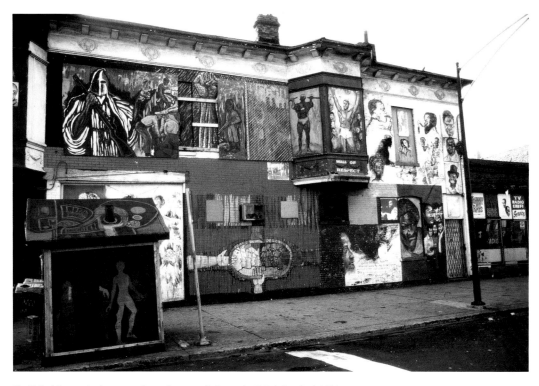

The Wall of Respect (with various edits to the original). Copyright © Bob Crawford, 1969.

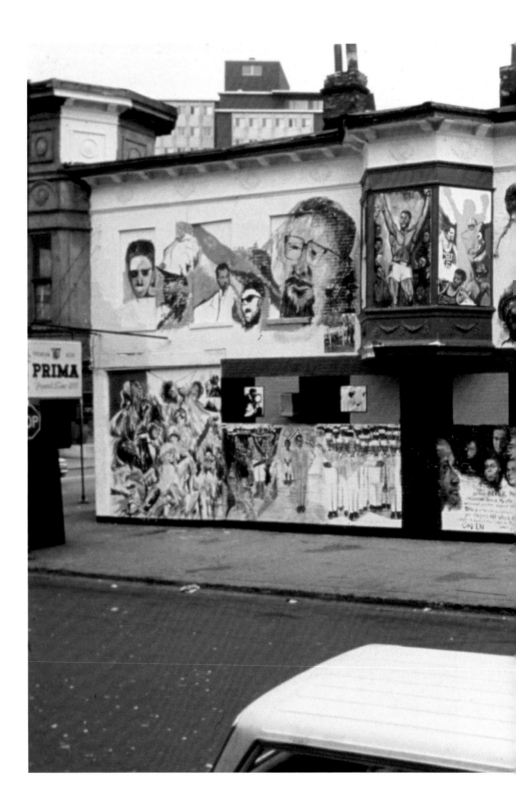

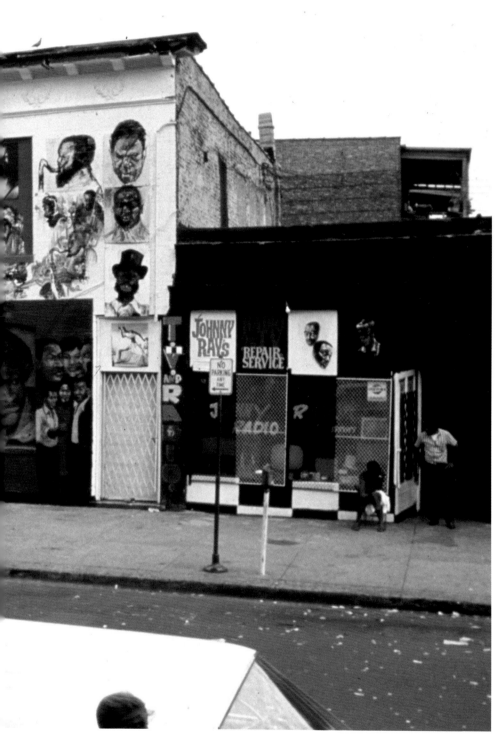

The Wall of Respect. Copyright © Robert A. Sengstacke, 1967.

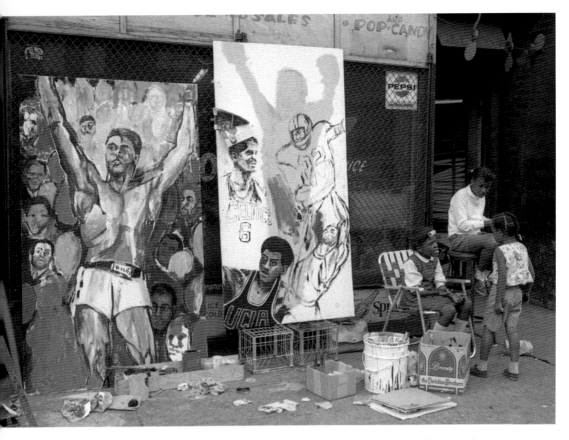

Muhammad Ali painting from the Wall of Respect and neighborhood children guarding art supplies.
Copyright © Bob Crawford, 1967.

OBAC, it seems, was conscious of this tier of social engagement. In "What Is a Black Hero?" (see page 165) they have the foresight to thank the neighborhood:

> We in OBAC wish to thank all of the beautiful Black people of this neighborhood for their protection of the Wall and our equipment, for their generous aid in moving the scaffolding, and their sincere criticism and general appreciation of the project.

Part of the Wall of Respect's success is due to the extent to which people in the neighborhood—the "beautiful Black people" who congregated around, touched, and leaned on it—were involved.

All of the aforementioned layers, which constitute important elements of the Wall's aesthetic formation, are instigated and signaled by the dynamic introduction of photography. The photographs initiate a layer of media in addition to paint, which signals the possibility of even more media at, on, or around the Wall of Respect.

Black Eyes

Because photography was so vital to the Wall of Respect, it's important to consider the effect of the Wall of Respect project on the Black photographers who are associated with it. The Black photographers who worked at the Wall were, like other factions of the Black Power Movement of the 1960s, insistent on an overt Black aesthetic that permeated all levels of what was called, in the eulogy statement for photographer Bob Crawford written by his wife Margo, their "Black life." Black life in this sense was a life fully immersed in the pursuit of leveling the historic oppression of Black people in America. It meant renaming themselves (Billy and Sylvia Abernathy adopted the names Fundi and Laini after working on the Wall), learning African languages, studying Black history, and adapting strategies (both religious and secular) to survive and overcome the pitfalls of American life in the 1960s and '70s. At the time, all of the photographers took part in these modes of affirming Black identity and culture. In addition, living a Black life meant making a contribution to the many fields (such as science, law, education, medicine, history, business, and art) that had left Black people out of the proverbial picture, including photography.[9]

The Wall of Respect helped to organize and concretize the Black life agenda for several of the photographers as well as other Wall of Respect participants. It was decisive in shaping not just their occupational lives, but also their familial, social, and political lives.

"Artist Family, A Very Strange Group" (*clockwise, from left*: Bob Crawford, Billy Abernathy, Phil Salter, Robert Paige, Sylvia Abernathy, unidentified woman holding baby), circa 1975. Copyright © Roy Lewis.

It is evident from interviews with them, and from the images they procured at the site, that the Wall of Respect helped collapse hard distinctions between the familial, social, and political—it offered a context in which all of these concerns were connected. In an interview with Darryl Cowherd, he declared, "we were race people."[10] He connects the Wall artists to the legacy of Black thinkers and makers, including W. E. B. Du Bois (one of the Wall heroes), who understood a productive life to be one that tackled rather than ignored the looming "problem" of the Black American subject, which "yields him no true self-consciousness, but only lets him see himself through the revelation of the other world."[11] Ostensibly Black life, as the photographers lived and practiced it, was enthralling, to be worked on and at, not against. A studious rigor went into how they absorbed the epistemological cues that came from both insurgent and more peaceable Black historical figures (from Nat Turner to Joe Louis to Martin Luther King Jr.) into their lives. Deb Willis, in the catalog for an exhibit at Kenkeleba House in New York that featured several of the Black photographers associated with the Wall of Respect, including Bill Abernathy, Bob Crawford, Robert Sengstacke, and Onikwa Bill Wallace, notes that they "were teachers, and these photographers were dedicated to the Civil Rights Movement, community development, documentary photography, and portraying the heightened African consciousness of the period."[12]

As such, they were mindful to impart these ideas to their families. Just as the Abernathys were both participants at the Wall scene, the wives and children of the other photographers were also brought into its ideological matrix. Lewis, for example, recalls the significance of having his partner Shoshonah and children at the dedication, and Crawford's wife and children occasionally joined him at the Wall. Notably, a good number of "Wall babies," the children of Wall of Respect artists, are in adulthood engaged in professions that relate to Black culture, the arts, and racial equity. This proves the efficacy of the immersive Black life in a multigenerational sense. For the Wall photographers, their practice of making Black photographs was tied up in this broader aim of living a Black life.

Given the connectivity of these goals, it is worth exploring how the ethos of OBAC and liberation are reflected through the camera works of the Black photographers. Similar to others across the country who pursued immersive Black lives, the photographers based in Chicago were attempting to be "Black heroes" according to the terms that OBAC sketched in their "Black Heroes" handout (page 166):

> OBAC declares that a Black hero is a Black person who:
> 1. honestly reflects the beauty of Black life and genius in his or her style
> 2. does not forget his Black brothers and sisters who are less fortunate
> 3. does what he does in such an outstanding manner that he or she cannot be imitated or replaced.

In a sense the photographers were doubly engrossed in these efforts. Even as their task was to help define and locate images of Black heroes among the everyday people who gathered around the Wall of Respect, they were attempting to reflect the tenets above in their own professional lives. In an interview, Roy Lewis described the gallant presence of the camera workers, each with their own sartorial manner. While this might be perceived as an aside, or throwaway comment, the first and third bullet points of the OBAC declarations help to contextualize why such a thing matters or need be mentioned. The first point reinforces the concern for style, and the third expands on this by logging how being "outstanding" or standing out had value.

The musicians and athletes, such as John Coltrane and Muhammad Ali, depicted on the Wall, as well as the other heroes, were all gifted at innovating and improvising to the point of being unique and irreplaceable. This helps to explain the Black photographers' selection process—why certain men and women, with flair and élan in their manner of hair, or dress, or general mien—are endorsed in their images. It also turns out that the Black photographers stood out in their own right, not only to Don L. Lee, who mentions them in the poem he wrote for the Wall of Respect's dedication event. Lewis recalls how a noted jazz musician, a member of the AACM, told him once that he enjoyed seeing the photographers from his perch on stage, moving around, not unlike dancers, working together, moving improvisationally through the space to capture the performance. It is poignant that the Wall photographers, who also regularly convened at AACM shows, would be attributed to the working context of their performances, players in the wider aesthetic scene. The Black photographers, there to capture images of the musical innovators, were also seen for their own unique contribution. All of the Wall photographers were jazz enthusiasts, collegial and friendly with the musicians who played at the Wall, such as Lester Bowie and Joe Jarman. Jazz and blues music are in fact the focus of another corpus of their respective archives. The uniquely collaborative and multiform nature of the Wall experience prepared them for working in tandem and with, not just for, makers from other disciplines. It acclimated them to being part of the happening that they covered in their work.

Lewis's anecdote also reinforces the sense of collectivity and fraternity that the Black photographers routinely speak to when describing their working process. Cowherd comes just shy of calling them a club, and cedes that informally they were. Lewis describes them variously as a family or fraternity, and Sengstacke says that they were like brothers. This is not to say that they had seamless, trouble-free relations, but that they were all highly aware of their collectivity as Black photographers who worked at the Wall of Respect.

Amassing the Camera Works

The larger effort of the Wall of Respect photographers, how they overtly deliver on the tenets of OBAC, is seldom queried because the photo works of the Wall are mostly in demand as a record or document of it. They have not been considered for their deeper connection to the Wall experience. What is even more lacking is an interpretation of their photographs that looks at them as both trace documents and artworks. The fact that Sylvia Abernathy planned for photographs to exist on the same plane as painting in her design suggests their merit as equally important art forms.

As a way to critique the overwhelming prevalence, at the time, of documentary photographs of the Civil Rights Movement, which so often captured Black subjects in a passive or physically defeated position—downed by police attack dogs and water hoses—the Black photographers at the Wall of Respect were somewhat skeptical of documentary and did not think of themselves as solely documentarians, but as artists as well.[13] They were heavily influenced by photographers such as Robert Frank, Danny Lyon, and Roy DeCarava, whose works straddle the boundaries of documentary and fine art photography. Additionally, all of them related to the photographic form intellectually and were well aware of a Chicago school of Black photographers that preceded them. This included the work of Ted Williams, who trained Roy Lewis at his studio space in the South Loop, Terrell Mason, and Jim Strickland. The Wall photographers were also highly respectful of Roy DeCarava, whose *The Sweet Flypaper of Life*, published in 1955 and then again in 1967, was a mainstay in several of their book collections. They were moved by the combination of DeCarava's images alongside Langston Hughes's poetic text. Several of the Wall photographers mention a meeting with Roy DeCarava in 1968 to discuss their work at an apartment in the vicinity of Drexel Square as a significant event.[14] Like their work at the Wall of Respect, the DeCarava and Hughes collaboration demonstrated the merits of interdisciplinary art making.[15]

Part of what also made DeCarava, and to a lesser extent the photographer Gordon Parks, so compelling was the concerted interest in the art form as well as the social document. The work of the Wall of Respect photographers reveals a similar ambition. Some of the work, especially that of Sengstacke, who regularly placed images in the *Chicago Defender*, and Lewis, who published photos of the Wall of Respect in the December 1967 issue of *Ebony*, did move out into the world under the banner of social documentation. Yet a close look at their practices reveals an additional interest and commitment. The social piece of their practice was evidenced in their effort to be part of a social context. Documenting the social was not the only, or even the primary, social concern. Their practice makes it apparent that what the "social" in social documentary photography

designates might challenge conventions of the genre. What the Wall of Respect photographers bring to the table is a resolute concern for a practice that is born from a social context, not just a practice that documents the social. What attests to this more than anything is the reality that several of the Wall photographers stopped shooting with the same regularity within ten years of the Wall's demise. Lewis and Sengstacke continued to work for magazines and newspapers as well as in other contexts, but Abernathy's, Crawford's, and Cowherd's efforts tapered as they lost the connection to the Wall and its animating ethos and ideologies. Onikwa Bill Wallace continued to work as a photographer but shifted his focus.

Just as it is important to point out their photo literacy, it is also important to note their interest in the process from start to finish—printing their own photographs was a crucial part of the Black photographers' craft. Original prints from the Wall photographers' archives reveal that in certain instances they opted for darker, rather than lighter, prints. More directly, Black skin was in no way mitigated, but rather accentuated, during the printing process. The printing process was a crucial component of making Black art, however literally, with the use of the camera. Forcing the technologies of the camera arts to work toward the goal of a Black art was part of the Wall photographers' agenda. Billy Abernathy's images in *In Our Terribleness* clearly demonstrate the preference for printing and publishing with an eye toward the possibilities for disregarding nuances of tone. Additionally, one could say that the black-and-white film stock that was their preference also signifies the black and white duality of the times.

On closer examination, the work from their archives shows other ways that they attained a uniquely Black camera art, emanating from their experience at the Wall of Respect. Like the Wall itself, the purpose of their art was to unite Black people by positing "heroic self-images and standards of beauty relevant to the Black experience in America" (see page 166). Images that reflect the oppressed economic state of Black persons, which might seem unflattering or slightly offensive to many, were to the Black photographers beautiful in their pertinence and relevance to the Black experience. In their awareness of the self-hate that bears on the Black experience in America, what Frantz Fanon describes as "a constant effort to run away from his own individuality, to annihilate his own presence," the Wall photographers offered a dose of Black presencing.[16] Cowherd, who also wrote poetry, addresses the matter in a poem he wrote in the 1970s titled "The Black Experience":

> The Black Experience is . . .
> Bird, Trane and Bo Diddley.
> Stylin and profilin'.
> Rats, Roaches and no rent.
> Hatin yourself and lovin' others.[17]

The OBAC tenets that worked against Black self-hate, and Black Liberation creeds in general, gave the Black photographers a problem set of sorts to work on—how to take what Don L. Lee in his poem described as "black pictures" to level the contending forces of negativity.

Notes

1. Billy Abernathy, whose archive is not available, is the fourth photographer who placed images on the Wall. Other photographers who worked near or around the Wall in 1967 include Bill Wallace, Edward Christmas (who also painted a section on the Wall), and Mark Rogovin.

2. In 1968 Val Gray Ward founded Kuumba Theatre.

3. Amiri Baraka (LeRoi Jones) and Fundi (Bill Abernathy), *In Our Terribleness* (New York: Bobbs-Merrill, 1970).

4. The Abernathys and Crawford and his wife lived together in Hyde Park in 1965.

5. Darryl Cowherd mentioned to me in a 2016 interview that his image was coated with a sealant of some sort before he installed it.

6. In an interview with Cowherd from 2016, he mentions taking it down circa 1970. He had a feeling that the Wall of Respect was not being cared for and valued as it had in past years.

7. Roy Lewis and Ed Arnold wrote a proposal for an Illinois Arts Council grant after Lewis received favorable feedback from Gwendolyn Brooks following the launch of his "Black and Beautiful" exhibit at the South Side Community Art Center. The show, which comprised his work from 1965 to 1967, had toured to D.C. at the New School for African American Thought, to Pittsburgh at the Ed Ellis Gallery, and to New York at the Countee Cullen Library before coming to Chicago.

8. Roy Lewis, interview with the author, August 2016.

9. Whereas James Van Der Zee had realized success as a Black photographer in his Harlem community, and there was a rather long tradition of working portrait photographers in most cities with a thriving Black population, such as James Presley Ball in Baltimore, the Wall photographers intended to move beyond studio-based portrait businesses.

10. Darryl Cowherd, interview with the author, August 2016.

11. W. E. B. Du Bois, *Souls of Black Folk*, in *Three Negro Classics* (New York: Avon, 1965), 215.

12. Corinne and Deborah Willis, eds., *Two Schools: New York and Chicago, Contemporary African-American Photography in the 60s and 70s* (New York: Kenkeleba House, 1986).

13. See Martin Berger, *Seeing through Race: A Reinterpretation of Civil Rights Photography* (Berkeley: University of California Press, 2011), 43–55.

14. Roy Lewis, interview with the author, July 2016.

15. Richard Avedon and James Baldwin also collaborated on a book of photography and social commentary, *Nothing Personal* (New York: Dell, 1965).

16. Frantz Fanon, *Black Skin, White Masks* (New York: Grove Press, 1967), 60.

17. Darryl Cowherd, "The Black Experience." Printed poster, 1974.

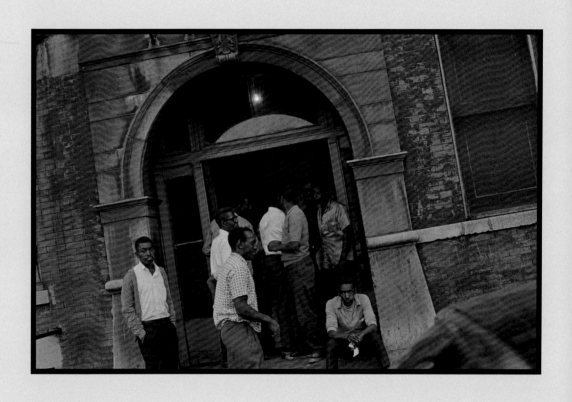

Doorway across the street from the Wall of Respect.
Copyright © Robert A. Sengstacke, 1967.

Camera Works and the Wall of Respect

Romi Crawford

> The eye is the best of artists.
> —Ralph Waldo Emerson, *Nature*

For people, such as the Wall photographers, absorbed in attempts to live an immersive Black life, taking Black pictures with Black eyes was not a long shot, and well worth the attempt. However, steeping their work in Black culture affected the reception of the work, which in its brazen affirmations of Black people and culture made it inaccessible and slightly distasteful to a wider audience. As a consequence, the specific merits of the photographic arts that emerged from the Wall of Respect have not been properly recognized. Similarly, Black photographers affiliated with the Wall have not been considered as a working cohort and have seldom, if ever, been interpreted as such, even though they make reference to the club, group, or fraternity, and their work resonates common visual and thematic cues. To this end, a selection of images by the Black photographers who worked at the Wall of Respect follows (images from Billy Abernathy and Onikwa Bill Wallace were unavailable). This effort to pull their work together reveals several significant tropes that delineate and also expand upon the OBAC precepts.

One of the noteworthy paradigms, for example, is what I refer to as "Looking at the Wall and Looking from the Wall." This category introduces the doorway across the street from the Wall of Respect and signals a concern and interest not just in the community members who lived near the Wall, but also in formal perspective. The doorway offers an ideal perch from which the Wall and its ancillary happenings could be observed. The images also reveal that the Wall itself was a perch from which to best take in the activity of the surrounding community. Such looking from the Wall and toward the Wall indicates an important redress

to what Frantz Fanon, in *Black Skin, White Masks*, refers to as the "crushing objecthood" that comes with the Black experience, of being excessively visible or over seen.

Key architectures, such as stoops, doorways, and windows, that are part of the urban landscape, can be interpreted in these images as helping to shape a communal and collective context in which Black persons might look even as they are being looked at. Looking upon, while being looked at, mitigates the encumbrance of objecthood. As such, these locales can be interpreted as spaces or territories for collective resistance, signaled through what is for Black people the adamant act of looking back, or seeing and interpreting from their own perspective.

Marking out more of these tropes is a crucial next step for understanding the full depth of the Wall photographers' work. More than a document of (or reporting on) the Wall of Respect, their oeuvre points to a carefully cultivated camera art. En masse, the work discloses an unequivocating tether to the principles of OBAC, including the cause to "enhance the spirit and vigor of culture in the Black community." The Wall photographers were deeply committed to this broader cause, which mattered in 1967 and still matters in 2017 if you consider how it is espoused in the work of countless social practice artists, including Theaster Gates in Chicago and Rick Lowe in Houston. Gates's Dorchester Projects and Lowe's Project Row Houses are both location-centric endeavors that seek to feed particular blocks or streets in a Black community by instantiating art within them. While the historical context is different, their efforts follow in the continuum of the Wall of Respect.

Additional paradigms emerge from a comparative analysis of the photographers' archives and are worth noting. With this objective of assessing the work of the Black photographers who made camera works at the Wall, the following gallery suggests a working taxonomy that might help to bring coherence to their archives. It reveals how they worked in tandem, imaging similar aspects of the Wall of Respect experience. The photographs cover the Wall of Respect, their own work and labor as photographers, and how the community was involved in animating it, taking care of it, lending to it in myriad ways which made it one of the most important murals in the world.

Conceiving the Wall of Respect

The Wall of Respect photographers were part of the early planning that went into the Wall's creation. They attended OBAC meetings and helped formulate the tenets of a Black Arts Movement. Many of them were close to Sylvia Abernathy, who designed the layout of the Wall, and she included them in the process from the ground up. The photographs in this section reflect a vibrant concern for the conceptualization and planning processes that went into making the Wall of Respect. Images of Jeff Donaldson and Bill Walker in dialogue with other artists and creators of the Wall corroborate the fact that, contrary to popular belief, it was not an impulsive art project but rather more akin to a conceptual work, animated by a well-honed idea about Black culture, aesthetics, and liberation.

In addition, these photographs are rare portraits of an African American arts collective. They reveal a gender-integrated planning environment and the group dynamic of various artists and thinkers who were unashamedly in pursuit of ideating around the potential of "Black art."

Jeff Donaldson at Wall of Respect meeting.
Copyright © Robert A. Sengstacke, 1967.

Sylvia Abernathy and Myrna Weaver at Wall
of Respect meeting. Copyright © Robert A.
Sengstacke, 1967.

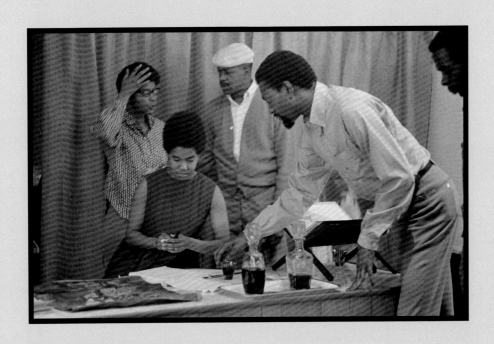

Sylvia Abernathy (*in black*) at Wall of Respect meeting with
Jeff Donaldson (*foreground*) and William Walker (*center
background*). Copyright © Robert A. Sengstacke, 1967.

Poet and OBAC member Alicia Johnson
at a planning meeting. Copyright ©
Darryl Cowherd, 1967.

Jeff Donaldson at Wall of Respect meeting.
Copyright © Robert A. Sengstacke, 1967.

Jeff Donaldson and Onikwa Bill Wallace
at OBAC planning meeting on the Wall.
Copyright © Darryl Cowherd, 1967.

Making the Wall of Respect

Just as the photographers at the Wall of Respect were present during and attentive to the planning stages, they were also at the making and inception of the Wall. They were involved in ways that encompass both immediate and more ancillary participation. As co-artists of the Wall, they (in most cases) actively placed works on it and they were alert to the labors of the various painters.

These works by the Black photographers focus on the Black artist. In 1967 it was as exciting for the Black photographers to capture a Black artist at work as it was to catch an image of a Black musician. Most of their archives disclose bodies of work on blues, jazz, and soul musicians of the time, yet there were scarce opportunities to image the Black visual artist, the province that most pertained to them. These images reveal how the Wall offered the photographers a rare opportunity to procure an image of a Black visual artist in the act of making. The images of Bill Walker, Jeff Donaldson, Edward Christmas, and Barbara Jones-Hogu painting the Wall indicate the photographers' zeal to explore through their camera works a terrain for Black creativity that extended beyond music.

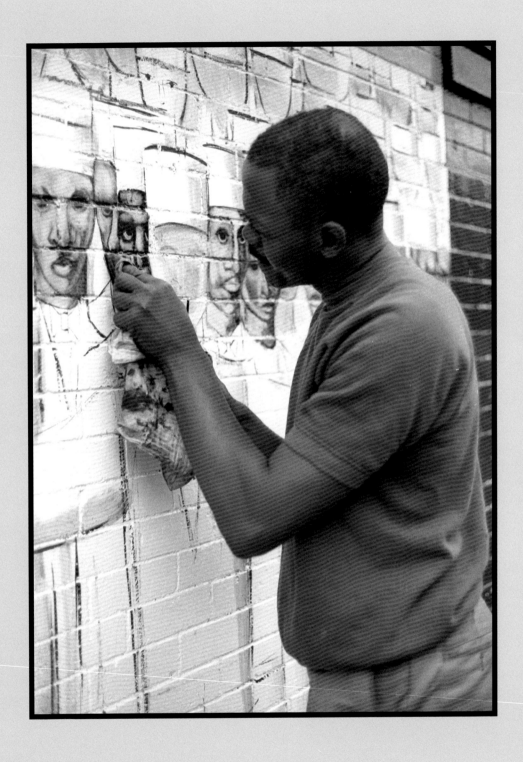

Bill Walker painting Nation of Islam
section on the Wall of Respect. Copyright
© Bob Crawford, 1967.

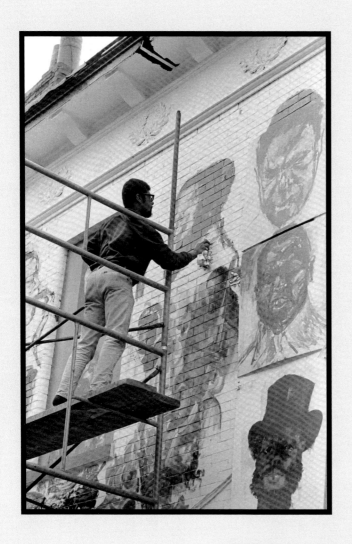

Elliott Hunter painting the
Wall of Respect. Copyright ©
Robert A. Sengstacke, 1967.

House painter who applied the first layer of paint
on the Wall of Respect. Copyright © Roy Lewis.

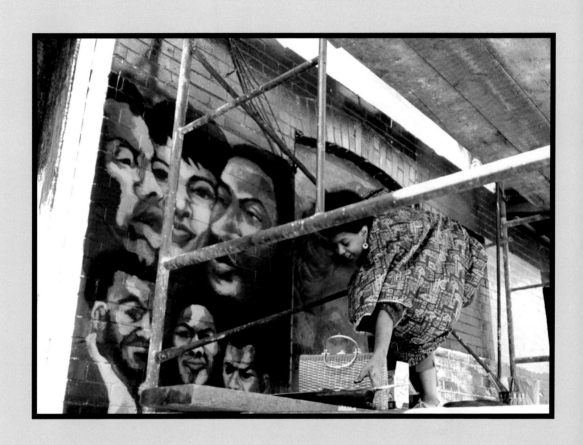

Barbara Jones-Hogu painting the Wall of Respect.
Copyright © Robert A. Sengstacke, 1967.

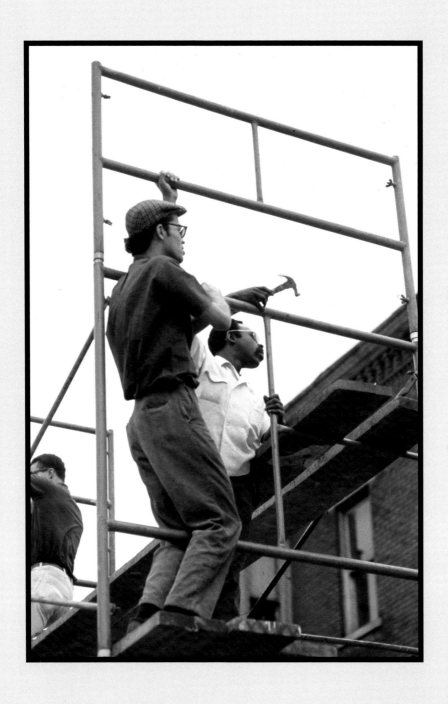

Gerald McWorter and Darryl Cowherd
making the Wall of Respect. Copyright ©
Robert A. Sengstacke, 1967.

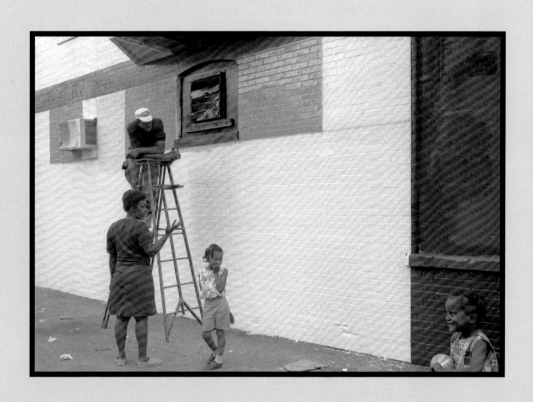

Bill Walker prepping the Wall.
Copyright © Bob Crawford, 1967.

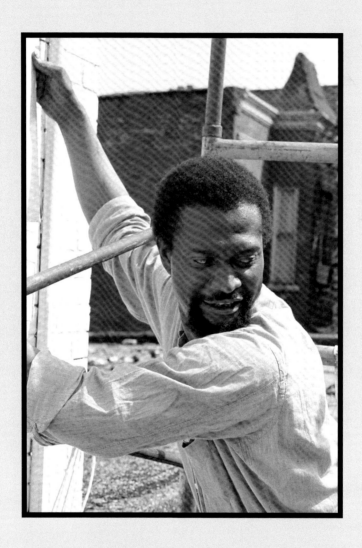

Jeff Donaldson working on the
Wall of Respect. Copyright ©
Robert A. Sengstacke, 1967.

Gerald McWorter at the Wall.
Copyright © Roy Lewis, 1967.

A Place for the People

The Wall was a crucial location that allowed for various forms of socializing as well as activism, demonstrating, and resistance to bubble up.

One of the Black photographers, Onikwa Wallace, who was involved in the OBAC meetings about the Wall of Respect, was in the end not able to participate because of his escalating activism. Images from this selection indicate police presence and activism at the Wall. They expose the role of children and youth participation at the Wall of Respect and show its importance to imparting mores of Black liberation to young people who lived in the surrounding community.

The images also point to the Wall's value for a wide range of social and political activities. It was a conducive scene for lectures and actions as well as more convivial socializing among community members and young educators and artists.

The Wall is not the central element in the images of this nature from the photographers' archives. Rather it is in the background of the images, aligning with its usefulness as a backdrop for the people to socialize and protest.

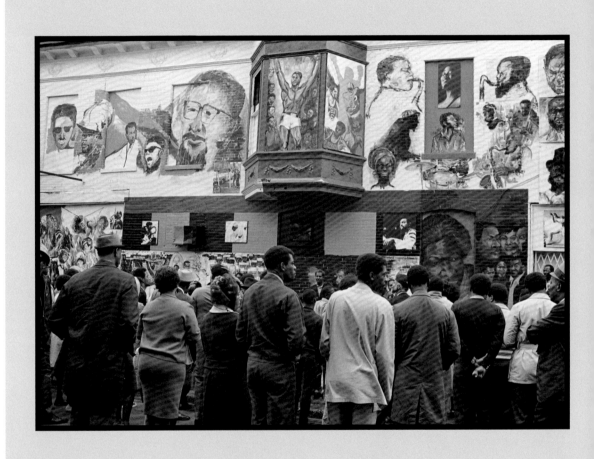

People gathering at the Wall of Respect.
Copyright © Robert A. Sengstacke, 1967.

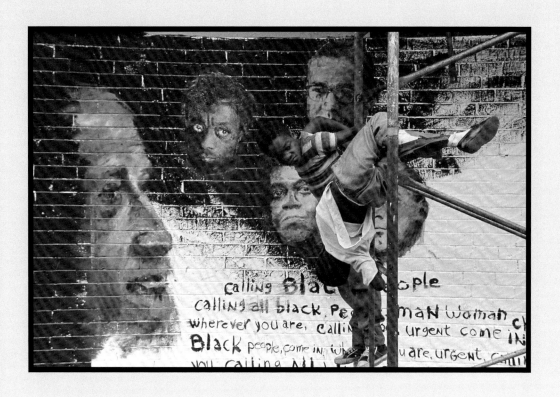

Ed Christmas section of the Wall of Respect with
boys on scaffold. Copyright © Roy Lewis, 1967.

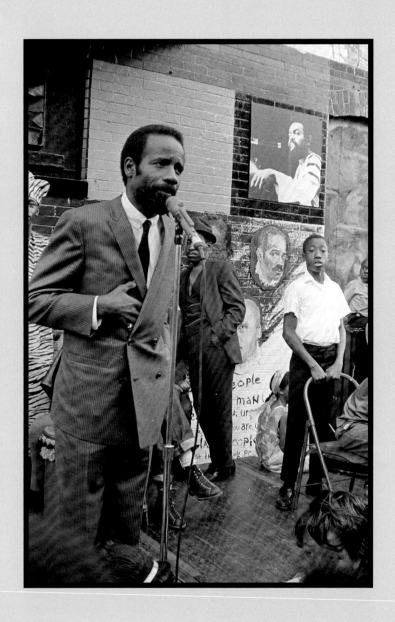

Lerone Bennett at the Wall of Respect.
Copyright © Roy Lewis.

Elliott Hunter (*left foreground*) and Gerald McWorter
and Jeff Donaldson (*center foreground*) at the Wall of
Respect. Copyright © Robert A. Sengstacke, 1967.

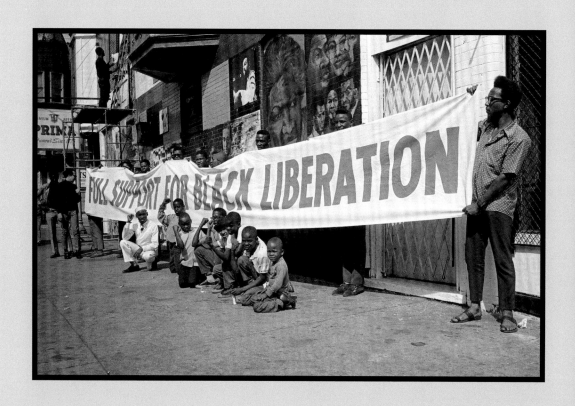

"Full Support for Black Liberation" banner taken from New Left Political
Convention Hall to the Wall of Respect by Gaston Neal, Darryl Cowherd,
and Roy Lewis. Copyright © Darryl Cowherd, 1967.

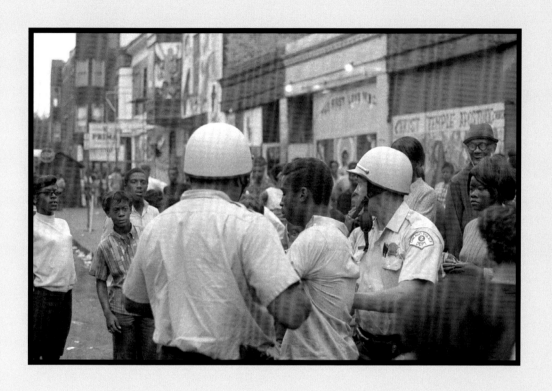

Police at the Wall of Respect.
Copyright © Bob Crawford, 1967.

A Place for the Artists

Artists who worked in various forms participated in the activities that took place at the Wall. As a site the Wall helped to anchor artist communities. Poets, such as Alicia Johnson, Don Lee, Amus Mor, Gwendolyn Brooks, and actor, theater director, and inspired reader of poetry Val Gray Ward, as well as musicians affiliated with the AACM, such as Lester Bowie, Joe Jarman, and Roscoe Mitchell, created work at the Wall of Respect.

As word spread of its forceful commitment to Black art and culture, celebrated musicians, artists, and writers, including Nina Simone, Larry Neal, and Valerie Maynard, sojourned to experience the Wall. In effect, the images disclose the Wall of Respect as a generative and permissive scene, which allowed and even encouraged additional layers of art making and performance.

In many of these images the Wall is only minimally evident, revealing that the photographers had equal concern for the other art forms that took place near the site of the Wall. The location came to have a ritualistic function that surpassed the Wall of Respect itself.

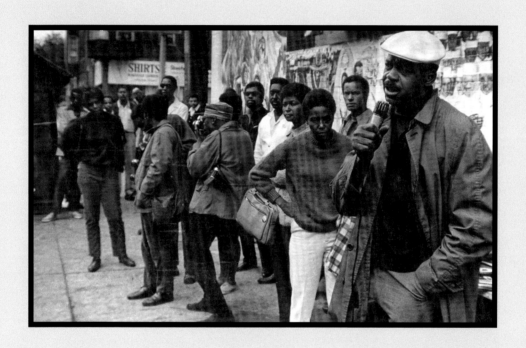

Bill Walker (with microphone) and artists Bobby Sengstacke,
Onikwa Wallace, Bill Abernathy, Ed Christmas, and Myrna Weaver.
Copyright © Roy Lewis, 1967.

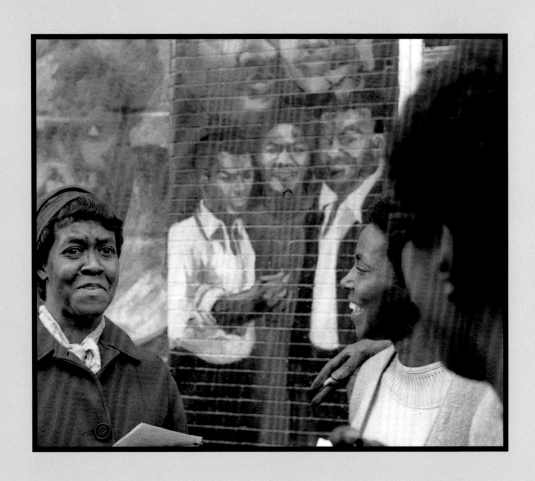

Gwendolyn Brooks (*left*) at the Wall of
Respect. Copyright © Bob Crawford, 1967.

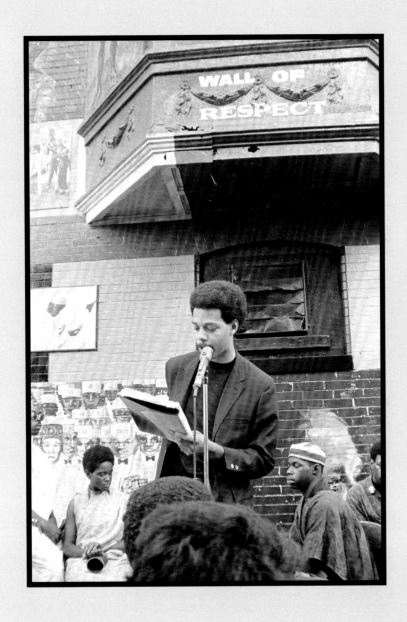

Don L. Lee reading a poem at the dedication.
Copyright © Roy Lewis, 1967.

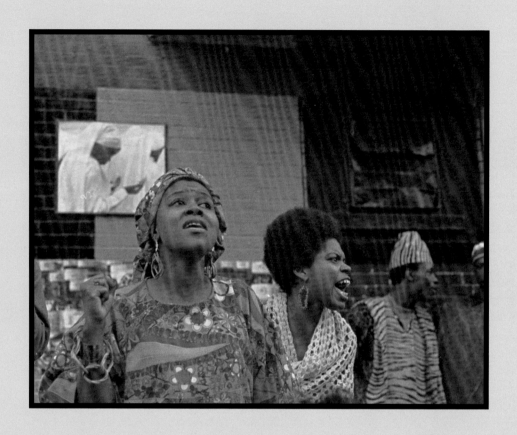

Val Gray Ward (*left*) at the Wall of Respect.
Copyright © Bob Crawford, 1967.

Sylvia Abernathy (*in striped shirt at left, sitting on car*), Billy Abernathy (*center foreground, with camera slung over his shoulder*), and friends, including Cathy Slade, Margo Arnold, Joe Simpson, and Harold Lee, at the Wall of Respect. Copyright © Robert A. Sengstacke, 1967.

Bob Paige and Barbara Jones-Hogu at the Wall of Truth. Copyright © Bob Crawford, 1969.

Lester Bowie at the Wall of Respect.
Copyright © Bob Crawford, 1967.

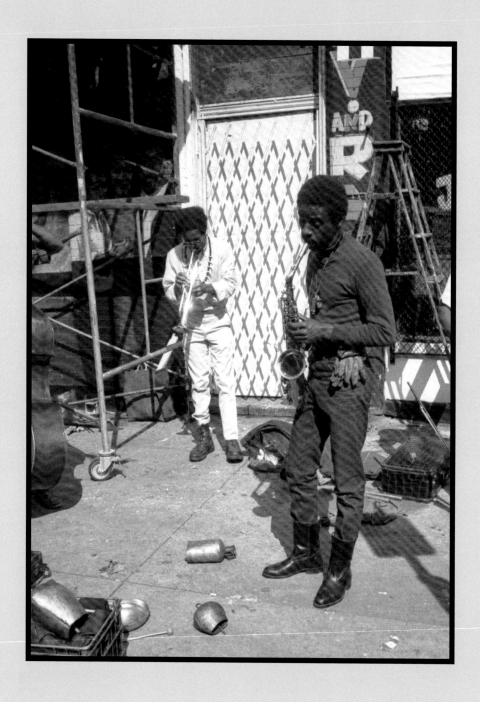

Roscoe Mitchell (*foreground*) and Lester Bowie playing at the Wall of Respect. Copyright © Bob Crawford, 1967.

"High Priestess of Soul" (Nina Simone) Sunday morning visit
to the Wall of Respect." Copyright © Roy Lewis, 1968.

Larry Neal and Valerie Maynard visiting the Wall of
Truth during CONFABA, the Conference on the Functional
Aspects of Black Art. Copyright © Roy Lewis, 1970.

A Place for Standing Up and Standing Out

Just as the Wall was an important site for art making of various sorts it was also a central hub for a range of Black people, including children, gang affiliates, business owners, and Black Muslims who were "portrait-ized" by the photographers. The photographers were interested in the everyday "heroes" (to use the language of OBAC) who stood out for their ability to innovate and improvise. These portraits of community members can be interpreted as an extension of the Wall of Respect's notable heroes who are depicted on the surface of the Wall paintings.

These images from the photographers' archives are important for what they reveal about their curiosity in extending and also innovating upon the popular tradition of studio portraiture within the Black community. All were well aware of and very taken with James Van Der Zee's photography in Harlem, an area that was equally saturated with Black people. While enthusiasts of Van Der Zee, they were also captivated by the possibility of making portraits of Black people that were less staged, less studio based, and also more connected to OBAC notions of a Black aesthetic. Van Der Zee's subjects are known for putting on their Sunday best (hair and clothes) often in a studio setting with genteel backdrops. With the Wall of Respect as a backdrop of sorts, the Wall photographers on the other hand made images that drew from their subjects' relation to the streets of Chicago. One of the Wall photographers' most important innovations was their use of that poignant artwork to derive a plein air portrait practice.

Portrait of man with Wall of Respect in the background. Copyright © Bob Crawford, 1967.

Wall of Respect neighborhood warrior/residents in
front of the Wall. Copyright © Darryl Cowherd, 1967.

Family at the Wall of Respect block. Copyright
© Darryl Cowherd, 1967.

Portrait at the Wall of Respect. Copyright
© Robert A. Sengstacke, 1967.

Portrait at the Wall of Respect with Nation
of Islam painting in the background.
Copyright © Bob Crawford, 1967.

Boy in doorway across the street from the Wall
of Respect. Copyright © Darryl Cowherd, 1967.

Looking at the Wall and
Looking from the Wall

These photographs reveal physical territories which were proximate to the Wall of Respect as similarly empowering scenes of collective liberation and resistance. Such terrains provide vantage points and opportunities for Black subjects to both look and be seen, an important double act. This is a significant logic that resonates with the trope of two-ness that is pervasive within the context of African American experience and culture. The images articulate a salient double-looking that aligns with notions of double consciousness and double-voicedness, which the photographers were well attuned to as devotees of Black writers and scholars such as W. E. B. Du Bois, Ralph Ellison, and James Baldwin.

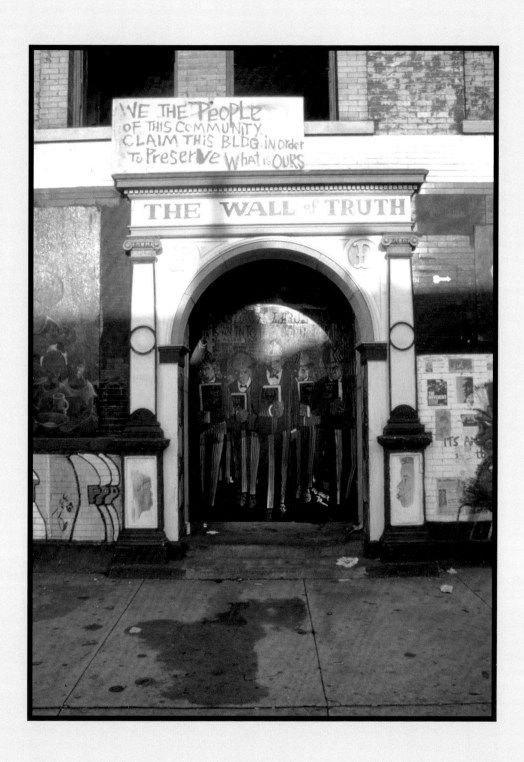

Doorway at the Wall of Truth.
Copyright © Bob Crawford, 1967.

Looking at the Wall of Respect from the window across the street. Copyright © Robert A. Sengstacke, 1967.

Looking at the Wall from a nearby rooftop.
Copyright © Bob Crawford, 1967.

A Place for the Black Photographer

These photographs disclose the Black photographers' iterations of self at the Wall of Respect. Each of the photographers' archives offers images of the other Black photographers who were involved in camera work at the Wall. The sense of camaraderie expressed by the photographers, variously described as family, fraternity, and collectivity, resonate from this set of images. Within the wider context of community, the Wall photographers also found their own community and cohort. Many of them ended up taking part in exhibitions and projects together into the '70s, including showing in the *Black Photographers Annual* publication and the "Two Schools" Exhibit at Kenkeleba House in New York.

The camera as an outward facing object around their neck is a key motif in these images. It marks them as camera workers and is a visible cue to the import of the camera as a significant instrument in helping to construct notions of Black beauty, Black liberation, and Black power.

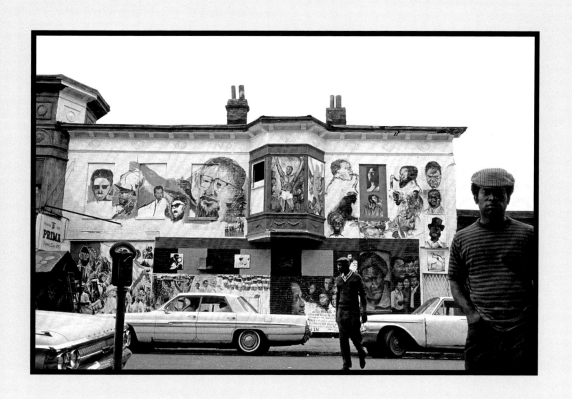

Billy Abernathy (*at far right*) in front of the Wall
of Respect. Copyright © Darryl Cowherd, 1967.

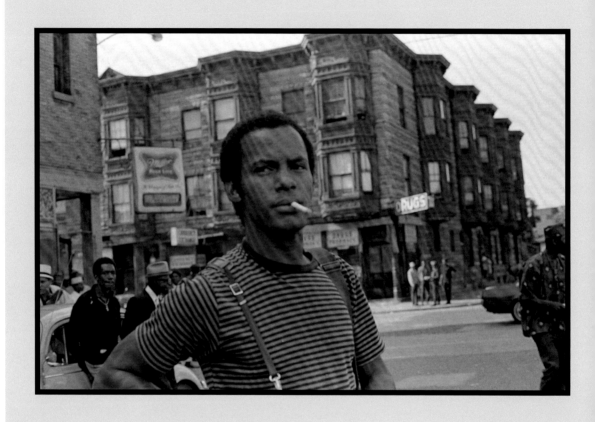

Robert Abbott ("Bobby") Sengstacke at the Wall of Respect.
Copyright © Robert A. Sengstacke, 1967.

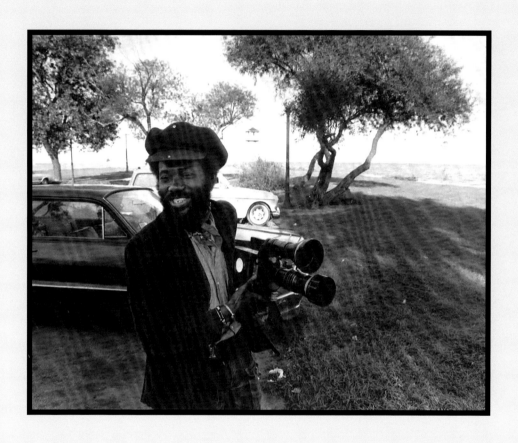

Roy Lewis at film shoot for *Save the Children*.
Copyright © Onikwa Bill Wallace, 1972.

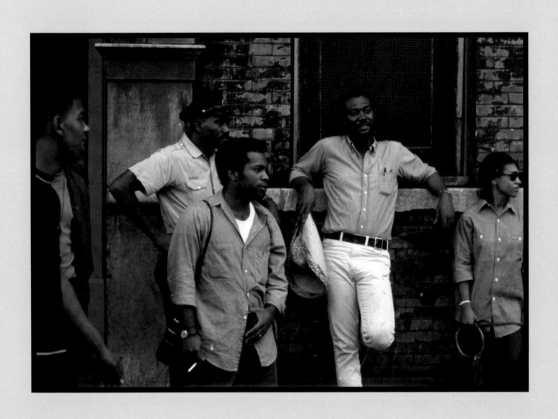

Billy Abernathy and Jeff Donaldson (*two center figures*).
Copyright © Robert A. Sengstacke, 1967.

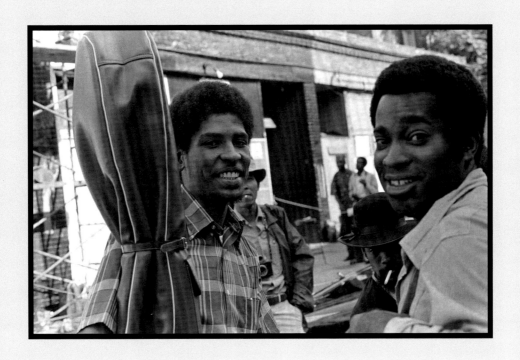

Charles Clark, Bob Crawford (*in background, partially obscured, camera around his neck*), Joe Jarman (*in dark hat, with cigarette*), and Billy Abernathy at the Wall of Respect. Copyright © Robert A. Sengstacke, 1967.

The Wall

The Black photographers gravitated to the Wall of Respect. In a sense they founded or reinvented their practices there. Sengstacke's image on the next page is perhaps the most iconic image of the full original Wall. Lewis's photograph of the Wall appeared in *Ebony* magazine in December 1967. Crawford ritualistically returned to the Wall. His is a later iteration of it. Cowherd's photograph is from a captivating angle that takes into account the wider landscape. While the Wall itself drops out of many of the images that they made there, they all returned to the Wall at quiet times to take photographs focused on the mural itself.

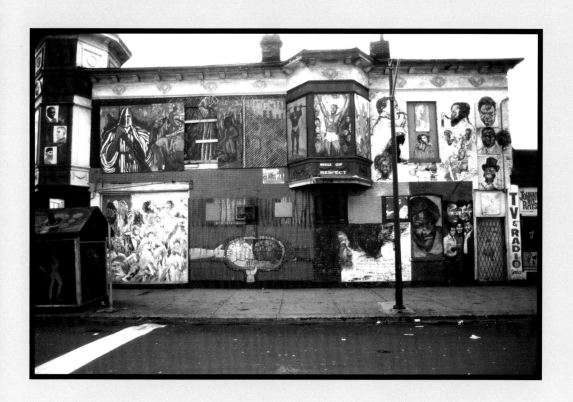

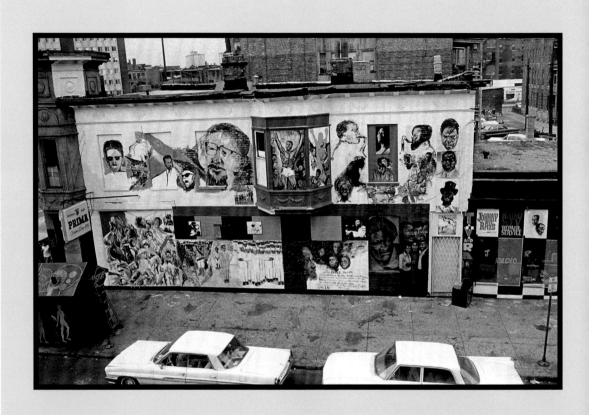

V. REVERBERATIONS

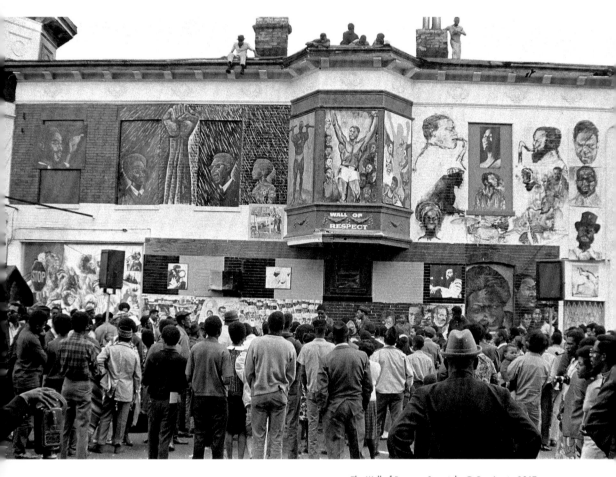

The Wall of Respect. Copyright © Roy Lewis, 1967.

Conflict and Change on the Wall

Rebecca Zorach

I began teaching college students about the Wall of Respect in 2004. Working on the South Side of Chicago, at the University of Chicago, I felt an imperative to encourage my students to look outside the confines of the campus to see the history and culture that surrounded them. I paired Gwendolyn Brooks's dedicatory poem on the Wall with her dedicatory poem on the Chicago Picasso, the other major public artwork installed in Chicago in 1967. Brooks's two poems, joined together as "Two Dedications," point to different sensibilities for a "public" art, and to two different Chicagos. I also assigned Jeff Donaldson's "The Rise, Fall, and Legacy of the Wall of Respect Movement," an essay written by a looming figure in the Black Arts Movement, who went on after the Wall to be a cofounder of AfriCOBRA and one of the architects of the very idea of a Black aesthetic.

I noticed that Donaldson's account did not agree in all its details with those of other participants, and as I read more, researched the Black Arts Movement, and spoke to more people, I came to understand the extent to which the history of the Wall of Respect was also a history of conflict and trauma—one in which collaborators on the Wall were pitted against one another through internal divisions and external pressures. The key moment of strife, one with far-reaching consequences, came when William Walker permitted neighborhood residents to whitewash Norman Parish's "Statesmen" section of the original Wall and invited Eugene "Eda" Wade to repaint it with entirely different imagery that bespoke a more militant mood (see image opposite). This incident raises questions: How important was Walker's role in originating the project? Who counts as a collaborator? What was the role of neighborhood residents? Who really was on the

rooftops pointing guns at the participants in the dedication? And larger questions of interpretation: What did the Wall mean to most people who saw it? How did the changes affect what came to mind when people thought of the Wall?

According to Jeff Donaldson, conflict first emerged over the issue of whether and how the artists should speak to the media.[1] In the course of this dispute, according to Donaldson, the artists who were interested in speaking with the media continued to visit the Wall while the others, the majority, remained absent.[2] Walker describes the situation differently. As he recounted in a conversation with other Chicago Mural Group members, "a number of problems" split the group, leaving him, Myrna Weaver, and her partner Lenore Franklin the only ones still working with the community (see the Chicago Mural Group meeting transcript, page 307). This initial fracture was then compounded by the much greater one over the whitewashing of Parish's section and repainting by Eda.

This change happened shortly after the creation of the original Wall. Eda (the name, originally spelled "Edaw," came from his last name spelled backwards) was an art student who had exhibited at Myrna Weaver's gallery The Arts, where the OBAC Visual Arts Workshop held its early meetings. One of the pieces he showed there was the portrait of Malcolm X that he later placed on the Wall. One day—as Eda recounts in the interview included in this volume (page 313)— Weaver told him there was a wall she wanted to show him, and drove him to Forty-Third and Langley to see the mural as it was under way. Eda was intrigued and began visiting the Wall. He asked Walker several times if he could work on a section. Walker had seen Eda's painting of Malcolm X and was impressed with the young artist's skills. The question was where to have him work; the sections had already been distributed. But Walker believed Norman Parish had left his "Statesmen" section unfinished (see page 310) and found in Eda's eagerness a remedy for the situation.

Why did Parish's section seem an apt one to repaint? Did it have anything at all to do with the artistic approach or success, or was it actually, as Walker asserted, about the section's state of completion? Was it simply expedient? Walker had seen Eda's painting of Malcolm X; was it perhaps just more to Walker's liking? Was the new version more to the community's liking? The collage aesthetic that the artists had used allowed for the expression of independent styles, but it did not smooth over the fact that some artists' skills were a better match than others' for the large-scale medium. Norman Parish was an excellent painter, but his section did not have the visual presence of some of the others. As one artist suggested to me, Parish was not primarily a portrait or figure painter. Did the figure of Malcolm look too wispy? And if so, was this a political problem for the community? It seems plausible that community residents—who were not privy to the collective process that the original artists had undertaken—believed the portrait of Malcolm X was not a sufficiently commanding image of the fallen

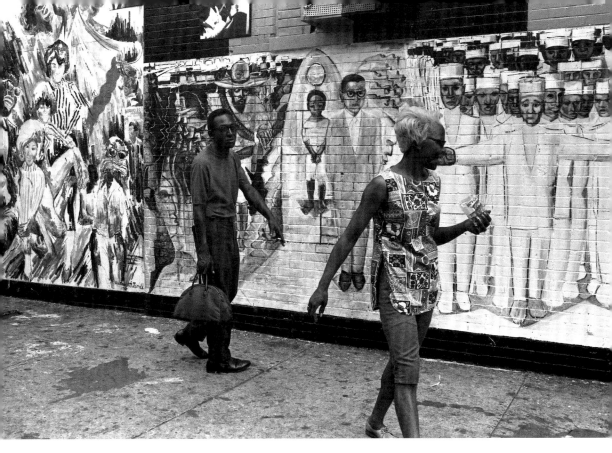

Bystanders at the Wall of Respect (showing Jarrell signature in the bottom right corner of the "Rhythm and Blues" section). Copyright © Robert A. Sengstacke, 1967.

leader. According to Eda, the key was the fact that the political mood in the neighborhood had changed, and people there desired something more confrontational (see interview, page 313). It's not hard to imagine that Walker thought it would be too difficult to call the collective back together to address the question—much as it would have been the right thing to do.

So Walker gave Herbert Colbert and his community organization, the Young Militants, the go-ahead to whitewash Parish's section just weeks after the Wall was originally painted. (Roy Lewis's photograph of Malcolm X Park stayed in place.) Eda then repainted the section with a central raised fist. Surrounding the fist were smaller faces, representing Stokely Carmichael, H. Rap Brown, and Malcolm X— the painting that had been on display at The Arts. That painting had been signed, and, not realizing that the OBAC artists had agreed not to sign their work, Eda didn't remove the signature. At some point, Wadsworth Jarrell also signed his section; the signature appears in some photos of the mural, as is faintly visible in the image above. A photo of a later state of the Wall (page 65) also reveals, on close inspection, under the elbow of Sonny Rollins, the names of the three artists responsible for the "Jazz" section: Hunter, Abernathy, and Donaldson.

275

It was a small thing, but may have added fuel to the fire of the resulting conflict. For Parish and many of the other OBAC artists who were close to him, it was an enormous breach of trust. It spelled the end of the Visual Arts Workshop of OBAC and created a personal divide that never truly healed.[3] For Roy Lewis, the Wall was now a Wall of Disrespect.[4] Meanwhile, OBAC members were receiving anonymous letters attempting to stir up conflict within the group. The Chicago police conducted extensive surveillance of the many events that occurred at Forty-Third and Langley, filing reports under the broad heading "Coordinating Council for Black Power" used by the notorious Red Squad.[5] Many participants remember seeing snipers on rooftops or being pulled over by police during or after events at the Wall.

The Wall became a symbol of a moment in the political struggle as well as a museum of Black heroes. *Ebony*'s piece on the mural, published in December 1967 (page 291), presented the revised Wall in Roy Lewis's photograph and described the Wall itself in celebratory terms. For most who became aware of the Wall, outside of the immediate group, the rift among the artists was not necessarily visible, and the Black Power fist was enshrined as part of the national public's first view of the Wall. It certainly spoke to a broad audience in a different way than the original "Statesmen" panel had. And while Eda continued his collaboration with Walker on several other walls and painted murals of his own, most of the OBAC artists shifted their attention back to their original media.

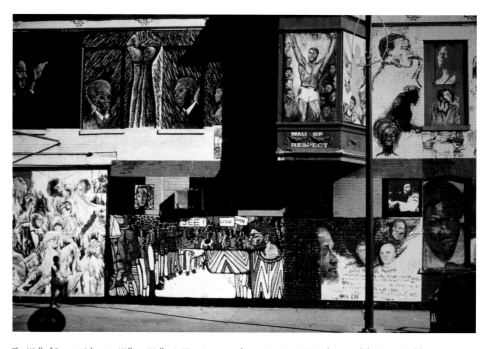

The Wall of Respect (showing William Walker's "See, Listen, and Learn"), circa 1968. Photograph by Georg Stahl.

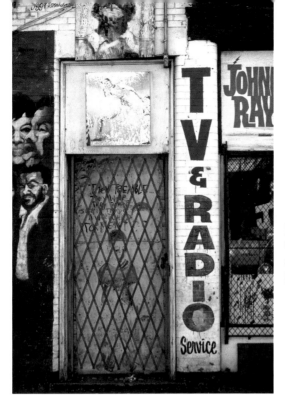

Door with painting of children by William Walker, circa 1969. Photograph copyright © 1970 by Bertrand Phillips. Courtesy Bertrand Phillips.

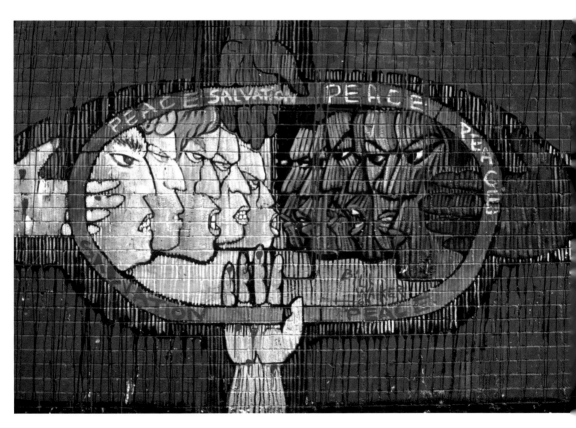

William Walker's "Peace and Salvation" (painted circa 1969) on the Wall of Respect. Photograph copyright © 1970 by Bertrand Phillips. Courtesy Bertrand Phillips.

In 1968, Walker revised his section, creating a crowd of figures carrying signs reading "See," "Listen," and "Learn" (thus, this section is sometimes referred to as "See, Listen, and Learn"). Walker also painted two children with a poetic text on the building door next to Barbara Jones's "Theater" section. Eda changed the "Statesmen" section at the same time, adding a large painted panel with a Klansman "under whose baleful eyes," as *Time* magazine put it, "policemen are beating black youths" (see image, page 25).[6] Finally, Walker changed his section to represent "Peace and Salvation." In it, two groups of heavily striped profile faces—white on the left, black on the right—confront one another angrily, in what was to become a signature motif for Walker. They are surrounded by a rounded oblong frame with the words "Peace" and "Salvation" held by four hands (perhaps indicating four ethnic groups): black, tan, white, and red. Black and blood-red drips heighten the tension of the piece—a brilliant work, but clearly far from the original conception of the Wall.

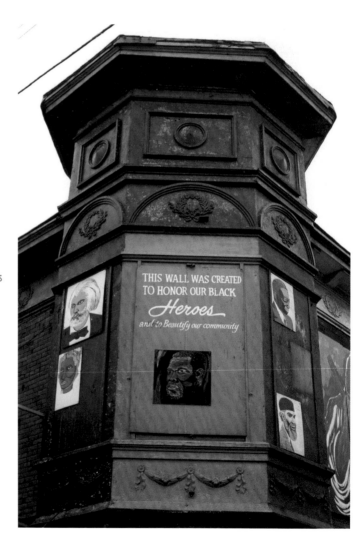

Corner turret with paintings of Frederick Douglass, Sojourner Truth, and local heroes by Will Hancock, circa 1969. Photograph copyright ©1970 by Bertrand Phillips. Courtesy Bertrand Phillips.

Small additions also came before or after the major break. Florence Hawkins had already painted Duke Ellington and Dick Gregory on a separate panel on Johnny Ray's storefront (see pages 27 and 268).[7] Will Hancock added a number of figures in a new section on the building's turreted corner oriel, over text that stated, "This Wall Was Created to Honor our Black Heroes and to Beautify our Community" (see image opposite). Several were "local heroes" from the community, but on the side that faced Forty-Third Street, Hancock also painted Frederick Douglass and Sojourner Truth. Curly Ellison painted "Wall of Respect" on the bay window that held the "Sports" section. The California artist David Bradford painted a mother and child on one of the nearby storefronts.[8] Kathryn A. Akin added a musician—a trumpet player seated on a rocking chair—on a wall leading to the Johnny Ray's entrance.

Doorway with musician by Kathryn A. Akin, circa 1969. Photograph copyright © 1970 by Bertrand Phillips. Courtesy Bertrand Phillips.

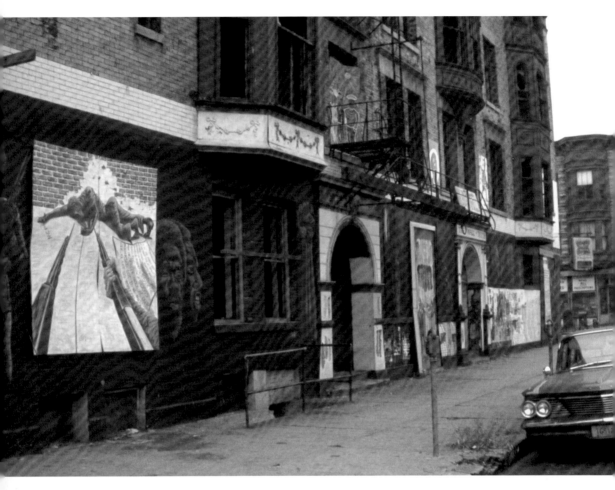

Photograph of the Wall of Truth (created by William
Walker, Eugene "Eda" Wade, and others), circa 1969.
Photograph by Mark Rogovin.

The *Chicago Defender* chronicled the progress of the Wall as it was being painted, and traced events that followed. Robert Sengstacke, a key participant in the Wall, was also a staff photographer for the *Defender*. The Catalysts, a political advocacy group, published a Black Cultural Directory in 1969 that included a section on "Places of Respect," with the Wall receiving pride of place. Other murals followed in Chicago, many of them, especially (but not only) those painted by William Walker, given the name "Wall of . . ." (Dignity, Brotherhood, etc.). Across the street from the original Wall, Walker and Eda, along with community members, painted a harder-hitting, critical Wall of Truth. After the destruction of both buildings, several panels from the two murals were displayed at Malcolm X College for a number of years; Eda's figure of the Klansman was eventually given to the DuSable Museum, and several other panels made their way to Chicago State University. Eda also later created a porcelain enamel mural commemorating the Wall—adding Martin Luther King Jr. to the heroes depicted—at the original site at Forty-Third and Langley. He considers this the fifth phase of the Wall itself.

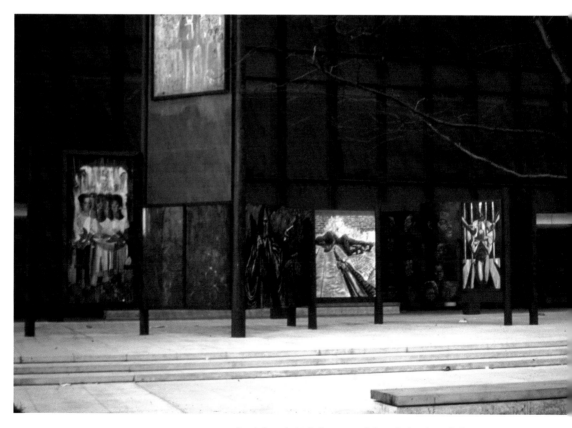

Panels from the Wall of Respect and the Wall of Truth installed at Malcolm X College, circa 1972. Photograph by Georg Stahl.

The Wall had reverberations in other communities. A mural movement of primarily Mexican American artists began in Pilsen around the same time as the creation of the Wall of Respect. Mario Castillo painted his first murals independently, without knowledge of the Wall, but later muralists were certainly aware of it, as they were aware of the tradition of murals in Mexico. Murals also called "Wall of Respect," some painted in vernacular styles by nonprofessional artists, sprouted in Chicago and elsewhere. One that still exists is "Sim's Corner Wall of Respect" at Forty-Seventh and Champlain, painted by Wardell McClain.

Other artists also saw and were inspired by the Wall. Mark Rogovin, a young white artist who grew up in New York State but came to Chicago direct from a stint working with muralist David Siqueiros in Mexico, visited the Wall as an art student. He joined Chicago's mural movement and went on to found the Public Art Workshop on the West Side of the city. John Pitman Weber saw the Wall too, and joined with Walker, Eda, and others in founding the Chicago Mural Group, or Chicago Mural Movement Group, precursor to the still-active Chicago Public Art Group. Mitchell Caton, listed early on as a member of the OBAC Visual Arts Group, did not in the end participate in the painting of the Wall, but he went on to paint many more murals around the South Side. Several of the original OBAC artists went on to participate in COBRA (the Coalition of Black Revolutionary Artists) and later AfriCOBRA (the African Commune of Bad Relevant Artists), which included Jeff Donaldson, Wadsworth Jarrell, and Barbara Jones as founding members and later added Carolyn Lawrence, among others.

Along with *Ebony*, other publications put the imagery of the Wall into national circulation. The *New York Times* put the Wall on the cover of its magazine section on August 11, 1968, accompanying an article on Black nationalism.[9] The journal *Arts and Society* reproduced imagery from the Wall to illustrate its 1968 issue on the arts and the Black revolution.[10] In an article entitled "Object: Diversity," in its April 6, 1970, issue on "Black America 1970," *Time* magazine devoted a few lines to the Wall of Respect, describing it as a space for changing imagery: "On The Wall of Respect, at the corner of 43rd St. and Langley Ave. in a desperately depressed part of Chicago's South Side, new scenes are frequently added to reflect changes in ghetto feelings."[11] This reflected Walker's sense of murals as newspapers of the street that could change with current events. It represents the changes as organic, not as a matter of conflict. In fact, even many viewers in Chicago were largely unaware of the controversies surrounding the Wall and experienced it essentially as a positive statement.

Elsa Honig Fine alluded to the mural movement in "Mainstream, Blackstream and the Black Art Movement," a 1971 article in *Art Journal*. She describes the Black Arts Movement as manifesting in murals designed to communicate to ghetto residents: "Young, militant artists, who, disdaining the traditions of Western art, seek to communicate with their brothers and sisters in the ghetto."[12] In 1972, the Civil Rights Committee of the Amalgamated Meat Cut-

ters and Butcher Workmen of North America published a pamphlet, *Cry for Justice*, that provided early documentation of what was by that time a flourishing mural movement inspired by the Wall of Respect. Later, in 1977, Eva Cockcroft, John Pitman Weber, and James Cockcroft published *Toward a People's Art*, which notes the signal importance of the Wall in the development of the community mural movement studied by the book. Based largely on conversations with Walker and on the *Ebony* article, the chapter concerning the Wall is slanted toward Walker's position, almost leaving out the controversy's traumatic effects on the artist group. On the other hand, it establishes the Wall as a founding moment in a tradition that carries on in the practices of the community mural movement around the country and, indeed, the world.

Notes

1. Jeff Donaldson and Geneva Smitherman Donaldson, "Upside the Wall: An Artist's Retrospective Look at the Original 'Wall of Respect.'" in *The People's Art: Black Murals, 1967–1978* (Philadelphia: African American Historical and Cultural Museum, 1986), unpaginated. This issue may have emerged over a proposed TV commercial for Robert Kennedy that Sammy Davis Jr. was involved in. See also Alice Thorson, "Africobra—Then and Now," *New Art Examiner* 17, no. 7 (March 1990), interview with Jeff Donaldson.

2. Donaldson and Smitherman Donaldson, "Upside the Wall."

3. See Derek Guthrie and Jane Addams Allen, "Norman Parish's Black Pride Shows thru the Whitewash" [review of Parish exhibition at South Side Community Art Center], *Chicago Tribune*, July 16, 1972.

4. Roy Lewis made this statement during the Sunday morning conversation at the South Side Community Art Center following the SAIC symposium in 2015.

5. Chicago History Museum, Red Squad papers, Coordinating Council for Black Power files.

6. "Object: Diversity," *Time*, April 6, 1970.

7. Ibid.

8. Visible in a photo in *Arts and Society: The Arts and the Black Revolution* 5, no. 2 (Summer–Fall 1968), 240.

9. Images of the Wall also accompany the article by Robert S. Browne, "The Case for Two Americas—One Black, One White," *New York Times*, August 11, 1968.

10. *Arts and Society: The Arts and the Black Revolution* 5, no. 2 (Summer–Fall 1968). An issue of Kendall College's literary magazine *Black Perspective* (ca. 1971) also included several pictures of the Wall of Respect and Wall of Truth. The *Chicago Seed* put the Wall of Truth on its cover in March 1970.

11. "Object: Diversity."

12. Elsa Honig Fine, "Mainstream, Blackstream and the Black Art Movement," *Art Journal* 30, no. 4 (Summer 1971): 374–75; quote on 374.

Reverberations

The pieces in this section represent responses to the Wall, both contemporary with its creation and later. Three of the articles—two from the *Chicago Defender* and one from *Ebony*—represent reactions in the Chicago-based Black press in the year of the Wall's creation. An essay by Jeff Donaldson, "The Rise, Fall, and Legacy of the Wall of Respect Movement," provides his later account of OBAC and the creation of the mural. Two pieces help establish William Walker's perspective: a recorded conversation about the Wall that was part of a Chicago Mural Group meeting in 1971, and his 1991 interview with Victor Sorell for the Archives of American Art. In 1992, for the Wall's twenty-fifth anniversary, journalist Norman Parish III wrote a piece that added additional details, including interviews with community members and several of the artists; he also gave voice to the anguish of his father, Norman Parish Jr., over the repainting of his section of the Wall. In 2015 the Art Institute of Chicago hosted a symposium on the Wall of Respect. This was the occasion for a new interview with Eugene "Eda" Wade, conducted by Rebecca Zorach and Marissa Baker. We also reproduce here Romi Crawford's opening address from the second day of the symposium and portions of the roundtable discussion among Wall artists that followed it, as well as an invocation read on its opening night by poet Roger Bonair-Asgard. Historical texts are reproduced uncorrected except for the spelling of proper names.

Wall Paintings on 43d St. Show Black Man's Triumphs

Sam Washington

from *The Defender*, August 28, 1967

A wall on the southeast corner of 43d st. and Langley ave. was the scene Sunday of a rally of about 200 black militants, who collectively noted expectations that the wall would reaffirm the black man's role in contemporary American life.

H. Rap Brown was slated to be at the rally, but according to an informed source, was delayed in Detroit.

The wall, prepared by 10 black painters and photographers, depicts nearly every facet of the black man's accomplishments, including theater, music, religion, sports and statesmanship.

A spokesman for the creative group said the wall was donated by the owner of the building, while the artists gave freely of their time and materials.

The spokesman noted that special commendation should go to the residents of the area, who gave their cooperation to the project.

The spokesman also cited the youngsters in the area, who took an interest in the painting effort and were said to have protected the wall from outsiders, in addition to keeping an eye on the painting equipment, which was left at the scene until the project was completed.

The 44 foot by 24-foot wall was started Aug. 5, and was dedicated last Thursday. The dedication was not however, highlighted by any formal ceremony.

The spokesman said the participants in the protest felt that a ceremony would have robbed the edifice of some of its desired effect.

"We wanted the people in the area to feel that the wall belongs to them," the spokesman asserted.

Before the project was completed the working weekends were filled with music and poetry, the spokesman said.

During the first weekend, jazz musicians played for the artists and residents of the block. On the second weekend members of the OBAC writers' workshop were on hand to read poetry while the music played.

The whole project was sponsored by OBAC—pronounced O-baa-See—organization, which stands for Organization of Black American Culture.

The group is composed of three divisions: visual arts; community workshops; and writers' workshops. Although the visual arts members carried out the wall project, they received the support of the entire membership, the spokesman explained.

Gerald McWorter, chairman of OBAC, noted that the wall project "reflects the very spirit" of the organization. "We formed to make an effort to better enhance the spirit and vigor of culture in the black community, and the wall is the very essence of that effort." McWorter said.

He declared that everyone depicted on the wall, "honestly reflects the beauty of Black life and genius, did not forget his or her less fortunate black brothers and sisters, and does what he does in a manner that cannot be imitated or replaced."

Crowds Gather as 'Wall' Is Formally Dedicated

Dave Potter

from *The Defender*, October 2, 1967

The multi-colored wall at 43d St. and Langley ave. was dedicated Sunday at a "black festival of creativity."

Sponsored by the 43rd st. Community Workshop, the festival featured singers, a dancer, black poets and several speakers.

Police cordoned off Langley ave. between 43d st and 44th st. and a heavy concentration of plainclothes policemen was noted in the crowd of about 400 persons.

The wall, a two-story by 80-foot mural, which depicts black heroes, is the product of painter Bill Walker and Mrs. Sylvia Abernathy, who produced "the workable layout," Walker said.

Though completed more than a month ago, the wall Sunday bore some minor changes. Dominating the 40-foot high mural is a painting of a clenched-black-fist & the black-power salute.

The wall is inscribed "Wall of Respect".

Though Sunday's proceedings were late getting to a start, the jazz-Afro rhythms of Phil Cohran and his A[r]tistic Heritage Ensemble, made up for the lateness.

Cohran, a trim-looking black musician chided the "slick heads" in his audience as he introduced a song, "Message From the Talking Drum."

The song's first line goes:

"Ladies, that wig has got to go."

According to artist Walker, 40, "the wall was created to promote beauty in the black community" as well as to "honor our heroes."

Depicted on the southside mural among others are former heavyweight champion Muhammad Ali; the late jazz [gap here in printed piece] John Coltrane; fiery militant leader H. Rap Brown; and Black Muslim prelate Elijah Muhammad.

Also appearing on the show was dancer Darlene Blackburn, and singer Ella Pearl Jackson.

Artist Walker said that he plans to create another wall. However, he did not reveal the new location.

While the 400 spectators watched the program, newly appointed deputy-in-Charge of community services, and 48th st., Police Commander, Robert Harness, watched nervously from inobstrusive vantage points.

At one point police feared a disturbance when a Negro woman—wearing a "natural" haircut—confronted three white women spectators.

No incidents were reported at presstime.

Wall of Respect: Artists Paint Images of Black Dignity in Heart of City Ghetto

from *Ebony*, December 1967

Forty-Third Street and Langley Avenue on Chicago's near South Side, an area where storefront churches outnumber laundromats, is a corner whose beauty is largely unseen and too often unspoken. Marcus Garvey proclaimed that beauty, "Bird" celebrated it, and Malcolm dared to believe in its possibilities. But none of them lived to see The Wall.

However, when the side wall of a typical slum building on the corner of Forty-Third and Langley became a mural communicating black dignity this summer, the faces of those three giants were joined with others to remind a people that the blackness and beauty that is their own has always been one. A group of black men and women—painters and photographers from the Organization of Black American Culture (OBAC)—in creating this newest of Chicago's landmarks, chose as their heroes persons who had incurred both the plaudits and scorn of the world of whiteness, but who, in their relation to black people, could by no account be considered other than images of dignity.

Rising two-stories above ground long grown barren, the mural depicts the intense intellectualism of W.E.B. DuBois who was a black prophet; the rare physique of Muhammad Ali who *is* a black champion; the folksiness of Nina Simone who sings with black simplicity; and the gentle rage of LeRoi Jones who writes poems about black love. The names seem endless—John Coltrane, Stokely Carmichael, Sarah Vaughan, Thelonious Monk, Gwendolyn Brooks, Wilt Chamberlain, Max Roach, John Oliver Killens, Ornette Coleman, and Rap Brown among them—and at the end of the names and the painting, the artists were perhaps left no choice but to call their work the "Wall of Respect."

In this era of the "happening," The Wall just might be called a "black-hap." OBAC, which includes writers and community workshops as well as an artists workshop, was formed early this year to enhance the spirit and vigor of culture in the black community of Chicago. Bill Walker, a member of the artists workshop, was given permission by the owner to paint on the Wall. Walker introduced the idea to his workshop fellows, and history evolved.

"Because the Black Artist and the creative portrayal of the Black Experience have been consciously excluded from the total spectrum of American arts, we want to provide a new context for the Black Artist in which he can work out his problems and pursue his aims unhampered and uninhibited by the prejudices and dictates of the 'mainstream,'" concludes the OBAC statement of purposes. Thus black artists whose particular talents and skills might have, in another time, taken them far away from Forty-Third and Langley, directed their genius to the community of their roots. In essence they told a community: "Our art is yours, you are us, and we are you."

Lerone Bennett Jr., who confides that he has received no honor as meaningful as being portrayed on The Wall, believes that the event marks a significant breakthrough in terms of black people, instead of white people, legitimizing black culture and black history. He notes, moreover, that The Wall is where it should be—in the midst of the people—as opposed to being in a museum or a special, out-of-the-way place. Adds Bennett: "For a long time now it has been obvious that Black Art and Black Culture would have to go home. The Wall is Home and a way *Home*."

In their initial venture towards the objective of seeking themes, attitudes and values that will unite black artists and the masses of black people, OBAC inspired reciprocal identification. The people of the community surrounding The Wall have become not only its praisers, but also its protectors. Novelists James Baldwin and Ronald L. Fair, viewing in appreciation this monument which includes them in its tribute, were taken aback by a youngster who asked: "How do you like *our* Wall?"

The creation, finally, is an authentic landmark signifying a specific development in the experience—"Black Experientialism," in the words of OBAC—of a people. The Wall, as young Don L. Lee ended his poem of the same name, is "layen there." Which in the idiomatic language of the poet, and the black life style, means something more than simply standing there.

The Rise, Fall, and Legacy of the Wall of Respect Movement

Jeff Donaldson

from *The International Review of African American Art*, 1991

Revolutionary art is both a product of struggle and a reflection of it.
—Frantz Fanon, *The Wretched of the Earth*

In 1967, Chicago's Wall of Respect, a 20 x 60 foot mural executed on the exterior of a southside tavern at 43rd and Langley, set in motion an outdoor mural movement by African American artists throughout America's inner cities that grew to more than 1,000 murals in urban centers between 1967 and 1975 and eventually inspired Latino, Native and, ultimately, Euro-American artists as well.

Chicago's Wall artists were members of the Visual Art Workshop of the organization of Black American Culture (OBAC). Organized in May, 1967, OBAC was founded by Gerald McWorter (Abdul Al Kalimat), sociologist; Hoyt W. Fuller, *Negro Digest* (*Black World*) editor; Conrad Kent Rivers, poet; Ann E. Smith, Donald H. Smith and George Ricks, university professors; Joseph R. Simpson, scientist; E. Duke McNeil, attorney; and this writer, visual artist and art historian. Other members included Ron Dunham, Bennett J. Johnson, Brenetta Howell and Val Gray Ward.

OBAC's goal was to organize and coordinate an artistic cadre in support of the 1960s bare-bones struggle for freedom, justice and equality of opportunity for African Americans in the United States. In addition to a Writers Workshop[1] organized by Fuller and a Visual Artists Workshop which I organized, OBAC established liaison with and participated in joint ventures with existing cultural organizations in Chicago such as the A[f]fro-Arts Theat[er], Ebony Talent Associates, the Kuumba Theatre and a close relationship with the Association for the Advancement of Creative Musicians.[2]

The OBAC Visual Art workshop included painters and printmakers Sylvia Abernathy, Elliot[t] Hunter, Wadsworth Jarrell, Barbara Jones Hogu, Carolyn Lawrence, Norman Parish, William Walker and Myrna Weaver; photographers Billy Abernathy, [Darryl] Cowherd, Roy Lewis, Robert Sengstacke and Onikwa Bill Wallace; and Edward Christmas, mixed media commercial artist.

At the initial meeting in mid-June, 1967, it was clear that most workshop members viewed cultural expression as a useful weapon in the struggle for black liberation. The group agreed that the essential function of "a people's art" was to build self-esteem and to stimulate revolutionary action. From this point of agreement the workshop began to consider a group project to establish its existence and to promote its objectives. During the discussion, William Walker revealed that he had planned to "paint a piece" on a building, and that there was adequate space for other workshop artists to "do their thing." Instead of individual images, however, the group felt the collective nature of OBAC warranted a similar collective artistic statement. In subsequent meetings, members brought examples of their work in an attempt to discover common characteristics and to forge an aesthetic consensus. Beyond political ideology, however, there was no stylistic uniformity in the work. The theme "Black Heroes" was chosen to include men and women, role models for positive self-identification and guidance toward black liberation.

Workshop artists agreed on three specific courses of action. First, there would be no signatures affixed to the Wall; second, all statements to the media would be subject to approval by the entire group; and finally, the Wall belonged to the community, and as such, there was to be no individual or group attempt to capitalize on its celebrity.

The fleshed out idea of a collective mural project was exceedingly compelling to the workshop for many reasons, not the least of which was that, since the 1920s, black artists had been producing outstanding interior murals portraying black heroes and epochs in African American history. This activity was also related to the tradition of the revolutionary Mexican muralists. The exciting part about the OBAC project, however, was the high visibility of an exterior mural in a well-traveled section of the city. But the single most important factor in convincing the group to adopt the project was the idea of a "guerilla mural." While Mr. Baker, occupant of the grocery and liquor store, welcomed the idea, the absentee owner of the building was never consulted. The unauthorized action was revolutionary in and of itself, even beyond the effects the project would engender.

By late July, workshop members had contributed enough money to support the project, adopted a community-approved list of heroes to be portrayed on the Wall[3] and established rapport with the neighborhood merchants, leaders and the ubiquitous street gangs in the area. A rented scaffold was erected, Sylvia Abernathy's color and space distributions scheme was accepted and work commenced.

The project immediately drew the focus of the community. Crowds of neighborhood people viewed the artists working and often offered unsolicited criticism of the works-in-progress. These discussions led to deep insights into the rich aesthetic sensibility of everyday black folk and gave most of the workshop

artists a new dimension, awareness and sensitivity to the inherent power of visual imagery to engage and to move people.

Curiosity seekers, uneasy tourists, art lovers and political activists of every stripe congregated daily and in ever increasing numbers. Musicians played as the work proceeded. Writers recited their works. Don L. Lee (Haki Madhubuti) and Gwendolyn Brooks composed special poems in tribute to the Wall. Dancers danced, singers sang, and the air was charged with camaraderie and pioneering confidence. Before the Wall was finished on August 24, 1967, it already had become a shrine to black creativity, dubbed the "Great Wall of Respect" by writer John Oliver Killens, a rallying point for revolutionary rhetoric and calls to action, and a national symbol of the heroic black struggle for liberation.

> There is nothing more difficult to take in hand, more perilous to conduct, and more uncertain in its success, than . . . the introduction of a new order of things.
> —Niccolò Machiavelli

Machiavelli was right. The Wall called into question the validity of art for art's sake (the prevailing notion in the academy) and drew national and international media coverage. Some artists detected the presence of undercover Chicago police and covert FBI agents in gatherings. These external elements tied into internal issues.

The completion of the Wall signaled the disintegration of the OBAC Visual Art Workshop. Meetings, always spirited, became rancorous as the group split into factions. Three members of the Workshop felt that the great interest in the Wall demanded a reassessment of the original position of non-cooperation with the media, arguing that the enormity of the project had transcended expectations and that workshop artists were bound to support factual reporting and "set the tone" for "appreciation" of the Wall. The majority, however, held the original resolve and insisted that the Wall now belonged to the community and any attempt to assert sovereignty would be viewed as an attempt at self-promotion and to reap capital gain.

Dissension was heightened by forces of the FBI's National Counter-Intelligence Propaganda Campaign (COINTELPRO), also launched in the summer of 1967 in Chicago. The FBI's intention was to infiltrate, disrupt and destabilize "subversive," "radical," "un-American" organizations. Members of both Workshop factions began receiving anonymous phone calls and unsigned letters accusing them of being spies and traitors to the group and of accepting secret payoffs to exploit the Wall and the community. The tragic effect of COINTELPRO machinations was suspicion, doubt and distrust in what had become a very shaky alliance of artists. These same tactics caused even more tragic consequences in other progressive African American groups throughout the country, for exam-

ple, the Black Panther Party shootings in California and the Black Art Movement shootings which resulted in the wounding of poet Larry Neal in New York City, as well as serious conflagrations in predominantly Euro-American organizations such as the Students for a Democratic Society (SDS).

Tensions continued to mount, as one faction maintained a virtual vigil at the Wall while the other stayed away. Taking advantage of the schism, Walker declared himself "Keeper of the Wall," and suddenly and surreptitiously, Norman Parish's "Political Heroes" [sic] section was white washed. An artist with no prior affiliation with the OBAC Visual Art Workshop painted a new version of the politics section—at Walker's invitation—without the group's knowledge or consent. The majority of the artists were outraged. Parish was devastated[4] and his young family was permanently traumatized.[5]

The dissolution of the Workshop was a downer to be sure, but the community itself suffered even greater damage. Visitors and even photographers who had contributed to the Wall were required to pay fees to view and photograph the mural by "gang bangers" from outside the immediate neighborhood; the Wall created a turf war for extortion rights. Brother Herbert, the neighborhood leader who had been instrumental in obtaining community acceptance of the project and had provided security for the scaffold and painting equipment while the work took place, was murdered. His lifeless body was found propped up against the Wall as an unmistakable assertion of territorial control.

However, there were many positive events and activities associated with the Wall. One of the most significant political acts occurred when Congressman Ralph Metcalfe (D-IL) announced his break with the powerful Mayor Richard J. Daley's Cook County Democratic Organization, which had provided John F. Kennedy's presidential victory margin. This independence of spirit led to early condemnation of the Wall as "unsafe," and by 1973 the Wall and the entire surrounding area was razed by the City of Chicago. To counter the strong reaction that ensued from the black community in Chicago, the city announced plans to rebuild and redevelop the area with a community center and an appropriate tribute to the Wall. Today, the area remains a vast open space and weeds cover the small plaque identifying the site of the Wall of Respect.

The Wall of Respect revived mural painting in America and more. Mural painting had last been popular in this country during the 1930s when over 2,000 works were commissioned by the U.S. government for interior spaces in schools and other public buildings. The outdoor mural movement of the 1960s introduced a distinctly new genre and reintroduced the moral dimension absent from European art for more than a century. It ushered in heightened respectability for the politically engaged African American artist and paved the way for the rise of present-day Africentric styles in art. This movement brought art to the people, and, at the same time, permitted people to participate in the process, of-

fering "a visual glorification of the human spirit, and a vital call to action."[6] The movement can be credited with uplifting the spirits of the people by recognizing their heritage, honoring their chosen heroes and focusing their righteous anger on real issues and the choices available to them. It is also important that the murals served to enhance the quality of life in African American communities by beautifying the surroundings and providing positive and powerful visual imagery of black people writ large. It should be remembered that blacks were rarely seen on billboards, in print or other public media before 1967.

Muralists from other ethnic groups capitalized on this energy, and the spread of the movement through cities in the U.S. as well as Europe reflected the influence of the African American regeneration. The later works reveal the influence of the black artists' penchant for high energy color, bold, uncompromising design techniques, and non-Western patterns and symbols. The trend carried over into the 1980s highly-acclaimed graffiti street art movement, which was marked by the dynamic design and color tendencies of the Wall artists. The African American artists of the 1960s and 70s popularized the use of flamboyant colors against which art schools so often inveigh. Although the work of mainstream artists often lacks the political lifeblood characteristic of the work of black artists in the genre, their use of the visual *franca* of black artists reflects a new worldview. These contemporary developments clearly reveal that black visual art is joining black music as a vital force in world cultural expression.[7]

Although the saga of the Wall of Respect is brief, it was a watershed event in a continuum. In subsequent years, artist groups formed to study and solidify the concepts and aesthetic principles. The political dimension of artistic expression attained new significance throughout the black American art world. Through study of African and other non-Western symbols, individuals and groups of artists developed new expressive modes and established a distinctive presence for the first time in world art history. Indeed, the impact of this collective work continues to be felt.

OBAC Visual Artworkshop [*sic*]

Wall of Respect Black Heroes

Rhythm & Blues

Painting by Wadsworth Jarrell

Billie Holiday, Aretha Franklin, Dinah Washington, Muddy Waters, Smokey Robinson and the Miracles, The Marv[e]lettes, James Brown, Stevie Wonder, Ray Charles

*Photograph of Stevie Wonder by Billie Holiday [*sic*]*

Jazz

Painting by Jeff Donaldson and Elliott Hunter

Charles Parker, Ornette Coleman, Nina Simone, Sarah Vaugh[a]n, Max Roach, Miles Davis, [Thelonious] Monk, Charlie Mingus, John [Coltrane], Eric Dolphy, Lester Young, Sonny Rollins

Photograph of Sarah Vaugh[a]n by Billy Abernathy

Theater

Painting by Barbara Jones

Claudia McNeil, Ruby Dee, Cecily Tyson, Sidney Poitier, Ossie Davis, Oscar Brown, Jr., Dick Gregory

Photo of dancer [Darlene] Blackburn by Roy Lewis

Statesmen

Painting by Norman Parish

Malcolm, Stokely, Rap Brown, Marcus Garvey, Adam Clayton Powell, Jr., Paul Robeson

Malcolm X Park Dedication photo by Roy Lewis

Religion

Painting by William Walker

Elijah Muhammad, Albert Cleage, Nat Turner

Photo of Elijah Muhammad's granddaughter by Robert Sengstacke

Literature

Photography and painting by Edward Christmas

W. E. B. Du Bois, Gwendolyn Brooks, LeRoi Jones, John O. Killens, Lerone Bennett

Photograph of LeRoi Jones by [Darryl] Cowherd

Sports

Painting by Myrna Weaver

Wilt Chamberlain, Jim Brown, Lew Alcindor, Bill Russell, Muhammad Ali

Dance

Painted on newsstand by Carolyn Lawrence

Notes

1. Johari Amini, Walter Bradford, Mike Cook, Ebon Dooley, [Sam] Greenlee, Angela Jackson, Haki Madhubuti, Barbara Malone, Sterling Plumpp, Carolyn Rodgers, and Sigmund Carlos Wimberli were some of the better known OBAC writers. Gwendolyn Brooks was also active and was a spiritual mentor to the group.

2. The AACM, headed by Muhal Richard Abrams, included Thurman Barker, Anthony Braxton, Charles Clark, Chris Gaddy, Joseph Jarmon, Leroy Jenkins, Steve McCall, Maurice McIntyre, Leo Smith, John Stubblefield, Henry Threadgill, and other prominent personalities in contemporary music.

3. From a roster including leaders such as Roy Wilkins, James Farmer, Whitney Young, and Martin Luther King, Jr., community leaders voted for more militant types such as Malcolm X (El Hajj Malik Shabazz), H. Rap Brown, Adam Clayton Powell, Marcus Garvey, Stokely Carmichael (Kwame Toure), Nat Turner, and Elijah Muhammad.

4. See Jane Allen and Derek Guthrie, "Norman Parish's Black Pride Shows thru the Whitewash," *Chicago Tribune*, July 16, 1972, sec. 2, pg. 20.

5. Norman Parish III, "Wall of Respect: How Chicago Artists Gave Birth to Ethnic Mural," *Chicago Tribune*, August 23, 1992, sec. B., pg. 10.

6. James Wishart and Joseph Sander, *Cry for Justice*, AMC and BW of the AFL-CIO, 1972, page 3.

7. See Sylvia Harris's comment on black vernacular visual art and its impact on successful artists such as Keith Haring in *IRAAA* 1301.

Interview with William Walker
(excerpt)

Victor Sorell

June 1991

Sorell: Bill, if we can move to 1966 and 1967, rather than taking a linear point of view on history, we're going sort of in retrospect here. If you would discuss OBAC, which our listeners might not know is the Yoruba word for "chieftain" and also is the acronym for the Organization of Black American Culture—if you could talk about that organization briefly and the place and role of the visual arts in the organization, and how you came to participate within their group and how this led to the painting of the Wall of Respect and at the same time if you could comment at length on the Wall of Respect.

Walker: Well, before mentioning OBAC, I think it's important to mention how the idea came about and what happened prior to my getting involved in OBAC. I stated earlier that when I was down in Memphis—and I don't want to get too far into that—I had a feeling that I should try to contribute something. Well, later on, after returning to Chicago, I got the idea of wanting to paint on a wall. I wasn't sure what I wanted to do. So I spoke with a writer at Forty-Third and Langley by the name of Al Saladine. I told Saladine that I was interested in doing a wall. I wasn't quite sure of the kind of wall, but asked would he be interested in contributing some text and he said yes. I also said that I was going to contact Mitchell Caton, which I did. Caton approved of the idea. The hold-up at that particular point was that Saladine dropped out of sight. Al Saladine was a very brilliant fellow, a writer, an activist and very concerned about the community. I knew he would have been able to make a very meaningful contribution. Saladine drops out of sight, and meanwhile I received a call from Jeff Donaldson—no, not Jeff Donaldson—Billy Abernathy, a friend of mine. He called about a group of artists meeting to possibly form an organization and encouraged me to attend some of those meetings. I don't know how happy he is about that, but in any case I did attend some of the meetings, and I was very impressed with Jeff Donaldson, Elliott Hunter, Billy Abernathy, Mrs. [Sylvia] Abernathy, Myrna Weaver, Kathryn Aikens, Barbara Jones, Edward Christmas, and I don't want to leave anybody out if I can help it. I've been accused of being a scoundrel. But in any case, yes, Roy Lewis, Wadsworth Jarrell, Carolyn Lawrence, all

300

those wonderful people who participated with the Wall. We met several times, and, of course, they discussed philosophy and things of that sort. Then we got down to the business of deciding what direction should this particular group take. So it was at that point that I said that I had planned to paint a wall, and I explained what I meant. Much to my surprise, they proved to be very interested. As a matter of fact, that same night we visited the Wall site. From that point on, we shared it with OBAC, and OBAC got its writers involved and they provided the research. At that time, OBAC had a community workshop, which consisted of writers, a writer's workshop, and the visual artists, at that point, were being asked to consider joining OBAC. OBAC came up with the idea of doing a wall of heroes. And they assigned—no. Prior to assigning anyone any subject or any particular character, they asked all of the artists to design a wall for spaces. We all presented sketches, but Mrs. Sylvia Abernathy presented the most workable and the most sensible design because her design was related to architectural structures, and she had a sense of understanding architectural structures that the other artists did not have because she had attended IIT, a very fine student, incidentally. So, Mrs. Abernathy designed the Wall, I believe, in seven sections. She created a color scheme for the Wall, and she made a very fine presentation. We all agreed. Then it was at that point that OBAC assigned the different artists the different subjects and spaces, and at that particular time, I was offered the space of religion. But I'd like to say first of all that Norman [Parish] had statesmen along with Roy Lewis providing photography. M[y]rna Weaver had sports along with [O]nikwa, who provided the photography. Jeff Donaldson was assigned jazz along with Billy Abernathy, who provided the photography. And Barbara Jones was assigned theater along with Roy Lewis providing photography. Edward Christmas was asked to do literature along with Darryl [Cowherd], who provided photography. I was asked to do religion along with Robert [Sengstacke], Jr., who provided the photography. Wadsworth Jarrell was asked to paint rhythm and blues along with Billy Abernathy providing photography. Carolyn Lawrence was asked to paint the newspaper stand. Later we had the late Will Hancock to paint local heroes, and later Curly [E]llison, who was a very fine sign painter and a graphic artist, painted the name *Wall of Respect* during the height of tension. There was a potential riot in the community because Russ Meek and some other civil rights leaders wanted to have a rally without having a police permit. Commander Harness came out and he confronted them and the police had completely surrounded the community and even had police on the rooftops and old men and women and young kids were crying in the streets because they were not permitted to have this rally. During that time, Curly [E]llison painted on the wall, *The Wall of Respect*. It was a glorious moment, if I might say so, because the artists were not involved in that. We were involved with trying to provide something for the community, and, of course, it was really something. But that was the experience. OBAC, incidentally, had some of the

most talented people that I've ever met. Wonderful people. I must say, it didn't end up that way. I must say along the way, I've had some wonderful experiences with the artists. When I think of OBAC, I think of Mark Rogovin and John Weber, Mitchell Caton and Eugene Eda. Eugene Eda was perhaps the most dedicated. He would drive any place and do public art—even spend his own money. But it was one hell of a period.

Sorell: I think as a footnote to OBAC, not long ago they celebrated an anniversary, and I think they still survive, do they not, as a literary collaborative?

Walker: I believe so, yes.

Sorell: They published an anthology of writings, which is really quite remarkable. They do very clearly acknowledge the important role that visual artists played, so I think you've had a tremendous impact on the organization. Bill, if I might cite a colleague of mine and friend of both of us, Ausbra Ford, who in writing about the *Wall of Respect* underscored the importance of the mural to the immediate community at Forty-Third and Langley. He describes the feelings the people had for the Wall as feelings one might harbor for another person. A person who might be inclined to harm the Wall, Ausbra pointed out, placed himself or herself in mortal peril. I'd appreciate hearing from you how this drama surrounding the meaning of a community mural that, if you will, hits home, why there would be such raw feelings about such a wall. It was the first such wall, was it not?

Walker: Yes.

Sorell: You hear people referring to future murals as other walls of respect. I wonder if you could comment on that, on the feelings that the Wall evoked as a kind of gathering place for the community.

Walker: Well, first of all I'd like to say that Ausbra is absolutely right, correct. The reason I know that he's correct is because of what I have personally experienced in that community. Why? I don't know. I don't even understand it myself. I do know that the people had a great attachment to that Wall. I suppose maybe it was because they didn't have anything. We came in the spirit of love and respect and giving. We didn't ask anything other than their cooperation and once we got into it, we could even [safely] leave our paint on the scaffold in a community that was dominated by drugs, drug dealers, drug users, thieves, rapists, robbers, murderers. That was Forty-Third and Langley Street. Isn't it strange that that particular Wall neutralized people? There were many youngsters killed about

that Wall because during that time my understanding was that the Blackstone Rangers wanted that community because of the Wall. Myself and Eugene Eda later offered to do a wall for the now imprisoned Jeff Fort and some of his Main 21 people such as Thunder and Puddin. But for some reason, they would not accept our offer to do a wall at Fortieth and Lake Park. We wanted to do it on the side of the "el" [elevated train] structure. That Wall meant many things to many people. I saw a young man sitting on the Wall and I was in the television shop and I walked out of the television shop. He was sitting in front of the Wall. His back was just resting. He was resting on the Wall. So I said, "How are you doing, brother?" He said, "I'm getting my strength." I saw people cry. I suppose, my friend, the people in that community realized they had something that other people wanted to share and deal with. It reached a point where some things happened. It was kind of unbelievable. I don't think we, the artists, fully realized what we had created in relation to how people would attach themselves to it, and I'm glad the people did attach themselves to it. I don't think the artists were altogether prepared to give back the love that the people were willing to shower on them. As far as doing anything to the Wall, that was just unheard of. You just couldn't do that. When the Wall was first executed, the people would come all hours of the night. It was truly a wonderful thing. Then other things started to happen. They started having gang wars. Incidentally, during that time the alderman was Ralph Metcalfe. He was not consulted about the Wall, and he was kind of like in a little confusion. He was a little confused because we, the artists, contributed our own funds to paint the Wall, and we didn't ask any political favors. Therefore, we didn't owe the politicians anything. Metcalfe himself was very offended that he had not been painted on the Wall. Of course, he turned out to be an independent near the end of his life. He stood up in an upright posture. The community respected him for his stand against the police brutality and things of that sort. The Wall was many things to many people and Ausbra was absolutely right when he said that anyone who would attempt to damage the Wall would be in great peril.

Sorell: I think it is interesting to observe that there was even a book, as you know, published by the University of Chicago by some clinicians there who titled their book *Behind the Wall of Respect*, which was a book about some of the drug addiction around the Wall, so that they undermined the mural, if you will, by using that title. But at the same time, I think they acknowledged the importance of the mural as a landmark in the community. Bill, it strikes me as an art historian that when you look at the titles of murals, *Wall of Respect*, *Wall of Truth*, *Wall of Dignity*, that these are titles that, in a sense, invite dialogue with a community and they invite dialogue among the artists themselves, the collaborators within the mural process itself. I thought it important for you to comment a little bit on

these titles. Clearly the *Wall of Truth*, which was across the street from the *Wall of Respect* and later the *Wall of Dignity*, which you were invited to do in Detroit, that those three words—respect, truth, dignity—for me underscore naming identity, issues of self-determination that I think were very important within the African-American community and later would be equally important within, say, the Chicano community, the Asian-American community and, more recently, the Native American community; ironically the last to be recognized and yet one that so much is owed to. Can you talk a little bit about these titles and give your own thoughts about them?

Walker: The *Wall of Truth* was across the street from the *Wall of Respect*. The reason we named it the *Wall of Truth* was because we dealt with the subject matter relating to what was happening in that community. In other words, we'd gotten away from the hero type thing. I painted a scene of some starving children. Eda painted some things…I think he did a thing relating to the poem of [Claude] McKay [the Harlem Renaissance poet] which begins: "If we must die, let it not be like hogs hunted and penned…," something, incidentally, that prime minister Churchill used. However he didn't give McKay the credit. We started painting about things that the people were actually experiencing, such as hunger, things of that sort—the reality of the Klan, the reality of hatred, the reality of things that we felt the community should deal with. It was unlike the thing that would later be painted by Eugene Eda, you know, after Elijah Muhammad sent me letters stating that he was considering suing because he was placed on the Wall with Malcolm X. That's why the Wall started to change. I had been responsible for painting the religious section, and not wanting any misunderstanding or any problems, I decided I would just remove him from the Wall at his request. That's when I painted "See, Listen, and Learn." That was a person speaking to a group of individuals. Then Eda changed from statesmen to a more current type thing relating to the Klan and whatnot. We would occasionally change our particular section. So now, when we went to Detroit, [Frank] Ditto wanted a wall called the *Wall of Dignity*—yes, I think the *Wall of Dignity*. At first, we did get Edward Christmas and El[l]iott Hunter involved. El[l]iott Hunter had a painting that was of the late Charlie Parker, the jazz musician, and the painting was so beautifully executed. It was on a panel, I believe a four-by-four panel, and someone removed it from the Wall. We didn't like that. Incidentally, we installed our Wall the same day that Martin Luther King's brother came through Detroit on that poor people's march to Washington. That was after Martin Luther King had been assassinated. But in any case, Frank Ditto had managed to secure a wall on the same lot—oh, maybe fifty feet on a three-story structure. Eda had painted a lot of beautiful things on a masonite board that he just contributed to the Wall. As a matter of fact, he had so many things in panel form that we were

able to cover the entire top part of the Wall in masonite paneling. Then I contributed a center part, and then we had some other things from the first *Wall of Dignity*. Then the Grace Episcopal Church became interested in a wall, and we painted a wall called the *Wall of Pride* for the Grace Episcopal for Rector Hunt and Rector Williams, along with Henry King, Enoch, Jim Malone, Benny White. I'm speaking of the artists now that were involved with painting their particular Wall. Eda and I were able to get a little subsidy out of that, which was minimal. But it was a pleasure doing the Wall with them. John Lockhart painted a portrait on the Wall. We had a wonderful summer there in Detroit. The following year, Father Kerwin asked us to do a wall called the *Harriet Tubman Memorial Wall*. He asked us would we like to paint directly on the church or on panels? We suggested on panels. They gave us a commission. We measured the wall, and we painted the panels in Chicago and drove them over to Detroit. That's how we came up with these different titles. You asked about those titles, such as dignity, pride and respect and things of this sort.

Sorell: Yes, which underscore again and reaffirm that notion of self-determination, which is so very important. Thank you, Bill. Bill, beyond titles, I think something that would be interesting to those who see a relationship between the visual arts and literature is the very fact or essence of OBAC, which was a literary collective or collaborative and remains a literary collaborative to this day, that some of the murals incorporated poetry, some of the murals incorporated other kinds of textual references. And one that will strike a chord with many people is Amiri Baraka or LeRoi Jones's "S.O.S." poem, which appeared on the face of the *Wall of Respect* in Chicago at Forty-Third and Langley and the *Wall of Dignity* in Detroit. I wonder if you might talk about that kind of a poem and other poems. For example, the poem that was incorporated into your Wall dealing with Delbert Tibbs and his trial and the outcome of that trial. I think that would be very interesting to people who see a need for us to look at images and words in juxtaposition and to see how they join and how they're sometimes to be understood independent of each other.

Walker: Well, I think the business of Edward Christmas, he painted the Baraka poem "Calling All Black People, Calling All Black People" in the literature section. It seemed to help some people, I guess, to understand more so beyond just the visual thing. They say, however, that visual art is a universal language. It speaks to all people because it will affect your feelings in some way or the other, depending on your circumstances and your experience as a person and your maturity and things of that sort. Sometimes people are not familiar with symbols—as an example, like the Phoenix or something of that sort. Maybe a less learned individual is not familiar with some visual symbols and things of that sort. I don't

know what Christmas had in mind when he introduced the text in the literature section, but it seemed to have spellbound some of the people who would read it. That's why I got the feeling that it perhaps assisted some individuals in understanding what he was saying visually, because although we painted about Black heroes in the Black community and we painted about people like [W. E. B.] Du Bois, Lerone Bennett, Gwendolyn Brooks, John Kill[e]ns, Baraka, a lot of those people don't even know Baraka, didn't know Du Bois, especially in that particular community, and a lot of so-called sophisticated people don't know about Du Bois and are not familiar with his writings. Of course, he had a dominant head of Du Bois and that was supported balancewise with heads of Lerone Bennett, John Kill[e]ns, Gwendolyn Brooks and LeRoi Jones. Those heads did balance that big head and then the saying by LeRoi Jones. As far as Detroit is concerned, I did introduce some writing with the slave ship poem and I used the words *Wall of Dignity* and I incorporated some visual heads and whatnot in that big saying, you know, *Wall of Dignity*. That worked pretty well. I was interested in experimenting with the words, which I don't usually do. However, people like Mitchell Caton have had walls with a lot of text. Cleveland [Webber] has been involved working with Mitchell Caton a great deal. Cleveland [Webber], better known as Siddha, has been involved in a lot of his own personal murals with a lot of text and explaining to people. It would be interesting one day if you're ever talking with Cleveland [Webber] or some of those individuals to ask them their feelings about that particular matter. I tend to think it's to assist the people who are less familiar with visual expression. It aids them in understanding more about what they're viewing visually.

William Walker Discusses the Wall

Chicago Mural Group Conversation, 1971

John Pitman Weber: [Boston] artists are thinking of working with each other, and I gather this was true from the beginning [here], with the Wall of Respect. In Boston it was actually City Hall that seems to have initiated the thing. The artists have never really gotten together to deal with problems of how to structure their projects in terms of who controls it or to even deal with the aesthetic problems . . .

William Walker: Artists in Chicago are much more responsible to the community. And I think they understand that they're doing things with a purpose rather than just for the sake of doing some decorative art or having some color exercise. I think it's a different attitude on the part of the artists in this city.

JPW: I'd really like to sit down and get more of the history of that in detail from you. Because the impression I'm beginning to get, more and more, was that that was a really crucial starting point. It made a hell of a lot of difference in Chicago.

WW: I think so.

JPW: In a sense, that sort of set the tone.

WW: It was difficult getting the artists started, on the Wall of Respect. I had to force the artists to get started. Because they were dragging their feet. After I learned that they were dragging their feet, I said to the artists "I'm just gonna do the Wall myself." And I really meant it, because I had planned to do it before, before I had even met the artists in OBAC. And then there was a lot of resistance within the community at the beginning. Naturally there would be, because people are suspicious, didn't know what it was about, they didn't understand. But after we got into the community, the community started acting . . . with a different attitude altogether. Children were simply wonderful about the whole thing. And Forty-Third and Langley Street is considered a higher-crime-

rate community, but we had no problems with our paint or anything. Left the paint on the scaffold, you know. No one bothered, no one defaced, during the time we were painting. Or afterwards. The children have only begun now, have just started now marking a little bit . . . since all the panels are gone. . . .

JPW: No actual defacement.

WW: No, not at all. You would think.

JPW: When you first did that, when it was done you actually, you did actually three sections.

WW: No, I only had one section. And that section was assigned to me.

JPW: I'll tell you why I'm asking, Bill: because, I had a chance to meet Hale Woodruff in New York. . . . He gave me a copy of a magazine called *Art and Society* that had been put out by the University of Wisconsin or something back in '68, that featured the Wall of Respect. And they didn't have "Peace and Salvation."

WW: Oh, I see what you're saying.

JPW: There were two other scenes, one with The Messenger . . .

WW: Elijah [Muhammad].

JPW: And another with a large number of faces in profile.

WW: I've done three sections on that Wall, *in* that section, yes. I thought you meant way in the beginning. You're right, I actually have painted three sections: The Messenger was the first mural that I painted; "See, Listen, and Learn" was the second; and "Peace and Salvation." But the reason I painted The Messenger out is because The Messenger requested that he be painted out.

JPW: And what did that get replaced with? That was replaced with "See, Listen, and Learn"?

WW: "See, Listen, and Learn." And then that was replaced with "Peace and Salvation."

JPW: When was "Peace and Salvation" actually painted?

WW: During the time that Eda put up his upper section there.

JPW: Which was also a later addition, right?

WW: That's right. Because Eda's first wall had the two portraits . . .

JPW: And the fist.

WW: Right. But later we put up the other scenes, which were panels.

JPW: So that was after '68, actually.

WW: Yeah . . . it was around '69, when me and Eda worked there.

JPW: It was about the time you were starting on the Wall of Truth.

WW: That's right, matter of fact it was a little before we started on the Wall of Truth. 'Cause I remember the photographer being in the second floor of the building, where the Wall of Truth is now, shooting from the window. That would be in '69 because in '68 [we were] in Detroit that entire summer painting for the Grace Episcopal Church and Frank Ditto, the Wall of Dignity. And then we returned to Detroit that December to paint the Harriet Tubman Memorial Wall. So, what did Woodruff think of the wall paintings?

JPW: He was very impressed; he said he hadn't realized that it was that much in Chicago. He said he was very impressed by the seriousness of the effort. He felt that the slides showed . . . very serious intent and a real sort of following of a kind that he hadn't seen elsewhere. He said that he thought our work was very important, that it had a lot of important social significance. I think he was genuinely impressed.

[**Unknown male voice**]: I'd like to ask, in reference to the Forty-Third Street Wall, is it true that it was the first wall in this country?

WW: Yeah. I believe so. I know it was the first Black wall, Black artists making social statements. Complimenting their Black heroes, I'll say. In the beginning you had three workshops connected to the Wall of Respect: Writers' Workshop, the Community Workshop, and the Visual Arts Workshop, all from OBAC. And the people in OBAC decided to section the walls off: "Statesmen" section, "Sports" section, "Jazz" section, "Literature" section, "Theater," "Religion," "Rhythm and Blues." Now, in the "Statesmen" section, originally, before Eda painted, was a fellow by the name of Norman Parish who did not finish his

section, and there was supposed to be photography by Roy Lewis and Norman Parish. That was their section. The "Sports" section was supposed to be Onikwa and Myrna Weaver. But Onikwa dropped out of sight, so Myrna Weaver painted the section with Muhammad Ali, Bill Russell, Lew Alcindor. Now the "Jazz" section was painted by Jeff Donaldson and Elliott Hunter. With photography by Billy Abernathy Jr. And there was another photo by Roy Lewis of Darlene Blackburn, this would be with the Affro-Arts Theater, in the time Phil Cohran had it. In the "Theater" section, that was painted by Barbara Jones, the photographs by Roy Lewis of Darlene Blackburn was connected with that particular section, however, it was not in the immediate section, it was kind of to the upper right of it. And then the "Literature" section was Edward Christmas and for photography Darryl Cowherd. And that was Du Bois, Gwendolyn Brooks, John Killens, some other cat, I'm trying to think of this writer's name. But I know LeRoi Jones was in there. And the "Religion" section, myself and Bobby Sengstacke had that section. Now, I was supposed to paint King, Elijah, and Nat Turner. Now, the community would not permit us to paint King. Because during that time, you remember 1967, Stokely Carmichael was moving very strong with SNCC, and it was considered the most revolutionary Black group within the Black community, throughout the country. And the people in that particular community were very much in sympathy, or members of, SNCC, so they refused to let us paint King. So I said that I would use Wyatt Tee Walker instead of King. Didn't like the idea. So then, the "Rhythm and Blues" section was painted by Wadsworth Jarrell and photography again by Billy Abernathy Jr. and he had a photograph of Stevie Wonder.

Well, in the meanwhile, we had a number of problems to occur, which caused many of the people from OBAC to split from the community. And I said to the group that I was remaining with the community, rather than go with the artists. So, that left Myrna Weaver, Lenore Franklin, myself. Then I was introduced to Eugene Eda. And Eda painted where Norman Parish had started painting, because Norman Parish had not finished his section and we felt that the section should be finished. So that's when Eda put in the fist, Malcolm, Stokely, and Rap Brown. Later on, we had some other people, such as Curly Ellison, to do the lettering, "The Wall of Respect," on the Wall. And state the purpose of why the Wall, you see. Then, we had a fellow by the name of Will Hancock to paint some portraits of some of the local heroes, such as Joe King and Otis Hyde, and some other people. We had another girl who painted the newsstand by the name of Carolyn Lawrence, incidentally. And then we had David Bradford, who's a very fine artist from out in California, paint the second storefront in the Wall section. And he painted a mother and child. We had a young lady within the community who was very gifted, by the name of Florence Hawkins, who also painted some things, Duke Ellington and Dick Gregory.

So all in all it amounted to about twenty-one people participating in the Wall, when you stop to think of the people who came along later on to paint. I mean, twenty-one including the photographers and Sylvia Abernathy, I consider her to be one of the best designers in the country, laid out the Wall. She had the most workable design for the Wall, insofar as sectioning off the areas for different subjects. And that in itself was a painting, I mean, the way she worked with lights and darks, you know, abstract shapes. And we were supposed to work, according to the way that she had designed things, she had me working in a very high key, Edward Christmas worked in kind of a low key, Barbara Jones worked in stronger colors than myself and Christmas. Wadsworth Jarrell worked in a very high key. That's the way she designed it, you see what I mean. Myrna Weaver was supposed to be a little stronger and Jeff Donaldson and [Billy] Abernathy and Elliott Hunter were supposed to work in a light key. And so was Norman Parish. But when Eda came along, with a different personality, made a different statement altogether. Because I think the fist itself was perhaps the strongest statement on the Wall at that time. Prior to the fist I think the strongest statement on the Wall was Edward Christmas's poem by LeRoi Jones, "Calling All Black People." But that was the first strong statement, I think, the fist. Even the newspapers played it up. And after that . . . we left from honoring the heroes and to the point of making statements about conditions in the community.

[**Unknown male voice**]: I've noticed though talking with various people in this community that a lot of what we would term common folk have some very strong feelings about the meaning of the Wall on Forty-Third and Langley. And it all seems to be positive. And it's sort of amazing in one sense that a person who has had no inclination to pursue the appreciation of art have indulged such strong convictions, on this subject of the Wall on Forty-Third and Langley. And surprisingly enough, it seems that most of the people in the community know of the struggle involved.

WW: Well there was a hell of a struggle, to the point that I almost lost my life twice. Because of stupid, wild, ridiculous rumors. There were some people, including the alderman of the ward, who at that time was Ralph Metcalfe, who actually thought that I was involved with some secret organization. That's a fact. Chances are he no doubt suspected that I was a Communist. And a lot of other people thought that I made a great deal of money—which was ridiculous. Who's gonna pay you to paint a wall? And if they pay you, they're gonna make it known! The first time that I received any subsidy was through the Community Arts Foundation and that was known in the newspapers. People just don't give you money, and not make it known! Unless it's some kind of secret organization designed to overthrow or create confusion within a community, or to create hate.

And none of the walls were created for the purpose of starting any hate. It was created to bring about consciousness.

[**Unknown male voice**]: I'd like to know, did you receive open opposition from Alderman Metcalfe?

WW: No, because Alderman Metcalfe at that time didn't know very much about what was happening in his ward. And you see, it just happened. Before he knew that it had happened it was there. And of course I think Alderman Metcalfe did keep the police off of us. Because I think there was some hostile feeling from the police. Because no one actually understood what was happening. Even some people in the community, some businesspeople, attempted to pay some people to deface the Wall, but they would never do it, when we first started. But after we got it started, and started getting publicity, everyone was proud.

Interview with Eugene "Eda" Wade

Rebecca Zorach and
Marissa Baker

Malcolm X College, April 17, 2015

Rebecca Zorach: Can you tell me about your work on the Wall of Respect, the Black Power fist?

Eugene Wade: I put the Black Power fist on the Wall of Respect. At the time, the members refused to have Martin Luther King painted on there. Bill wanted him on there, but we could have painted him there and could've gotten kicked out or shot at or hurt or whatever. The mood was militant. Although the community may have wanted to see him there, the more militant figures wanted it otherwise.

I came in with Bill, and Bill wanted to make a change. I wanted a section—so someone's section was painted out. Bill was never able to live that down. He said that if he could do it all over again, he would do it differently.

I came down to the Wall and was introduced to Bill by Myrna Weaver. Bill had seen my Malcolm X painting that I was exhibiting in Myrna's gallery. I kept saying, I sure would like to have a section of this wall, I sure would like to have a section. I think at that stage Bill decided maybe he'll move into a second phase and change his section as well. He had me to paint the section that had been whitewashed and at the same time changed his section. He said, I want this to be like a newspaper where people can read this from week to week, and from month to month.

Marissa Baker: How did you get involved initially with the Wall of Respect?

EW: Myrna Weaver and Lenore Franklin had a studio gallery located around Stony Island and Exchange, as I remember. And that was one of the places that the OBAC was meeting in. I was exhibiting there. Bill had seen the Malcolm I had painted on exhibition there before I met him. One day when we were leaving her gallery Myrna said, there's a wall I want to show you. I had no idea what she was talking about. Myrna carried me down to the Wall. I saw Bill and some of the other artists painting. "Wow—this is something I would really like to be a part of." With my type of artwork I've always wanted to paint larger than life on a wall

than on the surface of the small canvas. It was ideal in terms of the sheer size of it. You could paint large, and there was enough space. I used to go down every day. I would talk with Bill, he would introduce me to the people in the community, and I would say, I really would like to have a section. So that's basically how it got under way. He decided, OK, I'm going to call up Norman Parish and see can he touch up his section a little more. Shortly after that, Parish's section on the Wall was just whitewashed. He said, there you are Eda, it's yours. Now he was having a lot of trust in me because he had only seen the Malcolm I had done. But I guess it was something about what people can recognize in terms of a kindred spirit and Bill having the trust in me, in painting that section of the Wall. I could have gotten up there and just flopped in terms of what he figured I would do or could do but I tried to do my best and Bill was very pleased with my style and technique.

The mood of the community demanded the militancy. It demanded blackness on the Wall, less whiteness. That was the whole mood. The clenched fist—the dark colors that's going on. Artists from OBAC criticized that: "You destroyed the continuity of the Wall." No, I said it was the mood that was demanding less whiteness and more blackness. I was going along with that mood. The first thing I had to overcome was my fear. When I entered in the community I had to overcome my fear of being shot or injured or killed. That was the surrounding atmosphere.

RZ: And shot or injured or killed by…?

EW: By the militants.

RZ: So not by the cops?

EW: And the cops as well, right. Because, realize, I was down there painting militant signs, the clenched fist. I was redoing Stokely Carmichael and Rap Brown and Malcolm X. These were all militant, outspoken people, they weren't loved by the police, and neither did the police have any love for the Black Panthers or the Black Power movement. When I'm down at the Wall on the opposite side of the Wall of Respect painting out the Black Panthers with guns and whatever, now you tell me whether the police had any love for Bill or me or OBAC. Police were plotting to kill some of the Panthers already. I mean, what makes the police think I'm not a Black Panther? But this was the mood. There have been people that were writing books, articles, etc., who have gone and asked the police department, CIA, FBI, their activities around the Wall of Respect, and the question is are they going to get the truth? They had people down there talking with Bill. There was one lady that came down to the Wall when Bill and I were painting the inside between Johnny Ray and this church . . . this lady came down there, a well-dressed white lady. Sat in the corner, talked with Bill and I back and forth as

we continued to paint morning up until that evening. She never used the washroom, she never drank any water, she never ate. Bill and I talked about that. I mean, what type of person is that? What was it that she wanted? And we didn't have anything to hide. We've been called all kinds of names, Reds and this and the other. We were trying to paint and do something that can inspire and motivate the Black brothers and sisters, that's all. We weren't trying to get into some other kind of thing. We were trying to *expose* what was happening. The Klan has lynched people. You've had police brutality. We were just showing what was going on, what was happening at that time.

The first thing I had to do was overcome my fear and say look, either I'm going to trust the fact that these militant gangs are going to protect us like Bill said, or I'm going to be too frightened to come back down here. I had to get myself together in terms of whether I'm going to say OK, I'm going to just leave it in their hands. I'm coming down there sincerely. I'm not coming down here to exploit, to get money or whatever else. Bill had already won them over, I had to win them over. They had to learn to trust me. They didn't know who I was . . . they respected Bill. Bill introduced me to every one of the people down there, because he knew everybody. I mean Bill could walk up to a total stranger that he figured was a gang member or whatever else; he would shake his or her hand, introduce himself. I couldn't do that, I mean I just couldn't. Bill could do that, so that was the type of person that Bill was. He knew everybody and everybody knew him. And they knew what he represented, what he stood for. So I admired that in Bill and went along with the program, what Bill was saying. That's how I got involved in the Wall of Respect. In going down to the Wall every day, Bill seeing that I was not afraid, willing to put my life on the line so to speak and get up there on the scaffolding and paint.

MB: Was it Bill that made the decisions about who painted what, or was that made by the group? Were you involved in those kind of decisions?

EW: By the time I was introduced to Bill, the group had left. I didn't see anyone that was in the group still painting on the Wall. Apparently they figured they were going to give it a certain amount of time. As I understand, they were not supposed to put names on the Wall. I don't know, this is just what Bill said and what I've read. But when I took Parish's section and put the Malcolm X up, it had the name on it already. I had signed my name on it.

RZ: You had made that prior to knowing anything about the Wall.

EW: I had already painted the Malcolm X and it was there in the gallery. Bill had seen that painting of Malcolm. I had my name already signed on it. We put it up. I didn't erase my name off it. I didn't know that nobody was supposed

to sign their artwork at that time. But artists change, people change. When Bill changed his artwork I think he put his name on it. The clenched fist with those dark tones, representing the mood at the time. The other artists came back down and signed their names. They figured if they signed their artwork it would not be wiped out as Parish's was.

RZ: Can I ask a question about the part that was wiped out? Did you get a sense from Bill as to why he actually did it? I mean it sounds like partly he wanted to give you a section but why that section was the one that got whitewashed?

EW: That's a good question. What can I say? Myrna and Bill said that that section of Parish's was a nice section but needed some more work done on it. Bill said he contacted Parish concerning this matter of his art. What did Bill say in his interviews about that? I imagine Bill wanted to give me an opportunity to do something because he saw something in me that was kindred to his spirit. I overcame my discomfort or fear pretty soon, I said well, these are my people and if I go out this way, OK. I'm going to be painting on the Wall, I'm going to be doing what I think needs to be done as an outdoor gallery, and I just have to overcome that fear.

I cannot be frightened of my own people regardless, and especially when I'm not exploiting them, I'm not trying to belittle them, and all the other kind of thing. I'm trying to do something here where they can be proud of, they can understand and respect, you see. That was the commitment that I had and Bill felt the same way, you know. There was no money. I never got any money in terms of working on that Wall. But for the community mural movement, Bill and I got paid a salary, a minimum salary in terms of painting murals, but you can't forever do things just for free. Some of the other artists got money. Bill and I didn't make any money from painting the Wall of Respect. If the community had suspected we had, we would have been gone, all right? That's a fact. One day somebody had lied and said Bill had taken some money for painting the Wall and Bill came out of an interesting situation when he thought that his life was on stake and his integrity. He stood down at that Wall and he explained in a very loud, determined voice that no, he had not taken anything and if anybody figured that he had that they should bring it to him and let them confront him. He hadn't taken one penny for painting on the Wall. So he challenged whoever had said that and of course nothing happened. The person never showed up. It was just a rumor. I was there during that time. Bill was quite upset with that lie.

MB: So going back to the idea that the mural was painted in different phases, do you know if that was the idea from the beginning that the imagery would change and be repainted?

EW: No, that was not the beginning idea. They were meeting in Myrna's gallery, and Bill brought that idea to them. Once we were standing by the Wall talking with Johnny Ray and Bill said the reason he wanted to paint this wall was because he was just tired of all the graffiti and these gang names on this wall, and he had always had this idea, what if I just paint something on here that the people can relate to? That is what he was telling us, why he came up with the idea and why he did it. Others have tried to say it was their idea, but Bill knew the people in the community, it was his community. When the section was whitewashed and Bill signed his name, the other artists rushed back and signed their name by their section, left the community, and never came back to do anything else. Bill and I stayed. Bill sees that I'm not afraid. Not saying that other artists who left were afraid, I'm just saying that Bill saw that I was willing to stand with him every day.

RZ: It strikes me as you're talking about the issue of fear that it is quite a different thing to be painting on the Wall in a group with a whole lot of people around who are all working on this collective project and a different thing to be there as just one or two people, you know, if there's a concern about the safety in the neighborhood.

EW: They had strength in themselves because they had the numbers.

RZ: And then for you to continue to go day after day after day . . .

EW: And Bill. Sometimes Bill would be down there painting once we got under way and I would join in sometime. Sometimes I would be down there painting and Bill would join in. It ended up just with Bill and I. That's it. No one else even asked, not even Barbara asked, to put anything else on the Wall. That's how it ended, with Bill and I painting on the Wall.

MB: So as the mural is repainted the imagery shifts from portraits to represent the different difficult conditions in the community, things like that. And you repainted your statesman section to show images of police repression.

EW: That would be the second or third stage where I have the Klan. And if you read the history on the Ku Klux Klan you know what they stood for, what they did. You also have police brutality. What I did was record a realistic act that we saw on television where the police literally ratcheted this lady down to the ground and put their knees on her face and on her body. I got a Klan pointing to what is going on with the police brutality and then over to the right side I got people that were behind a fence, tall fence, like a concentration camp.

MB: Because originally the idea was this collective portrait of Black heroes and then there's this shift to representing the community. Why did that seem important at that time? Or why did that imagery change?

EW: Well, those were ideas of Bill's basically. He wanted to bring it into the Wall. If you're doing a newspaper and current event then we were saying we were dealing with the current event. It was also the concept of a museum that was 24/7, never had closed doors, never was locked up. You could see it any hour, day or night, and people did. We had no idea it would take on that type of momentum. A politician at that time asked Bill, why didn't he put him on the Wall. I was down there. I remember when two of them came down, and they were down at the Wall with news people, they spoke but when it came down for Bill responding to what they said, the newspaper reporters had their orders not to let Bill have the mic and talk. They would not let him talk. I was there. I don't know whether Bill ever has mentioned that, but I have pictures of the two politicians that were down there too. They talked, said whatever they wanted to say and these news people closed shop when Bill got up. Wouldn't let him talk, wouldn't film him.

RZ: Was it the alderman?

EW: It was Ralph Metcalfe. He questioned why he wasn't on the Wall. And of course if you read Jeff's article Bill answered him, and I've heard Bill say the people in the community didn't think that certain politicians had their best interests at hand. Alderman Metcalfe [was] doing it for political reasons.

Something happened with the people in the community around the Wall. A lot of the people weren't respecting it, they didn't understand what we were trying to do. When they kept seeing all kinds of people coming down, all times of night, all times of day. And they begin to say, well, what is it? What are they coming down, piqued their curiosity. So if the Wall is important to people from all over the world, they must be looking at something, they're seeing something. The people in the community begin to like and respect the Wall.

We could not put Dr. King on the Wall. And like I said, it was OK with me because I was mad at him anyway. Literally. Bill always did want Dr. King on the Wall because he figured he had made a great contribution.

Bill was older than I am. I think he was twelve or so, older than I am, so he had more of the insight, the importance of Dr. King's work, but I had gotten angry at him because of the situation, and his nonviolent concept.

MB: Would the community not allow it?

EW: It was basically the militant factor.

RZ: The militants in the community or among the artists?

EW: The militants in the community. When you accept the community, you accept the forces in the community, and who has the control and whatever else. And some of it is fear, let's face it. A lot of people would not speak up because what? Fear. They just would not speak up, and you got those that will speak up, that happened to be stronger. There were a lot of different kinds of people in the community that were militant. One thing they did gave Bill and I respect because they saw us as being sincere. And you can't fool them, I don't care what. Some of them are masters of con-gaming. Well they couldn't con Bill and I either because we had come up through the ranks in the sense of knowing what that is. We had the experiences.

RZ: So when you say militants, does that mean gang members who are espousing a militant ideology? Or is it actually political activists?

EW: Basically we're talking about the gangs. They were the ones that were writing their names and carving out and saying this is our territory, this is our section.

RZ: Had they also become more political?

EW: Well, they respected what we were doing and allowed us to go ahead and paint those type of things. Before I arrived and started working with Bill, Bill and the other artists were told you can't paint Martin Luther King up there. So in that sense they were political because they knew what they wanted and who they didn't want. What they want to be representative of them and who they didn't want.

MB: And what about the Wall of Truth that you painted across street from the Wall of Respect? Can you talk a little bit about how that got started and the imagery?

EW: Well after we had continued to change the original Wall, Bill decided to work on the Wall across the street. At that time there were people living in the other side when we were painting and somehow a fire gutted the building. Bill said, let's go over there, Eda, and paint. We start getting plywood. And there was a guy down there that was a carpenter. He sealed that door and put that plywood

on because they were still going in and out of there. He sealed it up so nobody could even get in the building. We were able to get young kids involved to paint on that side of the wall. We had boards lined up so that they could paint on them like easels. And so that's how that came about when Bill said that, OK, let's go and continue on this side over here.

MB: And were you the only two artists besides the community members that worked on it?

EW: We were the two professional artists. We had some of the young kids that were creative that painted sections. Otherwise, Bill and I were the only two painting in the community that continued to paint. No one else stayed and painted. We're the only ones that decided to continue to go to other communities, other areas such as Detroit. I painted a mural in D.C. when I attended Howard University.

MB: What was the Wall of Truth's relationship to the Wall of Respect? Was it another project or a continuation?

EW: I would say a continuation. It was on the opposite side. It was an available space and so we could continue painting murals, we just start painting on it.

MB: And what about the imagery?

EW: Well, Bill was painting the poor destitute family that is struggling to stay alive and survive, and get enough food. Bill has the father dressed up in a dashiki and the mother is holding the baby. In my section I painted the Panthers with the guns.

MB: What were the ages of the younger people that painted on the mural? Were they like elementary school or high school?

EW: There were some elementary school students as well as teenagers. So we had some that were teenagers, some of them that were younger. Bill knew all of the parents and he knew everybody so that was basically one of his pet projects. I was just down there painting and he [was] encouraging me to help with the young ones, helping them with colors and other kinds of things they needed. Teenagers as well as kids about eight or nine years old. If they wanted to come we would let them paint something on there and then we'd work in and around what they painted to make their design or composition a little more interesting.

The Wall of Respect: How Chicago Artists Gave Birth to the Ethnic Mural

Norman Parish III

from the *Chicago Tribune*,
August 23, 1992

Ruth Pikes had never seen anything like it. She couldn't believe people from out of state would drive into her gang-infested South Side neighborhood just to see the piece of art. "It was a tourist attraction", recalls Pikes, who has lived on the 4300 block of Evans Street since 1961. "When I looked at it I would say, 'We do have people with talent'."

That was 25 years ago. Today, the two-story attraction is gone. It was torn down by the city after a fire gutted the building in 1971. But the former mural covering the old grocery and liquor store at 43rd Street and Langley Avenue is credited with giving birth to thousands of ethnic murals worldwide. In fact, a 6-foot high four-sided mural now sits near the old mural site to commemorate the Wall of Respect.

"The Wall of Respect was one of the most important artistic events of the 1960s", says Edmund Barry Gaither, director of the Museum of the National Center of Afro-American Artists in Boston. "American art wouldn't have regained a sense of social consciousness if it wasn't for the Wall of Respect," he adds. "And the cultural life of countless black communities would have been poorer." Margaret Burroughs, founder of the DuSable Museum of African American History in Chicago, agrees. "It was that piece of work that sparked the whole public art movement in America," Burroughs says. "Even corporations started painting murals."

The concept of mural painting was not new when the Wall of Respect was done. In the 1920s and 1930s, the federal government sponsored murals by artists of all races. Mexican artists such as Diego Rivera and Jose Clemente Orozco also had completed political murals. But unlike earlier murals, the Wall of Respect was completed at the expense of the artists themselves, says artist Eugene "Edaw" Wade, a teacher at Kennedy-King College: "We were trying to beautify the community. The original concept was this was art that could be functional. This was the artists bringing the art to the community. The wall acted as a 24-hour gallery. There were no guards there to protect it."

If the Wall of Respect still existed, it would celebrate its 25th birthday Monday, the date it was completed. Black pride was the message of the controversial mural. Like a lyric in an Aretha Franklin song, these artists "wanted a little respect" for their heroes, community and themselves.

They were nine young black men and women, working artists and photographers, looking for a visual outlet for their works. And they said they didn't want a private foundation to tell them who to paint. "The artists told me that this was their way of letting out their frustrations," says Pikes, whose home is near the former mural site. On the mural, portraits ranged from activist Malcolm X to actress Cicely Tyson. The Rev. Martin Luther King Jr., however, was not included among the original 34 black figures. "King was viewed as too weak, while Malcolm was viewed with strength," says Norman Parish Jr., one of the artists.

The mural immediately became more than a mere painting, attracting several activities from regular poetry readings to controversial political rallies, including one held by the Student Nonviolent Coordinating Committee. Poets Gwendolyn Brooks and Haki Madhubuti, formerly Don L. Lee, composed special tributes to the wall. Dancers and singers also kept spirits high. "It was a special gathering place in the community," recalls Pikes' son, Lawrence Tate, 41.

Some artists claim there also were unwelcome visitors in the neighborhood: the FBI and Chicago police. "They would send letters that harassed and threatened you," says artist Jeff R. Donaldson, who is now an art professor and Dean of the College of Fine Arts at Howard University in Washington, D.C. "I once received a postcard from a group called the Black Tribunal," he says. "It said, 'You have been found guilty by the Black Tribunal. The next time you climb the scaffold, you will be dusted.' I believe that could have been FBI influenced. I wasn't the only one who got those types of letters."

Bob Long, a spokesman for FBI's office in Chicago, said recently that he was not certain whether the FBI monitored the artists' action. A Chicago police spokeswoman denied that police officers harassed the group. Daniel Frye, assistant professor of art at the University of Missouri in Columbia, notes that "The government understood that art was important. Art was socially powerful."

The artists were members of the former Visual Art Workshop of the Organization of Black American Culture (OBAC), which was organized in May, 1967. Its goal was to coordinate activities and promote black pride in the arts. Donaldson was one of OBAC's founders. Others who helped spearhead the group ranged from political activists to university professors. Artist William Walker said it was his idea to have the group paint a mural.

"I was involved in the arts movement—the black arts movement," says photographer Roy Lewis. Lewis, a former *Ebony* magazine photographer, had photos displayed on the mural. "It was exciting," Lewis recalls. "We knew each other. It was a moment to work with your peers. The 'Wall of Respect' was paying trib-

ute to heroes." Donaldson said the group painted on a building that was owned by an absentee landlord and never got permission to paint. Residents, including street gang members, supported the group's action, Donaldson says. "Some negative things happened around the wall," he says. Teens and gang members would extort money from people wanting to take pictures of the mural. "It was like they were saying, 'You come here to exploit our neighborhood, we are going to exploit you like you exploit us,'" Donaldson says.

Donaldson estimated that 25 to 100 people would drive by the mural while artists worked on it during a weekday and 200 to 300 people would visit the site on weekends. Artist Norman Parish Jr. says he enjoyed having people drive by the mural to examine it while he worked on it. "I would see it from the street and feel good," says Parish, who worked as a draftsman at a design company when the mural was being painted. Today, he owns Parish Gallery in Washington, D.C.

"I would come there and work on it on weekends and after work," he says. "It was an art activity. It was a group that had meaning—that is why I got involved in it. It was a place you could use your talent. There weren't many avenues for blacks to showcase our work. So this was an activity you could be involved in."

But soon Parish's joy turned to anger after a portion that he had painted was whitewashed by Walker. "A couple of members of the group said it needed to be more finished," Parish says, "But I thought it was complete." Parish painted the section of the mural called *the Statesmen*. It contained portraits of Malcolm X, Stokely Carmichael (now named Kwame Ture), H. Rap Brown (now named Jamil Abdullah Al-Amin), Marcus Garvey and Adam Clayton Powell Jr. "I believe some of the artists believed that I was not black enough in my thought", Parish says.

But Walker, one of three artists who wanted to have Parish's mural removed from the building, says Parish's section was whitewashed because Malcolm X's image was viewed as "weak." It was painted over a structural recess on the building. Twenty-five years later, however, Walker says that he now believes the mural was strong in its original form. "It was pure nonsense," Walker says about the whitewashing. "It caused me much heartache. It was something that should have never happened."

Sylvia Abernathy, who created the original design for the mural, was one of the people who broke away from the group because Parish's mural was whitewashed. "It turned out to be very ugly," says Abernathy, whose husband, Billy Abernathy, had photographs on the mural. "I saw something changed before my very eyes. A lot of people don't realize that the media pictures that they see of the mural is not the original wall."

Abernathy says she didn't even have any feelings for the altered mural after it was torn down.

Wall of Respect Symposium

School of The Art Institute of
Chicago, April 2015

Opening Address
Romi Crawford

> A drumdrumdrum.
> Humbly we come.

Those words are from Gwendolyn Brooks's 1967 poem in dedication to the Wall of Respect. We do come humbly to this topic. I want to preface my comments with an open acknowledgment that one of the ways that I suggested for thinking about a symposium on the subject was purely pedagogical, this notion of "teach, tell me"—because it set up a special opportunity for people to listen and learn about the Wall of Respect mural from those whom were there in 1967 and know something about it. Of course, who to listen to is one of the open dilemmas—and who is an expert on the Wall of Respect is worth questioning.

My main point is that, in a sense, I don't have much to lay down and teach you about the Wall and its history. There are others in our midst, in this audience, who will be on the next panels, who between them might be able to convey pertinent information to you. I myself am poised and ready to listen closely to what the artists have to say—and part of what I want to do here now is encourage you to do the same, listen to what those who know the most, those who authored and made the Wall, have to say about it. That part of our mission should be ceded I think to those who are worthy of the task.

What I can do is offer a conceptual and theoretical paradigm that I interpret from the Wall of Respect phenomenon. I am interested then in using this time to discuss the generative layering reflected in and through it as a case. Before this moment I did not use the plural to describe the Wall of Respect. The issue of the Wall's versions (1.0, 1.2, 2.0, etc.) or its various phases complicates the story to the point (often) of giving up on analysis. In fact, it introduces a way for us to embrace variance and evolution.

My aim here was to make meaning of the layers. The layers I speak to are formal in nature, in the fact that Sylvia Abernathy's design for the Wall of Respect attempted to fill the surface of the Wall with a swath of images and information.

Versions, phases, complications, and contestation can be read as indices of critical revisioning. The Wall was drafted and then redrafted. It offers an important setting for not just conceptual but also critical license by Black people. This interpretation of it derives from the Wall itself. Let's look at it, closely, carefully. There is the formal layering—of paintings close to and abutting others, sometimes covering up or laying over other paintings. Then there is the layer of photographs on the Wall. There is the layer of text, of the poem and later newspaper and magazine clippings that animated the Wall of Truth.

Then there is the layer of participation and social activity at the Wall of Respect—the gathering of poets, Gwendolyn Brooks, Haki (Don L. Lee), Amus Mor; musicians, Lester Bowie, Joe Jarman, among others. And the layer of many un-notables, noted just the same by the camera works that were taking place at the Wall of Respect. There are other layers that breathe life into the Wall of Respect phenomenon. Layers of anecdote.

Layers of paintings on top of other paintings. Occupational layers: writer, poet, painter, photographer, musician. What we think of as interdisciplinarity was rote and routine.

I had the opportunity to sort through the archive of images by my father, Bob Crawford, with support from a Graham Foundation grant. The layering I speak to might also be applied to our thinking about the multiple archives that need to be put into play in order to know more about the Wall of Respect. As someone working with this archive I pay close attention to how things have been named—he refers to many of the portraits as "Wall people," a simple and benign enough designation but one that conveys another layer of embodied closeness to the space of the Wall, produced by the people who collected and collectivized and decollectivized around it. (The Graham project is called "Leaning into the City," and I am very concerned with the moment of touch, how people make contact on a visceral level with their structural surroundings.) Lots of other people helped to hold down the Wall, people protecting the paint and materials, people making it a place.

Even the versioning that I mentioned earlier (1.0, 1.2, 1.3, etc.)—that reality that there were several iterations of the Wall of Respect—forces us to consider another layer, temporal layers, the August 1967 layer of paintings versus the October 1967 layer.

The definition and etymology of "layer" are useful I think: it is defined as "quantity, or thickness of material, typically one of several, covering a surface or body." And etymology prior to the seventeenth century addresses a quality of soil, but the middle English denotes a mason, "one who lays," and one of the early English uses was in cookery, this is perhaps from French *liue* or "binding"—used of a thickened sauce. This is helpful also in thinking through the makers at the Wall of Respect, who could be interpreted as lay-ers, those who lay something down, only to have that gesture repeated by another layer. Laying is

generative; it implies building and binding. Phenomenologically, the Wall of Respect is thick. It binds too many forms, elements, and authors to be in good taste.

I was interested in this aspect of the Wall of Respect and then the more I researched it the more relevant the complexities of layering seemed to interpreting the Wall and its agency. What is it that all this layering connotes? The Wall is instructive for its painted and marred, then patched-up surface. It teaches us through its multiple iterations that criticality has to be registered in and through aesthetic processes as well as those that are more obviously social and political. The revolving, evolving, devolving process through which the Wall phenomenon comes to fruition is a condition of its origins out of a collective authorship and its origins in the Black Power Movement.

The Wall of Respect offers unique ways of logging dissent and critique—critique of form—portraits, or expressive painting, or heroes and stars, or poetry, or photos, or music, or activism. All are insufficient in some way and all are contested even before the paint has time to dry. The Wall produced an open canvas, an analog screen space, for art making by those of African descent which was not settled in any way, and that didn't settle into any one form—with its mix of photo and paint. It didn't settle into hero worship, as they were variously disarticulated. It didn't settle on authorship, or even the spatial terms (it "jes grew" and went down the block onto Johnny Ray's shop and across the street into the Wall of Truth).

Haki's poem "The Wall" from 1967 [which appears on page 39 of this book] addresses the myriad forms that the makers or layers were grappling with. He ends the poem with an uncanny locution of laying and layers:

> the wall,
>
> the mighty black wall,
>
> "ain't the muthafucka layen there?"

How do we connect the contemporary makers and their work to those who worked on the Wall? I can't help but see the Wall's relation to other art histories and wonder why it is cut off from and disconnected from these histories. I speak to two moves within contemporary visual arts (in addition to graph and graffiti and the predominance of cultural murals and walls in other cities that come after the Wall (another aspect of its generative layering): social practice and the work of several significant contemporary artists who deploy processes of layering in their work stand out in relation to the Wall of Respect.

First I'll address the matter of participation-inflected art making and social practice. There are distinctions between these modes of making and the type of "social" that manifests as an effect of and in the process of producing the Wall of Respect. But it would be useful to more fervently include the Wall and its cues for social connectivity within the context of this sort of art making, when one

326

considers the way that a community of artists forged the project and a community takes it in and enlivens it.

The images that I have been looking to in the Crawford archive are pointed in this direction of the community and social environment that the Wall fosters. How this social faction is like and unlike the "social" of other community and participatory art projects is worth considering in more detail.

Counter to a minimalist effect predominant in 1967 in works like that of Barnett Newman's "Voice of Fire," the Wall is overwrought with layers and meanings and it is overburdened with participation, something which may be at the center of the problematics that surround it. How do you grapple with too many participants? Do the participants claim some authority as authors in the making of the work? That "feeling of being there" on the part of the community and a wide scene of participants, not all of whom are authors (in the literal sense), who were drawn in and felt a sense of involvement is worth considering. How do we register this? It is a problem for social practice in general. I am speaking to those social and community art practitioners, Theaster Gates among others, who may have to deal with a similar problematic somewhere down the line. Tethering the Wall of Respect to these more contemporary instances of community engagement offers pertinent information about the stakes of staging artworks in Black urban communities.

In addition to social practice, contemporary artists who lay images and text upon and atop of the preceding, and who often do so in referencing Black cultural artifacts, history, and literature also connect in important ways to the Wall of Respect. This province of art making consists of those practitioners, such as Mark Bradford, Glenn Ligon, Ellen Gallagher, who often make work by building the canvas layer by layer, and with material that references either Black urban space or other indices of Black literature and culture. They make work that deploys methods and processes of layering to create the effect of an errant visual surface—erased, smudged, painted, repainted, full of articulations and disarticulations. Their works reveal a process of critical revisioning by layering Black stuff. So, here the Wall and its formal ethos is instructive to a contemporary realm of makers. While call-and-response and improvisation are appreciable aspects of African American aesthetics, this layering and critical remaking (through removals, erasures, drop-outs, white-outs) is an underappreciated aesthetic tendency. The Wall of Respect's formal legacy has more connection to contemporary visual art by artists of African descent than is readily perceived.

This is all to say that the Wall of Respect is instructive. We should listen to those who were there and who know it best. We should also look at its surface, marred and dripping, crammed with knowledge and pathos that it can't contain and hold, that won't stick (forever). All of its layers teach us something about criticality and dissent of all forms—aesthetic, political, social. Being open, working with it, through it, hoping to lay down some scholarship and historical con-

textualization seems the best thing to do. This is what we might say is the trying out of an art historical layer of the Wall of Respect.

Roundtable Discussion

Moderated by Faheem Majeed, with Darryl Cowherd, Roy Lewis, Norman Parish III, Robert "Bobby" Sengstacke, and Eugene "Eda" Wade

Faheem Majeed: "Walls and Boundaries." I was thinking a lot about what a wall is. It is interesting how many of the contributors to the Wall of Respect took something traditional about the word a "wall," which is used sometimes as a boundary to keep things in, or keep things out. And kind of switched that around into a monument that was there for kind of encouraging community. So, the Wall as a community solution versus a political statement is something that I have a question about. Can someone talk a little bit about the intent? I've heard ideas about positive imagery, that people in the community needed positive images, but it evolved into something bigger and bigger. Was that the original intent, when everyone got together and sat down, did you realize that fifty years later, we'd be sitting on this stage? Or was it more of a response to something, a need? Is there someone who wants to start us off, maybe? And before we start: this is the student asking. You are the teachers, you represent the teachers, right? I'm a generation that benefitted from your breadcrumbs, feasting on that. So I'm asking you for clarity on that, and then later on we can talk about how I can build on that, how my students can build on that.

Robert "Bobby" Sengstacke: The Wall of Respect was started by a group called OBAC, and Abdul Alkalimat is not here, he was a founder of OBAC, he's the last surviving [founding] member. But they had a Visual Arts Workshop, the Writers' Workshop, and I think the Writers' Workshop is still going on today. The Visual Arts Workshop was founded by a group of artists: Darryl Cowherd, Roy Lewis, myself, and there's a few other artists. Now, I'm talking about the photographers right now. I have a thing I say, history's no mystery, when you see it you gotta believe it. And photography normally would not have been a part [of the group] but OBAC was so open, they had graphic artists, visual artists, and photographers, which was great. The only organization I ever joined was OBAC because I was with the *Chicago Defender*. I don't know how Bob Crawford missed becoming a part of OBAC, he should have been.

FM: I'm interested in hearing about the history. I'm trying to figure out what to do with the history, how to build on the legacy. Or should I build on the legacy? And when I say "I," I don't mean just *I*. I think a lot of us in the room are trying

to figure out: hey, here's this powerful thing, and we want to respect it, but we also want to . . . carry it on. And are we able to do that? I'm going to ask Eda to talk a little bit about improvisation, about the benefits and the challenges of working within a community. During that time, specific to that moment. Can you talk a little bit about that?

Eugene "Eda" Wade: The intent was in reference to beautifying the community, having something that was educational and functional. I started on the Wall with the second stage, I'm in the second phase of it. We have a little situation. What happened during the time of the creation of the Wall, this is not the first one. Most of you are familiar with the first stage. I came in on the second stage. We got a bit of a conflict, because as a struggling family of artists, you're going to make mistakes. And one of the things that happened was the second phase, when I came in, and was introduced to Bill by Myrna Weaver. Bill tested me out for a few weeks to see whether I was sincere. Because coming in, in that situation, meant that you could be killed, you could be injured, in that area there were pimps, hustlers, and a lot of the community family people who were afraid of the pimps, drug dealers, and hustlers. Bill Walker, who originated the concept and idea of beautifying the community, often talked to me about how he would come by and look at the wall with all the graffiti on it and say, "One day I want to paint over that graffiti and do something that the people can be proud of." The other thing in terms of intent is that it would be an outdoor gallery. You can come to that Wall and look at it for all hours of night, and people did.

I come in on the second stage of the Wall. [Norman] Parish's artwork ended up being painted out with the permission of Bill. I guess Bill cannot be blamed totally. Because I was down there every day, from the day I met Bill, drooling and looking and expanding on the concept of how I could be involved in that mural, but I had to go through a test: would I be brave enough to stay and work with him, because his idea was to use it as a newspaper, where week to week and month to month it would be changed. So that's how my involvement comes about in the second phase. Bill gives me that section, it's already whitewashed, he tells me to go ahead, after I proved myself. Now, by proving myself, I'm talking about, I met the people down there—these were all types of groups, these were family people. Bill knew the kids down there, and he introduced me to everybody. And once I had demonstrated to Bill and the community that I could be trustworthy, and was not afraid, and that I would allow the so-called young militants down there, to watch my back, protect the materials, and everything else. And then Bill said, well, there's a section there that you can go ahead and paint. So I ended up painting the clenched fist, because it was the mood that changed—the mood changed. It was more melanin that was needed, in terms of the mood of the community. Black Power symbols. Now, I used some of the same figures that Parish used, Stokely Carmichael, Rap Brown, and Malcolm X, but

the mood in terms of the Black movement changed—I used some of the yellows that Myrna had painted. There were some concepts of whether what I painted, with the dark colors, messed up the whole Wall or composition or whatever, but the mood of the blackness, in terms of the Black Power Movement and the whole thrust of that was calling for something that was a little more dramatic. The Black Power symbol, the blackness in terms of the black color which was representing more black, more melanin, on the Wall, that was the concept originally, why I painted that section with those colors.

FM: This notion of "don't paint over my stuff," you know what I mean, but there's a certain amount of ego. But what's interesting that comes up today, is this notion—you're talking about community, you're explaining the reason, that evolution—it wasn't about erasure, it was about adding. It was about layers. It was about a newspaper, it was about what was current.

EW: It was about the mood.

FM: It was about the movement.

EW: What was happening: movement and mood.

FM: So, which is a very contrasting thing. As artists—there's a lot of us in the room—we want our ideas front and foremost, but the notion of stepping back and realizing that we're all one piece in a movable collage of ideas, that change can come in and out, I never really heard of it talked [about] in that sort of way, as one fluid ballet where things recede and come forward, which is why the photography and documentation is so important. Because it's an ever-evolving thing—if you ain't there, you gon' miss it! But we can document it, and talk about it.

EW: Let me bring up this other point, Bill regretted the fact that he had white-washed Parish's section, the way it was done. Although he still had to get permission from the people in the community, that is, the militant factor especially, even to make the change. Herbert Colbert is the one that went up and painted over Parish's section with white paint. Bill was trusting me to be able to paint what I did, in reference to that section. But it was based upon trust and would I have enough courage to be able to stay there and rely on the militant factors to protect us, and the painting and whatever else, you see. But he regretted whitewashing that section. He mentioned that several times, that he regretted the fact that Parish's work was painted over. He felt that he could have done it a different way, but he's gone on now. I worked with Bill over the years and he truly regretted that act. But he also had the idea that he wanted to use that as a newspaper, something that could be changed from month to month, week to week or whatever. So

that was just the second phase of that. The second phase, Bill got a man named Curly [Ellison], he was a sign painter at that time. He got up there and put "Wall of Respect." If you go back to the original Wall, that name wasn't even there.

FM: Was that an improvisation? That you're referencing, those kind of things happening. We're able to sit now and kind of speculate on how things happened, but in the moment there were these small conversations?

EW: Yes, Bill insisted on that being changed, continuously.

FM: I want Norman to talk a little bit, too.

Norman Parish III: I'm going to admit, this is difficult to respond to. You're asking me to respond to what my father would say. And so, I'm going to say all this first before I get into a response. So, I am fifty-four years old. And I'm trying to respond to my father, who had way more knowledge than me in art. I'm a journalist. I'm a thirty-year veteran journalist, who's won all kinds of awards, was the only Black editor at the *Sun-Times*, until a month ago when I took a buyout. And so I'm in a position here where I'm trying to respond to things that happened almost fifty years ago. And I'm glad that the Art Institute of Chicago and the University of Chicago and all the other entities are involved in putting this together. I think that this should have happened twenty-five years ago so my father could be sitting here. So Bill Walker could be sitting here. So Jeff Donaldson could be sitting here. So, you're basically asking me to respond like a ghost! And I talk to [Wadsworth] Jarrell here, who's a good family friend. Watching him, growing up as a kid, I'd wake up and him and my father—struggling artists, they're going to art fairs, they come in late at night, and I'd wake up in the morning and Jarrell was sleeping on the couch. The art community was very close back then, in the '60s. And so I'm saying this to give you a picture for how close these men were, and how they worked together. And so when you talk about betrayal, issues like that, when you're close with people and you worked on something.

Jarrell has a book coming out, and he talks about how excited my dad was, he actually got my dad's words, he got a lot from some other artists too, and he talks about how excited he was. He never talked about being fearful. He loved the community. He grew up on the South Side. The only time I heard [of] my father being fearful was when he was a small boy, and—I brought his sister here last night, my aunt—he was born actually in the ninth ward, in New Orleans. He was excited about getting involved in this project, he was involved in it, he, at that time he had two kids—three kids, my brother was gonna be born that summer—he had a bit of a family, so he had other responsibilities that some of the other artists didn't have. And I remember, I was old enough to go down there: I was seven years old. So I went down there, I saw it. I remember it. And, so I'm

not like some of the other people here. I remember it. I remember when it was something bad happening. That's how I internalized it, as a set-up. I remember people coming to our house, talking about it. I remember people talking about police, that kind of thing. But my dad, he was very upset when it happened. Needless to say. He talked about the family unity, the closeness of the group. He was part of OBAC. In fact, I think he went and came and recruited Jarrell to be part of the project. And so he and my dad were like brothers, really close. And when he moved to D.C., he got really really close with you, Roy, I know you guys were really close, in fact you were there when my dad was dying, and you actually were there with him.

And so, when you take something like a project you're involved in, and the trust that people have, and something is broken, that was a deep thing. And for all of them, that caused a lot of disruption. I mean, that's the one point, I think that I can say. Now, how my father would respond—anyone who knows my father knows he was very articulate. Quick-minded and I don't pretend to have my father's skills in those ways, but I can hold my own. But he was upset, he moved on, he continued to promote Black art. He had a gallery he ran for twenty years in Georgetown, for a long time he was the only Black business in Georgetown. He had 170 artists that he promoted, some very well known, some not too well known, that he tried to promote and get their career going. Because it was important to be in the center of America, Washington D.C., and give African Americans, not just African Americans, but Blacks throughout the world, a high-profile presence in the art world. And so if you look at the Wall of Respect, in a sense, this is when Blacks weren't getting into the galleries, Blacks weren't in the museums. And so here were these Black men who were standing up.

FM: Roy, can you jump in a little bit, talking about intent.

Roy Lewis: But Bob Sengstacke, Fundi [Billy Abernathy], Sharif, Gerald McWorter, I know you've heard that name a lot—Gerald was down in southern Illinois and he put together a series of photo exhibits of these four photographers, and I was the one who wrapped it up. And so my exhibit was *From the Wall of Respect to FESTAC*. And so the young lady says, "Roy, you've got to put together a statement about this exhibit." Second World Festival of African Art and Culture, 1977. So the Wall of Respect was done in '67, FESTAC was in Lagos, Nigeria, in 1977, so some of the same people who were involved in the Wall of Respect were at the Second World Festival of African Art and Culture, which was the second one, the first one was in Senegal. And so it happened for a month. So the outgrowth, you talk about the Wall of Respect and the impact, that a lot of people who were involved in the Wall of Respect also went to FESTAC and we had over four hundred artists and musicians and writers who went

to participate in the Second World Festival of African Art and Culture. So, my exhibit, since I documented both, was to bring that exhibit down and show the *Wall of Respect to FESTAC.* So the exhibit was actually, the first photograph I took of that Wall, to the finish, and then FESTAC, our participation in FESTAC. This is what I wrote on April 3, 1984, and I started writing it in New York, so it says "New York to Washington to Urbana: The Wall of Respect at FESTAC."

The first artist was the Creator. His Blend of Time, Space, and Distance will never be duplicated. Yet artists try, and since the first cave drawing to electronic transmitting of images and sound through space, artists have been trying to outdo the Master Artist.

On May 28, 1967, at Lincoln Center in Chicago, we came together to create an organization that would be called the Organization of Black American Culture (OBAC).

Our purpose was to bring together community, art, music, dance, drama, and writing to enhance the spirit and vigor in the Black community.

The opening introduction was given by Gerald McWorter, later Abdul, one of the founding members. He danced with the singer, Sherri Scott, and we knew we were off on the right foot. David Moore or "Moose" read from his "Hip Generation" poem, Jeff Donaldson preached, and we had some music by Fred Humphrey Quartet.

We left there fired up; we had filled out forms that categorized us as artists, musicians, and community workshop performers.

The Visual Artist group met two or three weeks later, at Myrna Weaver's studio on Stony Island. We discussed ideas, goals and what we were going to do. Bill Walker proposed doing a mural drawing at Forty-Third and Langley, because he had been doing work in that neighborhood and felt we would be well received. The idea was discussed back and forth, and we decided to go down and see the wall—that same night. It was decided that the wall would serve our needs and bring some art to the community. I photographed the wall for the rest of the group to study and use for their paintings. Sylvia Abernathy's layout was selected to use as the blueprint on the wall area and selected artists decided what section they would work on. There were to be seven sections. First: "Rhythm and Blues." "Jazz," "Theater," "Statesmen," "Religion," "Literature," and "Sports." The community liked the idea and helped with the painting of the primer coat and was always there to give moral support; it was truly art and people as one. As the Wall progressed, the word spread and people from all over the country would drive by and check out the Wall. As we came close to the finish, a political action group decided to hold a rally at the Wall. They decided that OBAC as an organization should not attend. (It wasn't them. That was a mistake.) So we issued a statement about who OBAC was, our purpose and goals, we listed our sections and thanked the community.

Now, that's a document that will be in Useni Perkins's book that's coming out on Chicago. And so that lays the foundation for what was really happening there. A lot of other things happened: we finished, and then the dedication, the wall was named. It was just "The Wall"! And then I just found out today how "The Wall of Respect" got up there. So, a lot of things are being clarified. But this piece was representative of, the fact that the spread that wound up in *Ebony* [December] 1967, and Lerone Bennett wrote the article and my photographs are in there. The photos that went out to the world were the ones with Eda's piece on it. And as a result, a lot of people never even saw the first Wall. The original one. That's the one that went out to the world. And it was tragic that it happened. The first time—when I walked up on that. The New Politics Convention was in town. In September or October. A group of us went down there just to see it, at lunchtime, those people had gone out to lunch. Me and Darryl Cowherd and Gaston Neal and another brother, we went up there and took the banner down: "Full Support for Black Liberation" that's what it said up on a big, huge banner. We took it down, we took it down to the Wall, and that's when we walked up on it. There was no painting on the Wall. It was just white paint up there. And we fell out. Because none of us had been consulted!

It wasn't just Walker's wall, it was all of our wall. It was a community wall. And so, what we did was we took a photo of the banner, underneath the Wall, with Darryl holding it and we took the photo, gave it to Gaston to take back to D.C., which later got burned up during the riots in '68. But what I'm saying is—please expand. Darryl and I, we were called wide-angle shooters. Bob, a lot of people, were shooting narrow. We were wide-angles because we wanted to have as much information as possible. So start locking in on any one little phase, where you, because that's where your nut was. This thing was bigger than any of us! In no way there on Stony Island did we realize this thing was going to be as big as it was. We didn't know, we had no idea, but it did and it grew. Hell, the photographers, we wanted to take a 4×5 camera out there, take a photo of it and sell it, that's what we wanted to do, but we were voted down. We were voted down! We wanted to make sure that the people, that when they come there, and it would have been a fundraiser for the Wall or for the Organization of Black American Culture. But we didn't do it because we were voted down, the democracy in the Wall was OBAC. It was the Organization of Black American Culture.

FM: Wow. Darryl, can you jump in there a little bit?

Darryl Cowherd: First of all, I have to acknowledge Bill Walker. Billy and Sylvia Abernathy, and Onikwa Bill Wallace. They are not here, so I'm rapping for them. There are two people on this stage who were there at the absolute onset. That is myself and Wadsworth Jarrell. I can definitely corroborate that the naming of the Wall of Respect came very early on, by Myrna, long before we even began

work on it. Bobby said something about how history is no mystery. Well, maybe so, maybe not, but there is a considerable amount of misinformation as far as I'm concerned, that's getting out that probably should be corrected, I just don't know if this is the time and the place. As to intent, my real recollection is that from the very onset, it was about the community, it was about some politicization of the community, it was about bringing some art to the community. It changed as time went on, what the intent was, but originally that was the intent of the Wall. And brother Parish, with all due respect: it was Bill Walker's wall! It was Bill Walker's wall. And you know, my best memory is that Bill made the decision, we went along with the decision because it was Bill Walker's wall. There was no way on God's earth that any of that could have taken place without Bill Walker. The Wall itself wasn't proprietary. The *project* was Bill Walker's.

FM: He was the spark, we're talking about spark. We're talking about bringing people into the drum circle. It becomes something different. Everything about this is evolving, changing, some things work, some things don't work, depending on what angle you're looking into it, it changes. These are things that I'm very interested in. And I get the sense, Barbara Jones-Hogu, who isn't here today, is my hero. That *Unite* piece? Changed my life. And she's not here today but she talked a lot to me about the neighborhood. About the mothers and their sons, right, needing these positive images, needing all these Black men on the stage, present, fighting it out over imagery in the community. That's important. Yes, we're talking about this now but ultimately, who's watching?

The Wall
Roger Bonair-Asgard

> . . . they are ready to rile / the high-flung ground
> —Gwendolyn Brooks

I am a poet, and so, I tried to write a poem for the Wall of Respect. But some-
times, some subjects defy our efforts to confine or define them in the manners
we plan. But this is fitting. Of course the Wall of Respect said no to verse, said no
to patterned rhyme and meter, said no to all manner of chant and rant and holler.
The Wall did what the wall was meant and made to do, defy and force you, black
person, to see your own self most clearly. And so, like Bruce Lee I became water
and filled the vessel I was given, and so this, is about me.

I was born in 1968. Not old enough to have seen the wall, live. I was however,
alive and sentient enough to have heard the first rap song on the radio and to
know, even all the way in Trinidad, and at age 11 that I was witnessing history—
that something had come my way that was not about to ever leave, even as the
mainstream tried to convince us that it wasn't long for the world—long before
Vanilla Ice and Iggy Azalea said it was their music, too. I moved to New York
City in 1987. I was 19 and hungry and insatiable and a bottomless pit of energy
and remarkably stupid. But I stayed in the streets, and so I learned in increments
what it meant to be black not just in my skin, but in America. What some folk
like to call the Golden Age of hip-hop helped me parse that meaning. I landed
at JFK with Eric B and Rakim in my Walkman, KRS-1 already memorized, and
slid into the rising legend of A Tribe Called Quest, Leaders of the New School
et al. In a couple years, we'd have Niggas With Attitude, Public Enemy, EPMD,
and Naughty by Nature. Hip-Hop was beginning to develop a catalog and a
pedagogy. I was learning that the apprehension of Hip-Hop required the study
of emceeing, DJing, B-boying and graf writing. The last of these has its roots
planted most deeply. Of course the word mural has its roots in the Latin word for
wall. The walls of Brooklyn were occasioned in different neighborhoods with
sprawling canvasses of Muhammad Ali and Malcolm X, Martin Luther King Jr.
and Sojourner Truth, Arthur Ashe and Dr. J, Frederick Douglass and Adam
Clayton Powell Jr., Shirley Chisolm and Diana Ross and on and on and on. I
had no idea then that none of these walls would exist if not for the original Wall
of Respect here in Chicago, IL.

You Chicagoans would probably agree all too readily that ain't real quick that a New Yorker gon' say yeah Chicago had some shit first, but in those days terms like "singular black aesthetic" were foreign to me. Like most of us, I had been educated by the West, and of course that means by the white West, and so the idea that to be Black or African or African American meant to be in possession of anything, much less an aesthetic was something that was foreign for me as it might have been for many of us in this room before we had the good fortune to get woke and stay woke. There had been moments of woke for me. My mother reminded me every day as a child that I was black. She taught me the alphabet from something called the Weusi Alphabeti, which began A is for Africa, B is for Black, C is for Culture and that's where it's at. She prepared me to be able to see the Wall, and stay woke.

Depending on the hip-hop timeline you consult, you'll learn that the first graffiti made itself known anywhere from the late 60s to the early 70s. Graffiti is the unseen making itself, seen; making sure that you know they are present and accounted for. From tag to throw up to piece, writers get-up (the terminology underscoring that you get as high as you can) so that an entire city can see who you are. In the early 90s I was fascinated by the places a writer could put her name, imagined the body's logistics to arrive at specific spots on a bridge or overpass or under the eave of a high rise building. Of course we are in [the] Art Institute of Chicago, home of one of the most famous bombings in the history of the graf movement, This Is Modern Art. In New York City, in Chicago, in Los Angeles in every major American city, an entire industry and an entire category of criminalization has been invented to deal with those who will not remain unseen, who refuse to stay in the shadows and out the train yards. Entire political careers have been built on the backs of graffiti writers, and on their deaths, and what I'm saying now is that graffiti as an underground institution, as an art movement does not exist without the wall of respect, does not exist without Chicago, does not exist without the South Side. Remember that even as we are smack bang in the middle of another political dismantling of a neighborhood, just as a political dismantling of a neighborhood got rid of the Wall in 1971. The closing of 54 public schools here means that the neighborhoods that have given us this Wall, and all the following works that mimic the Wall, are under siege again, by politicians and developers. And they are under siege in every American city we have and we have voices that adorn and tear down Walls and build them back up and exalt them because the Wall of Respect once existed.

The Wall got an entire branch of art woke, and because this was the most public some Art could be, the most democratic some art could be, the most "for the people" some art could be, it meant that for many of us the moment of woke, was The Moment of the Wall, and for many future generations, The Wall and its descendant walls became the moment of Woke.

There are of course several lessons for us in this moment. As a live piece of Art in the world, the Wall existed for less than 5 years, yet here we are almost 50 years later not only talking about it, but celebrating its existence, its influence and plotting the trajectory of several artistic threads out from its massive epicenter. As the people would say, *well Look at God!* It is this essence, this power that is actually the one at the center of all African diasporic Art, the idea that legacy for us is not in our names on buildings or History with the capital H, but the idea that no matter how we got messed with, we were there, and we stayed relevant and woke and undeniable. Even the legendary quarrels that were involved in the competing ideologies for the wall are part of that legacy and part of the democracy of that legacy and part of why, we make an art that assures us that we will survive. This Wall and our art is evidence that we are not extinguishable, and that's why we are here today.

The mural, as a form, is designed to make its subjects massive, gigantic, unignorable. In this way, it asks to confront power much like the graf tag does, by announcing itself larger than the writer ever could. The concomitant effect is that the artist is rendered invisible, and maybe this is why we've only come to holler at the artists of the original Wall now. I'm sure those of us walking around in these skins can think of some other reasons too. Let us make this the last time this is true. If we can kiss this gone mural up to God, let's do so with an invocation of their names.

When I think of this Wall of Respect and various others like it in Brooklyn, the first face that comes back to me is Yusef Hawkins. One of the features of these murals is the local is always represented. Yusef Hawkins was a 16 year old boy who ventured into the largely Italian neighborhood of Bensonhurst, Brooklyn. He was killed by a group of white youths for the always unforgivable sin of visiting a white girl in their neighborhood. As a 20 year old in New York City, this story imprinted itself on my mind, and the Wall at the corner of Fulton Street and Brooklyn Ave I believe wouldn't let me forget him; wouldn't let me forget how he died. The Wall gave us this first neighborhood shout across the rooftops, warning, reminder, encouragement to stay vigilant and safe. As a not quite man in America, it was a legacy for me to inherit, to celebrate my life, to mind my body, to stay woke!

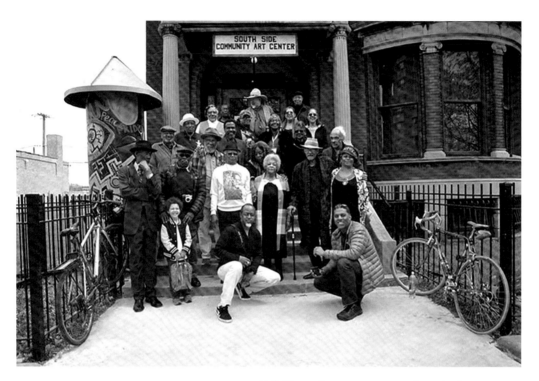

Wall of Respect Symposium convening at the South Side
Community Art Center, 2015. Copyright © Tony Smith/
Romi Crawford.

Acknowledgments

Many, many individuals and organizations supported the production of this book. We particularly wish to thank Darryl Cowherd, Roy Lewis, and Robert Sengstacke for their participation in this project, and all the contributors to the book. We are grateful for the support of OBAC alumni Bennett Jonson and Joseph Simpson, and to Daniel Schulman for spearheading a related exhibition at the Chicago Cultural Center. This book would not exist were it not for the talents and energies of staff at Northwestern University Press, in particular Gianna Mosser, Maggie Grossman, Anne Gendler, and Marianne Jankowski.

Before the manuscript could reach Northwestern University Press, the pieces had to come together. Kate Aguirre transcribed most of the original texts and recordings, with help from LaKeisha Leek. Mike Phillips copyedited the entire manuscript prior to submission. Most of the images were scanned by the University of Chicago's Visual Resources Center, and we are especially grateful for the expertise and generosity of Bridget Madden, Whitney Gaylord, and their staff. Several muralists and photographers—Mark Rogovin, Robert A. Sengstacke, and Georg Stahl in particular—facilitated our research by generously providing their images for digital collections hosted by the VRC. The Chicago Public Art Group and its executive director, Steve Weaver (and past executive director Jon Pounds), kindly provided access to recordings of Chicago Mural Group meetings.

Several institutions supported conversations that propelled this project forward. Northwestern's Black Arts Initiative, led by E. Patrick Johnson, hosted the conference "Black Arts United States: Institutions and Interventions," at which Abdul spoke in June 2015, sparking the project of this book. Two projects supported by the Terra Foundation, prior to the conceptualization of this book, also contributed to our research. A 2015 symposium at the School of the Art Institute of Chicago, "The Wall of Respect and People's Art since 1967," elicited conversations among original participants and later observers that made new research on the Wall possible. Drea Howenstein particularly deserves gratitude for her very hard work on that symposium, and Tony Smith and Drea Howenstein together facilitated access to the recording of the events. The Terra Foundation also supported research toward the South Side Stories exhibition project of the Smart and DuSable Museums, producing material that made its way into this book. Much of that research was carried out by Marissa Baker, with additional interviews performed by Jessica G. Moss. The Graham Founda-

tion provided funding for "Leaning into the City," supporting Romi Crawford's early research on the Bob Crawford archive. Funding for image reproductions and publication subvention was provided by the Terra Foundation, the Warnock Publication Fund of Northwestern University's Art History Department, and the Liberal Arts and Visual & Critical Studies Departments at the School of the Art Institute of Chicago.

While this book was in production, Robert A. "Bobby" Sengstacke passed away. We are grateful for the time we spent with him and glad he was able to know the project was in the works, though not to see it come to fruition.

Personal Acknowledgments

For the three most important women in my life: my wife, Kate; my sister, Aysha (Sandra); and my daughter, Mei-Ling.

—Abdul Alkalimat

I would like to acknowledge Darryl Cowherd, Roy Lewis, and Bobby Sengstacke for their commitment to this book. Additional thanks go to the scholars who conceived OBAC, notably Abdul Alkalimat. My gratitude also extends to members of Chicago's Black Arts community of the 1960s and '70s, who were inspiring—Bob Paige, Amus Mor, Cherie Wilkinson, Carol Adams, Veela Sengstacke, Laini, Fundi, Pat Akin, and Haki Madhubuti. Also a thank you to those who have been in the conversation with me—Dolly Meieran, Lauren Berlant, Amy Mooney, Leslie Williams, Rebecca Zorach, Valerie Cassel Oliver, Julio Finn, Timothy Knowles, Shawn Michelle Smith, Kym Pinder, Margo Natalie Crawford, and Deb Willis. Love and support from my mother Margo, Damien, and Zach Eagle have made this possible for me, and the memory of my beloved father, Bob Crawford, has served as a beacon from start to finish.

—Romi Crawford

I wish to acknowledge the many muralists and photographers who have given generously of their time to help make sense of the Wall's history. Along with thanks to my coauthors and to individuals already mentioned above, I thank Lawrence D'Antignac, Jameela Donaldson, Greg Foster-Rice, Juarez Hawkins, Wadsworth Jarrell, Rochelle Hunter Miles, Lavon Pettis, Bert Phillips, Gibran Villalobos, Eugene "Eda" Wade, the late C. Siddha Webber, and John Pitman Weber. And although he is mentioned in our collective words above, I have to express gratitude again to the late Robert A. Sengstacke: he tirelessly kept the glorious image of the Wall in our sights for so many years, and I wish he could see this book come to fruition. I cannot give enough thanks to my family and

especially to Mike and Oliver, for their patience and support. I hope they find the results worthy of the time it took me away from them.

—Rebecca Zorach

Robert Earl (Trees) Wilson, also known as Adeoshun Ifalade, was responsible for introducing me to the world of fine art, documentary, and reportage photography. I will be eternally grateful for his contribution to me. Perhaps equally important, I want to salute Bill Walker, members of OBAC, and the countless, awesome Chicago African American photographers. This extremely talented group inspires me every day.

—Darryl Cowherd

We came together in unity of purpose, as artists and members of the Organization of Black American Culture (OBAC), to create a work that became the Wall of Respect for the community that lived in the area of 43rd and Langley on the South Side of Chicago. For this Wall of Respect artists worked for three months with one another: with photographers William (Fundi) Abernathy, Darryl Cowherd, Roy Lewis, and Robert A. Sengstacke, and with other artists, including Sylvia (Laini) Abernathy, Jeff Donaldson, Ed Christmas, Hoyt Fuller, Wadsworth Jarrell, Carolyn Lawrence, Onikwa Bill Wallace, Barbara Jones-Hogu, and Elliott Hunter. Bob Paige and Bob Crawford were there, among others. There are very few times in an artist's life when he or she gives up their individuality to create a national treasure such as the Wall of Respect. That summer (1967) has become the most important summer that any of us ever had, and I hope this book will keep that spirit alive, so that the Wall of Respect will live forever.

—Roy Joe Lewis

Bibliography

African American Historical and Cultural Muscum. *The People's Art, Black Murals, 1967–1978*. Philadelphia: The Museum, 1978.

Africobra: The First Twenty Years. Atlanta: Nexus Contemporary Art Center, 1990.

Africobra II. New York: Studio Museum in Harlem, 1971.

Alkalimat, Abdul, and Doug Gills. *Harold Washington and the Crisis of Black Power in Chicago: Mass Protest*. Chicago: Twenty-First Century Books and Publications, 1989.

Allen, Jane Addams, and Derek Guthrie. "Norman Parish's Black Pride Shows thru the Whitewash." *Chicago Tribune*, July 16, 1972.

Anderson, Alan B., and George W. Pickering. *Confronting the Color Line: The Broken Promise of the Civil Rights Movement in Chicago*. Athens: University of Georgia Press, 1986.

Arts and Society: The Arts and the Black Revolution 5, no. 2 (Summer–Fall 1968).

Avedon, Richard, and James Baldwin. *Nothing Personal*. New York: Dell, 1965.

Baraka, Amiri, and Fundi Abernathy. *In Our Terribleness*. New York: Bobbs-Merrill, 1970.

Baldwin, Davarian L. *Chicago's New Negroes: Modernity, the Great Migration, and Black Urban Life*. Chapel Hill: University of North Carolina Press, 2007.

Becker, Heather. *Art for the People: The Rediscovery and Preservation of Progressive- and WPA-Era Murals in the Chicago Public Schools, 1904–1943*. San Francisco: Chronicle Books, 2002.

Bennett, Lerone. *Before the Mayflower: A History of Black America*. Chicago: Johnson Publishing, 1969.

Berger, Martin. *Seeing through Race: A Reinterpretation of Civil Rights Photography*. Berkeley: University of California Press, 2011.

Britton, Crystal. *African American Art: The Long Struggle*. New York: Smithmark, 1996.

Browne, Robert S. "The Case for Two Americas—One Black, One White." *New York Times*, August 11, 1968.

Burroughs, Margaret T. G. *Life with Margaret: The Official Autobiography*. Chicago: In Time Publishing and Media Group, 2003.

Campkin, Ben, Mariana Mogilevich, and Rebecca Ross. "Chicago's Wall of Respect: How a Mural Elicited a Sense of Collective Ownership." *The Guardian*, December 8, 2014.

Carmichael, Stokely, and Michael Thelwell. *Ready for Revolution: The Life and Struggles of Stokely Carmichael (Kwame Ture)*. New York: Scribner, 2003.

Cockcroft, Eva Sperling, John Pitman Weber, and Ben Keppel. *Toward a People's Art: The Contemporary Mural Movement*. Albuquerque: University of New Mexico Press, 1998.

Collins, Lisa Gail. "Activists Who Yearn for Art That Transforms: Parallels in the Black Arts and Feminist Art Movements in the United States." *Signs* 31, no. 3, special issue, New Feminist Theories of Visual Culture (Spring 2006): 717–52.

Collins, Lisa Gail, and Margo Natalie Crawford. *New Thoughts on the Black Arts Movement*. New Brunswick, N.J.: Rutgers University Press, 2006.

Crawford, Margo Natalie. "Black Light on the Wall of Respect." In *New Thoughts on the Black Arts Movement*, edited by Lisa Gail Collins and Margo Natalie Crawford. New Brunswick, N.J.: Rutgers University Press, 2006.

Dawson, Michael C. *Blacks In and Out of the Left*. Cambridge, Mass.: Harvard University Press, 2013.

DeCarava, Roy, and Langston Hughes. *The Sweet Flypaper of Life*. Washington, D.C.: Howard University Press, 1984.

Drake, St. Clair, and Horace R. Cayton. *Black Metropolis: A Study of Negro Life in a Northern City*. New York: Harper and Row, 1962.

Dolinar, Brian, and Writers' Program of the Work Projects Administration in the State of Illinois. *The Negro in Illinois: The WPA Papers*. Champaign: University of Illinois Press, 2013.

Donaldson, Jeff. "AfriCOBRA and Transatlantic Connections." *Nka: Journal of Contemporary African Art* 30, no. 1 (2012): 84–89.

———. "Africobra Manifesto?: 'Ten in Search of a Nation.'" *Nka: Journal of Contemporary African Art* 30, no.1 (2012): 76–83.

———. *The Civil Rights Yearbook*. Chicago: H. Regnery, 1964.

Donaldson, Jeff, and Geneva Smitherman Donaldson. *The People's Art: Black Murals, 1967–1978*. Philadelphia: African-American Historical and Cultural Museum, 1986.

Douglas, Robert L. *Wadsworth Jarrell: The Artist as Revolutionary*. San Francisco: Pomegranate Artbooks, 1996.

Drake, St. Clair, and Horace R. Cayton. *Black Metropolis: A Study of Negro Life in a Northern City*. New York: Harper and Row, 1962.

Du Bois, W. E. B. *The Souls of Black Folk* in *Three Negro Classics*. New York: Avon, 1965.

Ellsworth, Kirstin L. "Africobra and the Negotiation of Visual Afrocentrisms." *Civilisations* 58, no. 1, special issue, American Afrocentrism(e)s Américains (2009): 21–38.

Essien-Udom, Essien Udosen. *Black Nationalism: A Search for an Identity in America*. Chicago: University of Chicago Press, 1962.

Fanon, Frantz. *Black Skin, White Masks*. New York: Grove Press, 1967.

Fine, Elsa Honig. "Mainstream, Blackstream and the Black Art Movement." *Art Journal* 30, no. 4 (Summer 1971): 374–75.

Fish, John Hall. *Black Power/White Control: The Struggle of the Woodlawn Organization in Chicago*. Princeton, N.J.: Princeton University Press, 1973.

Foner, Philip Sheldon. *Organized Labor and the Black Worker, 1619–1973*. New York: Praeger, 1974.

Ford, Ausbra. "The Influence of African Art on African-American Art." In *The Visual Arts*, edited by Justine M. Cordwell. 1979. 513–34.

Gellman, Erik S. *Death Blow to Jim Crow: The National Negro Congress and the Rise of Militant Civil Rights*. Chapel Hill: University of North Carolina Press, 2012.

Gray, Mary L. *A Guide to Chicago's Murals*. Chicago: University of Chicago Press, 2001.

Green, Adam. *Selling the Race: Culture, Community, and Black Chicago, 1940–1955*. Chicago: University of Chicago Press, 2007.

Grossman, James R. *Land of Hope: Chicago, Black Southerners, and the Great Migration*. Chicago: University of Chicago Press, 1989.

Guzman, Richard. *Black Writing from Chicago: In the World, Not of It?* Carbondale: Southern Illinois University Press, 2006.

Haas, Jeffrey. *The Assassination of Fred Hampton: How the FBI and the Chicago Police Murdered a Black Panther*. Chicago: Chicago Review Press, 2010.

Harding, Vincent. *There Is a River: The Black Struggle for Freedom in America*. New York: Harcourt Brace Jovanovich, 1981.

Harris, Michael D. "From Double Consciousness to Double Vision: The Africentric Artist." *African Arts* 27, no. 2 (April 1994): 44–53.

Harris, Moira F. *Museum of the Streets: Minnesota's Contemporary Outdoor Murals*. St. Paul, Minn.: Pogo Press, 1987.

Hauser, Philip, et al., *Integration of the Public Schools, Chicago: Report to the Board of Education, City of Chicago*, 1964.

Hine, Darlene Clark, and John McCluskey. *The Black Chicago Renaissance*. Champaign: University of Illinois Press, 2012.

Howard University Department of Art. *AFRICOBRA, Groupe Fromaje: Esthétique Universelle=Universal Aesthetics*. Washington, D.C.: Art Gallery, Armour J. Blackburn University Center, 1989.

Huebner, Jeff. "The Man behind the Wall." *Chicago Reader*. August 28, 1997.

———. *Murals: The Great Walls of Joliet*. Champaign: University of Illinois Press for the Friends of Community Public Art, 2001.

———. "William Walker's Walls of Prophecy and Protest, and the Revolutionary Roots of a Public Art Movement." In *Art against the Law*, edited by Rebecca Zorach, 31–46. Chicago: School of the Art Institute of Chicago, 2014.

Hughes, Langston. *The Collected Works of Langston Hughes: Essays on Art, Race, Politics, and World Affairs*. Edited by Christopher C. De Santis. Columbia: University of Missouri Press, 2002.

Jarrell, Wadsworth. *AFRICOBRA: Experimental Art toward a School of Thought*. Durham, N.C.: Duke University Press, forthcoming.

Jones-Hogu, Barbara. "The History, Philosophy and Aesthetics of AFRICOBRA." *AREA Chicago*, no. 7 (2008).

Jones, Seitu. "Public Art That Inspires: Public Art That Informs." In *Critical Issues in Public Art*, edited by Harriet F. Senie and Sally Webster. Smithsonian, 1998.

Joseph, Peniel E. *Waiting 'Til the Midnight Hour: A Narrative History of Black Power in America*. New York: Henry Holt and Co., 2006.

King, Woodie. *Black Spirits: A Festival of New Black Poets in America*. New York: Vintage Books, 1972.

Knupfer, Anne Meis. *The Chicago Black Renaissance and Women's Activism*. Champaign: University of Illinois Press, 2006.

Lewis, George E. "Purposive Patterning: Jeff Donaldson, Muhal Richard Abrams, and the Multidominance of Consciousness." *Lenox Avenue: A Journal of Interarts Inquiry* 5 (1999): 63–69.

Lewis, Samella. *The Street Art of Black America*. Houston: Exxon U.S.A., 1973.

Junkin, Lisa. "Mighty Black Wall: A History of Chicago's *Wall of Respect* Mural." *http://www.artic.edu/~ljunki/mightyblackwall.doc*.

Mark, Norman. "A Matter of Black and White," *Chicago Daily News, Panorama* magazine, May 18, 1968.

Meier, August, and Elliott M. Rudwick. *CORE: A Study in the Civil Rights Movement, 1942–1968*. New York: Oxford University Press, 1973.

Moore, Natalie Y., and Lance Williams. *The Almighty Black P Stone Nation: The Rise, Fall, and Resurgence of an American Gang*. Chicago: Chicago Review Press, 2011.

Moore, Richard. *The Name "Negro": Its Origin and Evil Use*, rev. ed. Baltimore: Black Classic Press, 1992 [1960].

Mullen, Bill. *Popular Fronts: Chicago and African-American Cultural Politics, 1935–46*. Champaign: University of Illinois Press, 1999.

Neal, Larry. "The Black Arts Movement." *TDR: The Drama Review* (1968): 29–39.

"Object: Diversity." *Time*, April 6, 1970.

Organization of Black American Culture Writers' Workshop. *Nommo, A Literary Legacy of Black Chicago (1967–1987): An Anthology of the OBAC Writers' Workshop*. Edited by Carole A. Parks. Chicago: OBAhouse, 1987.

———. *Nommo 2, Remembering Ourselves Whole: An OBAC Anthology of Contemporary Black Writing*. Chicago: OBAhouse, 1990.

Parish, Norman, III. "Tribute to a Long-Gone Mural and a Father Who Helped Create It." *The Washington Post*, April 17, 2015.

Pinder, Kymberly. *Painting the Gospel: Black Public Art and Religion in Chicago*. Chicago: University of Illinois Press, 2016.

Prashad, Vijay. *The Darker Nations: A People's History of the Third World*. New York: New Press, 2007.

Prigoff, James, and Robin J. Dunitz. *Walls of Heritage, Walls of Pride: African American Murals*. San Francisco: Pomegranate, 2000.

Reed, Christopher Robert. *Black Chicago's First Century. Volume 1, 1833–1900*. Columbia: University of Missouri Press, 2005.

Rivera, Ramon J., Gerald A. McWorter, and Ernest Lillienstein. "Freedom Day II in Chicago." *Equity and Excellence in Education* 2, no. 4 (August 1964): 34–40.

Rogovin, Mark, Marie Burton, and Holly Highfill. *Mural Manual: How to Paint Murals for the Classroom*. Boston: Beacon Press, 1975.

Salaam, Kalamu ya. "The Black Arts Movement." In *The Oxford Companion to African American Literature*, edited by William L. Andrews, Frances Smith Foster, and Trudier Harris. New York: Oxford University Press, 1997.

Schiffert, Craig A. *"Wall of Respect": The Genesis and Impact of the First African-American Street Mural*. M.A. thesis, University of Wisconsin, 1993.

Semmes, Clovis E. *The Regal Theater and Black Culture*. New York: Palgrave Macmillan, 2006.

Smethurst, James Edward. *The Black Arts Movement: Literary Nationalism in the 1960s and 1970s*. Chapel Hill: University of North Carolina Press, 2005.

Sorell, Victor. "From the Studio and into the Street." *Art Journal* 39, no. 4, special issue, Command Performance (Summer 1980): 286–87.

———. *Images of Conscience: The Art of Bill Walker*. Chicago: Chicago State University Galleries, 1987.

Spear, Allan H. *Black Chicago: The Making of a Negro Ghetto, 1890–1920*. Chicago: University of Chicago Press, 1967.

Stuckey, Sterling. *Slave Culture: Nationalist Theory and the Foundations of Black America*. New York: Oxford University Press, 1987.

Theisen, Olive Jensen. *The Murals of John Thomas Biggers: American Muralist, African American Artist*. Hampton, Va.: Hampton University Museum, 1996.

Thorson, Alice. "AfriCobra—Then and Now: An Interview with Jeff Donaldson," *New Art Examiner* 17, no. 7 (March 1990): 26–31.

Togba, Edna M. "Barbara Jones Hogu in Conversation with Edna M. Togba." *Nka: Journal of Contemporary African Art* 30, no. 1 (2012): 138–44.

Tracy, Steven C. *Writers of the Black Chicago Renaissance*. Champaign: University of Illinois Press, 2011.

Travis, Dempsey J. *An Autobiography of Black Chicago*. Chicago: Urban Research Institute, 1981.

———. *Harold: The People's Mayor: An Authorized Biography of Mayor Harold Washington*. Chicago: Urban Research Press, 1989.

———. *I Refuse to Learn to Fail: The Autobiography of Dempsey J. Travis*. Chicago: Urban Research Press, 1992.

"Wall of Respect: Artists Paint Images of Black Dignity in Heart of City Ghetto." *Ebony*, December 1967, 48–50.

Walters, Ronald W. *Pan Africanism in the African Diaspora: An Analysis of Modern Afrocentric Political Movements*. Detroit: Wayne State University Press, 1993.

"White Women Set Off Two-Hour Melee in Chicago," *Jet* 32, no. 9 (June 8, 1967): 7.

Williams, Juan. *Eyes on the Prize: America's Civil Rights Years, 1954–1965*. New York: Viking, 1987.

Williams, Sonja D. *Word Warrior Richard Durham, Radio, and Freedom*. Champaign: University of Illinois Press, 2015.

Willis, Deb. Introduction to *Two Schools: New York and Chicago, Contemporary African-American Photography in the 60s and 70s*. New York: Kenkeleba House, 1986.

Zorach, Rebecca. "Art and Soul: An Experimental Friendship between the Street and a Museum." *Art Journal* (December 2011): 66–87.

———. "'Dig the Diversity in Unity': AfriCOBRA's Black Family." *Afterall: A Journal of Art, Context and Enquiry* 28 (2011): 102–11.

Credits

Every effort has been taken to secure permission and properly acknowledge copyright-protected material reproduced herein. Unless otherwise noted, photographs are copyright by the artists and used with their permission.

pages ii–iii: Background image for title spread copyright © Robert A. Sengstacke, 1967. See also photograph, page 230.

pages 14–15: Background image for part 1 copyright © Robert A. Sengstacke, 1967. See also photograph, page 230.

page 37: Gwendolyn Brooks, "The Wall" from "Two Dedications" diptych poem from *In the Mecca* (New York: Harper & Row, 1968). Reprinted by consent of Brooks Permissions.

page 39: Don L. Lee (Haki R. Madhubuti), "The Wall," copyright © 1968. This poem first appeared in the *Chicago Defender*; it then was included in Lee's anthology *Black Pride* (Detroit: Broadside Press, 1969). Reprinted by permission of Haki R. Madhubuti at Third World Press, Chicago, Illinois.

page 41: Useni Eugene Perkins, "Black Culture (For the WALL at 43rd and Langley)," from *Black Is Beautiful* (Free Black Press, 1968).

page 43: Alicia L. Johnson, "Black Art Spirits," from the anthology *Black Arts: An Anthology of Black Creations*, edited by Ahmed Alhamisi and Harun Kofi Wangeara (Black Arts Publications, 1969). Reprinted by permission of Alicia Griffin.

pages 46–47: Background image for part 2 copyright © Robert A. Sengstacke, 1967. See also photograph, pages 70–71.

pages 72–73: Background image for part 3 copyright © Bob Crawford, 1967. See also photograph, page 235.

pages 77, 78: Photographs by Marion S. Trikosko. Courtesy of the Library of Congress, U.S. News & World Report Magazine Photograph Collection.

page 160: "An Invitation to OBAC Dialogues: Rappin' Black." Copyright © Joseph R. Simpson.

page 175: Hoyt W. Fuller, "Culture Consciousness in Chicago," ("Happenings" column), *Negro Digest* magazine, August 1967, 85–87. Courtesy Johnson Publishing Company LLC. All rights reserved.

page 177: Muhal Richard Abrams and John Shenoy Jackson, "The Association for the Advancement of Creative Musicians," ("Special Report" section), *Black World* magazine, November 1973, 72–74. Courtesy Johnson Publishing Company, LLC. All rights reserved.

page 179: Hoyt W. Fuller, "OBAC: A Year Later, *Negro Digest* magazine, July 1968, 92–94. Courtesy Johnson Publishing Company, LLC. All rights reserved.

page 182: Hoyt W. Fuller, "Towards a Black Aesthetic," from *The Black Aesthetic*, edited by Addison Gayle Jr. (New York: Anchor/Doubleday, 1971), 3–11.

pages 190–191: Background image for part 4 copyright © Roy Lewis, 1967. See also photograph, page 272.

pages 270–271: Background image for part 5 by Georg Stahl. See also photograph, page 281.

page 287: Sam Washington, "Wall Paintings on 43d St. Show Black Man's Triumphs," *Chicago Daily Defender*, August 28, 1967, 3. Reprinted by permission of Chicago Defender Publishing Co. Capitalization and spelling are all per the original publication.

page 289: Dave Potter, "Crowds Gather as 'Wall' Is Formally Dedicated," *Chicago Daily Defender*, October 2, 1967, 3. Reprinted by permission of Chicago Defender Publishing Co. Capitalization and spelling are all per the original publication.

page 291: "Wall of Respect: Artists Paint Images of Black Dignity in Heart of City Ghetto," *Ebony* magazine, December 1967, 48–50. Courtesy EBONY Media Operations, LLC. All rights reserved.

page 293: Jeff Donaldson, "The Rise, Fall, and Legacy of the Wall of Respect Movement." Copyright © Jameela K. Donaldson, for Jeff Donaldson. Originally published in the *International Review of African American Art* 15, no. 1 (special issue, 1991): 22–26.

page 300: Victor Sorell, excerpt from oral history interview with William Walker, June 12–14, 1991, Archives of American Art, Smithsonian Institution.

page 307: Chicago Mural Group conversation with William Walker, 1971. Transcribed from tapes of Chicago Mural Group meetings kept by William Walker. From the Chicago Public Art Group archive (tape 25, 1 of 2). Courtesy of John Pitman Weber and Steve Weaver.

page 313: Excerpt from an interview with Eugene "Eda" Wade by Rebecca Zorach and Marissa Baker, conducted at Malcolm X College, 1900 West Van Buren, in Chicago, on April 17, 2015. Courtesy of Eugene "Eda" Wade and Marissa Baker.

page 321: Norman Parish III, "Wall of Respect: How Chicago Artists Gave Birth to the Ethnic Mural," *Chicago Tribune*, August 23, 1992.

page 324: Wall of Respect Symposium, "The Wall of Respect and People's Art since 1967," keynote address by Romi Crawford and excerpt from a roundtable discussion with Darryl Cowherd, Roy Lewis, Faheem Majeed, Norman Parish III, Robert Sengstacke, and Eugene "Eda" Wade at the School of the Art Institute (SAIC), April 2015.

Index

Page numbers in boldface refer to illustrations.

Second to None: Chicago Stories celebrates the authenticity of a city brimming with rich narratives and untold histories. Spotlighting original, unique, and rarely explored stories, Second to None unveils a new and significant layer to Chicago's big-shouldered literary landscape.

Harvey Young, series editor